from **COVERALLS** *to* **ZOOT SUITS**

ELIZABETH R. ESCOBEDO

from COVERALLS
to ZOOT SUITS

The Lives of Mexican American Women

on the World War II Home Front

The University *of* North Carolina Press *Chapel Hill*

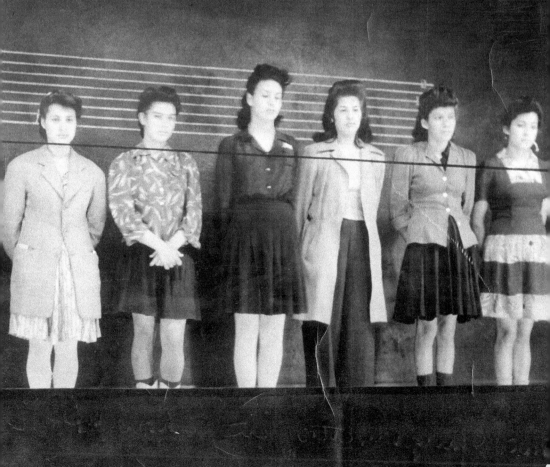

The paper in this book meets the guidelines for permanence and durability of the Committee on Production Guidelines for Book Longevity of the Council on Library Resources.

The University of North Carolina Press has been a member of the Green Press Initiative since 2003.

Library of Congress Cataloging-in-Publication Data

Escobedo, Elizabeth Rachel.

From coveralls to zoot suits : the lives of Mexican American women on the World War II home front / Elizabeth R. Escobedo.

p. cm.

Includes bibliographical references and index.

ISBN 978-1-4696-0205-9 (cloth : alk. paper)

1. Mexican American women—California—Los Angeles—Social conditions—20th century. 2. Mexican American women—Employment—California—Los Angeles—History. 3. World War, 1939–1945—Women—California—Los Angeles. 4. World War, 1939–1945—War work—California—Los Angeles. 5. World War, 1939–1945—Social aspects—California—Los Angeles. I. Title.

F869.L89M5156 2013

305.8968′72073079494—dc23

2012028591

17 16 15 14 13 5 4 3 2 1

Portions of this work appeared previously in somewhat different form in Elizabeth R. Escobedo, "The Pachuca Panic: Sexual and Cultural Battlegrounds in World War II Los Angeles," *Western Historical Quarterly* 38, no. 2 (Summer 2007): 133–56. © Western History Association. Reprinted by permission.

THIS BOOK WAS DIGITALLY PRINTED

for **AUNTIE ERNIE** *and* **AUNTIE IDA**,

and all the other women who lived it

CONTENTS

ILLUSTRATIONS

ACKNOWLEDGMENTS

I could not have written this book without the support of many generous individuals and institutions. Although it is difficult to find words adequate enough to express the gratitude I feel toward the friends, colleagues, and loved ones who helped me along the way, it gives me great pleasure to acknowledge them here.

I started this book during my graduate career at the University of Washington, where I had the good fortune to work with an incredibly talented and supportive group of teachers and scholars. I learned much from Suzanne Lebsock's thoughtful observations and dedication to uncovering the lives of ordinary women. Jim Gregory offered me encouragement and sage advice throughout this project and my career in general, and his astute reading of my work pushed me to make important connections and to broaden the scope of my study. I am deeply grateful to him. Susan Glenn served as an ideal mentor and adviser at every turn. She gave generously of her time to read and reread numerous drafts of this study in its earlier stages, always providing excellent suggestions and valuable criticisms. Her unflagging faith that I had the ability to tell this story sustained me over the years, and I consider myself among the most fortunate to continue to benefit from her wisdom and support.

Generous financial support also saw me through the research and writing process. I am thankful to the University of Washington's History Department, the Historical Society of Southern California, the Coalition for Western Women's History, the Woodrow Wilson National Fellowship Foundation, and the Haynes Foundation for providing me with funding. I am especially grateful to have received a Ford Foundation Post-Doctoral Fellowship in 2007–8, an honor that allowed me to take time away from my teaching responsibilities in order to focus on significant revisions to the manuscript.

While conducting research, numerous librarians and archivists kindly gave of their time to help me with my research. I would like to thank the staffs

of the California State Archives, the Huntington Library, Stanford's Department of Special Collections and University Archives, the National Archives and Records Administration at San Bruno and College Park, and the Southern California Library for helping me to locate key documents and making my research trips fruitful and comfortable. In particular, Jeff Rankin always greeted me with a friendly smile and witty story, making my work at UCLA's Special Collections especially enjoyable. At Boeing, Patricia McGinnis directed me to key sources; volunteer Jim Turner scanned materials for me; and Mary Kane assisted me in making sure that I could include key photos in the manuscript. I am also grateful to Wendy Aron, Willie Burton, Terry Truong, and Judge Terry Friedman of the Juvenile Division of the L.A. County Superior Court for helping me to navigate the petition process and ultimately granting me permission to look at 1940s L.A. County Juvenile Court case files. With much encouragement, Sherna Gluck also allowed me to quote from several volumes of the Rosie the Riveter Revisited Oral History Project, an indispensable resource at California State University, Long Beach. Robert Marshall of the CSU Northridge Urban Archives deserves special mention as well. From day one, Marshall expressed tremendous enthusiasm for my project, and our conversations about history provided me with many important insights.

For seeing this book to completion, I also thank the incredibly talented editorial and production staff at UNC Press. I am very grateful to Chuck Grench for his interest in this project and for serving as a model of professionalism and guidance throughout the entire process. I am thankful, too, for the care and attentiveness Mary Caviness provided in her edits of the manuscript, and to the efforts of Sara Jo Cohen, who always lent a helping hand.

One of the greatest joys of being a historian has been surrounding myself with an incredibly talented circle of friends and colleagues who have shared their knowledge, nurtured my research, and offered a friendly ear and a shoulder to lean on. I am especially thankful for Shana Bernstein, Marisela Chávez, Lisa Flores, Gabriela González, Monica Perales, Gina Marie Pitti, and Mary Ann Villarreal, all of whom provided me with me an invaluable network of friendship and unflagging support across the nation. In graduate school and beyond, fellow University of Washington alums Nelly Blacker-Hanson, Susan Bragg, Jeff Brune, Matt Klingle, Jen Seltz, Matt Sneddon, and Seema Sohi also offered sage advice and encouragement that I've come to rely on. I will always be especially grateful to Susan Bragg for reading numerous pages of the manuscript and for offering astute, incisive feedback at critical points in my writing process.

I have also benefited greatly from the tremendous collegiality of fellow historians who took time out of their busy schedules to comment on my work and to assist me in numerous ways as I navigated the world of academia. To José Alamillo, Luis Alvarez, Matt Garcia, Natalia Molina, and Catherine Ramírez, I offer my upmost thanks for your generous spirits. I must also thank the anonymous *Western Historical Quarterly* readers who provided thoughtful comments on my "Pachuca Panic" article; their perspectives encouraged me to think about the larger book project in new and exciting ways. For reading my book manuscript in its entirety I wholeheartedly thank Vicki Ruiz and Eduardo Pagán. I could not have asked for two more conscientious readers, as they both provided me with a wealth of valuable suggestions and insights that no doubt improved my work in countless ways. By far my greatest professional thanks go to Vicki Ruiz. In spite of her numerous commitments, she has served as a trusted mentor since my earliest days in academia. Many of my professional opportunities trace back to her assistance and support, and I feel so very fortunate to have benefited from her guidance. Her dedication to Chicana history, and to its cadre of scholars, remains a source of inspiration.

With my first teaching position, in the History Department at the University of Texas, San Antonio, I was welcomed into a tremendously supportive community of colleagues and friends who nurtured me in the earliest stages of my academic career. I am especially grateful to Kirsten Gardner, Gabriela González, Kolleen Guy, Anne Hardgrove, Patrick Kelly, and Catherine Nolan-Ferrell for providing me with important feedback on my work and giving me invaluable advice and support when I needed it the most. In the History Department at the University of Denver, I have been incredibly fortunate to be surrounded by a similarly talented and generous group of colleagues. I feel privileged to be in their company and continue to learn a tremendous amount from each and every one of their examples. I am especially grateful for the mentorship provided by Joyce Goodfriend, Carol Helstosky, Rafael Ioris, Beth Karlsgodt, Jodie Kreider, Tom Romero, Susan Schulten, and Ingrid Tague. I am also very appreciative to have had generous backing from the University of Denver's Division of Arts, Humanities, and Social Sciences; I thank Dean Anne McCall for her efforts.

Numerous dear friends also remind me of the world outside of academia, enriching my life in countless ways. In addition to those friends mentioned above, I thank Stacey Bosick, Jennifer Chen-Speckman, Hope Davidson, Erin Hirschler, Jessica Hunter, Amy Kim, Kristin Russ, Liz

Solan, Rachel Woodruff, and Jeremy Yu for their love, encouragement, and, above all, their ability to make me laugh. They have each helped me to keep my work in perspective and reminded me of the best things in life. This list would be wholly incomplete without special mention of Connie Chiang, whose friendship, more than any other, straddles my academic and nonacademic worlds. Connie was my first friend in graduate school and remains one of my best. She has been with this project from day one, and at every turn offered me wise advice and invaluable suggestions for improvement. I thank her not only for reading this manuscript in its entirety but for her kindness, warmth, and good humor. I am very grateful for her presence in my life.

I am also very thankful for my family, extended and otherwise. The Cochrans and Hartmans continue to cheer me up and on, and the Collissons have opened their home and hearts to make me feel like a true member of the family. I am especially indebted to my father-in-law and fellow history Ph.D., Roger Collisson, for sharing with me his passion for thinking about the past. Since I was three years old, Kim and Craig Jacobs, and their daughters Hope and Jess, provided me with a home away from home. I can say with upmost certainty that I would not be who I am today without their love and steadfast support. My father, Joe Escobedo, kindled my love for history with his lively stories about the old neighborhood on Bixel Street. Over the years his recollections, and those of his brother and sisters, imbued in me a deep respect and admiration for his generation. He and my stepmother, Nancy, have always encouraged my aspirations and provided a supportive atmosphere for me to pursue my studies. I am very grateful for their love. Finally, I thank my mother, Margie Cochran, for nurturing and encouraging me with a love and kindness like no other. Her compassion for others is a constant source of inspiration, and I count myself among the most fortunate to have been raised by such a caring and giving individual.

My deepest appreciation goes to my husband, Craig Collisson, and our son, Zachary, who remain daily reminders of what I value most in life. Since we first met in graduate school, Craig has been a wealth of ideas, support, and encouragement. I thank him for sharing my life with me—it is all the richer with him by my side. As for Zachary, I knew that becoming a mother would be a rewarding endeavor but never imagined the boundless joy that one person could bring to another. I am so appreciative of his love and laughter, and for his ability to make my future look so bright.

The most personally rewarding part of writing this book was the opportunity to spend time with the remarkable women whose life stories form the

backbone of its narrative. I am thankful to all who put me in contact with interviewees, and in particular to those women who so graciously gave of their time and confided in me their reminiscences. Their trust in my abilities and generosity in sharing their memories not only made this project possible but made it come alive.

ABBREVIATIONS

AFL	American Federation of Labor
ANMA	Asociación Nacional México-Americana
CCLAY	Coordinating Council for Latin American Youth
CIO	Congress of Industrial Organizations
CSO	Community Service Organization
El Congreso	El Congreso de Pueblos de Hablan Española (the Spanish-Speaking Peoples Congress)
FEPC	Committee on Fair Employment Practice
FTA	Food, Tobacco, Agricultural, and Allied Workers of America
HUAC	House Un-American Activities Committee
IAM	International Association of Machinists
ILGWU	International Ladies' Garment Workers Union
INS	Immigration and Naturalization Service
LACPFB	Los Angeles Committee for Protection of Foreign Born
LAPD	Los Angeles Police Department
LULAC	League of United Latin American Citizens

Mine-Mill	International Mine, Mill, and Smelter Workers Union
NAACP	National Association for the Advancement of Colored People
NLRB	National Labor Relations Board
OCIAA	Office of the Coordinator of Inter-American Affairs
OWI	Office of War Information
SCCIAA	Southern California Council of Inter-American Affairs
SLDC	Sleepy Lagoon Defense Committee
UAW	United Auto Workers
UCAPAWA	United Cannery, Agricultural, Packing and Allied Workers of America
USES	United States Employment Service
USO	United Service Organizations
WMC	War Manpower Commission
YWCA	Young Women's Christian Association

from **COVERALLS** *to* **ZOOT SUITS**

INTRODUCTION

It was 1943 when twenty-eight-year-old Connie Gonzáles left her job as a seamstress in a Los Angeles garment factory for a night-shift riveting position at the Douglas Aircraft Company in Long Beach. Having previously worked in low-wage occupations, Gonzáles jumped at the opportunity to earn more money and to demonstrate her patriotism as a laborer on C-47 transport planes. After successfully completing a two-week course where she learned to operate a rivet gun and work a jig, Gonzáles started her new job at the "immense" Douglas plant. As she recalled it, "The country needed war help. . . . I was very proud of helping out for the war."[1]

The wartime home front created numerous other social and cultural opportunities for Gonzáles. Living at home with Mexican parents who kept a tight rein on their elder daughter, Gonzáles received parental permission to carpool daily out of Boyle Heights with a group of Anglo girlfriends, her fellow coworkers at Douglas. Making good money, Gonzáles also began attending big band shows and dances at popular Los Angeles venues. For most of her life, Gonzáles had been sheltered by her parents, and even as a widow—her husband died abruptly in 1936 after just four months of marriage—she was expected to remain in the company of a male family member whenever she left the house. Yet as her four brothers enlisted in the armed forces, and eventually found themselves serving overseas, Gonzáles realized she could now experience a social life without a male chaperone. With her girlfriend Helen Torres by her side, she stayed out late, taking part in Los Angeles nightlife and reveling in the "patriotic" opportunities to date Mexican American and Euro-American servicemen on furlough. Although by 1945 she—like countless other American women—lost her job to postwar layoffs, Gonzáles would always remember World War II with particular fondness. "The war gave us a lot of money and a lot of exposure to people we'd never seen before," she explained.[2]

The World War II years proved equally significant in the life of Ida Escobedo. While still attending high school, Escobedo began her first summer

job in 1943, working alongside her aunt at a small downtown defense plant that manufactured incendiary bombs. She made good wages in the assembly position, far more than her mother and older sister had ever earned in the domestic and garment workforce. By June of 1944, Escobedo graduated high school and the very next day started a full-time position as a riveter alongside her sister Ernestine at Advanced Relay, a defense plant within walking distance of their neighborhood. Although Ernestine warned that some of her male coworkers "were kind of rough," the position promised to be rewarding enough that Ida was willing to overlook the potential for conflict. Rather, she focused on the good pay and the fact that she would be making an important contribution to the war effort. As Escobedo recalled with excitement, the job was "so secret even I d[idn]'t know what I [was] doing!"[3]

Much like Connie Gonzáles, Ida Escobedo made the decision to spend a good portion of her new earnings on leisure. After putting aside money to give to her mother and to purchase war bonds, Escobedo would steal away to buy beauty products and stylish zoot suit clothing. Certainly not naive to the disreputable behavior associated with female "zoot suiters"—popularly known as "pachucas"—Escobedo nevertheless "admired" the fashion. "There was a lot of discrimination against [Mexicans]," Escobedo recalled. "We got looks. We would go on the bus, you know, get on the bus to go downtown or whatever and they would look at us and think [we were] . . . gang members." Yet despite the negative treatment, Escobedo liked the "very expensive" and "tailor-made" clothing that made her feel "in style" with fellow Mexican American teens, and far removed from the more traditional worlds of her mother and larger society.[4] In her zoot attire, Escobedo forged a new identity based on independence, a more pronounced sexuality, and a sense of belonging to a distinctly Mexican American subculture.

This study investigates the multiple meanings of World War II for women of Mexican descent, capturing, in particular, the range of Mexican American women's wartime identities—and their reception—in the urban environment. As war workers and volunteers, dance hostesses and zoot suiters, respectable young ladies and rebellious daughters, women of Mexican descent navigated complex and at times overlapping identities that in the World War II era garnered acceptance in some circles and rejection in others. Ultimately, the fluidity of their collective behavior would expose the tensions between opportunity and limitation that the war years afforded Mexican women.[5]

The stories of women like Connie Gonzáles and Ida Escobedo underscore the many contradictions at work within Mexican American women's families and communities during the Second World War. In their day-to-day decision

making, second-generation women utilized wartime conditions both to serve the United States in its time of need and to pursue individual desires. Often, as was the case with Gonzáles and Escobedo, the ways in which they made meaning in their lives varied. From their choices in company to their choices in clothing styles, Mexican American women navigated their place in home front life, acculturating to some aspects of wartime society and rebelling against others. Yet informing these everyday personal choices were societal and familial constraints—from workplace discrimination to negative press coverage to strict gender conventions—constraints that illuminate firsthand the contradictory nature of World War II. Inasmuch as wartime conditions facilitated beneficial new freedoms for second-generation daughters to exercise control over their lives, long-standing gender and racial norms—both within and outside the Mexican community—circumscribed their new wartime options to one degree or another.

Why, and how, then, did World War II represent a simultaneously liberating and limiting experience for Mexican American women? What accounted for the contradictions in their wartime experiences? To date, existing historiography has by and large not attempted to grapple with these questions. General histories of race and World War II typically provide only cursory mention of Mexican Americans—usually in reference to the Zoot Suit Riots of 1943—or pay little attention to overlapping social categories—such as race, class, citizenship, and gender—that so profoundly affected Mexican women.[6] Additionally, recent historical scholarship on the ways in which the Mexican American community utilized World War II to facilitate civil rights activism has tended to focus on the role of formal organizations like the League of United Latin American Citizens (LULAC), the GI Forum, and El Congreso de Pueblos de Hablan Española (El Congreso) (the Spanish-Speaking Peoples Congress).[7] Often overlooked in these institutional perspectives is an understanding of the changing social and personal consciousness of the average, rank-and-file Mexican American woman as she negotiated new experiences and new encounters brought on by extraordinary circumstances. U.S. women's history, by comparison, has taken up such questions of individual consciousness but has tended to read race more narrowly. Histories of the Second World War's social, political, and economic effects on American women focus predominantly on Anglo and African American females, overlooking an opportunity to explore the ways in which the racially malleable position of Mexican American women allowed for privileges unavailable to their black counterparts.[8]

Recent scholarship on zoot suiters is an important area of study where wartime Mexican American women have received in-depth analysis. Scholars

including Catherine Ramírez, Luis Alvarez, and Eduardo Pagán provide nuanced investigation of the participation of Mexican American women in the rebellious zoot suit subculture of World War II, demonstrating the creative agency of these youths and the ways in which the wartime pachuca played the role as "constitutive other" in the creation of U.S. wartime nationalism.[9] *From Coveralls to Zoot Suits* builds on these important histories by exploring the wide-ranging variety of Mexican women's wartime identities and putting the Mexican American woman zoot suiter, war worker, and volunteer in conversation with one another. In so doing, it provides new perspective on the complicated intraracial relationships among Mexican American women—especially those desiring to play with pachuca identities, those trying to prove their respectability in light of the reviled pachuca persona, and those navigating a world somewhere in between.

The roots of Mexican American women's wartime experiences in Southern California can be traced to earlier decades of the twentieth century. With a growing second-generation Mexican population in the 1920s and 1930s Southwest, daughters of Mexican parents steadily entered the workforce in increasing numbers, earning wages to support their families and to gain social independence. In coming of age as Mexican Americans, they engaged in a process of what historian Vicki Ruiz terms "cultural coalescence," in which "immigrants and their children pick, borrow, retain, and create distinctive cultural forms." As such, second-generation women of Mexican descent navigated across and within varying cultural worlds and boundaries, creating new definitions of womanhood informed by their individual experiences. Eager to utilize their expendable income and participate in U.S. consumer culture, Mexican American women purchased cosmetics, adopting 1920s flapper styles and competing in barrio beauty pageants. Drawn to the allure of Hollywood, they expressed admiration for American movie actresses while feeling a sense of pride in seeing Latina celebrities like Lupe Vélez and Dolores del Rio on screen. At home, at work, and at play, young second-generation daughters creatively blended aspects of their Mexican and American social worlds.[10]

Yet the growing engagement of Mexican American women with U.S. society was not without its challenges, both internal to their families and external. Most Mexican parents attempted to circumscribe the social activities of the second generation, worrying that daughters would fall under the influence of loose American morals like going out late at night and dating without a chaperone.[11] Moreover, as familial responsibilities and economic survival drew Mexican women into the workforce, racial discrimination outside

barrio communities limited them to low-wage work in seasonal agriculture, food processing, garment making, and domestic labor, contributing to large-scale trends of restricted social mobility for the Mexican community more generally.[12] According to contemporary observers, Mexicans in Los Angeles represented one of the most impoverished groups in the United States, generally living alongside other working-class communities in blighted areas of substandard housing, often in neighborhoods lacking in sanitation and plagued by poor health conditions.[13]

By the onset of the Great Depression, the Mexican community faced a new set of hardships as the economy's decline sparked public demands for Los Angeles County officials and local businessmen to reserve scarce jobs and resources solely for American citizens. In just a short period of time, nativist depictions of Mexicans as outsiders likely to become public charges or likely to steal the jobs of "real Americans" prompted the deportation or repatriation of perhaps as many as a million members of the Mexican population—regardless of citizenship—by state and immigration officials throughout the Southwest. During the period from 1930 to 1939, Mexicans comprised 46.3 percent of all the people deported from the United States, this in spite of the fact that they constituted less than 1 percent of the total U.S. population.[14] In Los Angeles—home to the largest Mexican population in the nation—approximately 35,000 members of the Mexican community (close to one-third of the city's Mexican population) returned to Mexico during the decade, a phenomenon that divided devastated families throughout the 1930s.[15]

Those left to pick up the pieces of their fragmented communities increasingly turned toward labor and civil rights activism. If little else, repatriation had accelerated an important demographic shift already under way in the Mexican community: the transformation of a primarily foreign-born immigrant population to one composed mainly of American-born offspring. Whereas the number of Mexican-born residents in the city of Los Angeles declined from 56,304 in 1930 to 38,040 in 1940, the percentage of American-born members of the Mexican population grew from 45 to 65 percent.[16] Yet even as American citizens, native-born daughters and sons of Mexican immigrants remained all too aware of the contradictions in their social position. They were promised the privileges of first-class citizenship by birthright, but their day-to-day lives bespoke a harsh reality of marginalization and rights unfulfilled.[17]

Mexican American women in Southern California—eager to challenge strict gender conventions and remedy their second-class status in U.S. society—engaged in a variety of formal and informal political practices

during the 1930s and early 1940s. Drawing upon existing female support networks at home and on the job, they engaged in activities ranging from securing recognition of the United Cannery, Agricultural, Packing and Allied Workers of America (UCAPAWA), a Congress of Industrial Organizations (CIO)–affiliated labor union; to making women's rights a key element of the platform of El Congreso, a pan-Latino organization dedicated to labor and civil rights of the Spanish-speaking workers of the Southwest; to more personal and private clashes within immigrant families over the proper role and place of Mexican women in U.S. society, including courtship practices like chaperonage. Through varying strategies of outright resistance and subtle opposition, Mexican American women at once challenged sexual constraints and attempted to remedy social injustice.[18]

Yet as the United States entered the Second World War, a shifting gender and racial landscape played a significant role in changing the ways in which women of Mexican descent sought to exercise control over their lives in the home, workplace, and nation. Particularly unique to the worldview of Mexican American women of the 1940s was their coming of age during a time of war, a conflict that "delegitimated racism in the face of Nazism," and compelled Americans—in theory and, at times, in deed—to rethink notions of race and national belonging. As scholars of U.S. race relations note, World War II represented a critical moment in reconceptualizing ideas about race and liberalism. Although New Deal liberalism of the 1930s promised all Americans the helping hand of a large welfare state, more often than not federal policies remained inattentive to the plight of racial minorities. With the advent of war, however, national discomfort with Nazism demanded a reconceptualization of the American liberal agenda. Intellectuals and social commentators concerned with race increasingly engaged in educational campaigns to attack prejudice, emphasizing equal opportunity and the redress of racial inequality through antidiscrimination litigation and legislation. This position, known as racial liberalism, served to discredit biological assumptions of racial hierarchy and sought an expanded federal role in improving the plight of racial minorities in America.[19]

Wartime conditions and ideologies of racial liberalism played a key role in providing Mexican American women with new opportunities to challenge their position in the home and U.S. society with more legitimacy than previous years. In Los Angeles, an infusion of more than $11 billion in federal spending transformed the West Coast city into an industrial powerhouse capable of producing a lion's share of the nation's warships and planes.[20] Over the course of the war, more than a thousand defense plants in the region

underwent significant expansion, and, at the height of the conflict from 1942 to 1944, nearly 500 new war industries opened their doors for business. Federal defense contracts and expenditures to the "Big Six" aircraft companies—Douglas, Lockheed, North American, Northrup, Vega, and Vultee—and the city's burgeoning shipbuilding industry not only strengthened the manufacturing base of Los Angeles County but created record numbers of new, well-paid, skilled jobs.[21] Thus, in spite of long-standing discriminatory hiring patterns, war-related industries—desperate to fill defense orders—increasingly sought to hire women and workers of color, among them women of Mexican descent.

Just as the rapidly expanding industrial infrastructure of wartime Los Angeles influenced the everyday lives of Mexican American women, so too did the arrival of tens of thousands of new migrants to the city. By 1943, more than half a million people were employed in aircraft production, shipbuilding, and steel production in Los Angeles, and yet continued labor shortages of at least 60,000 workers ensured a steady influx of newcomers.[22] Although native- and foreign-born whites had long dominated the migrant stream to Los Angeles, the city did not lack in multiracial character. In 1930, non-whites—including Mexicans, Japanese, blacks, and Chinese—composed at least 14 percent of the Los Angeles population; the prewar city claimed the largest Mexican American and Japanese American populations in the United States, in addition to the most populous African American community in the West.[23]

Aside from prompting the removal of Japanese Americans from Los Angeles and other coastal regions in 1942, wartime conditions only contributed to the city's diversity.[24] Across the country, millions of Americans participated in massive wartime relocations, moving to manufacturing centers like Los Angeles in an effort to secure a piece of wartime prosperity. Those eager to cash in on the promise of good-paying jobs in Southern California ranged in background from "Defense Okies" of Oklahoma, Arkansas, Texas, and Missouri to Mexican American newcomers from the Southwest and Colorado.[25] Thousands more southern blacks also made the journey west, contributing to a phenomenon most commonly known as the Second Great Migration, the largest movement of African Americans out of the South since World War I. In the summer of 1943, blacks arrived in Los Angeles at a rate of 10,000 to 12,000 a month, constituting approximately 50 percent of the city's new migrants. Overall, more than 200,000 African Americans arrived in Los Angeles during the 1940s, resulting in a doubling of the black population by 1950.[26]

No less important, as social commentator Carey McWilliams observed, was the arrival of between seven and eight million soldiers, sailors, and marines who received their training in or traveled through wartime California as they "moved westward into the Pacific."[27] Southern California in particular witnessed a tremendous upsurge in armed forces personnel due to several large military installations in its proximity, including the U.S. Naval Drydocks at Terminal Island; the U.S. Navy Supply Depot at San Pedro; the U.S. Marine Corps Air Stations at El Toro and Santa Barbara; the Long Beach Naval Hospital; and the U.S. Naval Reserve Training School, located in the heart of the historically Mexican neighborhood of Chávez Ravine.[28] Day and night, public streets teemed with servicemen, many far away from home towns in the South, Midwest, and Northeast United States, and most having had little previous experience or contact with Mexicans prior to coming to Los Angeles. In these crowded public spaces, Euro-Americans interacted with racial minorities to an unprecedented degree, heightening the potential for racial conflict. As witnessed in skirmishes between Euro-American sailors and Mexican American male youths both before and during the ten-day outbreak of violence known as the Zoot Suit Riots of 1943, tensions remained high in a city turned inside out and upside down by its shifting demographics.[29]

Yet in spite of the volatile social climate, for Mexican American women the wartime growth of Los Angeles also provided unparalleled exposure to new types of people and experiences in their everyday lives. In wartime public venues, women of Mexican descent were more likely to meet and interact with non-Mexican members of the population—particularly Euro-American men—than in previous years. Throughout the 1940s, scores of servicemen stationed in Southern California met Mexican American women—many for the first time—and engaged in closer, and, on occasion, more intimate, contact. In a home front environment that highly promoted leisure as a patriotic duty, overprotected Mexican American women found a space to engage more legitimately in entertainment activities with the opposite sex—and, at times, men outside of the Mexican population—expanding their worldviews and loosening the boundaries of traditional policing.

As interactions across racial and ethnic lines became commonplace, so too did the federal government's interest in promoting morale and racial harmony. Aware of the potential for "shop floor and sidewalk conflict" in crowded U.S. production centers like Los Angeles, federal institutions paid closer attention to mediating social relations and promoting antidiscrimination in the name of wartime productivity.[30] Under the mantle of racial liberalism, and not without shortcomings, federal agencies like the Committee

on Fair Employment Practice (FEPC) and the War Manpower Commission (WMC) worked to investigate charges of racial discrimination in defense hiring, offering Mexican American women new opportunities for redress and negotiation. At the same time, the Office of War Information (OWI) and the Office of the Coordinator of Inter-American Affairs (OCIAA) embarked on a pluralistic reform campaign known as "Americans All," an effort to create the image of an inclusive nation, one where all racial and ethnic groups would unite under a common American identity. Imagery and discourses of "Americans All" often emphasized the role of women as upstanding representatives of the race, providing Mexican women with unprecedented positive recognition and state support.

Yet as the "Americans All" campaign illuminates, Mexican American women were more than just participants in the changing social landscape of World War II—they also played a symbolic role in wartime debates over culture and the future of race reform. In general, Mexican families welcomed women's participation in wartime activities as proof of the Mexican population's loyalty and commitment to the United States; yet at the same time, traditional families troubled over the long-term cultural implications of their daughters' readiness to explore new social avenues. Likewise, city and county reformers, in addition to the larger Los Angeleno populace, exhibited similar ambivalences about the changing social roles of the Mexican woman, but for different reasons. Officially, federal "Americans All" rhetoric hailed notions of unity and commonality; on a local level, however, the specter of Euro-American military men cavorting with Mexican American women simultaneously fanned everyday fears about "race mixing" and miscegenation.

The controversial "pachuca" figure represents one of the best examples of second-generation daughters becoming both a part and a symbol of shifting gender and racial ideologies on the World War II home front. Those Mexican American women who were typically thought to be "pachuca"—regardless of whether or not they self-identified as such—blatantly rebelled against Mexican and mainstream American social conventions by donning a zoot suit or a modified version of the male attire, a look that varied but often included a fingertip coat, a relatively short skirt, dark lipstick, and pompadoured hair. For the time, their clothing could be considered scandalous, especially because women in the 1940s typically did not wear pants outside the workplace, and skirts worn above the knee were considered short, if not immodest.[31] But more than just a fashion rebel, the so-called pachuca flaunted a sense of self that played with sexuality and highlighted cultural differences, posing a direct challenge to both second-class citizenship in the United States and rigid,

static notions of Mexican femininity. Although numerous Mexican American women worked, volunteered, and wore the zoot look during the war, the Mexican community and the larger populace focused on the latter behavior, condemning their particular style of rebellion. The pronounced presence of any young Mexican American woman deemed a pachuca threatened visions of familial stability, racial uplift, and racial unity and therefore rendered her a stigmatized outsider in the Mexican home and U.S. society.

The ability of Mexican American women to receive simultaneous commendation and condemnation attests to the malleability of their social position in America's racial order at midcentury. As members of an "in-between" community—historically considered neither racially black nor entirely white—women of Mexican descent found within the wartime environment an opportunity to be deemed just white enough to be tolerated—and, at times, genuinely accepted—as essential workers and volunteers to the wartime state. However, the not-black, almost-white status of Mexican women often depended on their conformity to an image of respectable womanhood—in the likeness of the laboring "Rosie the Riveter" or of the ladylike United Service Organizations (USO) hostess. For those who deviated from a path of wartime behavior deemed conventional and necessary, racial limitations remained.[32]

From Coveralls to Zoot Suits thus underscores the changing politics of race in the twentieth-century United States, illuminating the ways in which wartime conditions and racial liberalism both opened and closed doors for Mexican American women, depending largely upon their perceived behavior. Numerous women of Mexican descent found themselves readily accepted into wartime labor and leisure, due primarily to their attentions to respectability, in addition to their ability to negotiate arenas of intimacy in ways that their darker-skinned African American counterparts could not. However, not all women of Mexican descent wholeheartedly embraced the wartime vision of an America whose inhabitants claimed one common culture or the unity of all races and creeds. Similar to the ways in which the behavior of African American women came to signify the successes or failures of racial uplift movements of the twentieth century, wartime Mexican women served at once as symbols of both pride and shame. In their displays of respectability and propriety they actively refuted racial stereotypes; yet any rebellion as women made them vulnerable to disgrace.[33]

Looking back at the home front era, women like Connie Gonzáles and Ida Escobedo experienced clear benefits from their World War II experiences—including increased social and economic independence—and yet their overall options were just as likely to be circumscribed to one degree or another.

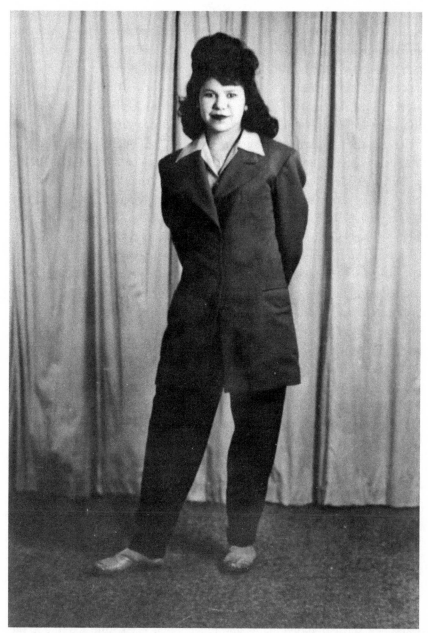

A Mexican American woman in a zoot suit, 1944. She also dons dark lipstick and a high hairdo. Los Angeles Public Library Photo Collection.

Many Mexican women certainly found it more permissible to participate in leisure culture during the war; but given sexualized stereotypes commonly imposed on racialized women, they could just as easily face accusations that they had loose morals. Here too was an era when Mexican women could more easily date white men within the context of wartime patriotism; yet more often than not cross-cultural socializing took place when Mexican and Euro-American family members remained unaware of their activities. Moreover, the unique racial climate of World War II offered opportunity for Mexican women to embrace pluralistic rhetoric as a path to inclusion in the nation; their attentions toward embracing a more "American" ethos, however, did not necessarily mean that Anglos would openly embrace them in any lasting way. As Ida Escobedo recalled, the wartime environment "promoted a lot of brotherhood," but the acceptance ended "as soon as the war was over."[34] In the end, home front life offered women of Mexican descent an abundance of new options to significantly challenge traditional gender and racial norms and to negotiate their place within American society. Yet the wide-ranging responses to their cultural experimentation shed light on the era as one of both opportunity *and* conflict, as even the most outwardly patriotic women could encounter tensions and opposition in simply trying to do their share for their country.

As the opening vignettes of Connie González and Ida Escobedo demonstrate, oral histories shed significant light on the home front experiences of Mexican American women, experiences that might otherwise go overlooked in the written record. In fact, the verbal storytelling of my Mexican American *tías* on my father's side of the family first inspired me to pursue this project. Like historian Vicki Ruiz, I encountered two types of history as a child: "the one at home and the one at school."[35] The Rosie the Riveter archetype figured heavily into my popular and scholastic understanding of women's wartime roles, but Ida Escobedo, my aunt, brought the home front to life. At family dinners, with a gleam in her eye, she shared vivid memories about how her world changed once the United States entered World War II. Although she and my aunt Ernestine worried daily about their brothers' safety overseas, they also reveled in new work and leisure roles, finding within the horrors of war a new sense of individuality and independence. As Aunt Ida told it, the Second World War represented a definitive moment in her overall sense of self as a woman of color. I could hardly wait to learn more.

Oral history served as an invaluable tool in my attempts to reconstruct a broader portrait of Mexican American women's wartime lives. This study draws from forty firsthand accounts of second-generation women who came

of age during World War II: I interviewed thirty-two of the women myself; the remaining eight interviews are housed at the California State University, Long Beach, Special Collections, and available at their Virtual Oral/Aural History Archive, as part of the Rosie the Riveter Revisited Oral History Project. Early on I made the decision to keep Los Angeles as the primary focus of my research, not simply because of its relevance to my own family, but because its unique wartime character provides a useful backdrop to explore how a city's exponential defense growth and multiracial composition could shape both opportunity and conflict for Mexican Americans. With the exception of three women, all of the interviewees included in this study were born in the United States and lived in the Southwest; those born outside Los Angeles typically came to Southern California at a young age, and all lived and/or worked in Los Angeles during the Second World War. Twenty-three interviewees were born in California, six in Arizona, six in Texas, one in New Mexico, one in Oklahoma, and three in Mexico. During World War II, they ranged in age from twelve to thirty-five years old, the majority single, living at home, and without children throughout the war. Three of the interviewees were married during the war—among them two were mothers and the other "completely on [her] own" while her husband was in the service.[36] I located the women in a variety of ways: some are members and friends of members of my immediate family; others contacted me—or had family members contact me—after reading about my project in community newspapers and on academic listservs; a good number I interviewed at Los Angeles senior centers. Their memories provide rich and otherwise irrecoverable personal details that cannot but help make a bygone era more readily understandable to a new generation.

Given the passage of time, however, I remain all too aware of the tendency for interviewees to reflect on their lives with hints of nostalgia and romance, and certainly with inaccuracies of historical memory. In order to address these concerns, *From Coveralls to Zoot Suits* draws equally from a wide array of local, state, and federal archival sources. I utilized Los Angeles County Juvenile Court records and Southern California English- and Spanish-language newspapers; papers of individuals and organizations prominent in the affairs of the Los Angeles Mexican community; and files of federal wartime institutions including the OWI, the OCIAA, the FEPC, and the WMC. It is my hope that the diversity of written records and spoken voices contribute to a more comprehensive and nuanced understanding of the history of Mexican Americans during World War II.

I structured this book to explore both the ways in which women of Mexican descent participated in home front life and how their place in U.S. society

came to be constructed and understood during the World War II era—from the shop floors where they worked to the dance floors where they played. Chapter 1 looks at the figure of the pachuca, or female zoot suiter, the rebellious young woman who challenged familial and communal norms by creating an affirming vision of racialized womanhood. I begin with the pachuca figure because the emergence of the new identity raised difficult questions about what it meant to be a Mexican American woman in the wartime era. At times a destructive personality, and yet also potentially liberating, the pachuca represented both a source of new options for Mexican American women and a burden in terms of personal and family reputation. A number of Mexican American women felt great personal satisfaction in adopting aspects of the zoot look, but popular perceptions of the pachuca as sexual delinquent allowed countless others to define themselves as proper and preferable in direct opposition to the pachuca figure. As one of the most extreme embodiments of female transgression, the pachuca became not only a lens through which Euro-Americans and first- and second-generation members of the Mexican population viewed women, but also a generally problematic figure that all Mexican American women had to acknowledge as they navigated the worlds of work, citizenship, and leisure during the World War II years.

Chapter 2 focuses on Mexican American women's changing relationship with the state and the media, detailing the ways in which the federal government promoted new, positive images about Mexican womanhood to advance the larger "Americans All" racial project. It then describes the efforts of Mexican mothers and daughters to utilize their contributions as defense workers and volunteers to the wartime state in order to dispel racial stereotypes and make equal claim to the privileges of Americanism and national belonging. Chapter 3 details the face-to-face interpersonal experiences of women war workers—particularly in the aircraft industry—where "respectable" labor facilitated new cross-cultural relationships and allowed Mexican women to serve their country and make the best wages many had ever earned. These women not only donned coveralls and engaged in skilled factory labor traditionally reserved for men, but they also used new state structures like the FEPC to fight for labor equity on the home front.

Chapter 4 continues my examination of the choices that Mexican American women made in the world of leisure, and the sometimes contradictory cultural politics they collectively employed in navigating through the rapidly shifting cultural and social boundaries of the war years. Wartime leisure created opportunities for second-generation daughters to "fit in" and mix socially and sexually with others, a phenomenon best illuminated by their

participation in the USO. Yet at the same time, the leisure realm also became a space for rebellion and articulation of cultural difference, as some Mexican American young women donned zoot suits in mainstream dance halls on the one hand and on the other hand worked to create community-building organizations like Señoritas USO, a Mexican American version of the USO. These new and at times conflicting ways of constructing Mexican American identities sparked public and private conflicts over the future of the Mexican family. Finally, Chapter 5 considers the long-term implications of Mexican American women's wartime roles. In spite of postwar layoffs and the repression of the Cold War era, the ideological beliefs and behavioral changes regarding race, sexuality, and sense of self that Mexican women developed during World War II continued to influence their lives long after war's end. In postwar Los Angeles, Mexican American women would witness a decline in chaperonage, a rise in intermarriage, and lasting multiracial connections. Given their desire to remedy their contradictory home front experiences, some embraced collective action and joined local civil rights organizations like the Community Service Organization (CSO) or the Los Angeles Committee for Protection of Foreign Born (LACPFB); others made decisions individually that challenged injustices in the everyday. The implications would be felt in the politics of the private postwar home and the broader civic arena of Southern California for generations to come.

1

The Pachuca Panic

On 9 June 1943, twenty-two-year-old Amelia Venegas left her East Los Angeles home, baby in arms, to buy milk at a local market. Concerned by news of recent skirmishes between Euro-American servicemen and Mexican American zoot suiters on city streets, the young mother impulsively grabbed a pair of brass knuckles she had found months earlier on a local sidewalk. With wartime emotions at heightened levels, a woman left alone while her navy husband fought overseas could never be too careful.

Yet for all of her precautions, trouble would soon befall Mrs. Venegas. As she and her baby witnessed police officers harassing a group of zoot suiters, Venegas felt a sense of injustice rise within her. Unable to contain her emotions, the Mexican American woman cursed the law enforcement officials for their hostile treatment of the young men. "They should leave the zoot suiters alone," Venegas later explained vehemently to reporters. Unmoved by her verbal denunciations, the officers immediately arrested Venegas for disturbing the peace and, upon finding the brass knuckles on her person, charged the young mother for carrying a concealed weapon.[1]

As newspapers got wind of the story, the Venegas incident seemed to confirm the then widely held belief that a Mexican American gang menace was overtaking Los Angeles. Venegas appeared never to have before been in trouble with the law, and yet the *Los Angeles Times* featured a photograph of her baring her teeth and shaking a threatening fist at the camera. Not only did the press deem Venegas a "pachuco" girl—a label suggesting gang affiliation—but her protests on behalf of zoot suiters—a much despised youth population—also made her a perfect target for a sensationalist media campaign.[2]

Although a public relations nightmare for the young mother, the experience of Amelia Venegas illuminates much more than just an example of the

press's sensationalist depictions of Mexican youths as dangerous wartime hoodlums. The Venegas story also sheds light on the changes taking place in the lives of Mexican American women in Los Angeles during World War II. Not simply victims of a press hungry for scandal, many second-generation Mexican American women did in fact adopt a new youth sub-culture that rejected aspects of both traditional Mexican and mainstream American culture. Known both as female "zoot suiters" and "pachucas," these young women blatantly rebelled against social conventions. They not only donned the controversial zoot suit, or a modification of the attire, but often kept company with fellow zoot-clad youth on city streets.[3]

More than just a fashion rebel, the wartime pachuca represented an important symbolic site on which debates regarding the changing social landscape of the war years unfolded. Using style and behavior as a way to challenge ideas of respectability and to assert a distinctive identity, pachucas defied mainstream notions of proper feminine decorum as well as static, traditional definitions of Mexican femininity. As women's social roles broadened more generally, and the Mexican family struggled to maintain a hold on its daughters, the pachuca came to represent a female figure whose dangerous sexuality demanded restraint.

All the more dangerous was how pachucas seemingly mixed their blatant sexuality with a politicized identity of Mexican American womanhood. Pachucas not only embraced a persona that celebrated cultural difference, but many of the young women also felt no qualms in expressing discontent with their second-class citizenship. In struggling with the question of how to occupy both their neighborhood and their nation, pachucas often rejected the wartime vision of Americans of all races and creeds embracing a single, common culture. Rather, the young women created an affirming identity that accentuated their status as racialized outsiders.

The struggles over the meaning of the pachuca often took place in the courts, where reformers and Mexican parents tried to make sense of what they found to be a troublesome, delinquent personality. Utilizing oral interviews and over 250 Los Angeles County Superior Court Juvenile Division case files of Mexican American women (excluding dependency cases) between the years 1939 and 1945, this chapter explores the communal, familial, and individual dilemmas created by the emergence of the wartime pachuca.[4] Immigrant parents blamed Americanization for their daughters' experimentations with zoot culture; reformers conceptualized the pachuca "problem" as a cultural pathology, a condition intrinsic to distinctive Mexican family patterns. At stake were the reformers' larger project of cultural assimilation and

the ability of the Mexican community to improve its image in U.S. society. Pachucas threatened both visions.

Over time, the notorious pachuca persona came to reveal the contradictions of the wartime environment, embodying both the new social opportunities available to young Mexican American women and a stigma in terms of female reputation and community status. On the one hand, pachucas posed a significant challenge to both their second-class citizenship in U.S. society and the patriarchal attitudes that defined the Mexican family and community. Yet, because of their perceived—and, at times, very real—association with juvenile delinquency and gang activity, the pachuca label also eventually came to identify any Mexican American woman who, like Amelia Venegas, seemingly defied social norms. In an effort to keep the gender and racial status quo in check, the Los Angeles populace—Euro-American and Mexican alike—embarked on a campaign to contain and stigmatize the young second-generation women who flew in the face of convention and adopted aspects of the defiant public persona.

PRIOR TO THE SUMMER OF 1942, the L.A. populace relatively ignored Mexican American women who adorned zoot suits, instead focusing almost entirely on their male counterparts. Mexican American men who adopted the zoot style—or "drapes," as the attire was often called in Los Angeles barrios— typically wore a fingertip jacket; trousers with wide knees that tapered at the ankle; heavy, thick-soled shoes; and hair in a duck-tail cut.[5] Although it is difficult to pinpoint the exact origins of the apparel, according to historian Eduardo Pagán, the zoot suit most likely originated among African American jazz artists and aficionados of the late 1930s, who no doubt increased the popularity of the style in the cities they toured. Indeed, Mexican American youths in Los Angeles gravitated with enthusiasm toward swing jazz during the war years, and thus it is not altogether surprising that the clothing and dance styles once associated with black urban subculture became just as popular among similarly marginalized populations.[6]

The zoot suit represented a spectacular style that was at once fashionable and defiant. Amid patriotic appeals for conformity and austerity, the conspicuous clothing came to signify the second generation's dissatisfaction with the hardship and segregation that defined their daily lives.[7] Although young Mexican Americans had begun experimenting with mass consumer culture in the 1920s and 1930s, it was not unusual for blacks and Mexicans to have restricted access to recreational facilities, including public parks and swimming pools, movie theaters, and restaurants, particularly in

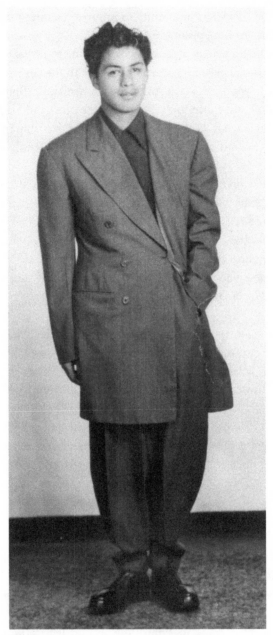

A Mexican American youth in a zoot suit, 1944.
Los Angeles Public Library Photo Collection.

working-class Los Angeles neighborhoods with large nonwhite populations.[8] But the greater job mobility and better wages made possible by the Second World War afforded the second-generation both the motivation and the opportunity to challenge their relegation to the social periphery. With more money in their pockets, and a desire for recognition, Mexican American youths increasingly ventured outside of their communities to frequent public spaces on the streets and in the dance halls, all-night cafeterias, and nightclubs of downtown Los Angeles, often dressed to the nines in zoot attire.[9]

As assertive, zoot-clad youth challenged segregation conspicuously and in greater number, city officials and law enforcement increasingly identified their dress and behavior as evidence of criminal tendencies. In cities nationwide, wartime rates of juvenile delinquency escalated among teenagers of all backgrounds—a phenomenon largely attributed to the recruitment of parents and older siblings into war work and the armed services, conditions that made it increasingly difficult to monitor the behavior of the nation's youth.[10] But in the diverse, urban metropolis of Los Angeles, authorities frequently cast the growing crisis of juvenile delinquency as an attendant "race problem," warning of a Mexican American gang crime wave taking over the city.[11]

Launching an all-out "war on crime," the Los Angeles Police Department (LAPD) engaged systematically in selective law enforcement during the World War II era, heavily patrolling Mexican neighborhoods and pursuing curfew and vagrancy violations in barrios with more vigor than in white sections of the city. Consequently, wartime arrest rates of Mexican American youths in Los Angeles swelled. As historian Ed Escobar notes, however, only small fractions of these arrests ever resulted in actual criminal prosecutions. Rather than documenting any notable increases in criminality among Mexican Americans, the high number of arrests bespeak the LAPD's adoption of more stringent police control mechanisms against youths of color.[12]

By August of 1942, the Los Angeles populace began to recognize young Mexican American *women* as an integral element of the gang menace allegedly plaguing city streets. After a young Mexican man named José Díaz was found dead near a Los Angeles water pit popularly known as the Sleepy Lagoon, police rounded up hundreds of second-generation youths of Mexican descent in connection with the now-infamous case. Despite a glaring lack of evidence, twenty-two young men connected with an L.A. neighborhood known as Thirty-eighth Street—all but one of Mexican ancestry—were arrested, charged with murder and assault, and tried. After months of court proceedings plagued by bigotry, the so-called zoot suit murder case came to

an end with seventeen of the defendants convicted of charges varying from murder in the first degree to assault.[13] Two years later, after tireless efforts by the Sleepy Lagoon Defense Committee (SLDC)—a diverse coalition of Mexican Americans, progressive whites, Jews, and African Americans—the defendants won acquittal upon appeal.[14] In the meantime, however, the case helped solidify the connection between delinquency and Mexican American youth.

During the initial round up of suspects in the murder of Díaz, law enforcement officials investigated ten young women, ranging in age from thirteen to twenty-one years old, most of whom bore Spanish surnames.[15] This presence and involvement of young women of color in the scandal provided one of the biggest shocks to the wartime populace. As the *Los Angeles Evening Herald and Express* stated, "Particularly disturbing in one of the new outbreaks was the participation of several girls. It was hoped that the prevalent delinquency might be confined to the boys who stand accused."[16] To readers, the notion of youthful Mexican American women participating in street life alongside male counterparts likely suggested a flagrant violation of conventional gender expectations that equated respectable femininity with submissiveness and domesticity.

The treatment of the young women involved in the Sleepy Lagoon case illuminates the extent to which law enforcement officials perceived Mexican girl gang activity to be a danger to wartime Los Angeles. Initially, police booked three of the women from Thirty-eighth Street—Frances Silva, Dora Barrios, and Lorena Encinas—on suspicion of murder, holding them in the county jail in connection with the L.A. County grand jury's investigation.[17] Although these particular charges were later dropped, all of the young women undergoing investigation were eventually held as material witnesses for the prosecution's case against the young men and/or had their cases turned over to the juvenile court for disposition. Those called upon to testify declined to answer the prosecution's questions, refusing to implicate their companions. Court authorities and the press, however, simply rendered the girls' lack of cooperation as evidence of a well-organized gang mind-set.[18] Even when the court failed to find any of the young women guilty of involvement in the Díaz murder, authorities refused to let the girls' disreputable behavior go unpunished. The Los Angeles Juvenile Court charged eight young women—Bertha Aguilar, Dora Barrios, Lorena Encinas, Josephine Gonzáles, Juanita Gonzáles, Frances Silva, Lupe Ynostroza, and Betty Nuñez Zeiss—with the crime of rioting, declaring the girls wards of the state under the Department of Institutions.[19]

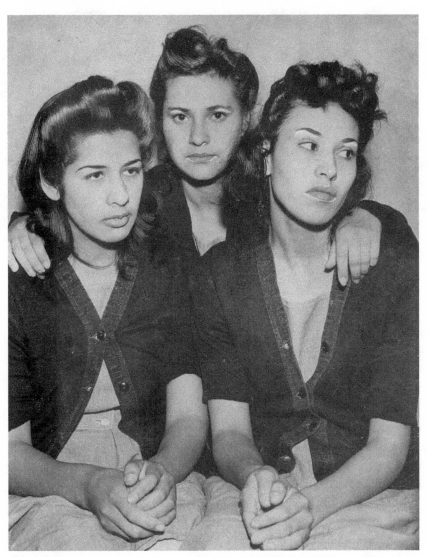

Dora Barrios, Frances Silva, and Lorena Encinas—arrested during the Sleepy Lagoon investigation, 1942. Los Angeles Public Library Photo Collection.

Most of the young women involved in the Sleepy Lagoon case eventually found themselves sentenced to placement at the Ventura School for Girls,[20] a California correctional facility, infamous at the time for its draconian discipline. The reformatory, whose picturesque location and academic name masked a repressive atmosphere, typically housed girls with long histories of delinquency, sexual promiscuity, and unsatisfactory stays at other reform

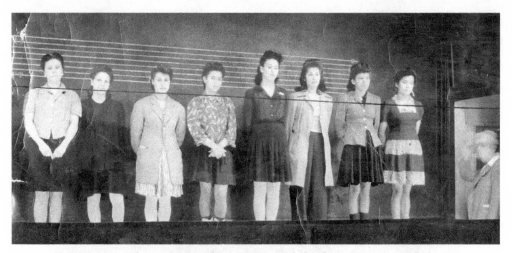

Young women under investigation for connection with the Sleepy Lagoon case stand in a lineup after the 1942 police dragnet. Left to right: Betty Nuñez Zeiss, Ann Kalustian, Frances Silva, unknown, Lorena Encinas, Dora Barrios, Josefina "Josephine" Gonzáles, and Juanita "Jenny" Gonzáles. Los Angeles Public Library Photo Collection.

institutions. These young women were on average paroled from the Ventura School after stays of sixteen months, but they remained wards of the California Youth Authority until they reached twenty-one years of age.[21]

Prior to the fateful night at Sleepy Lagoon, the term "pachuca" had not yet entered the lexicon of judicial discourse at the Juvenile Division of the Los Angeles County Superior Court. Juvenile court case files of Mexican American women living in Los Angeles between the years 1939 and 1945 reveal that not until immediately after L.A. newspapers broke the story of Díaz's death did juvenile authorities pinpoint female zoot suiters as a manifestation of wartime female delinquency. Subsequently, juvenile officials began to use the words "pachuco-type" and "pachuca" to describe a number of young women of Mexican descent brought before the court.[22]

In utilizing the labels "pachuca" and "pachuco-type," juvenile authorities mirrored terminology recently adopted by Los Angeles newspapers and local officials. Originally a term associated with Mexicans involved in vice trafficking in and around El Paso, the word "pachuco" expanded beyond its original meaning amid the anti-Mexican sentiment of the Sleepy Lagoon trial. Major newspapers in Los Angeles began using the term after the Office of War Information (OWI), in an effort to preserve friendly relations between the United States and Mexico, asked editors to cease making specific reference to Mexicans in their coverage of juvenile delinquency. Most agreed to

comply, but in searching for nouns alternative to "Mexican," reporters simply substituted labels like "zoot suiter" and "pachuca/o," value-laden terms that continued to conjure up images of criminality specific to Mexicans.[23]

According to legal records and contemporary observers, a pachuca could typically be identified by her controversial clothing, company, and behavior. Young Mexican American women often modified men's zoot attire to consist of a fingertip coat and cardigan or V-neck sweater; a skirt to the knee or above in length, a style that was, for the time, considered relatively short; and bobby socks pulled high toward the knee, with huarache sandals. The style varied from individual to individual, however, as some young women wore their skirts with saddle shoes or platform heels; others preferred wearing pants and thus adorned the zoot suit in its entirety. Many Mexican American women further emphasized their zoot look with dark lipstick, plucked eyebrows, and hair lifted high into a pompadour.[24] One juvenile authority described the "typical pachuco look" of a young Mexican American woman: "neat appearing, but . . . with high pompadour, plucked eyebrows, short skirts, black socks. She likes to decorate herself with jewelry and trinkets."[25]

The company a Mexican American woman might keep with zoot suiters, jitterbugging in dance halls or loitering on street corners after dark, also served as identifying characteristics. Most young women labeled "pachucas" by the juvenile court were not charged with crimes committed against others. Rather, authorities brought them before the court because they lacked adequate supervision, roamed neighborhoods, and stayed out late with companions deemed "undesirable"—allegations based largely upon assumptions of pathological, unrestrained sexual behavior. The probation officer of fifteen-year-old Amalia Cervantes recounted such concerns in a 1944 report to the court: "Father stated that minor . . . wants to be like a pachuco. . . . [She not only] wears heavy, vulgar make-up to school and in her home, [but] is quite impudent and defiant, stays out to 2 and 3 o'clock in the morning, continually necks and pets with boys on her front porch until all hours."[26]

But among the young women themselves, the label "pachuca" often remained a contested term. Many Mexican American women who played with the pachuca look, or associated with zoot-suited teens, did not necessarily self-identify as a pachuca.[27] Irene Malagon, a young woman who frequently wore a fingertip jacket and a high pompadour during the 1940s, in later years definitively denied ever being a pachuca because she associated the figure with young women who fought and belonged to gangs. "I couldn't belong to a gang," Malagon stated.[28] Others took great pride in the notorious pachuca persona as a badge of rebellion. According to the case file of thirteen-year-old

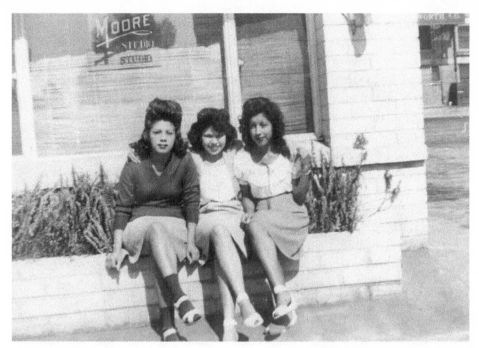

Young Mexican American women in Los Angeles, 1943. Note that the woman on the far left dons aspects of the zoot style, including high pompadour, dark lipstick, V-neck sweater, and high socks. Los Angeles Public Library Photo Collection.

Isabel Ramos, on more than one occasion the teen told her mother she was "a Pachuco, and w[ould] do as she please[d]."[29]

Court officials were not alone in their disdain for women deemed zoot suiters. In fact, almost nothing proved more disruptive to Mexican families than the pachuca phenomenon. While few immigrant parents looked favorably upon sons who sported zoot attire, the behavior of young women proved especially unnerving. For the Mexican immigrant generation, women occupying the public arena under most circumstances—let alone in questionable attire and with disreputable company—spelled trouble. Mexican parents typically subscribed to a double standard in sexual relations, closely cloistering daughters until marriage, while allowing sons the freedom to do as they pleased. Such strict rules traced back to the Catholic Church and social customs in Mexico, where virginity was highly valued and a family's reputation usually depended on the chastity of its women.[30]

But as the wartime environment created conditions in which familial control over daughters loosened, more and more Mexican American women utilized the zoot attire and persona as a means to experiment with their social

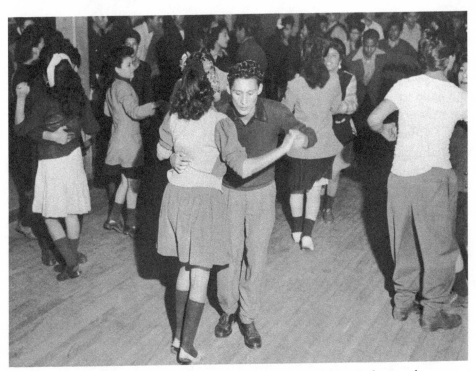

Mexican American and African American youths jitterbug at Club Los Pachucos, a dance hall and youth club begun by Los Angeles civic leaders to help combat juvenile delinquency during the war years, 13 November 1943. The zoot style of the female jitterbugs includes a blouse, sweater, or fingertip coat; a full skirt that falls at or above the knee; and huarache sandals with midcalf bobby socks. © Bettmann/CORBIS.

and sexual roles and assert new claims to public life. Some used their new status as wartime wage-earners to push for the privilege to socialize with peers outside of the watchful eyes of immigrant parents and to buy the latest fads in cosmetics and zoot suit styles. During the summer of 1942, seventeen-year-old Ida Escobedo started her first job—making incendiary bombs—at a small defense factory in Los Angeles. Entering the workforce in order to earn money for the family while her brothers fought overseas, Escobedo also had dreams of buying a tailor-made fingertip coat and matching skirt. The opportunity arrived when her mother gave her extra money to buy a dress to wear for her high school graduation. Well aware of the fact that her mother "didn't approve of [zoot] clothes or anything about it," she and her sister nevertheless went to a men's clothing store and purchased a "good looking" fingertip coat that she proudly flaunted at her graduation ceremony. "My mother just about died," Escobedo remembered. "She was ashamed of me."[31] By strategically

creating a visual display that tested social propriety, those Mexican American women who experimented with zoot clothing and makeup often did so as a way to declare autonomy and claims to public life. Like Escobedo, many second-generation Mexican American women took pride in their zoot appearance and public identity, welcoming the opportunity to be noticed and to assert some element of control over their lives.

Other so-called pachucas skirted notions of propriety altogether by entering public life for their own self-interest, completely outside the context of wartime necessity, wage labor, and familial needs. One thirteen-year-old, Alma Galvan, habitually ran away from her father's home in Pasadena and on one occasion spent over a week living hand to mouth, sleeping in cars and on the back porches of houses with other wayward Mexican American girlfriends. Although Alma resorted to drastic measures, her meanderings about the city allowed her, at least until she was picked up by the authorities, the opportunity for autonomy and to engage in her favorite hobby—dancing with "'pachuco' boys"—without parental interference.[32]

At a time when official rhetoric stressed the importance of wartime sacrifice, the acts of performance and self-indulgence engaged in by women with alleged pachuca tendencies suggested to some a striking disregard for the gravity of war. Some of the young women simply liked to jitterbug in dance halls. Others engaged in fistfights and frequented street corners after dark. Yet no matter how moderate or extreme their behavior, when men left daily to join the fight abroad and news of boys dying overseas dominated the airwaves, the contrast between sacrificing one's life for patriotic ideals and parading the streets in an effort to turn heads and find a late-night thrill grew ever more stark. Consequently, members of both the Mexican population and the Los Angeles general public grew increasingly concerned with the highly visible, public nature of pachuca activities.

Among fellow Mexican American women, the pachuca persona triggered decidedly mixed emotions and responses. Many Mexican American women condemned those who adopted aspects of the pachuca style and/or persona, claiming that the clothing was "stupid" and that those who chose to wear zoot styles meant "trouble" and "were asking for whatever they got."[33] Others admired or empathized with pachucas, recognizing the persistent racial discrimination of the time and insisting that the young women did not deserve the negative attention they received. As Teresa Pallan explained, "To me they were just people who dressed a certain way.... They weren't violent criminals in my eyes."[34] Noemi Hernández recalled how her mother associated pachucas with "lower-class people," but to Hernández, the short skirts, huarache

sandals, and high pompadours worn by pachucas were "just a fad." "I used to like it and I started emulating [them]," Hernández said.[35]

If second-generation Mexican Americans held differing opinions about pachucas, the immigrant generation tended to be more united in their condemnation of the young women. In a story detailing the alleged origins of Mexican youth gangs, *La Opinión*, the Spanish-language daily, bemoaned the scandalous appearance of pachucas, including their so-called painted faces and short skirts. The newspaper also likened the young women to prostitutes, asserting that their male companions served as pimps. And although referring to male zoot suiters as "pachucos," the newspaper deemed their female counterparts "las malinches," a reference to the woman (La Malinche) historically known as the archetype traitor of the Mexican people. According to both history and myth, La Malinche was the Christian Indian woman who aided the Spaniards in their conquest of the Aztecs by serving as a mistress to conquistador Hernán Cortés. The editors of *La Opinión* found this a fitting analogy to describe the wartime pachuca. Like Malinche, the young women publicly betrayed proper female behavior with their supposed sexual laxity, behavior that brought shame to the Mexican people.[36]

Major newspapers in Los Angeles exhibited a similar fixation with the presumed uncontrolled sexuality of second-generation youth. In 1943, for instance, the *Los Angeles Evening Herald and Express*—a Hearst newspaper well known for its lurid reporting—broke an exposé on the alleged promiscuity and delinquency of barrio women. Emphasizing the participation of "sexy-looking" zoot girls in "weird" sexual activity, the article stated that pachucas "have been quick to admit the free relationships that some have with members of boy gangs" and insinuated that these girls were infected with venereal disease by using the euphemism "not particularly clean." The reporter made further charges of sexual degeneracy and violent behavior, stating that a "gang girl gives herself freely, if she likes the boy. If she doesn't she knifes him or has other girls in her gang attack him."[37] Given earlier damning coverage of the female suspects in the Sleepy Lagoon murder trial, newspapers like the *Los Angeles Evening Herald and Express* helped shape perceptions of second-generation daughters as a significant threat to social stability.

Of course some young Mexican American women did, in fact, engage in sexual activity and a gang lifestyle during the war years. Evidence from juvenile case files suggests that many of the young women considered pachucas by the court desired sexual autonomy and engaged in sexual activity, often within the context of steady relationships with Mexican American men.[38] Even the names chosen by the young women to identify their peer group

toyed with images of sexual familiarity and innuendo. Newspaper and court case file references to the "Cherries" and the "Black Widows" indicate that this generation of young women wished to play up their sexuality in a manner markedly different from that of their mothers.[39] For these young women ⟨…⟩ d an opportunity to experience a sense of excitement and ⟨…⟩ text of lives typically defined by discrimination, poverty, ⟨…⟩ strictions.[40]

Yet most Mexican American young women simply adopted aspects of the pachuca persona in a spirit of adventure and independence, not delinquency.[41] As one thirteen-year-old of German and Mexican descent reportedly explained to the court, "The girl in Pachuco clothes is just as good as any other girl, except that the Pachuco girls have a bad reputation."[42] In fact, according to contemporary accounts, only a very small percentage of Mexican American girls demonstrated delinquent behavior during the war years. In 1942, for instance, one observer estimated that a mere 0.6 percent of the girls of the Mexican community necessitated "the attention of juvenile authorities."[43] Although youth gangs certainly existed in wartime Los Angeles, and a small number included Mexican American women, not every youthful social gathering represented a gang meeting, nor was every youth in a zoot suit a criminal.[44] But the uneasy wartime populace failed to distinguish delinquent pachucas from any Mexican American woman who rebelled against social conventions or adopted aspects of the pachuca look.

To Euro-American and Mexican communities, young women deemed pachucas represented a dangerous example of the increasing public role of *all* women during World War II. With more women entering the workforce than ever before, an anxious U.S. society feared that women with newfound freedoms would be unwilling to return to domestic life once the war ended. They might be encouraged to enter the public sphere as a wartime necessity but were simultaneously expected to maintain their femininity and sexual purity. Whether so-called pachucas actually retained "proper" sexual standards or not, their relatively short skirts, bold makeup, and more pronounced presence suggested a tainted sexual reputation, and they sounded alarms.[45]

As a woman of color, the pachuca figure also triggered both Euro-American and Mexican fears of miscegenation. The war years ushered in a time of heightened fears of unbridled sexuality, with authorities warning that the disruption of conventional family patterns and an increased lack of parental supervision could easily lead to a rise in sex delinquency. The press fed such anxieties with stories of sexually promiscuous "victory girls," women who allegedly enjoyed dressing in alluring clothing and loitering around military

bases and transit depots, looking to proposition servicemen. Understanding women's sexual activity outside the marital sphere as immoral, military and public health officials characterized victory girls as "amateur" prostitutes, warning that they were tainted by venereal disease and thereby represented a significant health threat.[46]

Media coverage equating pachucas with prostitutes and emphasizing the sexual delinquency of second-generation women mirrored condemnations of so-called V-girls.[47] But as women of color, Mexican American women were subject to additional anxieties about their sexuality, anxieties that at times focused on fears of sexual encounters across the color line. Since California's antimiscegenation statute did not consider sex between whites and Mexicans to be interracial, and thus unlawful, some did worry that, without legal deterrents, sexual relations between the two communities could easily occur.[48] Indeed, in the wake of the Zoot Suit Riots, a *Newsweek* reporter surmised that male zoot suiters had attacked servicemen who tried to steal their girls, since "a sailor with a pocketful of money has always been fair game for loose women, and the girls of the Los Angeles Mexican quarter were no exception."[49] By likening the companions of zoot suiters to allegedly loose victory girls, major Los Angeles newspapers and, on this occasion, a national newsmagazine, attempted to limit social mixing between the two groups, with hopes that Euro-American servicemen and Mexican Americans would not engage in sexual relationships. Pachucos may have proved troublesome as members of a minority group asserting a more public role in urban life, but the sexual power of those considered to be pachuca posed an additional danger to the white social order.

Mexican parents expressed similar concerns over the prospect of second-generation daughters having sexual relations with white men, but they worried simultaneously that their daughters would become intimately involved with pachucos. Apprehensions only grew as wartime work and leisure conditions increased opportunities for "trouble." In 1944, all too aware of the changing circumstances, the parents of thirteen-year-old Sandra Garza became so troubled by her association with local pachucos that they placed her on a train bound for Mexico to live with her aunt.[50] Similarly, the parents of fifteen-year-old Consuela Corral tried to keep their teenage daughter home in the evenings by locking her in the bedroom. Ever determined, Consuela escaped by way of the window, meeting her pachuco friends on a nearby street corner.[51]

To many Mexican parents, a daughter's experimentation with the pachuca identity ultimately represented the corrupting influence of American sexual

patterns on Mexican culture. As historian Vicki Ruiz observes, the Mexican immigrant community typically believed white women were morally lax in their dealings with men. Euro-American parents generally did not submit their daughters to chaperonage and, to the Mexican immigrant generation, seemed much more carefree in their attitudes about dating. Moreover, U.S. consumer culture, with its promotion of cosmetics and fashion, seemed to reinforce notions of loose American sexual mores.[52] As one Mexican mother described her daughter's impending adolescence during the 1940s, there would be "none of this running around all night with one boy, the way those American girls up on Tenth do. There is a lot to be said for the Mexican way of keeping an eye on your girls."[53] Mexican parents feared that adoption of American sexual attitudes, seemingly emblematic of the pachuca identity, might persuade daughters to abandon their traditional values and bring disgrace upon their families.

Aurora Preciado, a native of Mexico, expressed these concerns when she reported her fourteen-year-old daughter Cecelia to the Los Angeles Juvenile Court authorities in 1945. A devout Catholic, this Mexican mother had worried for some time about her daughter's desire to wear a high pompadour and to come and go as she pleased, both day and night, with a group of pachuco boys and girls from the neighborhood. Despite numerous parental remonstrations, Cecelia simply refused to stay home after dinner and even stopped attending mass with her family. Instead, the young teen preferred dressing in the pachuca style and frequenting American movie theaters and dance halls with her peers. To Mrs. Preciado, such behavior suggested involvement in immoral activities; her fears only seemed to be confirmed when she found contraceptives in Cecelia's bureau. This traditional Mexican mother attempted to see her daughter "do right" by filing a petition with the juvenile authorities in hopes that court action might "scare" the girl into submission. Cecelia, on the other hand, insisted to juvenile authorities that—in spite of their pachuco attire—her friends were not "bad" girls but young women who simply desired a little liberty from parental restrictions.[54]

To parents like Mrs. Preciado, their daughters' flagrant violation of gender expectations not only represented pachuca behavior but symbolized the flagging authority of the family to police sexuality. Like their Euro-American female counterparts, Mexican American women enjoyed leisure activities with the opposite sex, and thus rejected chaperonage. Moreover, they crossed geographic barriers by physically leaving urban barrios to frequent traditionally white public venues. Aghast Mexican parents thus watched in fear as daughters applied dark lipstick, teased their hair, and adorned zoot attire,

all in preparation for a night of jitterbugging in one of the many ballrooms in downtown and greater Los Angeles. Because women were considered the purveyors of cultural values within the Mexican community, mothers like Mrs. Preciado feared that a daughter's interest in the pachuca subculture represented a threat to Mexican customs and traditions.

But while parents fretted about their children's loss of cultural ties to Mexico, the larger Los Angeles populace typically characterized pachuquismo as a distinctly Mexican identity—anything but evidence of Americanization. According to a fact-finding report by Adele Calhoun, branch assistant of the Division of Immigration and Housing in Los Angeles, "The idea that a child born in this country of Mexican parents is an American, is only technically true. In spirit and tradition and culture he is still more Mexican than American. . . . Emotionally [Mexican youth] are somewhat more tensed up and unrestrained than the average American, and this condition, coupled with ignorance, of course lends itself to gangster trends."[55] Community leaders similarly warned that the pachuco phenomenon could possibly be tied to a fifth column movement of right-wing Sinarquistas in Mexico, while the press displayed coverage of crimes committed by Spanish-surnamed zoot suiters directly alongside stories of overseas Japanese atrocities. Because the zoot style failed to conform to standards deemed properly "American," Mexican American youths—like their Japanese American counterparts on the West Coast—came to represent yet another foreign enemy on the wartime home front.[56]

At the heart of the matter was the fear that beneath the outwardly flashy appearance of the zoot suiter lay a militant racial consciousness. Reports to the juvenile court frequently commented on the "race conscious" nature of pachucas and their propensity to stir up racial antagonism between minority groups and whites. Concerns over the behavior of Eva Flores, a fifteen-year-old Mexican American woman first brought before the juvenile court in 1942, reflect the heightened anxieties surrounding race relations during the war years. Between 1942 and 1944, Flores found herself before the juvenile court for various crimes, including intoxication, fighting, failing to return home at night, and petty theft. The young teen's behavior, in addition to her style of dress—a "pachuco" coat, pants, and high socks—raised significant concern among officials.

However, not until Eva's commitment to the county-run reformatory El Retiro School for Girls did Los Angeles Juvenile Court authorities connect her choice of attire to something even more troublesome—a politicized identity that threatened racialized norms. According to Superintendent Adelaide

Williams, El Retiro had historically prided itself on easily assimilating minority female delinquents into the reform school's diverse population—that is, until Eva Flores arrived. Eva completely disrupted the feeling of racial harmony at the Los Angeles reformatory by "causing dissatisfaction among the Mexican and Negro girls." As Williams explained, "She managed to speak a Spanish word here, a message to another there, talked her pachucoa [sic] slang to still another and almost before we knew it, she had developed a race feeling on campus." Williams further lamented the fact that, for the first time, young pachuca women stood together, talked in groups, and organized among themselves. "She simply was 'dynamite' on the campus and in the short time we had her, [Eva] had all the Mexican and Negro girls surly, impudent and race conscious," Williams told probation officials.[57] Ironically, even as Mexican parents feared the potential of the pachuca to undermine Mexican culture, in the eyes of reformers, those young women who adopted "pachuca" tendencies came to stand for a new kind of politicized and defiant Mexican identity.

Several court records, in fact, show pachucas in trouble with authorities for their involvement in "racial disturbances." Teresa Quiñones, a young woman caught "terrorizing a group of white girls," complained that she threw rocks at her junior high school peers because "they are down on the Mexicans."[58] Similarly, Gloria Magaña admitted that she and a group of "Mexican girls" had been involved in a fight with "American girls" at Garfield High School after being called "dirty Mexicans."[59] While these so-called pachucas expressed discontent with their treatment as second-class citizens, reformers lamented the appearance of "racial feelings," worrying that in magnifying difference and stirring up antagonism, pachucas threatened the wartime vision of a unified American nation.

To best understand reformers' fears, it is important to consider notions of racial liberalism developing in intellectual circles during the war years. One of the most influential works, *The Negro Problem*, written by social scientist Gunnar Myrdal and published in 1944, developed an optimistic thesis about the ability of the United States to overcome racial hierarchies due to the power of the "American Creed." Myrdal based this creed on the idea that the United States "has a national experience of uniting racial and cultural diversities and a national theory, if not a consistent practice, of freedom and equality for all."[60] According to Myrdal, institutional structures like the church, school, trade union, and state all served to Americanize blacks and whites, allowing them to shed attachments to "caste" distinctions and to create a new, universal national culture based on sameness, not difference. Racial subjects, in essence, would inevitably become transformed into national subjects.[61]

Myrdal came to his conclusions during the late 1930s and early 1940s when the culture-based concept of "ethnicity" was just coming into favor among social scientists as a way to explain what scholar Nikhil Singh calls a "difference *different* from 'race.'"[62] With the egalitarian vision of the New Deal, and the rise of antifascism during World War II, social scientists worked to refashion the race concept, exchanging biological understandings of race for cultural and environmental explanations of difference. Immigrant populations living in the United States now found themselves grouped under the umbrella category of "ethnicity," a term that served to advance the notion that assimilation had eroded any and all "Old World" ethnic differences in favor of a common Americanism. As Singh points out, the idea that immigrant difference could gradually be incorporated into a "normative nationality" ultimately became the template for Myrdal and other social scientists interested in solving the race "problem" in the United States. Assimilation, it seemed, would be a logical solution to the dilemma of racism.[63]

Yet as the behavior of Eva Flores and her cohorts at the El Retiro School for Girls suggest, many so-called pachucas refused to fit the mold of ethnic immigrants who accepted a common Americanism. Wartime reformers may have hailed the ethnicity model of "Americans All" as a cure-all to social tensions, but the paradigm remained fundamentally flawed in its inability to appreciate the extent to which the historical experiences of racialized minority groups differed from those of white European ethnics, a difference that many Mexican American women remained all too aware of. Rather, the paradigm solidified whiteness as the normative American condition and rendered any hint of racial discontent or difference as deviant and un-American. Thus, as these youths failed to integrate easily into mainstream society, reformers increasingly feared that their wards represented not simply young women engaged in delinquent behavior but, even more problematic, young women of color engaged in delinquent behavior with a dangerously political thrust.

In fact, the persona created by pachucas did take on a degree of political meaning, as the young women outwardly challenged the vision of American commonality by embracing a womanhood that emphasized cultural difference. To be sure, some Mexican American women chose to wear zoot suits for the simple reason that they liked the style or as a way to take part in peer-group socializing. Thus wearing a zoot suit was not necessarily an inherently political act. But certainly few zoot-suited youths were completely oblivious to the implications of their controversial choices in appearance and behavior, particularly given the conservative context of the times.[64]

Participating in one of America's favorite consumer pastimes—beauty culture—second-generation daughters utilized the zoot subculture to create new, unique styles that did not attempt to look "white" or to conceal their Mexican ethnicity. Prior to the pachuca phenomenon, Mexican American women, like many other daughters of immigrant parents, often used makeup to look more "American" and to express their new sense of national identity and personal freedom in the United States. Cosmetic companies actively promoted white mainstream ideals of beauty and femininity to the Spanish-speaking public, and, as Vicki Ruiz points out, the popularity of bleach creams and hair dyes attests to the influence of American beauty culture on many barrio consumers.[65]

But the style of the pachuca meant an adoption of beauty rituals that largely defied white emulation. In fact, Mexican American women interested in the zoot look consistently reappropriated cosmetics and beauty advice in order to fashion a racial identity that challenged the vision of mainstream U.S. beauty ideals. During World War II, cosmetic companies and the federal government typically promoted the wearing of makeup as an affirmation of American ideals and a way for women to help maintain both national morale and femininity when engaging in "men's work."[66] But the beauty standards these companies had in mind dictated that hair would be arranged and makeup applied with subtlety and discretion. The wartime pachuca wanted neither. Pachucas seemed to parody the understated updos and subtle makeup of everyday women and Hollywood starlets, using dark red lipstick and affixing "rat" accessories into their hair in order to lift their tresses into an especially high bouffant. They also rejected the practical buns and braids of their more traditional Mexican mothers.[67] Embracing a flashy and ostentatious style, their shared adoption of exaggerated pompadours, generous makeup, and shorter skirts visibly signified a sense of belonging to a distinctly Mexican American subculture.

For thirteen-year-old Isabel Ramos, a self-proclaimed "pachuco girl," participation in the zoot subculture was a means of fitting in on her own terms, a way to feel that she could make her life better. Ever since she befriended a group of pachucos, Ramos took great pride in applying makeup and hemming up her skirt "half way between her knees and waist" before meeting fellow Mexican American teens on L.A. streets. Looking for any opportunity to escape the impoverished conditions and strict upbringing of her home life, she indulged in a defiant appearance that sparked recognition and acceptance among her peer group.[68] Similarly, Maria, another young Mexican American woman who adorned zoot attire during the war, did so because she never felt

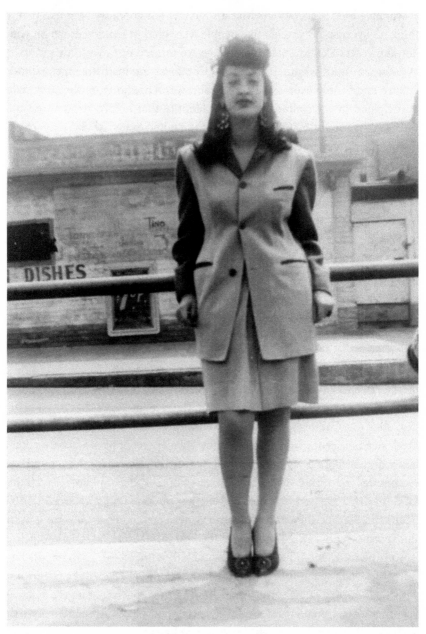

A Mexican American woman identified as Josie poses in her zoot suit while waiting for the Red Car in Los Angeles, 1945. In addition to a narrow fingertip coat, her zoot look includes high hair and plucked brows, dark lipstick, big earrings, and exposed knees. Los Angeles Public Library Photo Collection.

acceptance in U.S. society. As Maria stated: "I felt good dressing like that. I think it's because . . . you felt like people were kind of looking down on you. You didn't feel like you belonged . . . so we formed our own little group."[69] Whether or not it was their intention, by subverting mainstream consumer culture and visibly expressing discontent, women who wore the zoot style participated in a racialized, collective identity that helped them to escape their feelings about being outsiders in the United States by claiming an affirming identity *as* outsiders in the United States.

Even when confined to juvenile detention centers, Mexican American women often continued to engage rebelliously in the performative aspects of their public identities. Numerous court case files suggest the dismay of probation officers as they troubled over Mexican American women's insistence on altering the uniforms of various reform institutions to resemble pachuca attire. Young Mexican American women still pulled up their skirts to lengths unacceptably short for the time and styled their hair in exaggerated pompadours; some creatively used cleaning cloths, instead of the typical "rat" hair accessory, to keep the high do in place. Although wards of the court, they continued to use aesthetics defiantly as a means of public presentation and group consciousness.[70]

The collective stylistic and behavioral nonconformity of pachucas caused the most concern among juvenile authorities. In a 1944 study of the state-run Ventura School for Girls, Nan Allan, the reformatory's superintendent, explained to a California investigative committee that while juvenile women of Mexican descent made up approximately 20 percent of the inmate population at the Ventura School, it would be unwise to increase these numbers since it was "hard [for Mexican American women] to assimilate . . . with the kind that we have here." To substantiate her opinion, Allan referred to difficulties caused by the young Mexican American women who were sent to the Ventura School after testifying at the Sleepy Lagoon trial in Los Angeles. According to Allan, "They were a particularly difficult group to handle because they were so nationally conscious." Karl Holton, head of the California Youth Authority, agreed with Allan, stating that "pachuca gangs . . . have very much of a chip on their shoulder, as far a [*sic*] persecution is concerned. They feel that they have been discriminated against, and that they haven't gotten a square deal, and they are looking for trouble all the time, and they usually find it."[71]

In a period of heightened American consensus, some Mexican American women made a bold decision to engage in an oppositional culture considered threatening by the larger public. California juvenile authorities strongly

believed that the "nationally conscious" style and behavior of pachucas represented an attachment to a culture other than that of the United States. Rather than conform to the "American Creed," they instead desired to "speak a Spanish word," "to arrange . . . clothing in a gang fashion," and to insist on a "square deal," thereby endangering the reformist vision of integration and highlighting a strident refusal to concede to racialized norms.[72] For many of the young women, the pachuca persona represented a positive affirmation, and an awareness that being American did not necessitate erasure of every semblance of their cultural heritage. Reformers, however, found it difficult to accept an identity that challenged authority and emphasized a nonwhite womanhood.

The visible discontent some so-called pachucas demonstrated about the dominant culture prompted attempts by reformers to halt underpinnings of ethnic nationalism by discouraging any retention of Mexican culture. As one juvenile official told a young Mexican American woman in residence at the infamous Ventura School for Girls, "Begin to plan and be ready when you leave Ventura to . . . be a fine American girl and a good citizen. You will be doing your part in our great nation."[73] What, then, did it mean to be a "fine American girl"? The general consensus among juvenile officials was that as individuals, young Mexican American women seemed quite pleasant and pliable. Once befriended and influenced by fellow Mexicans, however, trouble ensued. Thus in an effort to combat cultural alliances, authorities frequently forbade Mexican American women from speaking Spanish within reformatory walls, conflating the use of a foreign language with a dangerous form of youthful rebellion. A young woman speaking Spanish represented a foreign outsider, not a citizen imbued with proper American values.[74]

In addition, court officials continually reprimanded Mexican American girls for interacting solely with young women of Mexican ancestry or for congregating in groups—behavior seen as a further hindrance to integration.[75] One probation officer disparaged the "unsatisfactory" behavior of her Mexican American client, remarking that the juvenile was "very clannish with Mexican girls and continue[d] to speak Spanish in spite of repeated requests not to do so."[76] The young women themselves often explained this "clannish" behavior as a natural choice, given their cultural background. Eva Flores, for instance, admitted to her case worker that she "finds it easier to identify with Mexican girls and felt that some of the American girls did not like her."[77] But for many law enforcement officials, manifestations of Mexican heritage among wayward youths represented a dangerous cultural pathology. Thus in addressing issues of juvenile delinquency, reformers tended to downplay

the role of economic inequalities and racial discrimination, concentrating instead on instilling their wards with new cultural values.[78]

With such a stigma attached to the zooter identity, Mexican American women deemed pachucas often fell victim to discriminatory practices with very material consequences. At the Los Angeles Convent of the Good Shepherd, a religious boarding home and school for wayward girls of various backgrounds, the nuns in charge refused to accept any young women considered to be of the "pachuco type."[79] Eva Flores, the young Mexican American woman who stirred up trouble at El Retiro, found herself turned away from the convent. As Sister Germaine explained, "It is our policy not to accept Pachucos. When [Eva Flores] came to the Convent her hairdress [sic], her clothing and her speech indicated that she was a Pachuco and the girl, herself, declared that she was one. We therefore felt it advisable not to accept her even on trial."[80] Those Mexican American women who did not demonstrate "pachuco tendencies" until after their placement at the convent inevitably found themselves removed from the institution. In 1945, the convent admitted sixteen-year-old Sarah Villa, with some reservations, after the young woman was brought in for spending two nights away from home in the presence of African American and Mexican American young men. Sarah's later participation in a dormitory disturbance at the reformatory, combined with her previous "immoral" behavior, led the nuns to conclude that the young woman was "definitely the Pachuco type" and that her removal from the institution would be "beneficial to the Mexicans we now have."[81] The nuns at the convent were not alone in their hesitancy to assist pachucas; individual boarding homes accustomed to taking in wayward youths also expressed concerns regarding "girls of this type."[82] Left with few options, many young Mexican American women either failed to receive attention from juvenile authorities or found themselves transferred to the notorious Ventura School for Girls. Demonstrating a behavior understood as culturally pathological, these adolescent women were simply deemed irredeemable.

Mexican American women were not the only women of color whose behavior was considered a cultural pathology. As historian Regina Kunzel argues, during the World War II and postwar eras, social workers explained white out-of-wedlock pregnancy as a symptom of individual pathology—and thus a condition that might be changed—while they simultaneously reconceptualized black illegitimate pregnancy as a symptom of cultural acceptance and cultural pathology, intrinsic to black families. Reformers may have repudiated biological theories about African American life as racist, but in their place they invoked sociocultural explanations for deviant behavior.[83]

Thus Mexican parents faced similar blame. As biological understandings of race gave way to cultural and environmental explanations, court officials typically blamed zoot-suiting teens' behavior on the failure of the immigrant family to adopt and adjust properly to "American" ways. As a 1943 article in the *Los Angeles Times* explained, "Juvenile files repeatedly show that a language variance in the home—where the parents speak no English and cling to past culture—is a serious factor of delinquency. Parents in such a home lack control over their offspring."[84] Justice officials often assigned blame for the pachuca phenomenon on inadequate parenting skills, use of Spanish in the home, and low standards of living. According to Celia Harrison, a probation officer with the L.A. County Juvenile Court, "The pachucas (the girls) are taking to drink, often learning about liquor in homes with little or no furniture; if there is one bed it is a luxury."[85] Similarly, the social case worker assigned to Cecelia Preciado's case decried the fact that the girl's mother was "not at all Americanized and d[id] not speak any English nor really understand a good many of the American ways, and that she ha[d] no discipline over [Cecelia]." The case worker continued: "[Cecelia] is an extremely smart child able to outwit her mother at almost any point."[86] Disapproving of immigrant lifestyles and child-rearing practices, juvenile authorities often treated Mexican culture as an impediment to the second generation's "proper" integration into American life.[87]

Probation officers typically traced the roots of the pachuca phenomenon to the Mexican family's reliance on "Old World" moral standards in raising American-born daughters. According to juvenile authorities, the tendency of Mexican parents to restrict female behavior severely risked pushing daughters into a life of promiscuous behavior and gang activity. In one 1943 juvenile court case, the probation officer of thirteen-year-old Gloria Magaña placed the blame for the young girl's sexual experience and participation in gang fights squarely on her Mexican mother's shoulders. According to the court, Mrs. Magaña's refusal to grant any freedoms to her daughter had directly caused the girl's delinquent tendencies. "A cultural conflict seems to be the basis of [the] girl's difficulties," the probation officer explained. "[The] mother[,] apparently coming from low peon parents[,] has not become Americanized and wants [the] girl to grow up according to Old World standards. . . . This American-born girl has rebelled against this paternalistic conception of the family and has sought an outlet in sexual freedom."[88]

Ironically, while the juvenile court system condemned Mexican families for their overly strict child-rearing practices, many immigrant parents—Mexican mothers in particular—also faced censure for parental behavior

deemed morally lax. Just as Progressive Era reformers had frequently targeted Mexican mothers in their attempts to Americanize the Mexican population early in the twentieth century, World War II reformers similarly traced the roots of the pachuca identity to a lack of maternal role models with proper moral standards.[89] One official singled out blame for the phenomenon on Mexican mothers who were "leading immoral lives right in the home and that children were born to these mothers by different fathers."[90] Others found fault with the alleged propensity of Mexican women to engage in premarital sex since common-law marriages were socially acceptable in Mexico.[91] Many court officials simply considered Mexican parents—no matter what their child-rearing practices—incapable of supervising their daughters properly.[92]

Ultimately, the condemnation that Mexican parents faced at the hands of law enforcement officials and the wartime press and public brought the immigrant community to a complicated cultural crossroads. On the one hand, Mexican families had a very critical awareness of how being "American" threatened their values and their hold on their children. On the other hand, the immigrant generation remained apprehensive that they and their American-born offspring would be treated as enemy foreigners—a dangerous reality in a wartime environment of exacerbated xenophobia.

As rumors swirled about overtly sexual, troublingly nationalistic Mexican women, the Mexican-born generation grew increasingly alarmed that the pachucas' spectacular public presence would damage the image of respectable Mexican families trying to eke out an honest living in the United States. *La Opinión*'s depiction of pachucas exemplifies such fears: The Spanish-language newspaper carefully chose the controversial term "malinches" to refer to pachucas in order to depict the young women not only as whores but as women who allowed pachucos—the hated enemy of respectable Mexican community members—to possess them sexually. Such terminology served to distance the more traditionally minded immigrant generation from the disreputable second-generation pachuca and to assert their own "civilized" position in contrast to that of the morally degraded young woman.[93] The defiant persona created by pachucas, women who seemingly rejected both traditional Mexican and mainstream American culture, significantly raised the level of anxiety among immigrant communities struggling to make sense of a new homeland and their place within it.

The immigrant generation's fears culminated as violence erupted between Euro-American servicemen and Mexican American youths during the Zoot Suit Riots in June 1943. After months of tense interactions and outright racial hostilities between the two groups, military men roamed Los Angeles

in search of young men in zoot suits, dragging those they found into the streets, stripping them of their clothes, and beating them publically. Mexican American youths frequently fought back. Only after senior military officials declared Los Angeles off-limits to all servicemen did the ten straight days of violence come to an end. In the meantime, the local and national press publicized the clashes as yet another example of the second generation's disloyalty to the United States, as well as their supposed propensity toward violence.[94]

Not surprisingly, press coverage of the Zoot Suit Riots reflected heightened tensions about pachucas as well. The *Los Angeles Evening Herald and Express* featured a story of a girl zoot suiter who robbed a young man with a "blow to his chin," stealing five dollars from his pockets.[95] Just a few days later, the newspaper warned its readership that female "auxiliaries" to boy gangs were gearing up to join the battle in Los Angeles streets.[96] And according to an article that ran on 11 June 1943, merchants in Watts found "all their black shirts and green sweaters sold out as 'pachuco girls' outfitted themselves to join their menfolk in the mob disorders." The story ended with claims that "pachuquitas" staged a meeting to organize, shouting, "We won't quit. It's them or us."[97]

This "us vs. them" perception caused great alarm in the Mexican immigrant community. The *Los Angeles Times*, for instance, featured a photograph of Mrs. Vera Duarte Trujillo, an "irate mother" of a fifteen-year-old zoot-suiting youngster who was shot in the leg during a skirmish at a movie theater in Azusa, a small citrus community in the San Gabriel Valley. "We tried to keep him home but he kept slipping away and what has happened to him is his own fault," said the frustrated parent.[98] Many years later, a woman from the White Fence neighborhood of Los Angeles remembered her mother's humiliation over her choice of activities as a teenage pachuca. She reflected, "My mother used to feel embarrassed with me when I used to go out on the street with her—especially downtown—because, you know, white people would look at the way I was dressed and my mother thought I was a punk."[99] As witnesses to their children's expressions of discontent in the United States, particularly during a time of hyperpatriotism, Mexican parents struggled to maintain a respectable reputation and to demonstrate a certain amount of allegiance to their adopted homeland. But the immigrant community also hoped to see the best of their Mexican culture and traditions persist. In the end, the notoriety associated with the wartime pachuca threatened to undermine these first-generation visions of both racial uplift and cultural preservation.

Ultimately, the pachuca figure became both an element and an emblem of the changing cultural and gender landscape of World War II. For many

Mexican American women, playing the part of the pachuca represented a liberating experience that provided them with a sense of personal freedom and control. But many so-called pachucas also learned all too quickly the limits of their individuality and autonomy. During the Second World War the United States looked for stability in social relations: women were expected to fulfill patriotic roles; minorities were expected to embrace Americanism. Pachucas seemed to do neither. Instead, their flaunting of a public sense of self and reveling in an unashamedly racialized identity appeared to threaten home front unity. In reality, many young Mexican American women worked in war jobs and wore coveralls by day, only to jitterbug dressed to the nines in pachuca attire by night. But as increasing numbers of women and people of color challenged traditional social relationships during the war, the wholesale stigmatization of pachucas served as a reminder to unconventional women of color that they should not stray too far from their "proper" place.

The flamboyant presence of the wartime pachuca would have long-lasting implications for a good number of women of Mexican descent coming of age in 1940s Los Angeles. She became at once the symbol and the reality of Mexican American women's new assertiveness and her unwillingness to stay in her traditionally assigned position in Mexican and Anglo society. And yet as the nation's war effort set in motion new federal policies and media opportunities to remedy the outsider status of the Mexican populace in the United States, more and more women of Mexican descent would feel compelled to consider the criteria by which they defined and presented themselves. This new generation would actively negotiate issues of femininity, nationality, and respectability on a daily basis, the legacy of women like Amelia Venegas never far from their minds.

2

Americanos Todos

MEXICAN WOMEN AND THE
WARTIME STATE AND MEDIA

To this day, the iconic image of womanhood during World War II is none other than Rosie the Riveter: a pert, rosy-cheeked young woman, muscular in body type yet resplendent with nail polish and lipstick to provide subtle but important reminders of her femininity. She is also, quite obviously, white.[1] Yet overlooked in these popular Norman Rockwell and U.S. War Production Board depictions is the image of a Mexican American Rosie—a visual antithesis to the wartime pachuca—whose likeness was adopted by diverse interests ranging from newspaper publishers to defense contractors to liberals eager to espouse an inclusive vision of "Americans All." Federal agencies, including the Office of War Information (OWI) and the Office of the Coordinator of Inter-American Affairs (OCIAA), developed and encouraged the racially pluralistic campaign by and large in an effort to foster home front unity, maintain international goodwill, and fulfill acute labor shortages. Thus, new images and narratives of Mexican womanhood—ranging from the patriotic, all-American defense worker to the sacrificial mother—captured the public's attention.

The new relationship between federal institutions and Mexican women proved particularly notable given previous categorizations of citizenship and belonging. While white women had utilized the politics of motherhood and virtue to secure a beneficial relationship with the welfare state in the early decades of the twentieth century, Mexican women, like their black counterparts, were in general seen as outsiders unworthy of state aid and support.[2] Even as Progressive reformers included immigrant Mexican

women in turn-of-the-century Americanization campaigns, citizenship status remained a burden for Mexican women's eligibility toward meaningful social protection, including welfare benefits.[3]

Yet by the 1940s, federal officials often relied on more inclusive gendered discourses of citizenship as an essential component to the wartime program of racial liberalism. Needing to draw more women of color into the workforce, and hopeful that the wartime environment might encourage the integration of the Mexican population in U.S. society, liberal propagandists at the OWI and OCIAA endorsed positive imagery of wartime work, volunteerism, and sacrifice that focused heavily on Mexican women. On front pages and radio waves, the American public witnessed second-generation daughters and an older generation of mothers undergoing the transformative process of "becoming American" as they riveted on the assembly line and stood loyally by as family members served in the armed forces.

To some degree, "Americans All" efforts echoed earlier visions of interwar Americanization programs. Apt to view Japanese and Chinese immigrants as "unassimilable," Americanization advocates more often than not tended to see Mexican immigrants as similar to their European counterparts in their ability to adapt to the "American way." Yet as historian George Sánchez argues, reformers established interwar Americanization programs explicitly to change the cultural values of Mexican women and their children, as they viewed Mexican traditions and customs as obstacles to their full integration into American life.[4] Accordingly, differing beliefs about the role of cultural pluralism in U.S. society set apart early Americanization efforts from those of OWI and OCIAA officials in the Second World War. Although advocates of the federal "Americans All" campaign believed strongly in an Americanism that prioritized nation over race, as supporters of racial liberalism, they also advocated for cultural tolerance and understanding, recognizing diversity as an integral part of the American people.

Thus with the advent of war, Mexican women found new opportunity to challenge their long-standing outsider status. In contrast to the negative depictions of Mexican American youths in Los Angeles newspapers, federal efforts at inclusiveness opened the door for mothers and daughters of Mexican descent to utilize wartime ideologies of racial liberalism creatively and to their advantage. Casting their attentions on the Los Angeles print media, numerous Mexican women strategically drew upon new wartime federal campaigns to counter negative stereotypes and establish themselves as fully reputable.[5]

The new attention paid to Mexican women's roles as respectable war workers, mothers, and volunteers in the English-language press and radio

challenged Los Angeles residents to rethink popular perceptions of women of Mexican descent as foreigners or threats to the wartime social order. At the same time, limits to the everyday application of wartime racial liberalism were evident in the ways in which discriminatory patterns persisted, particularly as national needs collided with long-standing local prejudices. In spite of their seeming willingness to promote "Americans All" ideologies, most major Los Angeles newspapers continued to draw upon salacious stereotypes of Mexicans, while some local officials wished to preserve aspects of the racial status quo in an effort to maintain the peace. Federal promotion of an Americanism based on toleration of diversity thus may have marked a new era for Mexican women and their relationship to the nation, but Mexican women's appropriation of mainstream media and state institutions remained possible only within limited parameters.

IN THE WAKE OF THE SLEEPY LAGOON INCIDENT, by late 1942 federal officials had grown increasingly concerned with the so-called Mexican problem, by and large out of a desire to maintain the international support of Latin American neighbors and to address the growing crisis of acute labor shortages in the United States.[6] Given the proximity of Latin America to the United States, officials worried that weakened alliances might pave the way for Axis countries to gain supporters in the Western Hemisphere, thereby strengthening the enemies' ability to sabotage the Allied war effort. Moreover, the need for specific support from Mexico remained especially crucial given wartime agreements between the United States and its southern neighbor. Mexico not only had arranged to supply much-needed Mexican agricultural and railroad labor to the United States as part of the Bracero Program, but also had permitted Mexican citizens living in the United States to be drafted into the U.S. armed forces. As a result, the issue of addressing discrimination against Mexican peoples living in the United States appeared all the more pressing.[7]

Historically, the Roosevelt administration had been a strong promoter of goodwill efforts aimed at Latin America, even as it overlooked the specific needs of Mexican people living within U.S. borders. Beginning in 1933, President Roosevelt promised a new era of cooperation and trade with Latin American neighbors, decrying previous U.S. military interventions into the region. As Roosevelt articulated in his first inaugural address, a good neighbor "respects the rights of others," an irony not lost upon those aware of the long history of racial discrimination experienced by Latino populations residing in the United States.[8] Thus amid wartime lobbying efforts by Mexican

American educators and politicians, and by social commentators like Carey McWilliams, federal policymakers came to the realization that promoting democracy abroad while remaining inattentive to the domestic situation of Mexicans might severely undermine the administration's long-standing Good Neighbor Policy.[9]

Recognizing the importance of maintaining Latin American goodwill, the OCIAA and the OWI each commissioned field studies to better understand the situation of the Mexican population living in the United States.[10] Both federal agencies had been established under President Roosevelt: the former in 1940 as a way to promote inter-American cooperation in the Western Hemisphere; the latter in 1942 via Executive Order, with the intended goal of "selling" the war to the American public. Yet in the end, the agencies' respective studies offered pointedly left-leaning critiques of the Roosevelt administration's relative inattention to race relations. By mid-1942, OCIAA investigators concluded that "socially and economically the Spanish speaking minority is among our most submerged class . . . subjected to social and economic discriminations," and warned that "this unwholesome condition weakens our morale, hampers our war effort, and interferes with the most effective implementation of the good neighbor policy."[11] Similarly, the OWI found that Spanish Americans and Mexican Americans in the Southwest represented an "economically destitute, educationally deprived, socially disorganized" population, "beset by severe housing, health, sanitation, and nutritional deficiencies." According to the OWI study, prejudice against the Mexican population in the United States posed an "irritant in hemispheric relations, a mockery of the Good Neighbor policy, an open invitation to Axis propagandists to depict us as hypocrites to South and Central America and, above all, a serious waste of potential manpower."[12]

Addressing manpower shortages remained a top priority for federal officials, particularly given the burgeoning defense industry's initial refusal to hire Mexicans. In Southern California alone, the airplane industry, according to the OWI, "has been consistent in asserting that it does not discriminate, but payrolls show almost no Mexicans employed."[13] Aviation was not the only industry reluctant to hire minority labor. A 1942 survey conducted by the Congress of Industrial Organizations (CIO) proclaimed that although more than six months had passed since the attack on Pearl Harbor, only 5,000 persons of Mexican extraction found work in Los Angeles's basic industries. As one government official explained, employers assumed Mexican Americans to be "incapable of doing other than manual, physical labor" and "unfit for the type of skilled labor required by industry and the crafts."[14]

Even as employers looked more and more to hire women workers to address labor shortages, Mexicans typically found lucrative jobs closed to them. Historically, Mexican women in Southern California could find employment in agricultural labor and in canneries and apparel factories, in addition to domestic work.[15] Training in new types of defense labor offered the possibility of movement into higher-paying jobs, yet those fortunate enough to learn new skills still found their newly acquired abilities insufficient to breach the color line. As the OWI reported, "American-born girls of Mexican ancestry in San Diego have taken training courses, have come out at the top of their class, only to find that employers have passed them up to take less competent white girls."[16]

Aiming to blunt anti-Mexican discrimination, the OWI hired as its chief cultural affairs officer Ignacio López, editor of the Southern California Spanish-language weekly *El Espectador*, to embark on a wide-scale media campaign to "integrat[e] this Spanish speaking minority so that it would more fully participate in the work of the community." Working with other members of the OWI's Foreign Language Division, López offered his specific expertise in how best to utilize the Spanish-language press and radio to engage the Mexican population in the U.S. war effort.[17] Considered to be one of the "best-known journalist-intellectuals of the Mexican-American era," López seemed a natural fit for the job.[18]

Although a strong believer in ethnic pride and what historian Mario García terms "pragmatic cultural retention," López also strongly supported the social and political integration of the Mexican population into American life. He advocated that Mexican children learn English and challenged discrimination against the Mexican population in public facilities and housing in the Pomona Valley. Segregation hindered acculturation, López believed, and prohibited Mexican Americans from being recognized as "full-fledged U.S. citizens." Further evidence of López's commitment to acculturation was reflected in the episodic bilingualism of *El Espectador*. Recognizing that a growing number of Mexican American youths preferred to read and speak in English, López's publication actively worked to engage the second generation's interest.[19] Thus in hiring López, the OWI hoped to capture a spirit of cultural pluralism that would encourage Mexicans to participate in the war effort while, simultaneously, "break[ing] down, in so far as possible, Anglo prejudices against resident Latin Americans."[20]

The plan to implement programming aimed at the Mexican population dovetailed, to a great extent, with the OWI's larger "Americans All" vision. By the time the United States formally entered the war in 1941, U.S. officials

had begun to embrace "a new, differentiating language of tolerance" deemed essential to the war effort.[21] In response to Nazi claims that social revolution could easily be stirred up in the United States given its diverse peoples, OWI propagandists countered with a vision of Americans united, no matter their background, under a universal wartime cause.[22] With federal support, even Hollywood combat films like *Bataan* and *Guadalcanal Diary* depicted a host of ethnoracial characters who, by film's end, transformed into "true Americans" as they valiantly battled Japanese troops.[23] As President Roosevelt stated in a 1943 speech to activate the 442nd Regiment—a combat team composed primarily of Japanese Americans—"Americanism is a matter of the mind and heart; Americanism is not, and never was, a matter of race or ancestry."[24]

Readily embracing a more inclusive vision of Americanism, Ignacio López joined the OWI with a desire to demonstrate the "opposition of the United States Government to *all* discrimination, in employment and otherwise," particularly that levied "against loyal Spanish-Americans."[25] In late 1942, members of El Congreso had prepared a report for the OCIAA, condemning the federal government for its refusal "to address the Spanish-speaking millions in their own tongue."[26] Mindful of their complaints, López offered specific guidelines for his OWI colleagues to follow in order to reach members of the Spanish-speaking population. The newspaperman promoted a Spanish-language media campaign that would "emphasize capacities and abilities of Spanish-Americans and reassure them of their own worth" through radio and posters, newspaper supplements, *corridos* (ballads), and films for Spanish theater, club, and church presentation. He also recommended highlighting compelling personal-interest stories that recognized the "outstanding merit" of Mexican women and men in the service and the civilian war effort, particularly those who could be "play[ed] up in the English press." "Numbers always seem to impress English readers," stated López, and thus he urged the OWI to gather figures on the numbers of Mexicans in all branches of the armed services, in addition to any information on the population's bond- and blood-donation rates. Finally, López advocated the use of pictures wherever possible, noting that color would play up "racial characteristics" and thus "convey much easier and stronger the fact that the person or group aiding the war is Mexican or of Mexican extraction."[27]

By 1943, the OWI adopted the phrase "Americanos Todos" ("Americans All") as a motto for its campaign to reach Spanish-speaking audiences. Utilizing simple yet powerful visual imagery, Mexican artist Leon Helguera contributed a colorful, bilingual poster to promote the slogan in the OWI's

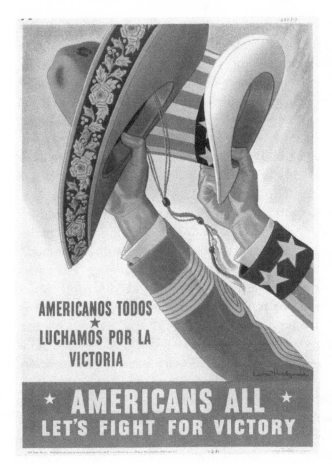

Leon Helguera, "Americans All, Let's Fight for Victory— Americanos Todos Luchamos por la Victoria," OWI Poster No. 65, U.S. Government Printing Office, Washington, D.C., 1943. UNT Digital Library, http:// digital.library.unt. edu/ark:/67531/ metadc426/ (accessed July 4, 2012).

AMERICANOS TODOS
★
LUCHAMOS POR LA
VICTORIA

★ AMERICANS ALL ★
LET'S FIGHT FOR VICTORY

propaganda art series. The illustration depicted two arms—one holding a Mexican sombrero and the other wielding a red, white, and blue Uncle Sam–type hat—raised side by side, pointed toward the sky. The words "Americanos Todos: Luchamos por la Victoria" ran next to the image, and the translation, "Americans All: Let's Fight for Victory," lined the bottom in bold yellow lettering. Few of its viewers would be hard-pressed to understand the poster's message of commonality and unity.[28]

From its inception, Mexican women played an integral role in López's program of "Americanos Todos." The OWI gave equal attention to the valiant service of uniformed men of Mexican descent and their patriotic home front sisters who volunteered their time and energy to defense production lines, bond and blood drives, and United Service Organizations (USO) dances.[29] By 1943, a nationally distributed booklet titled *Spanish-Speaking Americans in the War: The Southwest*—cosponsored by the OWI and the OCIAA—officially

recognized these "special contribution[s]" through photographic depictions and bilingual descriptions of women defense workers laboring on aircraft assembly lines in Southern California and utilizing needlework skills to complete cloth and leather fittings of planes at local Red Cross units in Arizona.[30]

Once the OWI began to persuade defense industries like Douglas Aircraft in Southern California to launch "high-powered employment drive[s] among local Mexicans," media emphasizing Mexican women's positive work experiences emerged in the Los Angeles vicinity as well. In late 1942, the OWI sent a representative before the West Coast Aircraft War Production Council to receive its assistance in convincing Douglas Aircraft Company officials to recruit workers of Mexican descent.[31] With the need for wartime workers skyrocketing, Douglas Aircraft subsequently embarked on a campaign that spent over $15,000 a month in print and radio advertising aimed specifically at the Mexican community.[32] Spanish-language signs claiming "Esta guerra es SUYA! También se necesita de usted" ("This war is YOUR war! You, too, are needed") and touting the availability of "trabajo para hombres y mujeres de todas edades" ("jobs for men and women of all ages") appeared in barrio neighborhoods. As is discussed in Chapter 3, interested members of the Mexican population—particularly women—soon began to flock to factory gates and secure employment.

Mindful of the need to demonstrate its acceptance of a multicultural workforce, and to assist in integrating Mexican women and other workers of color onto the assembly line without incident, Douglas management often made use of its company newspaper, the *Airview News*, to highlight personnel diversity and the unity of wartime purpose prevalent across the color line. Thus while Hollywood combat films like *Bataan* and *Guadalcanal Diary* transformed young men of Mexican descent into "true Americans" through depictions of their valiant service on the battlefields abroad, young women of Mexican descent found their ethnic difference reconciled into a common nationality on the defense production line. In a 1943 photograph titled *This Is America*, for instance, the El Segundo Douglas plant illustrated the spectrum of its wing subassembly employees with a caption reading: "Josephine Grajeda, Mexican; Patrick Hayes, Irish; Ethel Quon, Chinese[;] and Laura Miller, Negro, all at work on the same jig in department 509."[33] Countless aircraft employees witnessed the responsible and cooperative efforts of Spanish-surnamed women, as the *Airview News* repeatedly highlighted their blood and bond donations and solid work-attendance rates. In September 1943, the Santa Monica Douglas plant featured a photograph of Elaine del Castillo, who gave blood six times.[34] By the year's end, Thelma García, also of Douglas's Santa Monica plant, became one

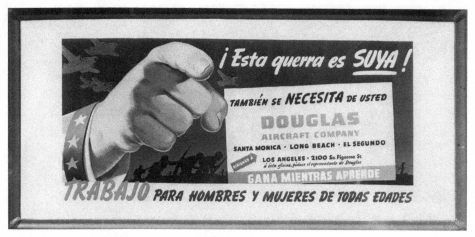

Douglas Aircraft billboard aimed at recruiting Mexican workers, circa 1942–44.
Courtesy Boeing.

of the top blood donors of the entire nation, one of several "patriotic employes [*sic*] helping save lives all over the world."[35]

Once racialized outsiders, young women of Mexican descent now found themselves depicted as insiders by the defense industry press. In 1944, for instance, Douglas's Long Beach plant highlighted the work of assembler Juanita Escareno in producing the two thousandth B-17 Flying Fortress. The *Airview News* article reported that, proud to be a part of the war effort on the home front, Escareno had composed a "beautifully written" letter to Col. James R. Luper, pilot of the No. 1000 B-17, in order to express her best wishes and support for U.S. troops abroad. Escareno, whose smile was splashed across the front page of the paper for all Douglas employees to see, received in return a letter of congratulations from Colonel Luper, who commended her on her key role in "turning out 2000 of these 'heavies' that have carried American might as well as American 'guts' to the very heart of the Axis." According to the colonel, Escareno had "every reason to be proud of [her] great contribution to final victory," as her efforts (and those of her coworkers) would be instrumental to "equip us to defeat the enemy and to bring us home."[36] Rather than epitomizing a foreign-born enemy, Escareno exemplified how members of the Mexican population helped in the defeat of America's adversaries.

Federal officials similarly encouraged attention to the patriotism of Mexican mothers who sacrificed their sons, husbands, and other loved ones to battlefields abroad. One installment of the *Spanish-Speaking Americans in*

Douglas Aircraft touts "Americans All" ideologies in its company newspaper, the El Segundo Airview News, *in December 1943. Courtesy Boeing.*

THIS IS AMERICA—Josephine Grajeda, Mexican; Patrick Hayes, Irish; Ethel Quon, Chinese, and Laura Miller, Negro, all at work on the same jig in department 509.

the War booklet juxtaposed the photographs of grieving Mexican and Euro-American parents: on the left of the broadside, a stoic New Mexican mother, shrouded in black, with a graveyard behind her, mourning the death of her son to the battle of Bataan; on the right, the solemn faces of a Kentucky mother and father, parents of two young men of the state's 192nd tank battalion, also lost at Bataan. The message was clear: mothers bore the noble responsibility of rearing America's war heroes; united in grief, mothers' losses transcended race and creed.[37]

With strong support from the OWI, Los Angeles newspapers and industrial publications also paid homage to the value of Mexican motherhood writ large by featuring human-interest stories of large Spanish-surnamed families participating in the "all-out" defense of democracy. In late 1942, as negative press coverage of zoot-suited Mexican American teens escalated with the advent of the Sleepy Lagoon case, the OWI sent Alan Cranston, head of the agency's Foreign Language Division, to Southern California in an attempt to improve the image of the Los Angeleno Mexican population. Asking local newspaper editors and publishers both to "stop using the term 'Mexican' in connection with the local disturbances" and "to carry positive stories of the war participation of Americans of Mexican extraction," he secured promises to comply from the *Herald and Express*, the *Examiner*, and the *Daily News*. Noting that a once "critical situation ha[d] been overcome completely," Cranston returned to D.C.[38]

Shortly thereafter, in January of 1943, all three leading Los Angeles newspapers ran a feature story and photo spread on the Cazares clan, a Mexican

LONG BEACH *Airview News*

Vol. 3 LONG BEACH, October 10, 1944 No. 24

Pilot of 1000th Fort Thanks B-17 Workers For 'Great Contribution'

When Flying Fortress No. 2000 rolled out recently, Juanita Escareno of Dept. 543 couldn't help feeling a deep sense of pride that she had had a part in turning out 2000 of these "heavies" that have carried American might as well as American "guts" to the very heart of the Axis.

She knew that her job was an important one—she knew it because the pilot, Col. James R. Luper, who flew No. 1000 had taken time out to thank her personally and congratulate her fellow workers for their untiring efforts in a letter addressed to her from the bomber base in England where Rene III was dishing it out.

The letter is reproduced below:

> 457th Bombardment Group,
> A.P.O. 557
> c/o Postmaster, N. Y. City

Dear Miss Escareno,

"I have your letter of May 25th and only the press of operations could have prevented my immediate answer. It was beautifully written, and the thoughts expressed in it are deeply appreciated by all of us who fly—not only "Rene III", No. 1,000—but all the other ships you and your co-workers have built to equip

(See—Luper's Letter—Page 2)

—We Have Just Begun to Fight—

Douglas Rod and Gun Club to Meet Tonight at Dude Ranch

The Douglas Long Beach Rod and Gun club will hold its monthly meeting tonight (Tuesday) at the Dude Ranch on North Atlantic blvd. at 7:30 p.m.

Membership cards will be distributed and several outdoor films will be shown. Every member is urged to bring a friend. In addition members will be given an opportunity to win a plaid sports shirt and a parka.

"BEST OF LUCK, NUMBER 2000"
—That's what Juanita Escareno seems to be saying as she takes her final look at the 2000th B-17 Flying Fortress to be produced at the Douglas Long Beach plant. In her hand she's holding a letter from Col. James R. Loper who flew Fortress Number 1000 into battle.

The front page of the Douglas Airview News *highlights assembler Juanita Escareno for her efforts in helping to build the two thousandth B-17 Flying Fortress. Courtesy Boeing.*

family perfectly emblematic of the OWI's vision. Hailed as "Los Angeles' No. 1 Victory Family of Mexican Descent," all twenty-two members had dedicated themselves in various ways to the war effort. Mother Maria ran a power machine, "turning out uniforms for war workers"; American-born sons and nephews served in the army, navy, and marines; and daughters and nieces produced war material and volunteered for emergency and first aid civilian defense. One daughter, Marta, even worked as the secretary to Guy Nunn, field representative for the federal government's War Manpower Commission. As the *Los Angeles Times* stated, "Officials believe this individual family record is unparalleled in any other part of the nation as far as all-out war effort is concerned." The OWI agreed and immediately urged widespread promotion of the Cazares story. Excitedly writing to Ignacio López, Alan

Cranston told his colleague, "When you get out [to Los Angeles], you've gotta plant ten of these [clippings] per day."[39]

The trope of the sacrificing, patriotic Mexican family provided a powerful corrective to stereotypical notions of Mexican parents as unfit to rear their American-born offspring. Immediately preceding the Zoot Suit Riots, the *Los Angeles Times* reported that parental over-reliance on the Spanish language and an unwillingness to assimilate contributed to juvenile delinquency among Mexican American teens.[40] Days later, Los Angeles newspapers published a photograph of Mexican mother Vera Duarte Trujillo as she tore up her fifteen-year-old son's zoot suit. According to Trujillo, her son "kept slipping away" as he associated with "older zoot suiters," ultimately leading to his gunshot wound during a gang riot. It appeared that the dysfunctional gang family had proved more influential over young Vicente than his own parents.[41]

As historian George Sánchez explains, since the 1920s, Americanization advocates had focused on the Mexican family as a flawed but malleable unit that "required intense education in 'American values.'" Reformers sought to teach Mexican families the importance of engaging in proper hygiene and dietary habits, speaking English, and, perhaps most importantly, limiting family size. Fears of "race suicide," and the belief that Mexican mothers with large numbers of children would become public charges, or have little time or energy to properly train members of the household in "modern" standards of living, compelled Americanists to urge Mexican women to engage in family planning.[42]

Yet in the context of wartime work and service, the need for military men and productive workers rendered Mexican motherhood patriotic and large Mexican families an all-American institution. In July 1943, the Douglas *Airview News* chronicled the life and work of Celia Dominguez, a wing driller for the B-17 at Douglas Aircraft in Long Beach (see her photograph in Chapter 3). Referring to Dominguez as a "modern young wife," the paper reported that management marveled at her impeccable punctuality and attendance on the job. She excelled equally as a mother of seven children, with daughter Carmen, a seventeen-year-old accomplished pianist and honor student; sons Alphonso, fifteen, and Lemuel, fourteen, YMCA camp stars; Eunice, twelve, and Evelyn, ten, blossoming violinists; and youngsters Mary Alice and Celia, eight and five. According to the reporter, even the two youngest children "[couldn't] do enough to help mother so that she can build planes." As Dominguez explained it, she prided herself on being a loving, loyal mother to both kin and country, remaining personally committed to American values of hard work and sacrifice: "My husband encourages me to do my part for our

country, and my Fullerton neighbors[,] where we have lived for 12 years, are so kind and helpful that I can gratify my desire to help my country with a free mind, and do my part to see that my six nephews in the Armed Forces get the equipment they need."[43] Dispelling the stereotype of the Mexican family as an unassimilable welfare drain, the Cazares and Dominguez clans received recognition as normative—even model—American families and citizens.

In spite of the achievements of the "Americans All" campaign, however, local officials did not always carry out federal programming in exactly the way in which it was originally intended. The model adopted by the Southern California Council of Inter-American Affairs (SCCIAA), a Los Angeles branch office of the OCIAA, serves as a case in point. During the Sleepy Lagoon trial, the OWI's Alan Cranston highly recommended an opening of an OCIAA branch in Southern California in order to "further good will between Americans and between the Americas" in a city with one of the nation's largest Mexican populations.[44] The SCCIAA opened its doors, coincidentally, on the first day of the Zoot Suit Riots and without delay began its work to "promote a better understanding between the Spanish-speaking minority of Southern California and the rest of the community." Among its many initial goals the organization included the fuller participation of Latin American youths in war industries, an extension of recreational facilities in Spanish-speaking districts, and the elimination of discriminatory practices against Mexicans in California.[45]

Yet not long after its opening, significant tensions began to surface between SCCIAA leadership and the local Mexican population it was established to assist. Mexican community leaders condemned the SCCIAA for establishing an advisory board that lacked any Spanish-speaking members, and argued that the institution appeared to be "set up to supersede Mexican leaders or to dictate to the Mexican American colony."[46] Indeed, the organization seemed well-equipped to sponsor "fiestas" but flawed in its tendency to view the solution to Los Angeles's racial tensions through a lens of cultural erasure.[47] Their vision of the World War II ethos of ethnic and racial pluralism would, in effect, come to stand for what historian Lary May calls "a modernized form of an older code of assimilation."[48]

Los Angeles radio listeners became well-acquainted with SCCIAA objectives in the months following the Zoot Suit Riots. Anxious to address the immediate concern of heightened tensions among youths of Mexican descent and the larger wartime community, the SCCIAA teamed up with the Columbia Broadcasting System (CBS) to produce a radio show that would attempt to assuage the city's racial animosities. The show's creators planned to draw upon

stock characters of Mexican descent, including the traditional yet ultimately pliable Mexican mother; her strictly supervised daughter and rebellious, zoot-suited sons; and the brave combat hero. Chet Huntley, a veteran CBS radio newsman, wrote and narrated the series, providing the voice of reason to Anglo characters who so clearly misunderstood their Mexican brethren.[49]

When the *These Are Americans* radio series ran in 1943 on the CBS-affiliate KNX Radio in Los Angeles, it included six weekly, fifteen-minute shows that called for acceptance of the Mexican population and urged Euro-Americans to help members of the Mexican community "speed up th[e] process of assimilation" to American life.[50] Huntley offered his listeners various platitudes about the evils of racial supremacy and the need to "[see] to it that no race or class or creed is left stranded outside the current of American life."[51] He asked white America to look inward in understanding why the Zoot Suit Riots had occurred, suggesting that, due to widespread discrimination, "you and I have had a hand in making them."[52] Like other media outlets, the show also commended the wartime service of the Mexican community, highlighting the bravery of Mexican American men on the battlefield and the wartime contributions of Mexican American women in the defense factory.[53] Finally, the series linked the advancement of the Mexican community to national wartime interests, arguing that the Zoot Suit Riots had "give[n] Tojo and Hitler the biggest news stories they could wish for" by making a mockery of the words of the Atlantic Charter and President Roosevelt's Four Freedoms.[54]

At the heart of *These Are Americans* lay the notion that the assimilation of the second generation rested squarely on the shoulders of its mothers. In the second episode of the radio series, listeners learned of the generational tensions to be "overcome" in Mexican homes, where daughters could easily disgrace their entire family by simply walking down the street on the arm of a young man: "Good girls don't have anything to do with boys . . . not until you are grown up!" listeners heard one Mexican mother sob. But "mother, don't you understand! This isn't Mexico City! This is California—the United States— and here boys and girls are supposed to be with each other. There's nothing wrong with that," responds her American-born, teenage daughter. Huntley's companion narration gently reminded listeners of the importance of patience and understanding in assisting Mexicans to fit in. As Huntley pointed out, second-generation Mexican Americans were "pulled two ways: by the traditions, language, customs of the parents' native country on the one hand; by the language, traditions, customs, and behavior of this community on the other." "In that respect," Huntley argued, "the Mexican-American is no different than the Irish-American, the Norwegian-American, or the Slav-American."[55]

While *These Are Americans* invoked the notion that strict Mexican parenting hindered the development of the second generation, the show simultaneously portrayed the Mexican mother figure as a hesitant—but ultimately willing—participant in the Americanization of her children. Following the narration of the heated conflict between mother and daughter, Huntley implored his audience to not "blame the first generation" for the woes of its youths. As evidence he offered a "true story" of three Mexican mothers who visited the radio station of Al Jarvis—a supporter of the Sleepy Lagoon Defense Committee and the man often considered to be America's first deejay— in an effort to implore him to help keep their sons off the streets. "Our boys are good boys," explained the mothers during the skit, "but maybe they soon get into trouble. You know, they soon join gangs or something like that, and that no good. We mothers don't know what to tell them—they don't listen to us, but they do listen to you, Mr. Jarvis, and they think you are very good. So would you talk to them and see what you can do?" At the behest of the persuasive mothers, Jarvis subsequently agreed to speak with the young men and staged a wildly popular, albeit respectable, dance for Mexican youths in their Eastside neighborhood.[56] With the help of Jarvis, these Mexican mothers had steered their sons toward a more straight and narrow path.

Indeed *These Are Americans* hoped to demonstrate that, given some time, the Mexican family would eventually cease to be ethnically and racially different, particularly if the Mexican mother could be educated on the value of helping her children to gain acceptance in larger society. Consider the following dialogue—broadcast in September of 1943—of a Los Angeles schoolteacher urging a Mexican mother, portrayed with a caricatured Mexican accent, not to fear her children's transformation into "Americans":

> Teacher: Someday your children will never think of being Mexicans.
> Mother: How you do that?
> Teacher: They'll do it themselves with the opportunity. They'll change.
> They won't be like their fathers and mothers. They'll talk and act
> and behave so that you may not understand them, but don't worry
> about it. It will mean that they're becoming just Americans. Tell
> your children not to be shy—to mix with other children—play their
> games—talk their talk—go to their dances—and join their clubs.
> Mother: Yes, I see. I tell them that.

Huntley's subsequent commentary explained the importance of "amalgamating" Latin Americans into "our pattern of life," specifically for the purpose of "increasing hemispheric solidarity." He ended the episode with the following

statement: "We hope this program has been another step in the direction of that happy day when the Latin-Americans of this community will no longer hear the term Mexican or Mexican-American or Latin-American used in reference to themselves—that they will be regarded as—and respond to—just American."[57]

Ultimately Huntley's commentary exposed both the possibilities and the limitations of the racial liberalism of the 1940s. Geared toward an audience appalled by Hitler, the radio series provided its listeners with important lessons about the dangers of prejudice, urging acceptance and the need for the Mexican population to receive opportunities in community life. Perceptions of unity thus provided a framework for once ostracized peoples to be seen as valued members of wartime society.[58] On the other hand, however, the promotion of absolute cultural assimilation left little room for those unwilling to abandon their Mexican culture and heritage. Moreover, the radio broadcast tended to focus its efforts on principles of tolerance, rather than any real commitment to doing away with discrimination. Take, for instance, the following dialogue, in which Huntley sought to address white America's fears about the changing role of Mexicans:

> Voice: These ideals of yours are fine, mister; but you can have 'em. All this talk about equality and opportunity. Let me ask you this: how would you like it if your daughter should marry a Mexican?
> Huntley: Oh, brother. Get a load of him! That's the clinching argument, and he's supposed to have me down and out. Look! I wouldn't like it, but I'm not going to worry about it because I think people can live next door to each other and get along fine without their children inter-marrying. Marriage has nothing to do with friendliness, good neighborliness, or human kindness.[59]

Huntley's remarks illuminate the boundaries faced by the Mexican population in fitting into the traditional melting pot paradigm. To the average white American, living and working amicably next to a person of Mexican descent was one thing, but the sacred institution of marriage, quite another. Thus, in an effort to offer a more palatable, and far less controversial, means of addressing societal inequalities, even the most well-meaning advocates of "Americans All" had a tendency to promote propagandistic messages of cultural celebration and acceptance over any true commitment to structural change.

Yet in spite of the broadcast's limitations, the image of Mexican mothers as indispensable to a strong and united democracy represented a significant

transformation under way on the radio airwaves of Los Angeles. This was not an unfamiliar story: according to historian Ruth Feldstein in *Motherhood in Black and White*, notions of good mothers as the backbone of a healthy citizenry and maternal failure as responsible for undermining the strength of the nation remained at the heart of mid-twentieth-century racial liberalism, and shaped perceptions of black and white womanhood from the 1930s to the 1960s.[60] Wartime officials specifically created, and relied upon, conservative family discourses to define the Mexican mother's home front purpose as well. In order to be a "good" mother and patriot, the immigrant Mexican woman would facilitate the larger project of Americanization. As the primary nurturer and caregiver of the second generation, she alone held the key to producing citizens that would ultimately adopt American values and customs, and thereby lessen the prospect of future interracial tensions.

Although Feldstein argues that a "pro-maternal ethos"—one that insisted on the centrality of women to the private sphere—ultimately "narrowed women's options," depictions of the Mexican mother as a necessary component to interracial harmony did render her a more useful and productive citizen, in ways that had never before been possible.[61] Given their racialized status, women of Mexican descent had typically been excluded from the historical idealization of white mothers as "good," "virtuous," and, therefore, worthy citizens; for the immigrant generation, a lack of formal citizenship rendered Mexican women's social position particularly precarious. As historian Natalia Molina documents, Progressive Era health officials regularly blamed Mexican women's "improper" nutritional practices and "unkempt" homes for high infant mortality rates in barrio neighborhoods.[62] By the late 1920s, this pathologization of Mexican culture led Los Angeles County officials to declare Mexican immigrants to be of "feudal background," making it difficult for them "to understand and not abuse the principle of a regular grant of money from the state." As a result, the Los Angeles County Outdoor Relief Department refused mothers' pensions—a subsidy program for families with dependent children but without an adult male income—to Mexican widows, in essence marking Mexican women as "bad" and undeserving mothers and thus rendering them "outside the bounds of social membership in the United States."[63]

The wartime remaking of Mexican women as potentially good mothers thus had significant consequences. In infusing Mexican motherhood with a purpose that both celebrated, and looked beyond, biological capabilities, Mexican mothers took on a civic role previously reserved for white, middle-class "republican mothers" and "municipal housekeepers."[64] Good mothers

equaled good patriots, and thus Mexican women found themselves uncharacteristically valorized as citizenry invaluable to national unity.

This expanding "umbrella of Americanness" promoted by federal officials did not go unnoticed by women of the Los Angeles Mexican community.[65] To the contrary, evidence suggests that Mexican women became increasingly comfortable in embracing "Americans All" rhetoric, particularly in the press, as a means to promote positive self-imagery and to counter anti-Mexican sentiment. As the war progressed, both Mexican mothers and daughters alike utilized their "service" to the nation to leverage respectability and social acceptance.[66] But unlike the SCCIAA's promotion of total cultural assimilation, Mexican women publicly took pride in their ancestry, advocating a vision of cultural pluralism based on principles of equality and acceptance.

Indeed, concern over the image of the Los Angeles Mexican community had reached crisis proportions by 1943 as the local Mexican population had, for over a year, witnessed the unrelentingly negative press campaign to demonize zoot suiters. While the federally supported "Americans All" campaign promoted idealized visions of American race relations, on a day-to-day basis Mexican Americans still faced local prejudices and treatment as criminals and foreigners. As such, several women of Mexican descent drew upon their status as patriotic mothers to voice their protests. In June of 1943, for instance, one frustrated Mexican American mother wrote a letter to Manchester Boddy, publisher and editor of the *Daily News*, on behalf of the "many Mexican mothers [who] feel just like I do but are afraid to express their opinions." Decrying the treatment of Mexican American youths as hoodlums, she focused her attention on the educational system that she claimed fostered both "hatred" and "racial discrimination." "In schools there are all nationalities," wrote the mother, "but only Mexicans are called by their ancestors' blood. There are Irish, Jews, English, French, Swedes, etc., but as long as they are born in this country they are Americans. Why not those of Mexican descent?" In order to highlight further the hypocritical treatment of Mexicans as outsiders, the mother drew attention to both her U.S. citizenship and her wartime sacrifice as a two-star mother—factors she hoped would legitimize her right to acceptance. Not only did her oldest son serve in the U.S. military, but the youngest was about to join, and she and her children were all born and reared in the United States. Replicating the rhetoric of "Americans All," she implored readers to accept her and her family, and the many other Mexicans like them, because "We are 100 percent Americans."[67]

This anonymous mother was not alone in claiming her motherhood status, and her wartime contributions, to justify demands for equality. Another

outraged mother lodged her protest with both the press and Mayor Fletcher Bowron after witnessing Los Angeles police officers harass and arrest two zoot-suited Mexican American men—her fellow coworkers at a local defense industry—"just because they were Mexicans." In a letter that expressed her discontent about "police brutality and persecution because of nationality," Dolores Figueroa began her complaint by establishing herself as both a war worker and a U.S. citizen, someone "proud of being a Mexican and not afraid to say it." She explained how she had grown "depressed" after the realization that her "boys [could] grow up and be thrown around like that." "I'm a mother of two boys, one 8 and one 4 years old and I'm working hard to raise them right and make good citizens of them," Figueroa explained. "I certainly don't want to even think that my boys will be kicked and slapped by a policeman without any cause, just because they are Mexicans and make 'good suspects.'" Invoking wartime necessity, Figueroa declared: "Our boys are also in the front lines fighting for a democracy which we all want . . . something should be done and done quick, otherwise morale of these boys will be ruined." Figueroa signed her letter as "a good citizen of these United States, law abiding and a registered voter."[68]

Daughters of Mexican descent took similar pains to address misrepresentations of their character in the mainstream press, but as youths they often centered their activism not in a traditional familial context, but rather with a more individualized focus on proving their decency and respectability as young, public women. Particularly in the wake of the Sleepy Lagoon incident, it was not uncommon for a Mexican American woman who was arrested and of interest to the reading public to find her name and photograph featured unflatteringly in the major Los Angeles dailies. As the Los Angeles Times told it, young gang girls with Spanish surnames were unlawful and dangerous; "carry[ing] long fingernail files as their weapons . . . [and] ranging the streets in their jalopies at night, they fight with each other, raid parties, hold up pedestrians and motorists and commit other crimes."[69] During the subsequent murder trial, reporters offered damning tales about the young women from the Thirty-eighth Street neighborhood in spite of their innocence in the Díaz killing.[70] Even outside the context of the trial, women deemed zoot suiters faced public derision. When twenty-two-year-old Amelia Venegas was arrested after verbally berating a group of police officers for their mistreatment of youths in zoot suits, more than one newspaper portrayed her unflatteringly, calling her a dangerous "pachuco woman." Emphasizing her foreign and treacherous behavior, the Los Angeles Times featured a menacing photograph of Venegas; the Herald and Express caricatured her Mexican accent: "I

no like thees [*sic*] daputy [*sic*] sheriffs," the reporter quoted her. In highlighting Venegas's supposed accent, the press clearly implied that were she more Americanized, her English would be better, and so therefore would her behavior. Thus to the average reader of major Los Angeles newspapers, Mexican American women simply "appeared both unladylike and un-American."[71]

In response to press coverage that categorized their behavior as threatening to proper visions of both gender and nation, second-generation daughters concentrated their protests on classifying and protecting their good names and good characters. In late 1942, reputation seemed to remain foremost in the minds of three young women—Victoria Audelet, Gloria Navarro, and Soccorro Tafoya—when they witnessed their faces splashed across pages of the *Los Angeles Times* as "suspects" held after a police "gang drive" that rounded up hundreds of youths on the Eastside, directly following the Díaz murder. Pictured next to two young men dressed in zoot attire, the young women are sitting solemnly as police captain C. H. Tucker stands over them, wielding a gun and chain allegedly found in their car. What the original article failed to mention, however, was that, after further investigation, the police realized an egregious error—the weapons had in fact been found in another car that belonged to a different group of arrested young men.[72]

Desperate to clear their names, upon their release Audelet, Navarro, and Tafoya immediately contacted the *Los Angeles Times* to "help us let folks know this." The *Times* agreed to report the mistake, and two days later it ran a retraction article that reprinted the damaging photograph, this time with the girls' explanation. "The chain found in our car was only a little piece that is used by one of the boys in his work. None of us has ever been in any kind of trouble and we have been very much embarrassed," Navarro stated. "We belong to no gang . . . we do not wish people to think that we are the kind that gets mixed up in anything like that."[73]

For the few times that the Los Angeles press cooperated in representing the perspective of Mexican women in its pages, however, unflattering coverage remained a mainstay. Just a day before the start of the Zoot Suit Riots, the *Los Angeles Times* published a piece devoted to youths and gang activities, with a focus on rising delinquency among young girls. Although never specifically referring to Mexicans, the article condemned the zoot suit as a "badge of delinquency" and discussed the ways in which native-born youths of foreign-born parents represented one of the greatest social problems facing wartime authorities. According to the reporter, "Girls are becoming delinquent mostly in sex matters and as runaways," a phenomenon explained by growing numbers of young women choosing to follow their boyfriends

in uniform to their military posts. As a result, one leading city health officer claimed that "the health of [Los Angeles]—as well as its moral and social structure—is suffering." Most problematic, claimed the article, was "the eagerness on the part of family and friends to shield a young girl's honor," making it difficult for authorities to deal properly with the delinquency crisis.[74]

In some respects, this broadly negative portrait of the second-generation's lifestyle held a hint of truth in that it captured with accuracy aspects of working-class Mexican American youth culture. As historian Eduardo Pagán points out, there were indeed Mexican Americans who experimented with premarital sex, liked to hang out in groups of fellow working-class teens, and fought with one another on occasion. But these traits did not characterize all working-class youths; nor were they representative of the Mexican community alone. Because so few Mexican American women actually fit the stereotype of the quintessential gang member, the *Times*'s look at the Mexican underworld of Los Angeles reveals a desire merely to boost readership by reinforcing public prejudice rather than to uncover a realistic representation of those involved in the zoot subculture.[75]

Outraged by the article's broad accusations and sexual undertones, a rush of Mexican American women contacted the Coordinating Council for Latin American Youth (CCLAY) to assist them in taking action.[76] Begun in 1941, the CCLAY represented members of Los Angeles's small middle-class Mexican community who had agreed to serve on the council in hopes of creating a cadre of Mexican leaders who would help fight against juvenile delinquency by "raising the moral and social standards of Spanish-speaking people." Leading the cause was reformer Manuel Ruiz, a young, bilingual attorney, among the first Mexican Americans to receive a law degree from the University of Southern California. Since Ruiz and his cohort embraced the notion of teaching zoot suiters and other Mexican American youths the kinds of social behavior that would win them acceptance, the CCLAY readily accepted the girls' cause as worthy of their larger campaign toward racial uplift.[77]

During a meeting with CCLAY leadership—including acting secretary Manuel Ruiz and chairman Eduardo Quevedo—in addition to the left-leaning Jewish journalist and news publisher Al Waxman, the young women discussed the damage done to their collective reputations by the Los Angeles daily newspapers. When a spokeswoman for the girls subsequently addressed the CCLAY body at large, members of the organization wholeheartedly agreed on the importance of making known "that 9 tenths of 1% of the Mexican girls only are considered juvenile delinquen[ts]." Some members, however, cautioned that, at the risk of further detrimental coverage, any publicity should

be "properly channeled" through a trusted media outlet like the OWI, or a historically sympathetic press.[78]

Soon thereafter Waxman offered the *Eastside Journal*—his own relatively small, community newspaper, known for its attention to liberal causes—to "serve as a vehicle for their message."[79] Indeed, his press proved the perfect trusted source, in spite of its modest circulation. Over the course of the Zoot Suit Riots, the publisher acted as a strong ally for Mexican American youths, diligently covering injustices.[80] The protesters agreed to stage a photo opportunity that would demonstrate the respectability of the Los Angeles Mexican woman and pledge her dedication to the United States and the war effort.

The photo spread that ultimately ran in the *Eastside Journal* presented eighteen young women of the Mexican community in a manner that epitomized reputable, all-American femininity. Adorned with frilly hair bows and wearing floral print dresses, some of the young women sat with legs crossed daintily and hands folded in their laps; others stood tall. One protester donned pants, perhaps a subtle proclamation of her status as a defense factory worker and the respectability associated with war work. According to the accompanying text, the girls wished to protest inferences that their "moral characters were questionable." "It is true that [the press] did not say that of every girl of Mexican extraction," said the spokesperson for the group, "but the general public was led to believe that such was the fact."[81]

Eager to claim acceptance within the Los Angeles community, the women of the photo shoot drew carefully from the narrative and language of "Americans All." Referring to themselves as "American girls of Mexican extraction," the protesters made a strategic choice to draw attention to their desire to be viewed as Americans first and foremost. Moreover, the young women utilized their contributions to the wartime state in order to make further claims to the privileges of Americanism. "The girls in this meeting room," the article stated, "consist of young ladies who graduated from high school as honor students, of girls who are now working in defense plants because we want to help win the war, and of girls who have brothers, cousins, relatives and sweethearts in all branches of the American armed forces. We have not been able to have our side of the story told."[82] From war work to relations with the fighting forces overseas, these young women combated damaging stereotypes based on their essential contributions to the wartime state.

By bringing their story to the metropolitan press, these Mexican American women demonstrated a new willingness to utilize public media outlets to articulate grievances. As the *Eastside Journal* protest article pointed out, "Not one of the girls in the above photograph has ever been in trouble with the law

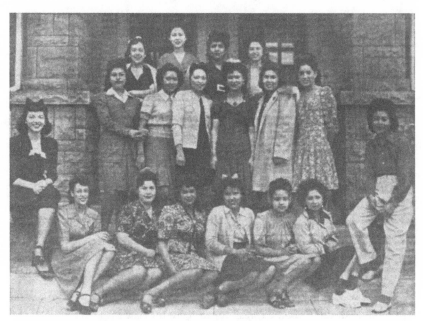

A photograph accompanying the "Mexican Girls Meet in Protest" article in the Eastside Journal, *June 1943. From the Carey McWilliams Collection 1243, UCLA Department of Special Collections.*

and not one of them has a record with the authorities. There are thousands of girls similar to these in Los Angeles County whose characters have been defamed by the inferences in the daily newspapers." This carefully planned, well-orchestrated effort introduced a new, respectable Mexican woman to the Los Angeles public, a far cry from the Spanish-surnamed tough girls typically highlighted in L.A. tabloids.[83]

Indeed, in posing a challenge to external criticisms against the Mexican community, the *Eastside Journal* protesters posed a direct challenge to pachucas themselves. The women who organized in protest and posed for the camera went to great lengths to ensure, in every possible way—through print and picture—that they were not to be mistaken as pachuca. None chose to wear zoot attire or to adorn other identifying markers of the pachuca style; the emphasis on their upstanding reputations only served to invoke the exact antithesis of rebellious pachuca behavior. Attesting to the investment that many young women had in both traditional Mexican values and new American ones, the construction of the pachuca as sexual delinquent allowed the protesters an opportunity to carve out a new social space based upon identities of respectable womanhood.[84]

Yet not all Mexican American women negotiated for respectability by outwardly condemning pachucas. Shortly after the *Eastside Journal* photo spread appeared, the *Los Angeles Evening Herald and Express* published its own salacious exposé of "girl 'zoot suiters,'" a feature story that called into question the moral character of those who engaged in the pachuca lifestyle. In response, yet another concerned group of Mexican American women, desperate to "show Los Angeles people just how Mexican girls are," secured a meeting with OWI official Alan Cranston to propose a publicized march on City Hall where they would undergo medical examinations by "an officially appointed board of physicians" in order to prove their virginity. Although many of the protesters, who numbered thirty in all, admittedly dressed in the zoot suit fashion, they wished to make it clear to the wartime public that the style did not go hand in hand with crime and sexual delinquency. "We were burned up at those papers and the things they said about us," stated one young woman, and "to prove our side, to take a chance, to have a good reputation, we were willing to do anything. It means a lot for a girl to have a clean reputation, but the *Herald Express* doesn't care for that."[85]

Apprehensive about subjecting the young women to such a public invasion of privacy, Cranston eventually convinced the girls to engage in a more subtle form of protest. Although, as one young woman claimed, "to prove it to the *Herald* [would have been] worth it," the group instead agreed that they would gather their friends to make a public blood donation at the local Red Cross. Although officials at the Los Angeles Red Cross initially hesitated to accept Mexican blood, Cranston "raise[d] hell" and persuaded them to change their policy. Likewise, he convinced news photographers to be present for the moment when fifty or more members of the Mexican community, many of them in zoot suits, would donate blood.[86]

Interestingly, the idea of "parad[ing] a lot of zootsuited young Mexicans down to the blood bank" ruffled the feathers of Los Angeles mayor Fletcher Bowron. Hesitant to welcome federal interference in community race relations, Bowron claimed outright that Cranston's plan "was wrong in principle and was hurting our local program." In an angry letter written to OWI head Elmer Davis just days prior to the blood drive, Bowron explained his position: "We have been trying to eliminate the word 'Mexican' in connection with acts of lawlessness and other things having popular disapproval, and striving to make those of Mexican blood in this community realize that they are Americans, rather than Mexicans. We do not feel that the people of Mexican parentage need to redeem themselves because of the acts of a few young hoodlums who have violated the law."[87]

Yet in spite of Mayor Bowron's remonstrations, Cranston's publicity stunt went off without a hitch. The day of the blood drive, the Red Cross touted "Los Angeles Mexican Day," and Angeleno newspapers were on hand to feature stories and photographs of Mexican American men and women donating their blood with "the hope that someday, somewhere, it [might] save the life of an American fighting on a world battle front." One *Los Angeles Times* reporter pointedly remarked on the "cosmopolitan" nature of the group, stating that "there were soldiers and defense workers, business and professional men, attractive young women and dapper young men, some wearing jitterbug zoot suits, but a far cry from those who were precipitated two weeks ago in the limelight of the so-called zoot suit orders." Rather, these youths remained "devoted to this, the country that saw their birth or adopted them without qualification."[88] Adjoining photographs provided striking visual evidence of the youth's patriotism: one photo spread depicted two Mexican American youths—one male and one female—donned in zoot suit attire as a Red Cross nurse greeted them. Behind the two youths stood a Mexican American serviceman, smiling in his neatly pressed uniform. To readers, these "Americans of Mexican ancestry"—no matter their attire—waiting patiently in line to give blood offered a familiar and comfortable image.[89] The OWI had thus successfully invoked yet another likeness of common Americanism; the young women had utilized the exigencies of war to reclaim their feminine respectability, without sacrificing their zoot suits to do so.

As second-generation daughters of Mexican descent took on new, more public social roles amid the wartime environment, twin desires to prove both decency and patriotism continued to frame their responses to negative characterizations in the press. In July of 1944, the *Los Angeles Times* ran yet another disparaging exposé—this time centered on revealing "youthful gang secrets" from "the lips of boys and girls who were forced into the gangsters' ranks and then were caught." Reserving particular derision for female gang members, the writer described a cadre of young women who served as lookouts to crimes, hid knives and fingernail files in high pompadours, and tended "to avoid and to hate servicemen." "Girl members of the gangs are forbidden to have even the slightest contact with members of the armed forces, although they are required to obey and yield to male members of their gangs in all things," the *Los Angeles Times* stated in a description rife with sexual innuendo.[90]

Incensed members of a Latin American USO affiliate immediately took issue with the article's "slanderous" claims of "Eastside" antimilitary sentiment. Discussed in greater detail in Chapter 4, the Señoritas USO had

originally been affiliated with Mexican youth auxiliary clubs and the Y's Owls, a youth group of Mexican American women sponsored by the Young Women's Christian Association (YWCA). In 1943, members of the Y's Owls expressed interest in forming their own USO, with the purpose of providing Mexican and Mexican American soldiers with dance partners and social companions from the Mexican community. Nationwide, USO girls prided themselves on good character; in fact, the organization took great pains to ensure that their women maintained middle-class notions of respectability and engaged in wholesome, chaste relationships with servicemen.[91] Who better, then, to counter rumors of the Mexican community's impropriety and subversion than those who counted themselves among the most virtuous young ladies in the nation?

In a heated letter to the publisher of the *Los Angeles Times*—again published in Al Waxman's *Eastside Journal*—members of the Señoritas USO drew upon their status as respectable wartime volunteers to counter the disparaging claims. "We are a group organized to serve Latin-American boys in service," the letter stated. "May we take the liberty to say that the statement you make about these boys and girls hating servicemen is entirely incorrect. We all have members of our families in the armed forces and have others just becoming of age proud to enlist before they are called, many of them supposedly belong to these 'gangs'—what better proof than that?"

The young women furthermore condemned the press for its negative generalizations regarding the behavior of Mexican American youth. Members of the Señoritas USO claimed that they were not aware of any "secret" behavior of "so-called 'juvenile gangs,'" nor did they consider the zoot suit to be a marker of criminality. As stated in the letter: the zoot suit could "be seen at any of the popular public ballrooms," being worn by "members of different localities," not just delinquent members of the Mexican American population.

Requesting that "corrective measures" be taken, the USO volunteers implored the publisher of the *Los Angeles Times* to live up to the promises of "Americans All." "Our group is also privileged to serve men in the armed forces of other nationalities," the letter stated. "It seems to us that if these boys are willing to fight, pray, and share the horrors of war together, then we here at home should do everything in our power to create unity so that they can be proud to return to the true 'democracy' that they are so willing to give their lives for." The letter was signed by thirty-six Spanish-surnamed USO hostesses. These young women understood quite clearly that their contributions to the wartime state gave them legitimacy to raise concerns about the effects of negative press on troop and civilian morale. In doing so, they

drew carefully upon the inclusive ideals of wartime liberalism to demand fair treatment.[92]

The outcome of this particular Latin American USO protest remains unknown, and the *Los Angeles Times* never did provide coverage of the Señoritas' wartime contributions nor print their letter of protest. The episode is notable, however, in its illumination of the contradictions faced by women of Mexican descent in wartime Los Angeles. On the one hand, the creation of wartime federal agencies signified new opportunities for Mexican American women to leverage improved treatment in U.S. society. Just a decade earlier, state policies had rendered Mexicans—regardless of citizenship—foreigners deserving of deportation and repatriation campaigns; in the 1940s, negative press coverage of zoot suiters further solidified Mexicans' outsider status. Given wartime exigencies, however, federally promoted, gendered citizenship narratives of "Americans All" enabled Mexican and Mexican American women new opportunities to make more powerful, legitimized claims to respectability and inclusion.

On the other hand, even as women of Mexican descent created new relationships with federal institutions, their continued second-class status was revealed in wartime society's inconsistent reception. Although major newspapers like the *Los Angeles Times* paid occasional lip service to ideologies of racial liberalism, only Al Waxman's *Eastside Journal* provided a consistent forum for Mexican American women to voice their grievances. Sadly, for the girls who sought larger public awareness, major metropolitan newspapers with higher circulation numbers were likely not interested in their concerns or protests. Ultimately, it would take more than a few months of federal campaigns to undo the years of disparate treatment and exclusion endured by Mexican communities across the Southwest. Like earlier Americanization programs, "Americans All" programming often only offered "idealized versions of American values." In reality, little more was attained than halfhearted attempts at fairness and cultural acceptance.[93]

Similar contradictions would play out for Mexican women on the defense factory shop floor, and yet the consequences of their employment often held the potential for more significant long-term change. By their very presence on the production line, women war workers of Mexican descent would contribute to a softening of racial boundaries. Given their changing relationship with the federal government, Mexican women would also utilize new agencies like the Committee on Fair Employment Practice in an attempt to help solidify an equal place for themselves and their community.

3

Reenvisioning Rosie

MEXICAN WOMEN AND WARTIME DEFENSE WORK

In 1943, Avion, a subsidiary of the Douglas Aircraft Company, hoped to tap teen workers by converting the industrial arts shop at Garfield High School into a small-scale factory making bomb doors for combat aircraft. With the "Four-Four Plan," the school, located in East Los Angeles, delegated four hours of a student's school day to defense work, and the subsequent four in classes. Recognizing a unique opportunity to earn money while attending school, Rose Echeverría became one of many students of Mexican descent who made the decision to volunteer for Avion's program. "Where else could we get all this: our education, our training to work?" she asked. Although Echeverría did lament that her job would cut down on time available to academics—compromising her dreams of going to college—the ninety-cent-an-hour wage represented a considerable raise in pay from her previous work as a store clerk. Feeling a tremendous responsibility to help her mother support the household, Echeverría ultimately welcomed the opportunity to make a contribution to her family, and the nation at large. This was "our opportunity to do something for the war effort and still graduate and make money along the way."[1]

As defense companies increasingly looked to women of color for hiring pools, Rose Echeverría, like thousands of Mexican women, provided U.S. war production with essential labor. Married and divorced, first generation and second generation, mothers and daughters all participated in the wartime workforce in record numbers. For those entering or already laboring in the manufacturing sector, lucrative, government-issued defense contracts meant

longer hours and better wages, especially with higher-paying defense indus-
tries now competing for the labor of garment and food-processing workers.[2]
Marie Echeverría, Rose's immigrant mother, witnessed her workplace trans-
form from a cannery into a bomb manufacturer, a shift that for her meant
going from "barely making it in this country" to "really [making] the money."[3]

In helping to feed, clothe, and arm the U.S. military, women like Rose and
Marie Echeverría thus ushered in an era of new workplace experiences while at
the same time challenging those workplace barriers that remained. Notably, in
comparison to other aspects of their daily lives, the defense workplace tended
to provide more opportunities than limitations for Mexican women, likely due
in part to the prevailing notion that they, like all women, would work solely
"for the duration" of the war, and thereby any changes in their social position
appeared less threatening to traditional racial and gender expectations. More-
over, efforts to regulate the defense industry by wartime federal agencies like
the Committee on Fair Employment Practice (FEPC) offered Mexican women
new avenues of support in their pursuits for on-the-job equity.

Aircraft production, in particular, represented one of Greater Los Ange-
les's key employers of the Mexican community. At the beginning of 1939, air-
craft companies in Los Angeles County employed 13,300 workers; by the fall
of 1943, the industry reached its peak at approximately 228,400 employed.[4]
Amid this unprecedented and exponential expansion, aircraft management
came to recognize the unqualified importance of utilizing women and work-
ers of color to address labor shortages. After pursuing the Euro-American
labor force, employers turned also to black and Mexican women, in addi-
tion to smaller numbers of Chinese women and Filipinas, making available
light industrial positions that allowed women of color to break away from
the harsh, dirty jobs of sweatshops, fields, and domestic work. As Tina Hill,
an African American wartime riveter recalled, "Hitler was the one that got us
out of the white folks' kitchen."[5]

Los Angeles aircraft plants also appeared relatively unique in their em-
ployment practices, especially in contrast to other companies and areas of the
country.[6] Whereas rigid racial divisions of labor informed hiring practices
and job assignments in defense industries across the nation, in the City of
Angels, aircraft factories hired black, Mexican, Asian, and white women to
labor side by side, allowing more intermixing between groups, and not just in
the least desirable jobs. While racism still colored on-the-job experiences of
employees, particularly African American women, the multiracial nature of
the workforce contributed to cross-cultural understanding and a breakdown
of traditional racial boundaries.

For Mexican women, the welcoming of women of color into wartime work had particularly unique ramifications, affording them both a status of respectability and, at times, a claim to whiteness. Legally, Mexicans had been considered "white" since the 1848 Treaty of Guadalupe Hidalgo, an accord that ended the U.S. war with Mexico and made Mexican nationals eligible for U.S. citizenship at a time when only "free white persons" could naturalize.[7] Given their legal status, Mexican Americans—in theory, if not always in deed—thus claimed certain privileges of whiteness unavailable to their black counterparts, including the right to marry whites or to send their children to white schools. Yet in the reality of the everyday, American society allowed few Mexicans any true semblance of "white" status, a social position that promised access to all of the social, economic, and political rights and privileges that the United States could afford.[8] For Mexican women, then, the patriotic connotations associated with war work represented a new and significant avenue by which to garner esteem and place themselves—at least for the time being—more firmly on the white side of the color line.

BY MID-1942, labor shortages in Los Angeles reached near dire levels as the aircraft industry lost almost 20,000 laborers to the military at the same time that nearly 550,000 newly created defense jobs awaited workers.[9] In an industry previously only open to Euro-American men, by January of 1944, 12,000 Mexican workers could be found working at Douglas Aircraft; at Lockheed, 10 to 15 percent of the total workforce at their two Los Angeles plants were Mexicans, and 80 percent of those were women.[10] African Americans found similar job opportunities awaiting them. By February 1943, Douglas Aircraft had hired 2,200 black employees, while North American employed 2,500, and Lockheed Vega employed 1,700.[11]

Unfortunately, it is nearly impossible to know exactly how many Mexican and Mexican American women entered the ranks of defense labor during the war years. In his study of "Rosita the Riveter" in the wartime Midwest, Richard Santillán points out that there are no accurate records on the total numbers of Mexican American women employed in the Midwest during the war, particularly since defense industries typically categorized Mexican American workers as "white" as opposed to "nonwhite" in company records. I have found that a similar situation exists in the Los Angeles defense industry, largely because company records have long since disappeared.[12] In Los Angeles, given the long-standing Mexican population, it seems probable that tens of thousands of Mexican American women joined the wartime workforce.

An array of motivations drove Mexican women to join the war effort eagerly and in great numbers. For most of her women friends, Rose Echeverría recalled, the decision to enter the workplace naturally followed the outbreak of the war and the departure of loved ones for combat duty overseas. As hundreds of thousands of Mexicans and Mexican Americans answered the call to military duty, those left on the home front desired to do their part to bring friends and family home. "Everybody down the street was gone and everybody I knew was gone," Echeverría said. "So of the women that were left, my age on up, as soon as you could get a Social Security number, you went to work; went to work in factories."[13]

Prompted by rumors of war, Lupe Purdy, a Mexican citizen living in the United States since 1922, immediately applied for U.S. citizenship so that she could work in America's defense industry and demonstrate her dedication and loyalty to her adopted homeland. "I didn't go to work because I wanted more money," said Purdy, an assembler and riveter at Douglas Aircraft from 1942 to 1944. "I wanted to help my country. It was tough. It was hard work, very hard work. Riveting is hard work. . . . I just felt very strongly that I should do my part because they were hiring people to do these rush jobs of production. I just felt that it was my duty that I should also do it."[14] Belen Martínez, an assembler at Lockheed from 1942 to 1944, echoed Purdy's sense of duty regarding her decision to enter the wartime workforce. "We had to fulfill our obligation to our country and to the boys that were fighting overseas," she recalled. "We didn't think about how much it was going to pay or how many hours we [were] going to work or what was going to happen. We just had to go in and do our duty.[15] Describing their relationship to the United States with possessive pronouns—"my country," "our country"—women like Purdy and Martínez demonstrate the sense of ownership and connection they felt for the nation, in spite of their historically outsider status.

In addition to patriotism, a desire for personal satisfaction also pulled Mexican American women into the wartime workforce. For daughters raised within rigid traditional Mexican families, defense work offered an escape from under familial oligarchy.[16] Beatrice Morales had spent most of her life under the protective wings of her father and brother and then at the early age of fifteen, of her husband. But as she searched for defense employment on behalf of her adopted sister, Morales realized that a wartime job outside the home might be a welcome change in her own life. Given the choice between working at the Burbank or downtown Los Angeles plants, the sheltered Morales could not even locate Burbank on a map. Ever determined, however, the now twenty-seven-year-old Morales defied her husband and accepted her

first wage-earning job at the downtown Lockheed plant as a riveter. "I took the [employment] forms and when I got home and told my husband, oh! He hit the roof. He was one of those men that didn't believe in the wife ever working; they want to be the supporter. I said, 'Well, I've made up my mind. I'm going to go to work regardless of whether you like it or not.'" Going to work daily to secure plate nuts and drill holes on the P-38 fighter plane drove a permanent wedge between Morales and her husband, but it also signified an end to her previously sheltered lifestyle. Over time, Morales gained confidence in her abilities and took pride in her expanded social autonomy. As she later reflected on her wartime experience, "I was just a mother of four kids, that's all. But I felt proud of myself and felt good being that I had never done anything like that. I felt good that I could do something, and being that it was war, I felt that I was doing my part."[17]

Just as importantly, defense work offered women of Mexican descent an unprecedented opportunity for cleaner jobs at higher pay. Before securing a drill press position at Lockheed in southeast Los Angeles, twenty-three-year-old Adele Hernández had bounced back and forth between jobs in packing houses and nondurable manufacturing, making small but regular contributions to the family till. Yet the long, tedious hours spent picking fruit, hand-painting ceramics, and packing chiles with bare, stinging hands hardly seemed to justify her pittance of a salary. Fortunately, her brother and sister obtained defense jobs at Lockheed and Douglas and, following in her siblings' footsteps, she secured an assembly position at Lockheed's Maywood plant. "These little jobs paid nothing. After I worked packing the strawberries, I quit there to go to work at Lockheed," remembered Hernández. "I guess I was just looking for something a little better all the time; something a little cleaner."[18]

Historically relegated to positions in agriculture or the domestic and service sector, women of Mexican descent, like their African American and Asian American counterparts, increasingly found that jobs in wartime industries were not only plentiful but also paid very well.[19] During the 1930s, Mexican women packinghouse and cannery workers earned a modest average wage of thirty to thirty-five cents an hour in piece-rate wages.[20] Garment workers fared little better, taking home wages of eight to ten dollars a week, a far cry from the California minimum wage requirement of sixteen dollars for a forty-eight-hour work week for women.[21] The wages of Mexican farm workers also remained substantially low during the Great Depression, with a typical migrant worker earning a mere $280 a year.[22] Likewise, during the 1920s, Mexican laundresses and domestics barely eked out a living of less than $200 a year.[23] Assembly work in the aircraft industry thus offered

a marked contrast, with wages beginning at sixty to sixty-five cents an hour, with an extra six- to ten-cent-an-hour incentive for those employees willing to work the swing or graveyard shifts. Periodic five-cent raises left many women earning an income of a dollar an hour or more by the time the war ended. According to wartime wage data surveys conducted by the Women's Bureau of the U.S. Department of Labor, welders were usually paid hourly wages of $1.32, light assembler, $1.10; riveter, $1.00; inspector, $1.10 to $1.20; filer, $1.15 to $1.30; and punch press operator $1.10 to $1.15. And with extended work schedules—defense employers typically mandated a six- or even seven-day work week, and encouraged overtime—working women could now earn paychecks of forty to sixty dollars a week, an extraordinary sum.[24]

Defense work also offered steady income for women accustomed to seasonal jobs or work paid by piece rates. In the canning industry, women employees were paid solely on the amount of fruit they processed each day; male cannery employees, on the other hand, were typically paid hourly for exclusive positions in warehouse and kitchen departments.[25] Moreover, because of the seasonal nature of cannery work, jobs typically lasted just ten to eleven weeks per year. During the peak summer season, California canneries employed from 60,000 to 70,000 workers, while in the winter months their labor force fell to 10,000 to 13,000.[26] Work in the garment industry offered little more stability. In Los Angeles, dressmakers received pay solely for the hours in which labor occurred, not for the total time spent at the workplace. As one Mexican dressmaker explained a typical workday in the 1930s, "I come in the morning, punch my card, work for an hour, punch the card again. I wait for two hours, get another bundle, punch card, finish bundle, punch card again. Then I wait some more—the whole day that way."[27]

Defense work, on the other hand, provided a steady income and a sense of stability, two factors noticeably absent in seasonal and piece-rate labor. Prior to her employment at Douglas Aircraft, Maria Fierro knew only the grinding labor of fields and canneries. Not until the local employment office referred Fierro to Douglas at the end of the packing season did she see her chance to secure more lucrative work. Although Fierro lacked any technical skills in heavy manufacturing, Douglas began a vocational training program for potential employees—a program Fierro eagerly embraced. Attending night training classes in riveting and welding for a total of 500 hours—daily from 6 to 10 P.M.—Fierro graduated to the position of assembler. The new job allowed her employment stability for the first time in her life, and the fixed wages—a far cry from her usual piece-work salary—gave her just enough added income to rear her three children without hardship.[28]

Mexican American daughters made vital contributions to the family wage economy before 1941, but during the war, the robust nature of their wages provided additional means of household support.[29] For Mary Luna, entering the assembly workforce at Douglas Aircraft in El Segundo meant her family could now become self-sufficient without the assistance of the federal government. "I remember I went home and my dad was so happy I had gotten a job. That meant that we could get off of welfare. . . . It was just like somebody gave me a million dollars."[30] Likewise, Ernestine Escobedo recalled that she spent the initial years of the war making relay devices at Advanced Relay, a job that supplemented the monthly allotment checks sent home by her older brothers in the service. The extra income assisted their widowed mother in opening a Mexican restaurant in East Los Angeles, allowing Josephine Escobedo a more productive living than her previous work as a domestic and seamstress.[31]

Word of lucrative defense wages spread rapidly throughout Eastside barrios and, typical of Mexican and Mexican American women, friends and relatives often joined the workforce as a group. Members of the Mexican community went in search of jobs together and, once gainfully employed, encouraged their siblings and peers to do the same. For Irene Molina, war work became a family affair when she and her sister secured positions at O'Keefe and Merritt, a stove company turned ammunition shell producer during the war. The two women worked as an inspector and a welder, respectively, and eventually saw many of their girlfriends from Roosevelt High join the payroll.[32] Often the presence of friends or relatives on the production line eased parents' concerns about their working daughters. Concepcíon Macías accepted an assembly job on the night shift at Lockheed in downtown Los Angeles, a position her parents did not seem to mind since the company also employed several of her girlfriends from their neighborhood in East Los Angeles.[33] Eager for new employees, defense plants encouraged such practices: Anna Gonzáles participated in Douglas Aircraft's 1943 "add a worker, win a bond" sweepstakes by persuading Filda Manzanares to apply for a job at the aircraft plant in Santa Monica. Gonzáles received a fifty-dollar bond for her efforts; and Manzanares started her career at Douglas with a twenty-five-dollar bond.[34]

Aircraft companies located in outlying areas of Los Angeles tapped into diverse labor pools by building subassembly plants as well as creating new bus routes into these areas. Thus in spite of the vast landscape of Southern California, women got to work by navigating various transportation options, whether walking, carpooling, or riding the local bus or streetcar. For most workers, the ease of their commute depended upon the location of the defense plant. The North American Aircraft plant, located in Inglewood, for

instance, was near the edge of Los Angeles's black community. Lockheed's subassembly plant, located at Seventh and Santa Fe in downtown Los Angeles, made it easy for the Eastside Mexican community to ride the Red Car or walk to work (whereas the Burbank location, nestled in a predominantly white community, was much farther).[35]

Others secured jobs well outside their home neighborhoods, and thus rode buses or streetcars, or engaged in ride-share programs, to get to work. During her daily commute between East Los Angeles and the Douglas Aircraft plant in Long Beach, Irene Malagon piled into a car with five Mexican girlfriends—and a sole male driver—likely in an effort to save money on gas and to keep each other company on the two-hour round-trip.[36] Some women were apprehensive about traveling outside the barrio for a new job. Mary Hurtado remembered many of her packinghouse friends as too fearful to leave their close-knit community in Orange County, but she and her sister, Annie, commuted daily from Fullerton to Long Beach to work at Douglas Aircraft.[37] Beatrice Morales, a resident of Pasadena, had never driven a day in her life—always depending on her husband to be behind the wheel—when she applied for a position at the Lockheed subassembly plant in downtown L.A. "I figured my own way to the streetcar," she proudly recalled.[38]

Although they were no strangers to factory work, a unique world of new experiences and challenges awaited Mexican and Mexican American women once they arrived at the defense plant door. Aircraft plants were particularly vast—often so large that they resembled small towns. In fact, efforts to hide the 1,422,350-square-foot Douglas–Long Beach facilities from potential enemy bombers included the use of heavy camouflage netting to cover the plant in its entirety, with an assembly of fake canvas houses, wire trees, and painted streets to give the appearance of a tranquil suburban neighborhood from the air.[39] On the inside, the hustle and bustle of the aircraft factory proved anything but serene. Most assembly workers, like riveter Mary Luna, worked in long, warehouselike buildings, full of "all kinds of planes and parts that everybody was working on."[40] In the windowless environment, thousands of lights created "daytime" twenty-four hours a day, seven days a week, and tens of thousands of employees worked at any given time.[41] At peak employment, North American employed 24,000 people; Lockheed, 90,000; and Douglas, 100,000, a far cry from the number of employees at even the largest of manufacturing operations in Southern California.[42] Alma Dotson, a black assembler at North American, quipped that she had "never seen so many people in all of [her] life" and that employees entered and left the plant "like cattle [crossing] the street in droves."[43]

For the first few days, even weeks, most new employees expressed awe and anxiety at the new work environment. On her first day at Douglas, Annie Hurtado cried in a plane cockpit for two hours straight because her sister was nowhere to be found in the intimidating environment.[44] At Lockheed, Margarita Salazar remembers trying to come to work with other girls because she "used to get lost going from one department to another."[45] Clothing requirements of pants or coveralls, heavy shoes, and hairnets could prove equally unnerving, although some Mexican American women took the opportunity to wear zoot styles and their drape zoot suit pants on the assembly line.[46] Unbelievably loud noise levels, however, made perhaps the biggest impression on defense workers of all backgrounds: African American riveter Rose Singleton remembered that she could hear the noise of Douglas rivet guns for blocks and blocks away from the actual factory, a sound that Mexican riveter Lupe Purdy described as "sheer torture."[47]

At work on the Southern California aircraft production line, Mexican women worked in a vast variety of positions. In order to identify the specific types of work Mexican and Mexican American women performed in the aircraft industry, I studied the entire run of the Douglas *Airview News* from 1942 to 1945. Although employee record cards from the era no longer exist, the company newspaper documented the names and department numbers of numerous Spanish-surnamed women, which I then cross-referenced with the Douglas Aircraft Company telephone directory from 1943 and 1944. These company records reveal that Spanish-surnamed women could be found in an assortment of departments, including the telephone office, parts painting, development, machine shop, and tank testing. The positions necessitated a variety of expertise and talents and offered an array of on-the-job experiences, ranging from the cleanliness and relative safety of office work to working with chemical agents and laboring alongside heavy machinery.[48]

But departments engaging in assembly work had by far the largest number of Spanish-surnamed women employees. In general, about 75 percent of the entire airframe workforce labored in assembly positions, and most aircraft plants assigned newly hired women workers of all backgrounds to jobs involving some aspect of assembly.[49] Mexican and Mexican American women thus worked with parts large and small for the construction of bombers and transport planes, utilizing rivet guns, bucking bars, jigs, punch presses, and electrical spot welders to assemble the wings and fuselages of World War II aircraft.[50]

Most women laborers described their defense work as not particularly difficult to learn but arduous and physically exhausting given the long (often

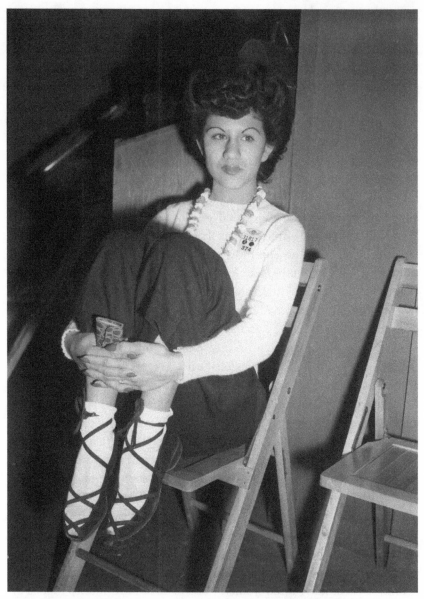

Douglas Aircraft employee Theresa Hernandez dons aspects of the wartime zoot look at work. Long Beach Airview News, *12 October 1943, 20. Courtesy Boeing.*

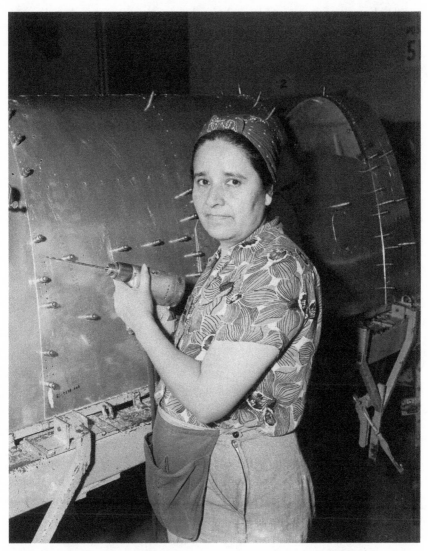

Celia Dominguez, a wing driller for the B-17 at Douglas Aircraft in Long Beach, July 1943. Courtesy Boeing.

late-night) hours, extended six- or seven-day work weeks, and lengthy commutes. Unlike riveter Lupe Purdy, who described the "sheer torture" of her job, Beatrice Morales considered her riveting position "a lot of fun," but she also described the workday as "tiresome." "I'd come home pretty tired," Morales explained. "At the beginning I was riding the streetcar and when I didn't get a seat, then I had to stand up. It was a little bit rough."[51] For those working on the swing or graveyard shifts, the challenges proved even greater. Finding

it difficult not to take care of household chores or childcare during the day, most late-night women workers struggled to stay awake or, like Mary Luna, found quick fixes. "That's where I learned how to drink coffee," Luna remembered. "I couldn't hardly keep awake being my first job and working [the graveyard] shift. I even tried smoking but I couldn't hack it," she recalled.[52] As the war dragged on, women frequently requested transfers to daytime hours in order to help their bodies recuperate from severe sleep deprivation.[53]

Most assembly work also took an enormous amount of strength and physical agility, as workers crawled around inside of tight areas and climbed ladders to get to hard-to-reach places in need of drilling and riveting. Moreover, outside of bench work, assembly positions typically required a good amount of standing, often taking a toll on employee health. Wing driller Margarita Salazar spent long hours on her feet, a position that eventually led to varicose veins. As such, she was compelled to seek a new, more sedentary position in the tool distribution shed.[54] But in spite of the toil and hazards associated with laboring with large machinery, defense work continued to attract large numbers of women workers by offering high wages.[55]

Central to these economic opportunities was the "equal pay for equal work" principle articulated by both the federal government and the labor movement during the war years. The War Manpower Commission (WMC) recommended that employers adopt a uniform wage scale for men and women, and in 1942 the National War Labor Board, in two separate opinions, upheld—although did not require—the policy of equal pay.[56] Additionally, both the American Federation of Labor (AFL) and the Congress of Industrial Organizations (CIO) argued for the inclusion of equal pay clauses in labor contracts, although for less than altruistic reasons. As women's historians have detailed, union leaders feared the possibility of employers embracing the employment of women for far less money, and thus jeopardizing the postwar job security of male workers. By and large, male unionists supported the equal pay movement in order to protect wages of "men's jobs" in the face of female substitutes.[57]

Yet while new job categories and pay opportunities opened up for women, sexual segmentation of labor by no means met its demise. Rather, as Ruth Milkman argues, "*new* patterns of occupational segregation by sex were established 'for the duration.'"[58] Although numerous women did work in durable manufacturing alongside men for equal wages, industrial employers more often promoted men to higher-paying supervisory positions or heavier jobs. Foremen typically determined merit increases and upgrading for employees under their supervision, and male prejudices about women's inferior

status and abilities tended to keep women workers paid at lower rates with less opportunity for promotion.[59]

Rosie the Riveter's work—what was once a "man's job"—also often took place in predominantly women-only departments, under sex-typed job classifications that allowed for supposed "female" qualifications of dexterity, attention to detail, ability to tolerate repetition, and lack of physical strength.[60] Prior to the war, aircraft employees (the majority male) had undergone years of training to manage diverse tasks and operations in the manufacturing process. Yet in order to speed up production during World War II, aircraft companies adopted an assembly line system, dividing the work as much as possible in order to simplify each task. Female wartime workers were thus given just a few weeks' job training and taught a relatively simple repetitive operation, broken down by task.[61] "My job was simple," remembered Mary Luna. "It wasn't where I was working on a plane; I was working on a panel. All we did on that was rivet the panels. They were standing by themselves. It wasn't hard."[62] At Lockheed, Margarita Salazar recalled that she "did the same thing for about a year: drilling, drilling, always drill work."[63] These jobs, although fast-paced and requiring significant stamina, paid less. As a result, women war workers earned considerably fewer dollars than their male counterparts.[64]

Yet war work in any job category meant a vast improvement in women's social and economic circumstances overall, particularly for women of color. As Sherna Gluck points out, women received better wages working in defense manufacturing jobs than they did in traditional women's work, and their labor challenged customary definitions of womanhood.[65] In spite of their repetitive nature, jobs like riveting and bucking required strength and expertise. As one wartime riveter described, "The riveter used a gun to shoot rivets through the metal and fasten it together. The bucker used a bucking bar on the other side of the metal to smooth out rivets. Bucking was harder than shooting rivets; it required more muscle. Riveting required more skill."[66] Thus amid the hardships and bustle of the shop floor, women workers fell into a routine and became experts in their respective positions. Note the sense of pride and accomplishment in Beatrice Morales's description of her wartime labors with fellow riveter Irene Herrera: "She was as good a bucker as I was a riveter. She would be facing me and we'd just go right on through. We'd go one side and then we'd get up to the corner and I'd hand her the gun or the bucking bar or whatever and then we'd come back. Her and I, we used to have a lot of fun. They would want maybe six or five elevators a day. I'd say, 'let's get with it.'"[67] Although a certain amount of monotony came with the job, "Riveting Rositas" experienced a sense of both personal and economic satisfaction.

Employers' decision to simplify jobs that had belonged to men in previous years, relabeling them "female" positions, did lead to conflicts on the factory floor. Men often mightily resented the women whose arrival signaled the loss of their special status as craft workers. As Marye Stumph, a Euro-American worker for Vultee recalled, "men got all up in arms" when she was sent to work on a spot-welding machine.[68] Torch welding had been a male field prior to the war, requiring special training and offering a skilled workers' wage. But as more and more aircraft facilities adopted electric spot welding, a "lighter" form of work, women welders replaced their male counterparts.[69] "It wasn't anything that anybody couldn't do," Stumph stated. "[But] they didn't want any women on there and they all protested." In Stumph's case, the male protests proved successful, and management transferred her to the machine shop.[70] But as the war years progressed, electric spot welding became an increasingly female domain, including for a significant number of Spanish-surnamed women.[71]

In spite of the largely sex-segregated nature of the work environment, men and women still labored in close quarters with one another on the factory floor. Employers typically assigned a small number of male workers to assist a team of women, particularly in the more physical labor of lifting and carrying heavy loads.[72] Margarita Salazar remembers that in her Lockheed riveting crew of twenty or thirty, there were about four men: "They would put the wing in its proper place so you could work on it—moving things and doing the heavier work."[73]

Many Mexican women, accustomed to strict rules of chaperonage, initially found the mixed-sex nature of the defense shop floor unsettling. Beatrice Morales remembered "feeling just horrible" about her assignment at Lockheed as an assembler, where she had to work closely with males. Never having worked with a member of the opposite sex, let alone interacted in close quarters with a man other than her husband, Morales had a difficult time adjusting comfortably to her new position. Eventually, she recalled, "I just made up my mind that I was going to do it."[74]

The challenge that women's workplace presence posed to traditional gender roles only added to the tensions. Katherine Archibald observed in her 1947 study of a wartime shipyard that "underneath the formality and politeness a half-concealed resentment still persisted, not against women as women, but against them as rivals of men in a man's world." Anxious about the threat to their breadwinner status, and especially fearful of women's entrance into skilled jobs, men reacted to working women with a range of emotions, from hesitation and indifference to outright hostility.[75]

Sexism thus pervaded factory floors, as most women workers experienced "teasing" and sexual harassment by men who "resented women coming into jobs" and "let you know about it."[76] Never having worked a day outside the home in her life, and fresh with a rivet gun in hand, Beatrice Morales spent her first hours on the job at Lockheed listening to a fellow male coworker berate her. "You're not worth the money Lockheed pays you," her coworker exclaimed.[77] Such degrading treatment proved more than a little unnerving to new employees. "My first night I wanted to quit," said Mary Luna about her experience as a riveter at Lockheed. "I went in there. It was all men. Right away they said, 'Oh, no, here they come.'"[78]

While gendered segmentation of the labor force continued during the war years, ethnic and racial segmentation at times lessened. Particularly in large-scale Los Angeles defense facilities—like aircraft—black, Mexican, Euro-American, and some Chinese and Filipina women worked together for the first time. At Douglas Aircraft, departmental assignments of workers reveal women of various ethnic and racial backgrounds working side by side in defense production.[79] Moreover, interviews with former "Rosies" of the three major Southern California aircraft facilities—Douglas, Lockheed, and North American—also speak to the multicultural nature of their wartime working conditions. "They had all nationalities," Josephine Houston claimed, calling it a regular "United Nations" on the assembly line.[80] Mary Luna, Beatrice Morales, and Margarita Salazar echoed similar impressions, commenting on the "mixture" of Anglo, black, and Mexican women workers.[81] Few women recalled women of Asian descent on the shop floor, although defense company newspapers highlighted small handfuls of workers with a Chinese or Filipino background employed in production.[82]

The well-integrated nature of Southern California aircraft can by and large be attributed to the forthright stance taken by aircraft company management. The sheer number of exclusionary job orders filed by the local United States Employment Service (USES) office in Los Angeles for "whites only," or with stipulations for "no Mexicans" and "no Negroes" or "colored workers," attests to the widespread persistence of prejudicial attitudes by local businesses during the war years.[83] Smaller employers frequently rationalized discriminatory hiring practices with claims that white employees would engage in slowdowns or strikes if faced with an integrated workforce. As the manager of the National Car Loading Company in Los Angeles claimed, his refusal to hire Mexican and black workers was "entirely an employee problem," since integration would lead to the "disruption of his entire office force."[84] But behind these claims also lay the deep-seated racism held by managers themselves

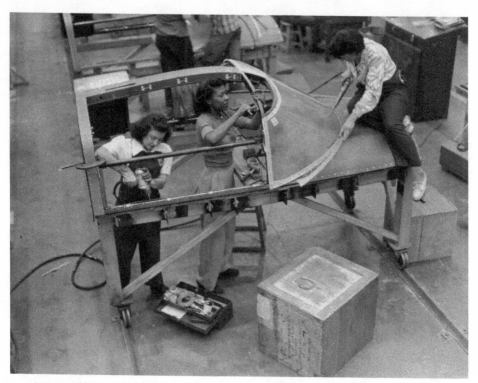

Mexican, black, and white women work alongside one another on a cockpit enclosure at Douglas Aircraft in January 1945. Courtesy Boeing.

who, even when faced with numerous examples of successful workplace integration, used the potential threat of work stoppages as an excuse to continue putting their own prejudices into practice.[85]

Larger aircraft factories, on the other hand, eventually adopted a low-tolerance policy for overt racial tensions. According to Susan Laughlin, the former director of Lockheed's women's counselor program, wartime management initially expressed concern over integrating African Americans into the workforce, generally viewing them as a population difficult to "assimilate."[86] But as labor shortages became increasingly acute, employers became more and more willing to approach the issue head-on. For instance, in 1941, local black leaders with the Los Angeles Urban League initiated a meeting with Lockheed and other leading aircraft companies, imploring management to integrate the industry without delay. Their suggestions did not fall on deaf ears. Soon thereafter, Lockheed officials began to comply, encouraging supervisors to take responsibility for integration in their own departments.[87] By midwar, white Lockheed workers had no doubts about management's stance

on integration: the *Lockheed Star* celebrated the hiring of the 100th black employee, and the black YMCA regularly received charitable donations from the employee buck-o'-the-month club.[88]

Thus while white women in cities like Detroit and Baltimore led hate strikes in objection to laboring alongside black women, Los Angeles aircraft company management fired white workers who refused to work with blacks.[89] As Josephine Houston recalled, southern white women who made a fuss at North American Aviation were told to do their job "whether [a coworker] was black, white, green, brown," or face the consequences.[90] "We just didn't accept a problem," Laughlin explained. Management asked hostile white workers to find work elsewhere if they refused to abide by company rules, and, in time, "they pretty well accepted it" if they wished to remain employed.[91]

This blurring of the industrial color line was unprecedented in scale, offering new opportunities for women of color to be paid equal wages for equal work. In the food-processing industry, as historian Vicki Ruiz demonstrates, Spanish-speaking women were given the harshest work for the lowest pay, earning considerably less than their Euro-American counterparts.[92] African American women, moreover, had been completely shut out of industrial jobs for much of the twentieth century.[93] But as labor shortages in Southern California became more acute, aircraft companies increasingly hired Mexican and black women to work alongside white women in assembly positions. To be sure, African Americans were still the most likely laborers to be found in the most arduous, dirtiest defense jobs. But for the first time, black women also had a relatively good chance of securing higher-paying assembly positions. By 1943, at Lockheed, for instance, the 3,000 African Americans working at the company were employed in assembly positions rather than custodial work.[94] For those women of color accustomed to lower wages and little to no access to the production line, integration offered a welcome change.

In spite of the workplace gains, few women of color received promotions to supervisory posts or upgrades to higher-paying positions. Gender and racial discrimination no doubt played some role in the arbitrary method in which work rankings were assigned. For example, Rose Singleton, an African American resident of Los Angeles, applied for an inspector position at Douglas in the early years of the war, passing the examination with flying colors. But upon seeing her test results, personnel explained that she would be hired as a riveter instead, as white southerners would refuse to work under her.[95] Additionally, as the aircraft industry's newest workers—a majority of whom found themselves assigned to jobs considered to be lesser skilled and more routine—many women of color simply did not hold the seniority considered

necessary for advancement. Women universally may have found it difficult to receive wartime promotions, but women of color in particular found these positions significantly out of their reach.[96]

The general lack of African Americans in managerial positions often led to their differential treatment on the shop floor. In a 1943 letter to President Roosevelt, Mary Hines, a black woman war worker, expressed her frustration over the "little consideration" given to African American employees at Lockheed. According to Hines, her white, southern supervisors were "nasty" and refused to give good write-ups to blacks. "I don't see why there [aren't] some colored supervisors and group leaders to represent us," she wrote. "As far as I can see the Negro workers do just as much work and more as the white workers."[97] Similarly, a black woman known as "JK," a former domestic who became a sheet metal worker in the machine shop at North American Aviation, recalled that her departmental lead man "tried to give all the best work to the white ladies," leaving JK and her fellow black coworker with "dirty work" like metal filing.[98]

Likewise, not all war industry employers and workers welcomed the Mexican population, and it was not unheard of for company management to express particular distaste at the hiring of Mexican women. In August of 1944, for instance, the owner of Arrowhead Food Products refused to hire three qualified Mexican women as pie makers for the simple reason that he believed all Mexican females "were not clean" and "w[ore] dirty dresses."[99] Oftentimes war-related industries also refused to hire any workers born in Mexico, claiming an extra burden in the clerical work necessary to seek employment permission from the federal government for non-U.S. citizens. Bermite Powder Company in Saugus, California, had a long track record of discriminating against Mexican aliens, and in the cases of Lola Impusene and Sally Orozco—both Mexican citizens—refused to put in the paperwork time necessary to hire the women because, as members of the "San Fernando Mexican colony," they were "without a proper sense of loyalty to the employer and of responsibility toward their work."[100]

When Mexican women were faced with discrimination, however, the wartime workplace offered them more options to protest and challenge unequal treatment than they had in earlier years. First and foremost, acute labor shortages meant that Mexican workers could leave intolerable job situations with more security since alternative employment would be relatively easy to attain. Such could likely have been the case when, in 1944, two Mexican women at Gillcraft Aviation Co. were reprimanded by a supervisor for speaking Spanish on the job. Rather than abide by his order to speak English only,

the women simply decided to resign. Although a fellow coworker brought the matter to the attention of the shop floor foreman—and even offered to speak with the Mexican consulate on their behalf—the women urged him to forget the matter and instead chose to walk off the job, no doubt well aware of the favorable labor climate awaiting them.[101]

But perhaps the most significant change to the wartime workplace was the unprecedented presence of the federal government. President Roosevelt's Executive Order 8802, issued on 25 June 1941 to ban employment discrimination in government and the defense industries based on "race, creed, color, or national origin," established the FEPC in order to investigate violations. For African and Mexican American populations, the issuance of Executive Order 8802 represented a mixed bag of both hope and frustration. In theory, the order signified a bold sea change, as it represented the federal government's first formalized effort to guarantee equal employment opportunity in the United States. And yet in reality Roosevelt had only reluctantly issued the order, responding to a threat by union leader A. Philip Randolph and other black activists to hold a march on Washington in order to protest discriminatory employment policies prevalent in America's defense industries. Alarmed by the prospect of 100,000 determined African Americans converging on the capitol, the administration adopted the fair employment policy only grudgingly, refusing to strengthen the order with any meaningful enforcement power.[102] For the Mexican population, the FEPC represented a particularly acute disappointment given the federal government's desire to maintain appearances in light of its Good Neighbor Policy. Upon the agency's initial implementation, FEPC officials had planned to hold public discrimination hearings in each region of the nation in order to intimidate noncompliant employers into abiding by federal nondiscrimination policy. But fearful of the international ramifications of exposing the rampant and systemic discrimination against Mexican workers throughout the Southwest, federal authorities cancelled critical hearings in El Paso in an effort to save face. The move left hundreds of hopeful Mexican laborers without the powerful weapon of public attention to their plight.[103]

In spite of the agency's weaknesses, the FEPC can be credited for exposing prejudice in war industries, chipping away at racial stereotypes, and breaking down racial barriers faced by minorities. Historians have long critiqued the overall efficacy of the agency, pointing to its ineffectiveness in ameliorating the nation's most incendiary social problem due to a lack of enforcement power. More recently, however, the work of scholars like Andrew Edmund Kersten and Megan Taylor Shockley point to a reevaluation of the FEPC, demonstrating

the ways in which the agency facilitated an important and changed relationship between the federal government and African Americans, in spite of its many flaws. Indeed, in wartime Los Angeles, given the experiences of African Americans and Mexican Americans who utilized the agency, it seems that the FEPC offered a significant new avenue for redress, legitimizing demands for equality and encouraging protest among people of color.[104]

Throughout the war, African Americans remained the population most likely to lodge complaints with the FEPC, followed by Mexicans, who were classified as a national group. According to federal estimates, between 70 and 80 percent of the FEPC's "national origin" complaints involved peoples of Mexican descent. In Los Angeles, specifically, by December of 1944, one hundred complaints of discrimination against Mexicans were filed with the local FEPC office, seven of them on the basis of discrimination due to citizenship status. Grievances typically addressed a wide range of issues, including wage differentials, refusal to hire and promote, work conditions, and firings.[105]

It is not entirely clear why African Americans utilized the FEPC more frequently than their Mexican counterparts. In Los Angeles, for instance, African Americans filed 276 discrimination complaints—almost triple the number of Mexican cases, and in spite of the fact that the Mexican population outnumbered blacks in the Southern California region by at least four to one. Nationwide, 80 percent of the FEPC's work was on behalf of black complainants, no doubt attesting in large part to the harsher racial climate faced by African Americans during World War II.[106] But perhaps this discrepancy can also be explained, to some extent, by the lack of a nationally broad-based organization for Mexican American interests during World War II.[107] In Southern California in the early 1940s, El Congreso de Pueblos de Hablan Española (the Spanish-Speaking Peoples Congress) (El Congreso) showed tremendous promise in its Latino civil rights platform and promotion of Latino cultural preservation. Moreover, El Congreso activists like Luisa Moreno formed interracial coalitions in Los Angeles during the war years, working closely with members of the black community to assist the Sleepy Lagoon Defense Committee in its effort to release the youths wrongfully convicted of the murder of José Díaz.[108] Yet in spite of their collaborative antiracist efforts, a national network of El Congreso branches never came to fruition, and red-baiting would undermine fledgling chapters in California in the postwar era.[109] Additionally, the League of United Latin American Citizens, the largest Mexican American organization in the nation, focused its civil rights efforts primarily on the state of Texas until the postwar era, when it would play a more prominent role in Southern California.[110] At a time when African Americans could call upon the National

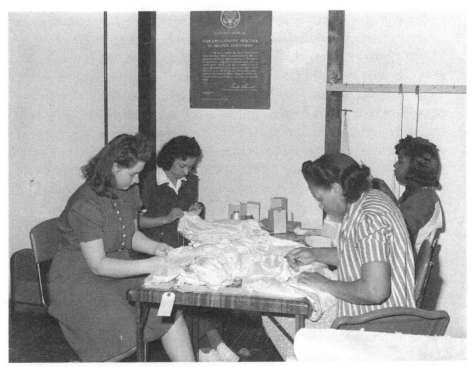

With an FEPC sign hanging above them, black, Mexican, and white women sew together at the Pacific Parachute Company in San Diego, California, 1942. FSA/OWI-J61177, Courtesy of the Library of Congress.

Association for the Advancement of Colored People for assistance, the advocacy needed to encourage members of the Mexican community to utilize the FEPC on a widespread scale at times paled in comparison.

Most Mexican and Mexican American women responsible for registering complaints with the FEPC seem to have done so on individual initiative alone. Mindful of the Mexican community's historic distrust of the federal government, FEPC employees did attempt to make the agency more accessible (and less intimidating) to the Mexican population, hiring Spanish-speaking employees in Los Angeles and advertising in the Spanish-language media.[111] Even so, it still must have taken great courage for women of color to voice their concerns regarding potential or current employers to an outside federal agency, particularly given fears of workplace reprisals. Yet in spite of the real or imagined risks and concerns involved, more and more women of Mexican descent recognized the potential of state structures to give credence to their claims of discrimination and to strengthen their negotiating power.

Certainly Mrs. Francisco Torres recognized the risks when she visited her local FEPC office to wage a complaint on behalf of her husband in December of 1944. Thirty-four-year-old Francisco Torres had worked for Southern Pacific Railroad since he was a teen, starting as a water boy and working his way up over a period of twenty years to the position of section hand, a job where he earned fifty-eight cents an hour with no opportunity for overtime. According to Mrs. Torres's complaint, her husband recently developed a kidney condition and the family doctor had recommended a change of work and more adequate living conditions. Although Southern Pacific had announced the availability of a carman helper position—a job that paid seventy-five cents an hour and included overtime privileges—the foreman had repeatedly refused to upgrade Torres, a situation that Mrs. Torres attributed to her husband's Mexican national origin.

Not surprisingly, Southern Pacific officials denied Mrs. Torres's claim, stating that the company utilized employees based on manpower needs, without regard to race, creed, color, or national origin. However, once pressed more firmly by FEPC officials, management did find that the manpower situation "ha[d] become a little less acute during the past week or two," enabling the superintendent to transfer Torres to the desired position.[112] Whereas women and men like the Torreses found that individual complaints to management often carried very little weight, the FEPC and other state structures did, at times, put just enough pressure on company officials to assist members of the Mexican community in breaking down barriers.

While Torres utilized the FEPC to help her husband, other Mexican women registered grievances on their own behalf. In May of 1945, thirty-six-year-old Artemisa Carranza was referred by her local USES office to a job as a wrapper at Atlas Export Packing Company, a manufacturer of packing boxes and liners for war materials shipped overseas. When Carranza arrived at the company to start her position, however, she was advised that no openings existed and told to leave. Confused, she returned to the employment office, only to witness a troubling telephone conversation between a USES placement officer and the Atlas personnel department. "I will refer another one to you," said the USES officer. "She is all right. She is white." Carranza immediately confronted the USES official. "Wasn't I hired because I am a Mexican?" she implored. The USES official admitted as much, and asked a fellow USES coworker if a "Report of Discriminatory Hiring Practices" form should be filled out. When the USES employee replied, "Oh, well, what's the use," Carranza made the decision to instead take her grievance to the president's FEPC.

Upon receiving Carranza's complaint, Ignacio López, a special examiner for the FEPC, contacted the president of Atlas Export and explained the federal committee's goal of eliminating discriminatory practices in war industries. Company president D. E. Partridge immediately denied any policy of discrimination, arguing that not only had the wrapper position been filled prior to Carranza's arrival, but Carranza was unqualified for the job since she did not have "knowledge of the different types of paper used" in the packing process. Finally, the president argued, the company had hired numerous male Mexican employees in the past and thus could not be accused of discrimination.

Upon further investigation, however, López uncovered information that contradicted Partridge's claims. According to the original work order, Atlas Export requested three female wrappers from USES and quite clearly specified "no colored or Mexican." An additional report revealed that Atlas would not consider workers of "Mexican extraction" given the lack of separate accommodations for nonwhites. "30 or 40 employees would quit if a non-white were hired in," Partridge offered as justification.

Armed with the damning evidence, López attempted to set up a meeting with Partridge. In the end, however, no meeting between the two parties occurred. Perhaps alarmed by FEPC pressure, Partridge's tune changed dramatically. On two separate, subsequent occasions he contacted the FEPC offices in order to extend an invitation to Artemisa Carranza to work at a new Atlas Export plant in Alhambra. His demonstrations were too little and too late. Carranza had already secured employment elsewhere, and the r lant was simply too far away from her home. But having spoken h seen her initial grievance reach a satisfactory conclusion, C ed the FEPC for its services and most likely took some c small victory.[113]

The increased presence of union activity in a provided yet another forum for Mexican women to remedy v conditions. The Depression era years of 1936–37 witnessed the begin g of the labor movement in the Southern California aircraft industry as Lockheed Corporation welcomed with open arms the International Association of Machinists–American Federation of Labor (IAM-AFL) after witnessing a protracted sitdown strike by the more radical United Auto Workers–Congress of Industrial Organizations (UAW-CIO) at Douglas Aircraft in Santa Monica. Although it would be another six years before the National Labor Relations Board oversaw official union representation of the Santa Monica plant, by 1941 the UAW-CIO had successfully organized North American Aviation and immediately

engaged in a wildcat strike, at the time a seeming bellwether of more labor activity to come. With the attack on Pearl Harbor, however, strikes came to a halt, with no labor stoppages occurring in the Los Angeles aircraft industry for the remainder of the war. This being said, union locals in general experienced steady growth in the aircraft industry during World War II, due in no small part to the intense and aggressive campaigns for union representation at the three major Douglas Aircraft plants. By war's end, Douglas El Segundo and Douglas Santa Monica received IAM-AFL representation; the UAW-CIO captured support of the Long Beach plant.[114]

As more and more women of Mexican descent obtained employment in the wartime aircraft industry, their experience and familiarity with labor organizing grew. According to former Lockheed riveter Hope Mendoza, most Mexican workers had no trouble joining unions at the aircraft workplace since "during the war, all the barriers were down."[115] In 1944, recognizing the importance of Mexican employees at Douglas Aircraft, the organizing committee of the CIO placed an ad in the Los Angeles Spanish-language daily *La Opinión*, asking workers at the Long Beach and Santa Monica plants to vote for the UAW-CIO in upcoming union elections.[116] Many Mexican women took advantage of improved pay and working conditions provided by union contracts, or to enlist official grievance procedures. As an example, Consuelo Andrade filed a grievance in 1944 after her foreman denied her complaint that stated that she had been improperly classified as a Tool Crib Attendant "B," when, in fact, she had consistently been doing the work of a higher-paid Tool Crib Attendant "A" employee. As a member of the UAW-CIO Local 887 at North American Aviation, Andrade brought her complaint before the union and, upon arbitration hearings, won the desired "A" classification with over a year of retroactive pay.[117]

Of course Mexican women aircraft workers were not all of like mind when it came to involvement in union activities. Some, like Mary Luna, fondly attributed better working conditions to the IAM-AFL's collective bargaining efforts at Douglas Aircraft in El Segundo.[118] Evidence also suggests that a good number of Mexican American women, including Angela Fuentes and Alicia Shelit, became active in UAW-CIO Local 148 at Douglas Long Beach, finding the union a useful mediator when conflicts with management or fellow employees arose. Shelit's experience with the local ultimately prepared her to spend many years of the postwar era as a UAW union steward.[119] But others, like aircraft worker Lupe Purdy, disliked paying union dues and only joined the union because it was a requirement for her to remain employed at Douglas.[120] Despite their differing opinions, the presence of union organizing made a

significant difference in the work lives of Mexican women. As Mary Luna explained, "After we got the union, then we started getting more raises . . . vacation pay, sick pay, and all that . . . I saw the improvements that they gave us right away."[121] Especially for those women who had never before worked in a unionized industry, opportunities for collective bargaining offered an important avenue to fight for an improved standard of living and to exercise more control over their work lives.

Mexican women also found opportunity in the fact that they tended to occupy a kind of "racially in-between" social position in the wartime workplace, receiving a noticeable level of tolerance over blacks. Indeed, the unique racial positioning of the Mexican population developed out of a long and complicated history in the Southwest, where historically Mexicans faced denigration as foreigners and members of an inferior "mongrel" race yet legally could make claims to whiteness. Federal and state laws accepted people of Mexican descent as "white"—or at the very least did not define them specifically as "Negro" or "colored"—thereby shielding Mexicans, to some extent, from the legalized and at times more pervasive forms of segregation and exclusion blacks faced.[122] In the face of federal pressure to diversify shop floors, wartime employers appear to have practiced similar racial stratification, at times preferring "racially ambiguous" Mexican employees to their black counterparts. Indeed, as historian Josh Sides argues, often in industrial Los Angeles, "the specter of black integration mitigated, to a degree, anti-Mexican sentiment."[123]

In their attempts to prove compliance with federal antidiscrimination laws, industry managers frequently made it a point to boast of the number of Mexicans on their payroll, even as they refused to hire any black employees. Approached by USES for discriminatory hiring practices in 1944, California Almond, for instance, stated in unmistakably racialized terms that it would hire "'only high type persons' and therefore would not employ negro women or men," especially given the large number of white women employed. However, the manager explained that his company did "employ other minority group members such as Mexican and Chinese," workers who apparently met management's "very high standard."[124]

Other manufacturing companies insisted that while amicable relations existed between white and Mexican women workers, the introduction of black women to the assembly line was another matter. The L.A. Paper Bag Company, for instance, argued that its refusal to hire black women stemmed from the presence of a large number of southern white women employees. According to the company's secretary, white newcomers seemed to get along favorably with their fellow Mexican co-workers, but the firm felt that it was

"avoiding trouble by not hiring colored help."[125] Similarly, the owner of E. J. Jenkins Service Company told USES investigators in 1944 that the women of his plant were "like 'a family,' and while the workers there did not protest Mexican co-workers, he felt that the hiring of Negroes would cause conflict."[126] Charlcia Neuman, a Euro-American war worker at Vultee Aircraft, perhaps put it best: during the war, blacks "were just treated very badly," she explained. But "then there were the Mexican girls. They were treated just like we were. There was no such thing as brown; they were white as far as we were concerned."[127] Her interpretation of the social position of women of Mexican descent speaks to a privilege of whiteness available to some members of the Spanish-speaking community—particularly those with lighter skin—a privilege that African Americans could simply not attain.

Interestingly, whereas former black war workers spoke quite openly about racial discrimination in the workplace, women of Mexican descent tended to recall racism as it occurred *outside* the realm of employment. In their memories of World War II, most interviewees recounted little to no discrimination on the job, and instead focused on discriminatory experiences in society at large. Beatrice Morales expressed disappointment for her difficulties in finding housing in Pasadena, a city where landlords refused to rent to Mexicans; Rose Echeverría described Garfield High School as a divisive environment where Mexican and white students did not interact without conflict; Annie Hurtado was refused service by a San Bernardino hairdresser simply because she was a Mexican.[128] Thus in spite of their day-to-day familiarity with racism, these women—and many others—never expressed discontent regarding workplace relations. Indeed, as historian Naomi Quiñonez observes, the World War II workplace appears to have provided women of Mexican descent with a "temporary refuge" from racism.[129] Given their ambiguous racial status, in combination with the fact that war work was often perceived as an impermanent situation for America's women, Mexican women garnered a certain level of reputability on the wartime factory floor.

Amid the multicultural nature of the Southern California wartime workforce, then, women of Mexican descent walked a fine color line. Represented variously as nonwhite foreign "others" and as "almost whites," growing numbers hoped that their entrance into "respectable" labor might improve their social status. In 1943, a group of Mexican women food-processing workers in Northern California made pointed claims to privileges of "whiteness" by refusing to share facilities and work side by side with African Americans. Problems began at Pacific Fruit Express in Oakland, California, when the company attempted to integrate restrooms utilized by both black and Mexican

female workers. Although race relations remained harmonious in the company's Los Angeles facility—where management provided separate, on-site restrooms—an entire crew of Mexican women had refused to use the same toilets as African American women in the Northern California plant. Moreover, a half a dozen of the Mexican women had left their jobs for this reason alone. The company's spokesperson stated to WMC officials that while the facility did not object to hiring African Americans, black women simply "did not mix well" with Mexican women. "The Mexican women were good workers and the company labor problem was not acute," management explained, and thus "[we] did not see any reason to antagonize the present workers."[130]

Since the advent of World War II, white women nationwide had railed against the integration of workplace restrooms—a symbol of social equality. Stereotyping blacks as dirty and diseased, white women frequently engaged in hate strikes and work stoppages so as not to be forced to use the same toilets, showers, and locker rooms as their black counterparts. In Detroit and Baltimore, white women workers desired a certain modicum of social distance between the races, reinforcing, as historian Eileen Boris observes, that "a domestic's touch could be ignored in ways that bodily closeness at the job apparently could not."[131]

Similarly, the Mexican women of Pacific Fruit Express hoped to stress to management, and the general public, a sense of entitlement to better treatment than their African American counterparts. In a society that denigrated blackness, these wartime cannery workers entered into what historian Neil Foley terms a "Faustian pact" for privileges of whiteness, embracing racism toward African Americans in an effort to improve their own social position.[132] Reinforcement of racist boundaries separating white from black, as historian Gary Gerstle argues, represented one of the key ways for ethnic populations to enjoy the full fruits of acceptance in U.S. society.[133]

And yet in many wartime workplaces interethnic and interracial relations and friendships blossomed in spite of racial hierarchies. If nothing else, the diversity of wartime hiring pools allowed women to encounter and interact with other ethnicities and races outside of neighborhood enclaves. Until she was assigned to work with a black woman in aircraft assembly, Mary Luna had never met an African American, as she lived in the city of Hawthorne, a "sundown town" where blacks were not allowed in the vicinity after sunset.[134] Likewise, Rose Singleton, an African American living in Westside Los Angeles, recounted befriending a Mexican girl from East Los Angeles at the Douglas plant in Santa Monica. Typically working the swing shift, the women would keep each other company on the nightly bus ride until they

reached their respective destinations.[135] During the 1920s and 1930s, inter-ethnic, cross-cultural friendships or "work buddy" relationships formed with frequency on cannery and packinghouse shop floors.[136] But blacks and Mexicans had tended to occupy distinct occupational niches prior to World War II, as African Americans were often confined to domestic work and excluded from industrial jobs. Thus the on- and off-site workplace connections and communication of the Second World War fostered new ruptures along old racial boundary lines.[137]

The diversity of the defense workplace also offered invaluable opportunity for cultural exchange and understanding. African American assembler Josephine Houston remembered eating lunch on the job with Euro-American women, never feeling the same social distance that she had experienced between blacks and whites in the South.[138] Helen Studer, a middle-aged Euro-American woman, fondly remembered her friendship with a fellow Douglas war worker, a young woman of Mexican descent who exposed her to a slice of Mexican culture on the factory floor: "She'd always bring this hot good stuff to eat. One day she had something, and I said I'd seen those things and wondered what they were. She said, 'Well, tomorrow, I'll bring you one.' She did and it must have been extra loaded with hot stuff, 'cause I took one bite and I like to—Whew, I couldn't get my breath. Oh, it just tickled her to death."[139]

The memory of eating Mexican food for the first time clearly made a lasting impression on this former riveter. But beyond sharing "exotic" culinary delights, women of Mexican descent found that the diverse defense workplace also led to a general breakdown of negative racial stereotypes about their community. During the zoot suit scare, Belen Martínez remembered Euro-American women at Lockheed expressing surprise that she did not carry weapons or engage in violence. Never having encountered Spanish-speaking peoples before, Martínez's southern coworkers had been taught two things: Mexicans "kill" and "always had knives." Only after working side by side with Martínez did her Euro-American peers come face-to-face with their ignorance.[140]

Given the large numbers of Mexicans employed by the aircraft industry, opportunities also arose for women of Mexican descent to meet coworkers who shared similar ethnic ties to Mexico. Mary Luna grew up in Hawthorne, a city directly south of Los Angeles, and attended Inglewood High School, where she encountered few families or young people of Mexican descent. In fact, most of Luna's high school friends were Euro-American, or what she termed "American" girlfriends. Once at Douglas, however, Luna immediately befriended a group of Mexican American women with whom she socialized

both on and off company time.[141] Sharing advice, engaging in *chisme* (gossip), and swapping stories to while away the long and tedious workday, the kin and friendship networks—or "comadres"—of workers like Luna reinforced ethnic community ties within American defense industries.[142]

Perhaps as importantly, defense work provided Mexican women with opportunities to embrace an "almost white" social status. Just years earlier, women of Mexican heritage had found themselves relegated to the status of "inferior newcomers," worthy only of low-status, low-paying jobs.[143] In the 1940s skilled war jobs offered first- and second-generation women a civic opportunity to prove themselves not only loyal, patriotic Americans but citizens capable and deserving of upward social mobility. As Rose Echeverría explained, "We felt that if we worked hard and that if we proved ourselves, we, too, could become doctors and lawyers and professional people."[144] Although "whiteness" did not always follow Mexican women workers outside factory gates, their racially in-between social status, in combination with the patriotic connotations associated with their war work, contributed to a softening of racial boundaries. Ultimately, Mexican women strived to achieve acceptance from the Los Angeleno populace on their own terms, both at work and at play.

4

Respectable Rebellions

MEXICAN WOMEN AND THE WORLD
OF WARTIME LEISURE

In her 1993 autobiography, *Hoyt Street*, Mexican American writer Mary Helen Ponce describes the World War II years as a time when "everything" changed—clothing styles, hairdos, and especially attitudes. Trina, one of her older sisters, moved away from the "old-fashioned" world of their Mexican parents, instead choosing to wear zoot suit styles and hanging out with peer groups who were "hep to the jive." Jealously eyeing the new social freedoms of her elder siblings, Mary Helen noted that the young women creatively used the war effort to bypass traditional Mexican social restrictions. Unlike the outwardly rebellious behavior associated with "pachucas," Elizabet, Nora, and Ronnie obtained parental permission to attend dances with "dark-eyed" Mexican American "soldados" in their hometown of Pacoima, a leisure activity that could easily be considered patriotic.[1]

But inasmuch as the Ponce sisters enjoyed new wartime freedoms with fellow Mexican Americans, the home front environment also provided Mexican American women war workers and volunteers with occasion to fraternize more frequently across ethnoracial lines. As tens of thousands of servicemen poured into Los Angeles from around the country, daughters of Mexican descent came into contact with Euro-American men more often and in greater number. In an effort to showcase home front unity and provide support for the nation's soldiers and sailors, wartime racial liberalism tended to encourage cross-cultural encounters in Los Angeles leisure spaces, enabling Mexican American women to at once negotiate and transform ideas about race and sexuality in ways unimaginable in the pre–World War II era.

Numerous Mexican American women readily welcomed the opportunity to mix across cultures, and yet the fluid nature of their racial status, and the varieties of wartime recreation, also allowed them to emphasize a vision of "Americans All" that was less assimilative than that promoted by some state and local officials. Embracing concurrent desires to fit in and stand out, to be deemed reputable and to dabble in rebellion, they found in wartime leisure the freedom to experiment with new behaviors and personas. This engagement in "cultural coalescence" in Los Angeles night life signified both a promotion of ideals of upright American patriotism and an emphasis on their distinct Mexican heritage and cultural difference.[2]

Yet inasmuch as Mexican American women encountered new abilities to negotiate leisure pursuits during the war, limitations remained. As laborers on the defense production line, Mexican women garnered praise and experienced tolerance. Although the leisure realm offered similar "respectable" avenues to participate in home front life, the possibilities for physical intimacies outside of a clear-cut patriotic context proved unsettling to some Euro-Americans and Mexicans concerned with maintaining the racial and gender status quo. Depending on the circumstances, and larger societal perceptions of their behavior and racial position, doors of opportunity both opened and closed for second-generation daughters.

AMID THE HORRORS OF WAR, Americans of all backgrounds managed to engage in a wide range of leisure activities during World War II, and Mexican American women proved no exception. With higher incomes, and rationing precluding purchases of some material goods, record numbers of Americans splurged on movies and dances, often feeling that they had nothing to lose since "they might not live to see tomorrow."[3] Additionally, the federal government actively promoted recreation as a way to raise the spirits of civilians, soldiers, and sailors, diverting attention from war deaths and home front tensions.[4] U.S. officials rationalized that employees happy on their off hours of work would make for a contented labor force, thereby keeping wartime production levels at peak capacity. Likewise, entertained and satisfied troops could more easily remember what they were fighting for abroad, and what they had to look forward to once they returned. Leisure thus became infused with patriotic national purpose, and from dance halls to roller rinks, war workers, volunteers, and servicemen and -women flocked to commercial entertainment to enjoy the precious few hours off duty and escape the devastating news overseas.[5]

Young Mexican American women found the new emphasis on public leisure extremely alluring. Traditionally, entertainment for the Mexican

population centered around communally based mutual aid events, wedding banquets, or neighborhood parties, leaving little opportunity for Mexican women to be in the company of men other than those of the family or community.[6] Outside the home, familial protectiveness was a way of life, prohibiting daughters from going out on their own or at night unless accompanied by a parent, elder brother or sister, or close relative. "My date was my brother," said Connie Gonzáles. "My father wouldn't let me go out otherwise."[7] This system of chaperonage served to police the sexual purity of the Mexican woman—and thereby her family's good name—but its constraints could prove frustrating for the second generation. "Every time I would try and sneak out then they would always find me," Teresa Rivera recalled. "[My mother would] send my oldest brother. Everybody knew that little green car—beep beep!—and I'd just have to run in and go home."[8] Scholars of Mexican American history have documented the many creative ways in which second-generation daughters bypassed traditional social restrictions, including elaborate plans to sneak out or leave the house with an older brother or sister, only to meet up surreptitiously with other friends on a nearby street corner.[9] But during the World War II years, these specific patterns of transgression became less necessary.

Higher wages, which equipped young women with both the expanded authority and the material means to engage in wartime leisure pursuits, contributed to this growing trend of women's autonomy. Historically, the inadequacy of working-class Mexican men's wages had often necessitated the economic contribution of all members of the family, reinforcing parental dependency on children.[10] As Ortencia Contreras stated, "[My parents] preferred [me] to go to work . . . especially after our brothers went into the service and we had no money coming in except for my father."[11] Consequently, as daughters labored and made significantly more money during the war years, relationships of authority within the Mexican family unit tended to shift. Mary Luna recalled a noticeable difference in her father's behavior when she secured a job as an assembler at Douglas Aircraft, ending her family's reliance on government relief. Once a strict man who "wouldn't let [his daughters] go out," her father subsequently trusted Luna to "go and come as much as [she] wanted to."[12] Other Mexican parents, like the Velardes, were at times troubled over their daughter's desire to socialize with coworkers at the end of her shift as a telephone operator. And yet even the strictest and most skeptical parents found it difficult not to capitulate to an essential wage-earner. As Connie bought her own clothes, and even furniture for the household, Mr. and Mrs. Velarde recognized that their daughter's vital contributions earned her more authority to demand new rights and privileges.

"We had more freedom than we had had before," Connie Velarde remembered. "There was more money . . . to do whatever we wanted to do."[13]

The temporary absence of overly protective husbands, fathers, and brothers also facilitated a broadening of social worlds for Mexican women. Approximately 500,000 Latinos entered the U.S. armed forces during the Second World War.[14] This noticeable dearth of patriarchal authority significantly changed both the demographic and the social makeup of barrios. "There was nothing but women," explained Rose Echeverría. "We were becoming a female society."[15] Mexican women of all ages mourned the loss of loved ones as news of wartime casualties reached home front doorsteps and devastated families. But while praying daily for the safe return of friends and relatives, many also realized that strict social rules and customs could not be as easily enforced when the primary enforcers were absent. Virgie Gonzáles, a teenager during the war years, admitted to being "wild" while her four brothers served overseas, reveling in the ability to come and go as she pleased, never having to hear a protective older brother say: "'You shouldn't be out there, you should be home, helping mother wash dishes.'" "I was more independent," she recalled.[16] Ernestine Escobedo similarly observed that strict supervision of her and her sister "loosened up" during the war, especially with the departure of her eldest brother to the navy. "He was the one that was the boss," Escobedo explained, "and so now we were on our own."[17] At times, Mexican American daughters witnessed their mothers experiencing similar patterns of newfound independence. When the father of Mimi Lozano took a lucrative defense job making parachutes in Lancaster—a far drive from their East Los Angeles home—her mother secretly became a car hop at a local drive-in restaurant. "It wouldn't have been possible [for my mother to work] except for the war, because I know my dad wouldn't have let her do that," explained Lozano. "[The war] made it easier for mom to have that kind of freedom."[18]

New forms of late-night sociability, facilitated by the extended hours of defense production lines, further motivated Mexican women to push at the boundaries of traditional understandings of womanhood. Across the nation, aircraft workers with flexible schedules and few familial commitments— usually younger women—occasionally chose to work from four o'clock in the afternoon until midnight in order to receive slightly higher wages, typically an extra six to ten cents an hour.[19] Not expected to report on the job until four o'clock the next day, hundreds of defense workers, known as "swing shifters," would frequent dance halls, bowling alleys, movies houses, and roller- and ice-skating rinks until early morning. Local leisure establishments, eager to capitalize on the phenomenon, went out of their way to rearrange business

hours and accommodate wage-earning swing shifters with money in their pockets and the energy to spend it.[20]

Although in traditional Mexican culture, staying out after dark without a chaperone suggested a woman of ill repute, at work, swing shifters met employees of diverse backgrounds who were accustomed to participating in late-night activities without severe social repercussions. Women less supervised by parents shared stories of nighttime or weekend fun on the town, inviting their more sheltered coworkers to join in the pleasure-oriented leisure activities of movies, dances, and recreation.[21] Douglas riveter Mary Luna, like Lockheed assembler Hope Mendoza, remembered the fun of clocking out after long evening shifts with the expectation that the night had only just begun. For them, after-hour meals and competitive bowling matches with men and women shop floor friends represented a cultural terrain distinct from familial traditions, signifying a new identity as autonomous wartime wage-earners.[22] Former Lockheed assembler and swing shifter Adele Hernández excitedly recalled her own escapades at all-night movies, moonlit horseback rides, and early-morning breakfasts with coworkers, disbelievingly exclaiming, "I don't know when I got to sleep!"[23] Her recollections and experiences, like those of other women workers of Mexican descent, reflected a desire to reject the Mexican custom of policing women's bodies, and their relative ease and comfort with an environment that gave them the freedom to do so.

The freedom to express themselves and their new public identities became even more possible with the popularity of swing music and dance. Patriotic fervor lent an air of respectability to this once potentially scandalous activity. As historian Lewis Erenberg argues, big band artists like Glenn Miller who enlisted in the army and went to war infused the popular music with national purpose. People came to understand the conflict overseas as a fight to defend America's superior culture, and thus nationwide, music and dance became to adolescents of all backgrounds as vital to American society "as food and ammunition," explained one observer.[24]

According to scholar Anthony Macías, Mexican American youths gravitated toward swing not just as a patriotic endeavor but as a means to "differentiate themselves from the traditional Mexican music of their parents' generation."[25] Thus of all the leisure activities that appealed to second-generation women, listening and dancing to big band music became a youthful fad and favorite pastime. Connie Rivera, for instance, remembered distinctly disliking her parents' parties because the "old fogies" listened to Mexican music; instead, she preferred to jitterbug.[26] On their off hours from work, young women thus seized any opportunity to dance to the big band sounds of black

artists Count Basie and Duke Ellington and white artists Artie Shaw, Tommy Dorsey, and Glenn Miller.[27] As a teenager, Lupe Leyvas, sister of Sleepy Lagoon defendant Hank Leyvas, greatly anticipated those weekend afternoons when she could take the Red Line downtown and jitterbug the day away to swing musicians in theaters such as the Orpheum or the Million Dollar Theater.[28] Young women at times concocted elaborate schemes to see their fantasies realized: Ophelia Ferguson frequently lied about her age to get into the eighteen-and-over Hollywood Palladium; Margaret Rodríguez regularly persuaded her girlfriends to chip in money to fill up her father's car with gas so they could get downtown.[29] Once they were at their desired destinations, the scene rarely disappointed. Gloria Rios Berlin described wartime dance halls as "exciting," and Gloria Vargas, a self-proclaimed "zoot suit girl," fondly remembered "the high that [she] would get hearing the band playing."[30]

Yet for these second-generation women, the desire to pursue a very "American" pastime did not supplant their desire to do so with their own flair. The liberating aspects of swing—from its emphasis on improvisation to the diversity of its musicians—allowed Mexican American women to blend aspects of Americanism with cultural difference. For many adolescents, this meant emulating the style and persona of the pachuca. In dance venues, women often chose to wear low-waist dresses, wide at the bottom so that they could turn and dance with ease, enabling skirts to sail easily through the air as bodies bustled around them.[31] But the high hair and relatively short length of the skirt truly denoted a "pachuca" look. Mexican American women like Alice Castillo expressed deep admiration for the pachuca style, by and large because of what the clothing and makeup said about the women who wore them. "I thought [pachucas] were very liberated; they were lucky they got to do what they wanted," Castillo remembered. "Everybody said it was so wrong, and yet they had the nerve to do what they wanted, to go against, [and] rebel."[32] According to at least one contemporary observer, two-thirds of Mexican American youths in Los Angeles adopted at least some aspect of the zoot suit style during the war years.[33] Their vibrant public display reflected the desire of Mexican American women to flaunt autonomy and to set themselves proudly apart from other clientele. According to Lupe Leyvas, the higher the hair and the shorter their skirts, the better they looked—and the better they felt about themselves.[34]

The creation of new dances like the "Pachuco Hop"—a "Latin version" of the popular Lindy Hop—provided further opportunity for Mexican American women to challenge the gender and class restrictions particular to their cultural backgrounds.[35] While both male and female dancers of the Lindy

Hop engaged in active, rhythmic steps, Pachuco Hop dance steps separated along gender lines. Men stood tall and still, only moving their arms in the slightest manner to steer their dance partner, demonstrating a cool demeanor at all times. The female dancer, on the other hand, took center stage by displaying her talent for all dance hall attendees to see, definitively expressing individual freedom over ballroom gentility.[36] Although males still led and, as former zoot suiter Arthur Arenas described it, perceived the interaction as "órale" and "my day," the public expression and sexually bold moves of females provided a significant challenge to stereotypes of the domestic and docile Mexican woman.[37] Thus the swing scene did not entirely supplant or entirely embody Mexican cultural forms; rather Mexican American women used the dance floor to create a distinct cultural terrain that displayed their difference and autonomy in a public fashion.

Significantly, swing music and dance also made possible what one scholar terms the "democratization of dance hall culture," facilitating greater interaction and bodily intimacy between whites, Mexicans, blacks, and Asians in urban spaces.[38] The ethnic and racial diversity of jazz and swing musicians encouraged pluralism on the dance floor, and in large urban areas it was not uncommon for mixed-race bands to play for mixed-race audiences. Mexican American youths traversed the multicultural Los Angeleno landscape—from Hollywood and Central Avenue downtown to South Central and the Westside—and rubbed elbows with "every color and creed" in dance halls, ballrooms, and auditoriums.[39] Although several Los Angeles establishments were not above refusing entry to African Americans, or clientele of any color wearing zoot suits, by and large members of the Mexican population could patronize most mainstream establishments, even those deemed whites-only.[40]

Daughters of Mexican descent tended to embrace the social and spatial mobility that provided for cross-cultural contact. Familiarity with different races and ethnicities—facilitated by multicultural shop floors—at times led to diverse encounters on dance floors, posing an implicit challenge to norms of segregation and long-standing taboos against race mixing.[41] Juanita Villalobos, a war worker at a Los Angeles food-processing plant, frequented Los Angeles big band venues where she danced with Euro-American, Mexican American, and African American men: "I danced with anybody that would ask me," remembered Villalobos. "You go there to dance, not to sit on the chair! It was very mixed; if you had the money to go, you went. . . . It was just a really wonderful, fun time. . . . You just mixed."[42] Gloria Rios Berlin also recalled that during the war she "danced with several different people at every ballroom—all ages and all denominations"; Margaret Rodríguez laughingly

proclaimed that she had "no preference" who she danced with during the war, "as long as they were good looking!"[43] For these and other Mexican American women, wartime dance halls offered an environment where barriers to intimacy softened.

The Los Angeles defense industry, reliant upon "Americans All" ideologies to maintain shop floor harmony, both implicitly and explicitly sanctioned ethnic and racial "crossings," particularly between whites and Mexican Americans.[44] As George Roeder explains, during World War II Americans encountered an extensive visual dialogue on what he terms "racial reconciliation"—a reference to the vast array of positive, respectful images of minority groups that permeated U.S. society in order to facilitate unity across ethnic and racial lines. But wartime propaganda drew the line at depictions of social intimacy between whites and blacks. In 1943, the War Department's Bureau of Public Relations officially censored from publication any photographs depicting black servicemen socializing with white women. Hollywood films did not dare display images of racially mixed dancing on the silver screen, and defense factory publications like the Douglas *Airview News* rendered interracial romances visually invisible by never featuring mixed sex, interracial social interactions in the leisure realm.[45]

Yet under the temporary wartime context of "doing something for the boys," World War II visual imagery granted Mexican women social permission to fraternize across ethnoracial lines. Newspaper coverage of Douglas Aircraft beauty contests to choose the most "all-American" defense worker of the "largest aircraft factory in the world" frequently counted Spanish-surnamed women among its many contestants. Black and Asian women, however, never made the list of contenders. Although these contestants were always fair-skinned and never took the crown, their inclusion in the pageant denotes a blurring of social and sexual boundaries between whites and Mexicans in the wartime workplace. Unlike the noticeably absent black woman, who frequently met exclusion from universal standards of beauty, Mexican women war workers could more easily occupy definitions of "white," respectable femininity, and thereby transcend racial and sexual barriers in ways that their black female counterparts could not.[46]

Throughout the war years, brown and white social intimacies received regular visual endorsement in the pages of the Douglas *Airview News*. In 1943, Mexican American war worker Gerry Ciqueiros, described as "sooty lashed, raven-haired and fascinating," received high praise for her tireless devotion to the men of the U.S. armed services during a KFWB radio appearance with Los Angeles radio disc jockey Al Jarvis. As Jarvis interviewed

Ciqueiros, listeners and readers learned of her volunteerism visiting war veterans in local hospitals, where she delivered cigarettes and the "magic of [her] smile."[47] Readers continued to keep abreast of Ciqueiros's social exploits; just months later the *Airview News* highlighted the marriage of the "lovely" Geraldine to Lieutenant Glen Overton, a Euro-American serviceman of the U.S. Army Air Forces.[48] Other Mexican American "Douglas girls" received similar high praise for their efforts to "help entertain lonely soldiers." In 1944 the company newspaper featured Rae Romo, laughing beside a sergeant, during a trip where she and eight other "Douglas lassies" traveled to the central coast of California to spend the weekend wining, dining, and dancing under the mistletoe on the arms of servicemen.[49] The cross-cultural social interactions of these and other women of Mexican descent served a direct wartime need, thus rendering all fair in love and war.

Mexican parents, on the other hand, often held negative feelings about their daughters socializing intimately with men of non-Mexican descent. A majority of Los Angeleno Mexican American women grew up and attended schools in very heterogeneous, multiethnic neighborhoods on the East and Southside; but when it came to matters of intimacy and romantic partnership, protective parents clearly privileged Mexican ancestry.[50] In the diverse neighborhood of Boyle Heights, Mexican American musician Don Tosti recalled the commonplace practice of teens socializing with one another across ethnic lines. However, when it came to lifetime commitments, most Mexican youths understood that the ultimate expectation was "when you married, you married your own."[51] Adele Hernández learned this lesson the hard way after she began seriously dating a Jewish coworker at Lockheed Aircraft. Given their different cultural backgrounds, and the sting of familial disapproval, she eventually decided that the relationship "wasn't getting us anywhere" and ended it.[52] Other Mexican American women like Alicia Arevalo very consciously "always [dated] Mexican boys." As she described it, growing up in Palo Verde, a mostly Mexican community in the Chávez Ravine area, "if you dated outside your ethnicity they would say 'is the race gone? Aren't there any more Mexicans? Why do you have to date outside [the Mexican population]?'"[53]

Some Mexican parents had looked to traditional community groups to provide their American-born daughters and sons with culturally appropriate recreation. By the early twentieth century, mutual aid organizations like the Alianza Hispano Americana (Hispanic American Alliance), established in Arizona in 1894 to "protect and fight for the rights of Spanish-Americans," implemented several youth auxiliaries in Los Angeles.[54] Clubs associated

with various Mexican sociedades included names such as Superba, Imperior, Alma Joven, Monte Verde, Alegria, and Ideales Señoritas, and offered Mexican American youths both single-sex and mixed-sex social interaction amid an environment of cultural pride.[55] Typical of the immigrant-era generation, the Alianza and similar organizations promoted a vision of Mexican ethnicity and culture transcending the border. Viewing their adopted country as "México de Afuera" or "Mexico of the Outside," parents hoped the youth organizations would assist their offspring in remaining united as Mexicans, no matter their birthplace. A 1937 Alma Joven program reflected this worldview, stating that although the Mexican youth of Southern California had struggled with the "rigors and sorrows of life," Alianza lodges provided them with the opportunity "to make themselves dignified citizens of Mexico and to feel proud."[56]

Based on the principles of "morality, education, and respect," Mexican youth groups served a variety of functions, ranging from social control to social opportunity. On the one hand, the immigrant generation wished to keep sons and daughters from "dissipating their hours in vice and corruption," by and large by providing recreational alternatives that would "reflect dignity for their country and parents." Clubs held monthly Black and White balls—modeled after those in Mexico City—at upscale venues like the Royal Palms Hotel and the Riverside Drive Breakfast Club in Los Angeles; here patrons could "admire the beauty and distinction of the young ladies and the gentlemanly behavior of young men" as they danced to Latin orchestras and displayed their evening finery.[57] According to former Alma Joven member Margarita Salazar, every social activity—be it a dance, a swimming excursion, or a horseback ride in the mountains—was "well supervised." "It wasn't just a bunch of kids going to raise holy heck," Salazar explained.[58]

But the clubs also provided youths with a measure of freedom to interact with peers in an environment socially sanctioned but not fully controlled by parents. Until she joined Alma Joven, Margarita Salazar lived a life that she described as "so sheltered and so kept at home."[59] The Mexican youth club network allowed her and her friends to foster leadership skills as they took initiative in planning and attending meetings; the youths also built strong peer networks that served to expand their social worlds beyond the domestic realm. Yet the very nature of the Mexican social club movement served to keep both single-sex and coed interactions within the community, reflecting the maintenance of parental expectations.[60]

Mexican youth auxiliaries slowly began to lose their influence, however, with the advent of World War II. Coverage of social club events in *La Opinión*

waned in the 1940s, and as Margarita Salazar described it, she "broke away from the clubs" as she experienced "more mixture with others." "During the war, that's when the clubs just went down the drain," she explained.[61] Given the social upheavals of the wartime environment, the breakdown of the clubs' structure likely reflected larger patterns of declining parental influence.[62]

Levels of rebellion varied: some young women, like Margarita Martínez, simply avoided conflict with parents by dating outside the Mexican community surreptitiously. Long after World War II, Martínez revealed that she met a marine of Italian descent at a wartime dance and continued to date the young man throughout the war, but never told her mother.[63] Douglas worker Mary Luna was more forthright with her parents about her social life but experienced no less angst because of it. She recalled how her father would pace the floors waiting for her to return home after a date with an "American boy." Expressing his distaste for her choice in company, Luna's father felt little comfort in his daughter's explanation that " '[it] doesn't mean I'm going to marry him, I'm just dating him!' " "He wanted me to marry a Mexican fellow," Luna recounted.[64]

Mexican American women creatively sought out wartime outlets to advance their social lives and reshape the rigid gendered conventions of their parents. One institution in particular—the United Service Organizations (USO)—offered a reputable setting for women of a variety of nationalities, including those of Mexican descent, to socialize with the opposite sex across class and ethnic lines. Founded in 1941 by religious welfare groups, the USO relied largely on female volunteers to provide "wholesome recreation" to servicemen on their off-duty hours. As reformers and federal officials stressed concerns about rising venereal disease rates among military personnel, USOs offered a space for dances, board games, and friendly conversation—positive alternatives to risky casual sex. As historian Meghan Winchell argues, the volunteer efforts of junior USO hostesses certainly served a sexual function in their efforts to use beauty and charm to entice male soldiers away from brothels and into policed USO spaces; however, the organization's emphasis on proper femininity, middle-class values, and purity ultimately rendered the young female volunteers' sexuality reputable.[65]

In general, the USO promoted itself as an upstanding institution that only accepted "good" and "respectable" women to interact with American soldiers. Women volunteers were required to pass a careful screening process of personal interviews and character references in order to participate; the organization also stressed strict in-house rules. Senior hostesses always supervised the young girls, and, indeed, the young patriots could not date or

have personal contact with soldiers outside of the USO.[66] As Rose Echeverría remembered it, "You had to be approved in order to be allowed to dance. You had to be of good character."[67]

Yet, according to Meghan Winchell, USO officials typically identified femininity and "good character" as rooted in white, middle-class cultural mores. Euro-American women were thereby inherently considered sexually respectable and feminine, making it more difficult for women of color to meet the racialized requirements of respectability. Thus, while the national USO promoted the inclusive vision of "Americans All" and encouraged the selection of hostesses across class, ethnic, and racial lines, in practice, local USO clubs integrated solely where public sentiment would allow—a phenomenon that generally did not occur, particularly for the African American population, in major cities like Los Angeles. Wishing to avoid racial conflict, the national USO never pushed its racially inclusive agenda on local USOs that were too reluctant and unwilling to challenge social norms that condemned interracial dancing.[68]

Yet given the temporary nature of the war, and Mexican women's racially flexible social position, they—unlike their black counterparts—could generally participate without hindrance in mainstream USO activities in Southern California.[69] During a federal conference on the "Spanish-Speaking Minority Program in the Southwest," the Office of the Coordinator of Inter-American Affairs had officially recommended such interactions, advocating "Spanish-speaking personnel" to be enlisted in agencies that "work with servicemen" like the USO and the Red Cross.[70] Thus women like Margarita Salazar regularly attended mainstream USO events, feeling it was their patriotic duty to keep servicemen company and to make them feel at home with coffee, doughnuts, and an opportunity to dance.[71] Other young Mexican American women participated in USO functions to fulfill their own desires, finding in volunteer work a new source of personal freedom. Rose Echeverría, for instance, grew tired of the fact that men of military age were away in the service and that only older men and younger boys could be found in the factories during the war. Longing for casual relations with men more her age, Echeverría recalled that she attended USO benefits in order to see new faces and dance. "We kept thinking where could we, these nice young ladies, dance with some men?"[72] She and her friends found the answer in the USO.

USOs in greater Los Angeles provided women of Mexican descent with the opportunity to interact intimately with men from diverse backgrounds. Dancing represented one of the most popular diversions desired by servicemen, and whether it was waltzing or jitterbugging, the very intimate, physical

act of dance brought male and female bodies close together in an atmosphere of sexual undertones well removed from communal and familial networks. Thus for the historically overprotected Mexican woman, USOs represented a space of freedom. At the same time, however, given USO objectives, women, regardless of ethnicity, were valued for their emotional work as the objects of the male gaze, as reasons to fight and possibly die overseas. But for those young women who made the decision to participate in the mainstream USO, and to "cheer up the fellas," wartime volunteerism fulfilled a desire to advance social lives with men both inside and outside the Mexican community.[73] As Connie Velarde explained it, the USO offered a venue where she had the freedom to dance with Mexican and Euro-American servicemen. In her memory, white servicemen chose to dance with Mexican girls just as much as they did young Anglo women. "Our playground was in Hollywood," Velarde stated as she recollected USO dances with fondness.[74]

Evidence does suggest, however, that Los Angeles was unique in its relatively open acceptance of Mexican American women and Euro-American men keeping company at local USOs. In some segregated Texas communities, Euro-Americans openly discriminated against Mexican American women engaging in cross-cultural leisure.[75] The small town of Del Rio, Texas, became a hot spot of conflict in 1943 when not only did local business owners refuse to serve Euro-American soldiers who socialized with "Latin-American girls," but the neighborhood USO quickly turned away any Euro-American men arriving with Latin American women on their arms. As the associate director of the Inter-American Committee of the University of Texas explained it, "Newcomers, such as soldiers, who are seen with Spanish American girls are warned against such conduct."[76] Members of the Mexican American–operated Continental Club subsequently registered a complaint about the treatment of Mexican women to the national USO, only to have their protests rebuffed with a statement that the USO would not get involved in local racial situations.[77] That same year, University of Texas professor George I. Sánchez lamented the racism faced by young Latin American girls looking to become USO hostesses in an unnamed Texas border town, perhaps Del Rio. Here, patriotic young women had inquired about the process of joining the USO, only to be brushed off and told to visit their local Catholic church for wartime volunteer opportunities, an option that Sánchez argued "would only be another form of segregation." Sánchez described the incident as one of "keen disappointment" and "deep humiliation" for the young women, especially given the lack of "opportunity to do their rightful part, as American citizens, in furthering the war effort to which their loved ones are daily dedicating

their lives."[78] For the larger Texan population, however, fears of miscegenation prevailed over equal opportunity.

But in those areas of the country where local USOs encouraged or, at the very least, accepted, the presence of Mexican women, wartime volunteerism provided young women a safe space to balance expectations of both their American and Mexican social worlds. USO efforts to recast American servicemen as good neighborhood boys serving their country often helped immigrant parents to perceive their daughter's volunteer activities as less threatening. As historian Meghan Winchell points out, a soldier's or sailor's uniform provided men with immediate respectability, no matter their diverse economic, regional, and/or ethnic background.[79] Because of the outpouring of patriotism and the fact that almost all families knew someone in the service, tremendous sympathy existed throughout the United States for "the boys" away from home, and Mexican immigrant parents proved no different. Explaining her mother's acceptance of USO activities, Margarita Salazar declared, "[My mother] thought it was all right, because her sons were in the service, so she didn't see anything wrong with it. She was so wrapped up in missing her boys, you know, that she didn't see anything wrong with the servicemen. Her sons were servicemen."[80]

Similar to Mexican social clubs, the USO emphasized social propriety and chaperoned events, allowing even the most apprehensive of Mexican parents to feel comfortable permitting daughters to participate in activities for the benefit of soldiers and sailors. Junior hostesses had to abide by a strict dress code that emphasized respectable femininity, including full skirts and bright sweaters, or evening gowns for more formal affairs. (In most USO clubs, slacks and suits were not allowed, as they emphasized a more masculine work identity.)[81] For those young women forbidden to go out without a chaperone, the supervision policy of the USO often satisfied parental demands. Connie Velarde participated in USO dances during the war because her employer, a local telephone company, took its operators to the Hollywood USO at shift's end. Her strict father did not seem to mind her late-night interactions with servicemen, however, as the activities were always supervised, and "they knew that I wasn't alone," Velarde explained.[82] The well-chaperoned environment of the USO assuaged parents' fears about threats to their daughters' safety and sexual reputations.

Nowhere was the desire of second-generation daughters to blend their American and Mexican social worlds more readily apparent than in the efforts of a group of young women to form a USO especially for Mexican enlistees. Immediately following the Japanese attack on Pearl Harbor, members

of a Los Angeles group known as the Y's Owls—a Mexican girls' club under the auspices of the YWCA—organized the "first social affair for the Spanish-speaking youth in the Army."[83] Tracing its roots to the 1850s, the YWCA had initially focused reform efforts on the needs of white, native-born working women, but by the early twentieth century it began to profess—in word, if not entirely in deed—women's commonality across racial difference.[84] In the spirit of interracialism, Y reformers increasingly reached out to women of color, and the Y's Owls emerged as one of many Girl Reserves clubs founded in Los Angeles to serve adolescent women in business and industrial clubs, providing members with know-how in self-government, leadership, and wholesome recreation.[85] In a vein similar to the Alianza youth auxiliaries, members of the "Mexican Club" regularly planned and hosted club meetings and community charity events, which highlighted traditional Mexican dress, dishes, and dances, a reflection not only of the Y's commitment to "individuals of many different experiences and backgrounds" but also of the young women's desire to express pride in their Mexican heritage.[86]

Upon U.S. involvement in World War II, members of the Y's Owls found it increasingly pressing to focus their leadership skills on better serving the needs of Mexican servicemen. In January of 1943, members of the Coordinating Council for Latin American Youth (CCLAY) had received word that the national USO would cooperate with the establishment of a facility for "Mexican boys in the Armed Services . . . if the need exist[ed]." Indeed, CCLAY surveys of Eastside neighborhoods found that on any given Sunday, nearly 300 servicemen of Mexican descent could be found walking the streets, and presumably would have welcomed an opportunity to stop at a "Spanish-speaking" USO for a light snack, friendly dance, or long talk with a Mexican American hostess.[87] Eager to address the community's need, members of the Y's Owls immediately headed up a campaign to start an official organization. Since a handful of Y's Owls members also belonged to the Mexican social club Ideales Señoritas, members of the two groups joined ranks to form what came to be called the Latin American USO.[88]

Despite the enthusiasm, getting the Latin American USO off the ground initially proved difficult. Efforts to sponsor dances at the International Institute in Boyle Heights were unsuccessful when events went unpublicized and no young men attended.[89] Particularly irksome was the inflexibility in the national USO's "iron rule" of serving coffee and doughnuts to servicemen. As the volunteers pointed out, Mexican American servicemen would be much more likely to attend USO functions with a menu of tacos and enchiladas, and yet the USO refused to cooperate. A frustrated Josephine Cuevas, representative

of the Y's Owls, complained to the CCLAY that the USO seemed to be engaging in "unnecessary stringency and formal rules," creating bureaucratic hoops. Perhaps fearful that the uncompromising attitude of the USO might stem from general doubts about Mexican women's reputability, Cuevas defensively remarked that the Mexican hostesses were members of the YWCA, a group well-known for its "extreme care" in accepting only the "highest type" of young women, and thus should be treated accordingly.[90]

Overall it remains unclear why the national USO seemed initially hesitant to give a stamp of approval to the young women's vision of a Latin American USO. Long-standing racial anxieties over the behavior and comportment of Mexican women may have played some role in shaping the USO's initial responses to the Mexican community's patriotic overtures. But as emblematized by the disagreement over serving tacos versus doughnuts, it seems also possible that the national organization simply felt uncomfortable with a USO auxiliary promoting cultural difference, particularly at a time when the federally supported "Americans All" creed called for a common unified national purpose. In keeping with wartime national objectives of racial harmony, the USO may simply have envisioned Mexican women fitting in rather than standing out.

Ultimately, USO policy privileged the needs of male soldiers and sailors—no matter their color. Thus, after four months of wrangling, the Latin American USO officially began its "laudable program of making servicemen feel at home" in August of 1943.[91] Approximately thirty-six hostesses of Mexican descent—a good number from Mexican women's clubs like Club Ideales Señoritas and the Y's Owls—joined the organization, referring to themselves collectively as the Señoritas USO. The young women immediately embarked on a campaign of "providing a spiritual and material benefit for those Spanish-speaking and Latin American origin servicemen," and spent their free time visiting Southern California military camps, hosting dances for men in uniform at the International Institute, and buying war bonds.[92] The Los Angeles newspapers *La Opinión* and the *Eastside Journal* regularly publicized the young women's spirited social affairs and volunteer activities, and by 1944 the organization had established provisional headquarters for an official Mexican USO Center, a place where servicemen on leave could pick up tickets to Spanish-language shows, obtain information about dances and "wholesome entertainment," and receive a listing of patriotic Mexican families willing to take in a lonely soldier or sailor for a night or two.[93]

In their efforts to keep up the spirits of servicemen of Mexican descent, the Señoritas USO promoted a vision of "Americans All" that subscribed to

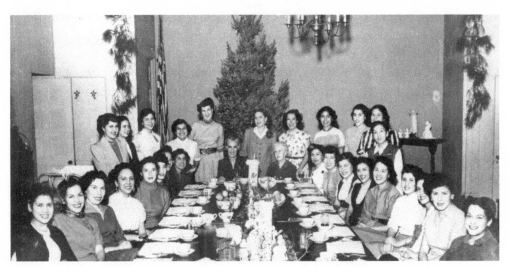

Members of the Señoritas USO *at a 1943 Christmas dinner. Los Angeles Public Library Photo Collection.*

both patriotic wartime aims *and* cultural difference. Given the acceptance of Mexican American women in the mainstream USO canteens in Los Angeles, it is conceivable that women could be both USO Señoritas and canteen hostesses. But as their agenda attests, those women who joined the Señoritas specifically wished to care for their Mexican brethren as they would have cared for members of their own families. Demonstrating community appreciation and motherly or sisterly love could be done much more authentically if the boys encountered an environment like the typical Mexican home, chock full of Mexican dishes and with women who looked like their mothers and sisters.

Thus in their involvement in the U.S. war effort, the Señoritas USO emphasized their Mexican heritage. The hostesses planned fiestas for servicemen, and their events included Mexican food, song, and dance. During one particularly successful program, over 3,000 Los Angelenos gathered in La Placita—a public park central to the Mexican community located at the end of Olvera Street—to take part in a night of "Mexican Serenade." The Señoritas USO headlined the event, showing off their artistic talents by performing several regional Mexican dances and songs to roaring applause from the "Spanish-speaking colony and other races." Although the young women were indeed "privileged to serve men in the armed forces of other nationalities"—as demonstrated by their regular travels to military camps throughout Southern California—their primary attentions focused on tending to and promoting an appreciation for the Mexican community, as Mexicans.[94]

Yet in their cultural work for the war, the Señoritas USO also made a concerted effort to present their nonwhite womanhood in a manner palatable to the larger American public. These young women of color did advocate for equal treatment in U.S. society, but ever mindful of the importance of reputation, they also strategically utilized the patriotic, all-American USO to secure their position as "good girls."[95] As Señoritas USO vice president Aida Almanzán wrote to CCLAY secretary Manuel Ruiz in a letter asking for his support, "We have had great success with obtaining Señoritas that are representative of the most elite type of young Mexican woman. The distinguished place they hold in our society, and their excellent character and behavior with the men of the military service, is a guarantee of their cultural and patriotic objective."[96] Efforts of the Señoritas USO thus challenged presumptions of all-American womanhood as white, but they did so in a manner that presented a virtuous and respectable vision of Mexican ladyhood.[97]

In many ways, this was not a battle easily won. No matter how meticulous their attention to virtue, or how emphatically wartime officials touted their inclusion, Mexican American women still faced resistance to their newly urban public presence. Particularly unnerving was their ability to be considered white one minute and nonwhite the next, as they permeated long-standing societal boundaries meant to keep intimate relations from crossing ethnic and racial lines. Sex lay at the heart of the matter. What might the future hold if Mexican women fit in just well enough to marry whites? Marriages between Spanish/Mexicans and whites in the Southwest had long existed since the early nineteenth century, but such unions were by no means routine.[98] Thus the new, more frequent opportunities for cross-cultural relationships—made possible by the wartime environment—did not go unnoticed. Nowhere did these anxieties become more readily apparent than in the gendered conflicts that arose during the Zoot Suit Riots in June of 1943, when Euro-American sailors and Mexican American youths took to the streets.

Prior to the ten days of violence that characterized the riots, several racial and sexual confrontations between Euro-Americans and Mexican Americans had occurred. As documented by scholars Eduardo Pagán and Catherine Ramírez, the presence of hypermasculine servicemen in historically Mexican communities like Chávez Ravine—home to a U.S. Naval Reserve Training School—created a situation where Mexican American men felt a need to protect both their neighborhoods and their women from intrusion.[99] Military personnel shipped in nationwide from homogeneous small towns, or areas of the country accustomed to a black/white racial divide, many bringing with them racialized notions of sexuality that viewed women of color as

readily available and easily possessed. As they navigated Los Angeles streets, women of Mexican descent encountered behavior ranging from cat calls to outright harassment from white servicemen, a phenomenon detailed by African American writer Chester Himes in 1943. According to Himes, in one instance, a blond sailor jumped at the opportunity to taunt a young Mexican couple as they rode the local street car. Leaning over and leering at the youths, the man jeered: "'Boy, did those native gals go fuh us. Boy, uh white man can git any gal he wants. Can't he, boy, can't he git 'em if he wants 'em?'" Underscoring the racial overtones of the incident, Himes decried the propensity of white servicemen to roam "Mexican districts" in search of Mexican women, and he sarcastically implored his readers: "For what else could pretty Mexican girls be for other than to satisfy white men?"[100]

Ultimately, alleged sexual malfeasance on both sides became the rallying cry for violence. Los Angeles newspapers published allegations of zoot suiters raping white women; testimonies of angry Euro-American citizens and servicemen stressed the need to "make the streets of Los Angeles safe for sailors, for sailor's girls, and for the general public."[101] Likewise, Mexican American men saw themselves as protecting their mothers, sisters, and sweethearts from "predatory" white men. As Lupe Leyvas, sister of Sleepy Lagoon defendant Hank Leyvas, noted, males of Mexican descent were "raised from babies as real macho" and thus remained particularly protective of women's reputations. "Not anything happened to the girl who was with you," Leyvas explained, and thus any harassment of Mexican women "naturally . . . incited riots."[102]

But as Mexican American men sought to defend their sisters and girlfriends from abuse by white men, they also desired to protect their own deteriorating social control. Increasingly fearful that the Mexican woman's occupation of public space opened doors for sexual intimacy across ethnoracial lines, arguments over how women would spend their time and with whom took place anywhere from domestic spaces to public street corners. Margarita Martínez recalled a particularly startling moment when she and her date, a tall, blond sailor, waited for a city bus at the intersection of Main and Olvera Streets after attending a movie together. Because he was shipping out later that day, her date wore his navy uniform. As Martínez explained it, out of the blue, "this Mexican guy comes over and hits [my date] in the face! He was just a Mexican guy, but saw a Mexican woman with a blond sailor," she recalled. Neither she nor her date knew the perpetrator, and thus a baffled Martínez attributed the incident to "prejudice against the fact that I was going out with an Anglo."[103] In her work *The Woman in the Zoot Suit*, Catherine Ramírez

underscores the sexual policing present in wartime Mexican communities, stating that "Mexican American men controlled—or were supposed to control—the barrio, the Mexican American home, and Mexican American girls and women." But as these very women experienced public contact with the larger Los Angeleno populace, their behavior compromised the historically "closed society" of Mexicans, undermining familial control over the Mexican female body.[104]

Notably, the fears of Mexican men were not dissimilar to those experienced by their Euro-American counterparts. According to historian Eileen Boris, wartime racial confrontations between whites and peoples of color were commonplace nationwide due to an environment that lessened barriers to workplace integration and bodily closeness in public spaces. As Boris argues, from the race riots between whites and blacks in Detroit, Michigan, and Beaumont, Texas, to the conflagrations between whites and Mexican Americans in Los Angeles, Euro-American men feared the potential for white women to share public spaces with men of color, particularly those who expressed a new public assertiveness and defiance of white privilege. Thus the violence of the Zoot Suit Riots can be understood not only as evidence of anti-Mexican sentiment but as attempts by both Euro-American and Mexican men to reassert their masculinity, and reclaim "their" women, by upholding the color line.[105]

Miscegenation fears lay at the heart of Mexican and Euro-American anxieties. Although in the early decades of the twentieth century state laws across the country attempted to prevent to one degree or another blacks, Asians, and American Indians from engaging in interracial marriage and sex, the unique history of Mexicans placed them in a more ambiguous social and legal position. As an Arizona judge explained in the 1922 Kirby v. Kirby miscegenation case, "Mexicans are classed as of the Caucasian Race. They are descendants, supposed to be, at least, of the Spanish conquerors of that country, and unless it can be shown that they are mixed up with some other races, why the presumption is that they are descendants of the Caucasian race." Some states did in fact name "Indians" in their miscegenation laws as a way to outlaw marriages between "whites" and those "Mexicans" whose origins could ostensibly be traced to Indian (and therefore nonwhite roots)—but this was not the case in California. Indeed, California did not specifically name either "Indians" or "Mexicans" in its miscegenation statute, making it possible for a Mexican man or woman, even those considered to be "Mexican Indian," to legally marry a "White" person.[106] It is thus not altogether surprising that the efforts of "Americans All" advocates to break down social boundaries and

promote home front harmony backhandedly set in motion extralegal means to keep traditional social and sexual relationships intact. Mexican women may have successfully occupied their racially in-between status in the context of wartime necessity; outside the purview of war, however, their newfound mobility and visibility in the urban environment posed a more substantial threat to the status quo.

As Catherine Ramírez aptly points out, the social battles that raged in wartime Los Angeles should not categorize Mexican women as mere "pawns" in the clashes between "warring groups of men."[107] Rather, conflicts over bodily intimacy and public space point to the myriad ways in which second-generation daughters utilized the World War II environment to fulfill with imagination individual desires, desires that attempted to balance the oft-conflicting expectations of American and Mexican social worlds.[108] Mexican American women utilized wartime leisure culture as a way to articulate identities that promoted varying degrees of commonality and difference, "good girl" gentility and rebellion. Their broadened public presence and sense of empowerment would well outlast the war, paving the way for a politicization that would continue long into the twentieth century.

5

Civil Rights and Postwar Life

On 24 August 1945, Guadalupe Cordero, a packing employee at the Breakfast Club Coffee, Inc., was fired. Cordero had worked for the company for nearly seven months when management dismissed her and several other Mexican women without notice or provocation. Angered and frustrated, Cordero contacted the Los Angeles Committee on Fair Employment Practice (FEPC) office to file a complaint. In the affidavit to FEPC investigators, Cordero stated that during the war, "she[,] like the other Mexican girls[,] worked hard, without days of rest nor recreation and felt that she was working for a future." But her hopes were effectively quashed as the company dismissed all Mexican American employees en masse, replacing them with "an equal number of girls, all so called Americans." Her letter of dismissal stated that Cordero's work had "proved quite satisfactory," and no reason was given except that "she is no longer needed here." For Cordero, this statement could only be interpreted as "she, being Mexican[,] is no longer needed."[1]

Four of Cordero's fellow employees filed identical complaints with the FEPC. According to their affidavits, Emma Acosta, Luisa Martínez, Reina Ramírez, and Agrippina Guillen believed that their former employer did not want any Mexican women in his establishment now that the war had ended and Euro-Americans were now more readily available. As stated in the FEPC case file, "They are of the firm conviction that they have been dismissed solely because of discrimination against the Mexican race or any other minority group and now that they have filled a need during the man hour [sic] labor shortage are no longer desired." Unfortunately, FEPC documentation is unclear as to whether Guadalupe Cordero and her former coworkers were rehired by Breakfast Club Coffee or if they found postwar jobs elsewhere in the Los Angeles workforce. In all likelihood, given the nature of the postwar

atmosphere and the declining influence of the FEPC, Cordero and her co-hort would eventually find work in low-paying service jobs or less-desirable manufacturing positions.[2]

The experiences of Guadalupe Cordero and her coworkers testify to the decidedly mixed legacy of World War II on the lives of Mexican women. As discriminatory hiring patterns returned, Cordero and her coworkers found themselves on the losing end of postwar downsizing, with little alternative but to air their grievances before the state in an attempt to retain their foot-hold in higher-paying employment. Yet, in their sworn affidavits, Cordero and her fellow workers utilized language that revealed a distinctive sense of entitlement for insider status, not simply because they had "been reared in the United States and [were] familiar with customs and conditions here," but because of a worldview that had been profoundly shaped by their wartime experiences. "[We] consider [our]selves on the same plane as any American and all have relatives in the armed forces of the United States," the affidavit stated. "It would be a mockery to deny [us] the elemental human rights ac-corded to every American."[3]

Ultimately, racial liberalism would fail to usher in a postwar era of equal opportunity, particularly as federal support of "Americans All" shifted toward a Cold War domestic policy based less on inclusion of working-class com-munities of color than on outright state repression. And yet as Guadalupe Cordero explained in her FEPC grievance, she and other Mexican women believed quite definitively that their wartime experiences had earned them a right to equal treatment. Thus from involvement in collective community activism to individual pursuits for broadened social worlds, Mexican Ameri-can women would continue to confront barriers at work, leisure, and home, and to challenge narrow definitions of what it meant to be "American," long into the postwar years.

AS THE SECOND WORLD WAR CAME TO AN END, employment oppor-tunities available to women, and particularly women of color, declined dra-matically. With servicemen returning home from overseas, women across the nation were called upon to relinquish higher-paying jobs traditionally defined as "male" work. Typically, discriminatory practices dictated postwar reconversion efforts, with African American and Mexican American women among those employees first fired from wartime jobs, even in lower-paying occupations. All the more troubling was the attitude that women in general had entered the workforce temporarily and solely "for the duration." Nation-wide, social scientists and writers of popular magazines touted traditional

images of female domesticity, urging women to retreat to their homes in order to make way for veterans seeking employment.[4]

In Los Angeles, specifically, large-scale cancellations of federal military contracts resulted in the loss of over 100,000 aircraft jobs in 1945 and 1946 alone. Lockheed's immediate postwar employment dropped from 57,000 workers to 16,000; by war's end, North American had laid off about two-thirds of its workforce.[5] Given prevailing gender expectations, and the fact that female workers tended to have less seniority than their male counterparts, women found themselves disproportionately affected by the postwar layoffs. A wartime survey by the Los Angeles Chamber of Commerce found that 51 percent of women aircraft workers—no matter race, color, or creed—desired to keep working at their jobs, yet by June of 1946, just 14 percent had retained their employment.[6]

As Southern California war-related industries made the transition to a peacetime economy, Mexican women experienced a range of emotions and reactions to postwar downsizing. Unlike Guadalupe Cordero, a good number of Mexican women war workers had always viewed their defense jobs as temporary and expected to quit working when no longer needed. Lupe Purdy, who married in 1935, identified herself first and foremost as a wife and mother even as patriotic duty drove her to seek a riveting and bucking position at Douglas Aircraft in 1942. As a working mother, Purdy consistently struggled with her decision to labor outside the home, largely because she missed spending time with her children and felt that her household was falling into disarray. She eventually left Douglas in order to obtain an assembly job closer to home, and yet even this new arrangement failed to satisfy her. By war's end, Purdy was more than happy to put away her rivet gun and "just stay home and do my job [as a wife and mother] the best I [could]."[7] Other Mexican American women desired to continue earning a wage outside the home but had no qualms abandoning positions in heavy industry for preferred occupations in "women's work," even if the positions paid less money.[8] Margie Salazar took this route even before war's end, preferring work as a "desk girl" to the dirtier and more taxing labor of the Lockheed shop floor and tool shed.[9] Likewise, in 1944 Adele Hernández quit her job as an assembler at Lockheed for a more "glamorous" position as an usherette at the Olympic Theater in Los Angeles. She worked there until her marriage in 1954, when she made the decision to become a full-time homemaker.[10]

Perhaps just as many women of Mexican descent were not as eager to return to domestic responsibilities or lesser-paying jobs. For Beatrice Morales,

war work at Lockheed left her feeling "more independent," but after her son became sick with pneumonia in 1944, she felt compelled to quit. A mother of four, Morales described her return to domestic life and childcare duties as unsatisfying and "kind of quiet." She missed earning her own money, interacting with friends and coworkers, and feeling proud of her patriotic accomplishments on the assembly line. After working more than a year as a stay-at-home mother, she "started looking for ways of getting out and going to work." Eventually Morales found a job at a local shoe manufacturing company and later labored as a janitor alongside her husband. Yet while working these jobs she could not help but remember the prestige and higher wages that she had garnered at Lockheed, and longed for a similar feeling of satisfaction. On a whim she contacted Lockheed in 1950 to let them know of her continued interest, and by the following year—given expanded Cold War defense spending—she achieved her dream. Lockheed rehired Morales, seeing fit to place her in a position as lead riveter given her previous work experience. Morales retired happily from the company in 1978, recalling her experience in the defense industry as a significant factor in her transformation from a timid, shy mother to a capable more confident one.[11]

In spite of Mexican women's varying emotions regarding work outside the home, postwar conditions dictated that most women, and particularly women of color, did not have much choice in whether or not to keep their jobs in war-related industries. As detailed in a 1945 report by the War Manpower Commission, just a week after V-J Day, nearly fifty Los Angeles firms had cancelled employment orders with the local United States Employment Service (USES), stating that "they no longer wanted colored and Mexican help." Although the report attributed the massive layoffs to companies' need for "letting off steam" after years of strict wartime controls, it also warned that renewed discrimination against minority laborers represented a "serious problem" that could "well spread on the West Coast."[12]

And spread it did. As acute labor shortages became a thing of the past, the employment of African Americans began to drop in the Los Angeles aircraft industry almost immediately. Between 1945 and 1949, the proportion of black aircraft workers at North American fell steadily from approximately 7 percent to 3 percent, and from 8 percent to 1 percent at Douglas.[13] Although similar statistics for Mexican American aircraft workers seem not to exist, the numbers more than likely follow a pattern similar to that of African Americans and women aircraft workers in general. While in the fall of 1943 women of all backgrounds made up over 40 percent of aircraft workers in Los Angeles, these numbers fell to 18 percent in 1946 and 11.9 percent in 1948.[14]

Outside the aircraft industry, employment options remained equally bleak. An FEPC study of postwar employer job orders—including those in the manufacturing, service, and garment industries—reported consistent and unyielding discriminatory hiring practices in regard to race, a particularly stark contrast to the democratic ideals professed so readily just a few years earlier.[15] For Connie Rivera, the contradictions were revealed when she attempted to find a job at a beauty shop while attending cosmetology school in the early 1950s. During World War II, Rivera had worked as a cookie packer on the National Biscuit Company assembly line, and yet she had always dreamed of becoming a beautician. With war's end, she quit food-processing in order to look for beauty work, preferably in Westside Los Angeles, near where she lived. Much to Connie's despair, however, employers in West Los Angeles consistently turned her away because of her Mexican heritage, instead preferring to hire "Anglo girls" to work with the predominantly white clientele. Not until she applied for jobs in East Los Angeles was she hired in a local beauty salon.[16]

As unequal hiring and firing patterns resurged in the immediate postwar era, options for women of color to combat discrimination through official government channels also greatly diminished. Shortly after V-J Day, President Truman signed an executive order to disband the Office of War Information and the Office of the Coordinator of Inter-American Affairs, reassigning their functions to the State Department and thereby prioritizing the use of propaganda and information as an important component in foreign policy rather than domestic issues.[17] In spite of a declaration by Acting Secretary of State Dean Acheson that "the existence of discrimination against minority groups in the United States is a handicap in our relations with other countries," the FEPC also underwent a dissolution process as congressional funding dwindled and resulted in rampant field office closures into late 1945.[18] University of Texas historian Carlos E. Castañeda—a senior examiner and special assistant on Latin-American Problems for the FEPC—testified before the U.S. Senate, urging lawmakers to enact legislation that would continue to prohibit employment discrimination based on race, creed, color, national origin, or ancestry. The wartime FEPC, however, officially dissolved in 1946. Subsequent attempts to create a permanent national FEPC met a similar fate as conservative and southern opposition effectively blocked passage of FEPC bills in 1948 and again in 1950.[19] In California, after several failed attempts to pass fair employment legislation through the state legislature, supporters initiated a campaign to put a fair employment practices initiative on the November 1946 ballot. In the end, more than 70

percent of California voters cast their ballots against Proposition 11.[20] Only in 1959, following a long and protracted battle, did California pass its own Fair Employment Practice Act, joining about a dozen other states with similar legislation.[21] Yet it would not be until the 1964 passage of the Civil Rights Act—Title VII of which established the Equal Employment Opportunity Commission—that the federal government would again play a more active role in fighting employment discrimination.[22]

In spite of bleak employment patterns, women of Mexican descent did make some significant inroads and gains in postwar work. Between 1940 and 1950, the number of single Mexican women in the Southern California labor force had grown by 7 percent, while the number of working Mexican wives rose 9 percent.[23] These numbers mirrored the growing general trend of working wives and mothers on the national level, as the expansion of sales- and service-oriented jobs in businesses and corporations in the 1950s provided opportunities for female workers—particularly white women—to work part time for low wages while their children attended school.[24] For Margarita Salazar, the need to go back to work became apparent when she and her husband purchased a house. In order to help out with the "large bill" associated with home ownership, Salazar decided to obtain a part-time job at a small neighborhood bakery while her children attended school.[25] Such decisions were typical of the women in my interview sample: of the thirty-two Mexican American women who worked during the World War II years, twenty-eight eventually returned to the workforce whether directly after the war, while married and raising children, or after their children had left home. Consistent with women across nationality, most attributed their reentrance into the workforce to a combination of reasons, including a desire to earn their own spending money, supplement the family budget, and maintain a wage-earning identity.[26]

Like their black counterparts, women of Mexican descent also experienced modest yet noteworthy occupational mobility in the postwar era. Prior to World War II, almost 70 percent of employed black women in Los Angeles worked as domestics; by 1950, 30 percent of these black females had left domestic work, and increasing numbers of black women could be found in durable manufacturing positions and clerical work in the public sector.[27] Similarly, whereas Mexican women prior to World War II had labored in low-paying domestic, agricultural, and garment and food-processing jobs, by 1950, 24 percent also worked in the widening field of lower-paying white-collar positions as sales clerks and secretaries in California.[28] Tellingly, while black women made significant postwar inroads in governmental clerical positions—at times more so than Mexican women—they experienced a

A Mexican American clerical worker, circa 1955. Los Angeles Public Library Photo Collection.

much harder time pursuing clerical and sales work in the private sector. Given persistent racism, white employers typically preferred Mexican women for retail and office work, testifying to their continuing in-between racial status.[29]

The 1950s saw an equally significant growth in state-sponsored defense jobs as aircraft and aerospace industries expanded to meet the needs of the Cold War, a development that proved especially relevant for former World War II defense workers. Given U.S. involvement in the Korean War, and later Vietnam, government subsidies provided a significant boost to aircraft manufacturing, and, as the industry expanded into space and other defense technologies, a thriving electronics sector also created tens of thousands of new jobs.[30] According to the Los Angeles County Chamber of Commerce, in 1957 the aircraft industry in Southern California employed over 220,000 workers, roughly one-third of the region's entire manufacturing workforce.[31]

Although the proportion of Mexican and black women aircraft and aerospace employees remained relatively small, industries dependent on profitable government contracts appeared more inclined to comply with what little pressure the federal government did exert to keep a diverse labor force, providing job opportunities for a number of women of color in the postwar

defense workplace.[32] According to U.S. Census estimates, by 1950, just 247 Mexican women were employed in "aircraft and parts" in Los Angeles County, a minimal yet substantive number given that none had been employed in the industry in 1940.[33] Although comparable data for later years in Los Angeles County is unavailable, by 1960 an estimated 4,500 Mexican women could be found working in aircraft and parts manufacturing throughout the state of California.[34] In all likelihood, the quantity of Spanish-surnamed aircraft workers in Los Angeles County rose at a slow but steady rate, especially given that the overall number of women employed in aircraft and aerospace industries of Southern California grew from approximately 11 percent in 1948 to 25 percent during the Korean War.[35] According to scholar and labor economist Herbert R. Northrup, by the late 1960s, one Southern California aerospace plant reported 10 percent of its 21,000 employees to be Mexican American and black, with people of color comprising 16.3 percent of all hires.[36]

Thus in the postwar era it was not uncommon for women like Beatrice Morales or Tina Hill to be rehired by their former wartime employers. Morales worked at Lockheed for nearly thirty more years; Hill retired at North American after almost thirty-five additional years on the assembly line.[37] Other women of color found new employers based primarily on the job skills that they had developed during World War II. In 1952, Ida and Ernestine Escobedo secured jobs as inspectors at Hughes Aircraft, a hiring decision that they both credited to their earlier work at the Advanced Relay defense plant in Los Angeles. Although Ernestine in particular believed that as a Mexican she needed to work twice as hard as fellow Anglo employees in order to maintain her employment at Hughes, overall she and her sister appreciated the financial security that the aircraft industry provided. Eventually a recession at the end of the Korean War led to their respective layoffs, but, for much of their remaining work lives, the two sisters bounced to and from a variety of jobs in the electronics and aerospace industries.[38]

In an era predicated upon the "American Dream" of returning GIs and their families buying a home and moving to the suburbs, Mexican Americans found ambiguities in home ownership similar to those in postwar employment. Many Mexican American women did indeed settle down with their veteran husbands in integrated suburban neighborhoods throughout greater Los Angeles, due in large part to housing assistance provided by the federal GI Bill.[39] Legal challenges to racially restrictive housing covenants, a long-standing barrier to neighborhood integration, proved equally influential. Notably, the earliest court case to strike down housing covenants involved a thirty-two-year-old Mexican American man named Alex Bernal,

his Mexican-born wife, and their two daughters, who moved into a racially restricted area in Fullerton—a city located in northern Orange County, California. In 1943, Euro-American neighbors sued Bernal for violation of a neighborhood covenant that specifically restricted Mexicans from moving in. Instead of leaving, however, Bernal hired a Los Angeles lawyer to challenge the lawsuit. In the case *Doss, et al. v. Bernal, et al.*, Bernal's lawyer argued his case on the basis that housing covenants violated both the equal protection clause of the Fourteenth Amendment and the due-process clause of the Fifth Amendment. In November of 1943, the presiding Superior Court judge ruled in favor of Bernal, declaring Fullerton's 1923 housing deed restriction unconstitutional. The *Bernal* case paved the way for future challenges to housing segregation, with the 1948 Supreme Court decision *Shelley v. Kraemer* declaring housing covenants unconstitutional nationwide.[40]

To be sure, old barriers in some Los Angeles communities were coming down. As historian Josh Sides observes, in postwar Los Angeles, Mexicans and Mexican Americans "gained far greater entry into Southern California suburbs than blacks did." According to Sides, by 1960, Mexicans had made significant inroads into working-class suburbs surrounding South Central Los Angeles, including Hawthorne, Huntington Park, Inglewood, Lynwood, South Gate, and Bell Gardens—all neighborhoods that housed comparatively fewer blacks. Moreover, in more distant suburbs, Mexicans far outnumbered their black counterparts. Outlying blue-collar suburban communities such as Alhambra, Arcadia, Baldwin Park, Burbank, Carson, Culver City, Downey, Glendale, Manhattan Beach, Norwalk, Paramount, Redondo Beach, Torrance, and West Covina housed only 1,100 African Americans but over 47,000 Mexicans by 1960. According to a 1952 study of an anonymous Southern California suburb, 45 percent of whites surveyed said they would tolerate living next door to Mexican Americans, while only 23 percent felt the same about African Americans.[41] Startling in its revelations of persistent racism, the study simultaneously reveals a growing level of acceptance of residential integration for the Mexican American population.[42]

Yet in spite of their increasing presence in postwar suburbs, Mexican Americans were by no means immune from exclusion. Although the Supreme Court declared restrictive housing covenants unconstitutional in 1948, resistance to the desegregation of the private housing market continued long afterward. The Federal Housing Authority consistently refused federal loans for neighborhoods where blacks, Mexicans, and Asians constituted a "subversive racial influence," and real estate agents engaged in practices aimed at keeping certain neighborhoods "white."[43] Following the *Shelley* decision,

for instance, the realty board in the suburban community of South Gate imposed fines on a realtor who sold a home to a family of Mexican descent. Upon refusing to pay the fines, the realtor found himself expelled from board membership, and in violation of the Code of Ethics of the National Association of Real Estate Boards, for "introducing into a neighborhood a character of property or use which will clearly be detrimental to property values in a neighborhood."[44] In 1955, yet another local realty board in Los Angeles County expelled members for selling a home to a Mexican American family, arguing that the transaction did not abide by the organization's bylaws, which promised to "make every honest and honorable attempt to place families in a neighborhood where such families will and do fit in with the neighbors and general character of the neighborhood."[45] Indeed, Hope Mendoza—a former riveter at Lockheed—recalled that she "found it very difficult" to buy a house in Los Angeles, by and large because, as a Mexican American, "[realtors] wouldn't even show [a house] to you."[46]

Outside of the realm of housing, Mexicans' education levels also reflected a significant need for improvement. According to a 1964 report by the California FEPC, "Mexican Americans and others of Spanish-speaking origin lag[ged] seriously behind the majority of Americans in schooling, jobs, and income." The report called attention to the fact that young people in the Mexican community were "often discouraged or alienated" from receiving educational preparation or skills. Thus even as the 1946 *Mendez v. Westminster* case found the segregation of Mexican children in California schools to be unconstitutional, significant barriers to equal educational opportunities remained. According to the FEPC report, in 1950, more than half of Spanish-surnamed men and almost half of Spanish-surnamed women fourteen years and older in California never completed an education beyond the eighth grade. The numbers of those who completed their secondary-school education and aspired higher also remained quite low.[47]

As in previous years, Mexican women often responded to inequities in their communities by engaging in political activism. In light of the Second World War's reshaping of ideas about race and American national identity, activism in postwar Los Angeles tended toward the broad, multiracial coalition-building efforts of wartime organizations like the Sleepy Lagoon Defense Committee.[48] As argued by historian Shana Bernstein, interracial civil rights activism represented a crucial and pragmatic strategy in postwar Los Angeles. Given memories of the Zoot Suit Riots, diverse constituencies rallied around the universal cause of preventing future racial disturbances, a position made possible in large part because the war had opened up a

window for activists to advance ideals of racial liberalism in the name of war-time necessity. Moreover, as Bernstein points out, securing ties with "legitimate" and "acceptable" (read: anti-Communist) allies from other ethnoracial communities also allowed multiracial civil rights organizations both a means of protection from red-baiting accusations and a way to broaden support amid the harsh political climate of the Cold War.[49]

For the Mexican American community in Los Angeles, interracial alliances figured prominently in grassroots, progressive groups like the Community Service Organization (CSO). In 1947, Edward Roybal, a Mexican American from Boyle Heights, ran for a seat on the Los Angeles City Council and lost. Upon his defeat, a largely Mexican American but diverse group of disillusioned Angelenos and community activists joined together to form an organization dedicated to encouraging the civic participation of residents in East Los Angeles. In the postwar era, the Eastside populace was more and more predominantly Mexican-origin, but also included Jewish, Japanese, Italian, Filipino, and African American constituencies. Thus although primarily a Mexican American organization, the CSO both worked with and addressed the needs of the full gamut of diverse communities east of the Los Angeles River. In addition to voter registration drives, the CSO concentrated on issues such as overseeing neighborhood improvement projects, including the addition of street lights to areas in need; advocating for public housing projects and against restrictive covenants; and ending police brutality. In the courts the CSO helped secure two major civil rights victories, including the conviction of five L.A. police officers and the dismissal or suspension of seventeen others after their severe beating of seven young men—five of whom were Mexican American—during a 1951 Christmas party. In 1956, the CSO assisted in the conviction of two L.A. County deputy sheriffs for the unprovoked beating of thirteen-year-old Daniel Hidalgo. Ultimately, the interracial, cross-class coalition would lead Roybal to a successful second bid for the Los Angeles City Council in 1949. In spite of the fact that less than one-fifth of the voters in his district were of Mexican descent, Roybal became the city's first Mexican American council member since 1881, and the council's only nonwhite member.[50]

Mexican American women played an integral role in the CSO from its inception, quickly becoming the "backbone" of the organization's coalition.[51] Hope Mendoza, one of the CSO's charter members, had worked in the Los Angeles garment industry as a teenager before finding a riveting position on the Lockheed assembly line. In the aircraft industry, Mendoza experienced her "first exposure to a union," as employees were required to join the

International Association of Machinists (IAM-AFL) Local 727.[52] As the war ended and she was forced to return to lesser-paying, nonunionized garment work, Mendoza became increasingly politicized.[53] Over time she found herself drawn to the efforts of the International Ladies' Garment Workers Union (ILGWU). She volunteered to organize her own shop and—after walking picket lines and successfully convincing coworkers to unionize—was hired by the ILGWU as an in-house organizer. As historian Margaret Rose points out, Mendoza's unionizing activities gave her "valuable experience, confidence, and prominence in local labor circles and in the Mexican American community." After showing interest in candidate Roybal and the burgeoning movement of the CSO, Mendoza became chair of the CSO labor committee. Working alongside a cadre of Mexican women who served in a range of roles including leadership positions, clerical work, fund-raising campaigns, meal preparation, and canvassing, Mendoza and others kept the organization thriving and functioning on a day-to-day level.[54]

Postwar community activism was not without its challenges, especially given the political repression faced by progressive activists in the wake of the Cold War. Perhaps nowhere were the contradictory legacies of World War II more sharply revealed than in the federal government's postwar shift away from "Americans All". Much rhetoric of the Second World War had rested firmly on the notion that the United States' strength lay in its diverse peoples, and that in war Americans would "[cast] aside old enmities to unite as a single people in a common struggle."[55] Once an all-out ideological struggle against the Soviet Union came to dominate U.S. foreign policy, however, a strong anti-Communist movement permeated American society. As historians of postwar Los Angeles document, "advocates of social reform risked being pilloried as agents of a foreign state," and Communist infiltration was commonly linked with "multicultural sensibilities."[56]

Much of the promise of wartime racial liberalism thus went unrealized in the postwar era as a direct result of Cold War politics. In Los Angeles, fueled by the passage of anti-Communist legislation on a national level, the U.S. Justice Department focused on potential "Communist sympathizers" who had participated in the local labor movement of the 1930s. Passed in 1947, the Taft-Hartley Act mandated non-Communist oaths from union leaders as a prerequisite for protection and representation from the National Labor Relations Board.[57] Such blatant efforts to destroy left-wing control of labor organizations inevitably took its toll, as progressive unions with large numbers of women and people of color, like the United Cannery, Agricultural, Packing and Allied Workers of America (UCAPAWA)/Food, Tobacco, Agricultural,

and Allied Workers of America (FTA), fell into disarray under the pressure of accusations of "un-American" activities. Wishing to distance itself from charges of Communist activity, the national Congress of Industrial Organizations (CIO) ultimately purged ten of its left-led unions, including the FTA, for alleged Communist domination.[58]

Members of the foreign-born population remained especially vulnerable to risks of red-baiting. In 1950, the Internal Security Act gave the federal government authority to deport aliens who admitted to, or were suspected of, having joined the Communist Party or an affiliated group.[59] Consequently, Luisa Moreno—labor organizer for UCAPAWA and founder of El Congreso— left for her native Guatemala in 1950 after the federal government issued a "warrant of deportation" for her based on charges that she had once belonged to the Communist Party.[60] Just two years later, the McCarran-Walter Act allowed for the "denaturalization" of any naturalized aliens found to have been Communist sympathizers at the time of their citizenship proceedings.[61] Both acts served to harass and intimidate left-leaning community organizers, part of a nationwide campaign that historian Zaragosa Vargas argues "stripped the Mexican American civil rights movement of its most capable activists."[62]

Operating within an environment of anti-Communist frenzy, organizations like the CSO not surprisingly found it politically prudent to detach themselves from more seemingly "radical" associations. CSO members sought to bolster their credentials by portraying community service work as an anti-Communist measure, arguing that "to drive out Communism we must strike at conditions which foster its growth."[63] The organization also distanced itself from otherwise likely allies such as Carey McWilliams, a progressive journalist and attorney, whose sympathy for Communists and fellow travelers simply made them too great a political risk. Testifying to the limitations of the "hyper 'all-American'" environment of the Cold War era, the CSO depended upon securing ties to other "safe" civil rights and reform organizations like the National Association for the Advancement of Colored People (NAACP) and the Jewish Community Relations Committee in order to reinforce its own reputation.[64]

Not all coalition-builders in the Los Angeles Mexican community went to such great lengths to distance themselves from the political milieu of the Left. Like the CSO, two postwar civil rights organizations in particular—the Asociación Nacional México-Americana (ANMA) and the Los Angeles Committee for Protection of Foreign Born (LACPFB)—relied upon, and provided significant leadership roles for, Mexican women. Both groups also remained committed to democratic ideals and formed community alliances across

ethnoracial divides. However, unlike the CSO's more cautious political approach, the organizations of ANMA and the LACPFB emerged within, and remained firmly grounded in, a strong left-wing tradition.

Founded in 1949 with the purpose of serving as "a national organization for the Mexican people," ANMA by 1950 boasted a membership of 4,000, consisting primarily of blue-collar workers and members of the International Mine, Mill, and Smelter Workers Union (Mine-Mill).[65] Mine-Mill and other Mexican American CIO leaders involved in the Independent Progressive Party's efforts to elect former vice president Henry Wallace to the presidency in 1948 intended for ANMA to function as labor's "political arm" on behalf of both Mexicans and Mexican Americans.[66] Given ANMA's strong union ties, thirty or more local chapters quickly emerged throughout the Midwest and Southwest, including Los Angeles.[67] In its day-to-day operations, ANMA's membership tended to gravitate toward a more radical political tradition, with some members finding the Communist Party to be "a militant and supportive ally in the struggle to achieve democratic rights."[68] Hopeful of broadening its progressive political base, the organization also made concerted efforts to reach out to fellow peoples of color, including African Americans, arguing that "the only way to win this fight is to have the closest unity with our strongest ally, the Negro people."[69] Thus in their search for the overall economic, social, and political advancement of the Mexican population, ANMA targeted a wide range of issues relevant to both Mexicans and other communities of color, including job discrimination, segregated housing, police brutality, and anti-immigrant legislation like the 1950 Internal Security Act. Strong supporters of the peace movement, members of the organization also vigorously opposed the Korean War.[70]

As leaders and organizers, Mexican American women played an instrumental role in advancing ANMA's civil rights platform. Many, like Francisca Flores, brought to the organization considerable experience in progressive political activism. Flores, a longtime community activist and former member of the Sleepy Lagoon Defense Committee, served as a founding delegate in the organization's first official meeting in Phoenix, Arizona, in 1949. She also coauthored one of the organization's first official publications, "Towards the Unity of the Mexican People," a pamphlet that articulated the Mexican population's long history of struggle and resistance and implored attendees at the founding national convention to embrace the "more mature social and political consciousness" afoot in the community.[71] Indeed, delegates at the convention resolved to integrate women into all levels of the organization, paving the way for Mexican American women to serve in high-profile positions in both national and regional

offices. Julia Luna Mount—a former cannery worker, UCAPAWA organizer, and wartime employee of Douglas Aircraft—served as secretary-treasurer of the Southern California regional office. Together with her sister, former cannery worker Celia Luna Rodríguez, she organized the Eastside chapter of ANMA; in 1952, Celia would be elected vice president of the national office.[72]

In their efforts to address the needs of Mexican nationals, ANMA members in Los Angeles would find common ground with another local, left-leaning organization, the Los Angeles Committee for Protection of Foreign Born. Founded in 1950, the LACPFB followed the principles of its national organization, the American Committee for Protection of Foreign Born, advocating for, and providing legal protection of, working-class immigrants threatened with deportation and/or denaturalization for political reasons. Amid the repressive climate of the Cold War, both ANMA and the LACPFB made pointed criticisms of the Internal Security and the McCarran-Walter Acts, arguing that the laws served in direct violation of the nation's founding democratic principles.[73] Their collective efforts on behalf of the foreign-born only became more relevant in 1954 when the U.S. Immigration and Naturalization Service (INS) officially launched "Operation Wetback," a federal campaign to deport undocumented Mexican immigrants living in the American Southwest. From 1953 to 1955, the INS apprehended 801,069 Mexican migrants, more than double the number of apprehensions made from 1947 to 1949.[74] As Josephine Yañez, executive secretary of the LACPFB's Eastside branch, explained, "The role of the immigration authorities—their dragnet operations wherein they swoop down upon fields, factories, and entire communities—is so well-known and feared in any Mexican American community that the word 'Los Federales' strikes terror not alone to the non-citizen but to Mexican American citizens of the first, second, and third generations."[75]

Throughout the 1950s, the LACPFB worked to reverse individual deportation orders and to raise public awareness about the prevalence of mass deportations. Members of the organization called press conferences, distributed brochures about recent deportation cases, and gathered signatures in an effort to see the McCarran-Walter Act repealed.[76] They also secured loans and assisted with bail for clients, in addition to providing legal and social support to potential deportees and their families.[77] Typically, LACPFB demands for justice drew upon class-based, multiracial appeals, portraying targeted deportees as "all-American" and connecting the shared racial histories of working-class communities. Indeed the LACPFB staff itself represented a diverse group of activists, including a number of Jewish and Mexican community members, some of whom were Communist or held close connections to Communists.[78]

Yet given their ties to the political Left, organizations that espoused ideals of racial liberalism earlier promoted by the federal government now faced active persecution by the state. Throughout the 1950s, ANMA and LACPFB members and supporters encountered frequent harassment. With hopes of listing ANMA as a security threat under the 1950 Internal Security Act, FBI agents engaged in extensive surveillance of the organization's membership; by 1951, the U.S. attorney general officially designated ANMA a subversive organization.[79] Activists involved in the LACPFB garnered similar suspicion. At the height of the Cold War hysteria, Irene Malagon, a former Douglas Aircraft riveter who wore a zoot suit during the war years, served as immigration aid director of the LACPFB, acting as an interpreter for those facing deportation and assisting them in addressing financial and other repercussions. As a result, in 1956 Malagon found herself called to testify before the House Un-American Activities Committee (HUAC), an investigative arm of the U.S. House of Representatives.[80] By the late 1940s and early 1950s, members of the committee had cast a wide net in their investigations of people and organizations suspected of Communist ties or leanings, holding widely publicized hearings across the nation in an effort to expose publically those under investigation. In Los Angeles, the LACPFB came under particular scrutiny for its ties to the American Committee for Protection of Foreign Born, an organization HUAC deemed "one of the most powerful . . . agencies of the Communist Party in the United States."[81]

Like many others, Irene Malagon demonstrated her political opposition to HUAC by refusing to serve as a cooperative witness. During her testimony at the Los Angeles hearings, HUAC members implored Malagon to admit to her work with the LACPFB, and to answer whether or not she was "a member of the Communist conspiracy." Refusing to respond to any questions, Malagon invoked her First and Fifth Amendment rights.[82] Fellow LACPFB activists, like Josephine Yañez, followed a similar strategy. As Yañez told the committee, "Where I have been employed is my affair. . . . I don't believe it is necessary to give you any information at all of any activities I may have had." Yañez further chided HUAC for its attempts to identify her attorney as a member of the Communist Party, behavior that she called "extremely shameful" and in violation of her "free right of choice of counsel." Ultimately, neither Malagon nor Yañez would be cajoled into testifying against themselves or others at the local HUAC hearings.[83]

Inevitably, the nation's obsession with domestic Communism took its toll on the Mexican American community. The LACPFB would continue its work on behalf of the Mexican community into the 1960s, although as politically

charged deportations declined with the completion of "Operation Wetback," so too did LACPFB activity. ANMA, on the other hand, would not be as fortunate. By 1954, the FBI reported no ANMA activities in cities like Los Angeles, Phoenix, San Francisco, or Albuquerque. Red-baiting and FBI infiltration, in addition to the political and social ramifications of mass deportations, simply proved too damaging for the organization to survive.[84]

In spite of the "un-American" connotations associated with ANMA and the LACPFB, Mexican women behind the organizations, like Irene Malagon, tended to understand their community activism in decidedly democratic and patriotic terms. In later years, Malagon recalled with fondness the fund-raising events sponsored by the LACPFB, in particular the Festival of Nationalities, a day-long occasion that celebrated the music, food, and traditions of a variety of ethnicities in Los Angeles.[85] Likewise, Malagon compared her work with the LACPFB to her labor on the wartime assembly line, as both positions represented "helping the people . . . helping your country. There was a purpose with these jobs," she stated. For Malagon, her time and energies spent on behalf of the community represented a clear indication of her support for American values and traditions. But amid the repressive Cold War climate, her efforts came to be understood as the antithesis of Americanism.[86]

Indeed, the loyalties of many women of Mexican descent were undoubtedly "American" in both their war effort participation and their promotion of democratic values postwar. Yet at the same time, it is clear that Mexican women tended to embrace a more complex view of what being "American" actually meant. Mexican women of the wartime generation were by and large not interested in erasing their heritage or identity, which had been the goal of Americanization efforts of earlier decades and some "Americans All" campaigns of the Second World War. Rather, through their lives, choices, and contributions, they implicitly offered a counterargument to Americanization, standing for the idea that they could identify with, support, and celebrate their Mexican heritage and community while still being loyal and productive Americans.

Mexican women would continue to reshape definitions of Americanism not only in their postwar activism but in the day-to-day decisions of their personal lives as well. Perhaps nowhere were the reverberations more intimately felt than in the cross-cultural encounters that resulted in marriages across color lines, a phenomenon that occurred with greater frequency for Mexican women in the years following the Second World War. Among the most influential of these love stories was that of Andrea Pérez—a Mexican American woman—and her African American fiancé, Sylvester Davis.

Pérez and Davis first met at Lockheed Aircraft during the early 1940s. Davis was one of the first black men to be hired to work in assembly at Lockheed's factory in Burbank, and, about a year later, Pérez secured a job at the same plant. Smitten at first glance, Davis volunteered to train Pérez on the job, and the two began to carpool to and from work together. Their friendship was briefly interrupted when Davis was drafted. But, after a year of duty, he returned to Los Angeles, and after a more serious courtship, in 1947 the two decided to wed.[87]

Although Pérez and Davis's courtship had all the markings of a typical "Good War romance," California law saw differently. Upon their decision to marry, Pérez and Davis visited the Los Angeles County Clerk to obtain a marriage license, only to have their request denied. The clerk rejected their application due to the California Civil Code's prohibition of "all marriages of white persons with Negroes, Mongolians, members of the Malay race [Filipinos], or mulattoes." By the clerk's estimation, Davis was Negro and Pérez was white.[88] Thus by law, their union in marriage would represent a clear violation of California's miscegenation statute.[89]

Pérez might easily have skirted the issue by stressing her "mixed" ancestry as a woman of Mexican descent, thereby calling into question her "whiteness." But in a decidedly political act, the couple applied for their marriage license with every intention of making their relationship a test case regarding the constitutionality of antimiscegenation law in general. In the 1948 landmark case *Perez v. Sharp*, the California Supreme Court ruled in favor of Pérez and Davis, striking down the state's antimiscegenation law as a violation of the equal protection clause of the Fourteenth Amendment. Interestingly, in trying the case before the court, their lawyer, civil rights advocate Dan Marshall—a family friend of Pérez and member of the Catholic Interracial Council—initially made no explicit attempts to challenge the racial categories that the Los Angeles County marriage license bureau had applied to his client. Rather, he hinged his argument on the fact that both Pérez and Davis belonged to the Catholic Church—an institution that did not explicitly prohibit interracial marriage—and thus the denial of their right to marry represented an unconstitutional infringement on their right to religious freedom. Roger Traynor—a junior justice on the court—saw things differently, however. Heavily influenced by social scientists like Franz Boas and Gunnar Myrdal, Justice Traynor shifted the conversation in a direction that explicitly questioned the very legitimacy of racial classification. Ultimately, in questioning the very nature of race itself, Traynor led the court to a 4–3 decision in favor of Pérez—the first case of the twentieth century to overturn a state miscegenation law.[90]

Unfortunately for Pérez and Davis, the social turmoil caused by their relationship continued despite their court victory. Andrea Pérez's parents—particularly her father—had long condemned her relationship with a black man and thus refused to attend the 7 May 1949 wedding. In fact, not until the birth of their granddaughter did Andrea's parents reluctantly reconcile with their daughter and her husband. Regardless of the continued familial resistance to the couple's relationship, however, the marriage of Pérez and Davis points to a fundamentally changed climate of opinion made possible by the Second World War. Not only had Pérez and Davis met because the war had opened up new spaces for intercultural and interracial contact, but, in the words of historian Peggy Pascoe, ultimately they made a successful challenge to Jim Crow due to the fact that "the way Americans conceived of the relationship between race and American democracy was beginning to change," at least when it came to intimate relationships.[91] In light of discredited theories of biological racism, in addition to the wartime celebration of American pluralism, a door had opened for increasing acceptance of intercultural and interracial marriage.[92]

For Mexican American women like Ida Escobedo, the *Perez* ruling had profound personal implications. At the end of World War II, Ida and her sister Ernestine both started dating African American men after attending a multiracial social affair for the American Youth for Democracy, a progressive Los Angeles civil rights organization. After months of courtship, Ernestine's boyfriend, John, proposed, and the two decided to marry in spite of California's antimiscegenation law and the fact that Ernestine's mother knew nothing of her relationship. The day finally came when Ernestine and Ida nervously finished up their household chores, not saying a word to anyone in the family about their plans to make the four-hour drive to Yuma, Arizona, known for its laxity in enforcing miscegenation restrictions, in order for Ernestine and John to elope. In the end, the plan went off without a hitch, apart from the fact that it was weeks before Ernestine mustered up enough courage to tell her family that she had married an African American man. Ida recalled her family's reaction to the news with regret, painfully recounting how her mother cursed Ernestine in Spanish, claiming that "as far as she was concerned, she had cast the first fist of dirt on Ernie's grave."[93] So aggrieved by Ernestine's actions, Josephine Escobedo declared her daughter dead in her eyes.

Ida remained particularly distressed by these events because she, too, had hoped to marry her African American boyfriend. And thus when she heard word of the *Perez* decision in 1948, she felt a profound sense of relief—her actions might be condemned by her mother and brothers, but at least her

interracial marriage would be recognized in the eyes of California law. On the heels of the *Perez* ruling, Ida and Wilbert Winston married in his parents' home in Los Angeles. As was the case with Pérez, Ida's mother and immediate family did not attend the ceremony. Not until Ida and Ernie attended their brother's funeral in 1950 did the Escobedo sisters see their family members again; even then, it would take the passage of a good amount of time for the family to reconcile and set aside their differences.[94]

In spite of the experiences of Andrea Pérez and the Escobedo sisters, marriages between Mexican women and African American men were rare. According to one study, between 1948 and 1951—the three years directly following the *Perez* ruling—just thirty-two marriages took place between "Mexicans" and "Negroes" in Los Angeles.[95] However, given that an earlier intermarriage study of Los Angeles found that only 1 of the total 11,016 marriages in the Mexican community from 1924 to 1933 involved a "Negro," the increase in post–World War II marital relationships between Mexicans and African Americans seems notable.[96]

Given shifting racial boundaries, Mexican American women of the World War II generation experienced vastly different choices about life partners than those available to their immigrant parents. By 1950, Mexicans were more likely to marry native- and foreign-born whites, in addition to blacks and Filipinos and other Asians than just a decade before.[97] In part this trend can be attributed to the nullification of California's miscegenation law—which had disallowed "whites" from marrying not just blacks but Asians as well.[98] But increases in intermarriage can also be attributed to Mexican American women's increased relations with non-Mexican men, including relationships that developed during, and simply outlasted, World War II. Studies of marriage records in Los Angeles County document the intermarriage trend more broadly: between the years of 1924 and 1933, 17 percent of the marriages of Mexicans occurred outside of their group; by 1963, 40 percent of Mexican marriages in Los Angeles were exogamous, a near doubling over the roughly thirty year period.[99] In my own interview sample, 70 percent married men of Mexican descent while 20 percent married Euro-Americans; the remaining 10 percent married African American men or wed more than once to either Mexican American and Euro-American men or African American and Euro-American men. Falling in step with more general trends of postwar marriage, the vast majority of my interviewees' unions took place in the rush of marriages that occurred in the United States following the end of the Second World War.[100]

Thus even amid familial and cultural reservations, Mexican women continued to pursue individual desires in the postwar era, particularly in regard

to romance and marriage. As historian Vicki Ruiz points out, chaperonage became more of a "generational marker" by the 1950s, with "typically only the daughters of recent immigrants ha[ving] to contend with constant supervision."[101] According to one postwar study, by 1947 the practice of Mexican families rearing "protected and cloistered" daughters and sisters had subsided significantly, as evidenced by the number of Mexican American women going "stag" to social affairs.[102] The desire of family members to dictate the social activities of daughters and sisters certainly remained no less strong; yet, as Ruiz notes, chaperonage as a "method of social control" had proven unsuccessful.[103]

Not only did chaperonage become a relic of the past, but women of Mexican descent pursued multiracial relationships with more frequency. Motivations, not surprisingly, varied considerably from one individual to another. Reflecting on her decision to wed an Irishman, Rose Echeverría Mulligan admitted to worrying about the possibility of facing a lifetime of discrimination if she chose a Mexican partner. As she described it, there was the fear that, given the racism of the time, "perhaps we didn't have a future as Mexicans." As such, her impulse to intermarry proved strong.[104] Others described their intercultural and interracial crossings as a rebellion against the rigid control of their family upbringing. Prior to meeting Wilbert Winston, Ida Escobedo had turned down the marriage proposal of a Jewish coworker, largely because his sisters had made it clear that they did not like the idea of their brother marrying a Mexican. Yet Ida longed to be out from under the thumb of her mother and brothers, and thus when another suitor—Winston—proposed, she saw it as "an escape." Not only was Winston "a very good person" whose family was relatively accepting of her, but he had a 1947 Buick that the two would ride around town in together. Winston offered Escobedo a type of freedom she had yet to know, and she embraced it.[105]

More often than not, however, Mexican American women chose to intermarry simply because they shared like interests with their prospective husbands, no matter their background. According to Hope Mendoza, marrying Harvey Schechter, a Jewish activist with the Anti-Defamation League, seemed a natural choice given her own life's passions. The couple met when Schechter—then a UCLA graduate student writing his thesis on the ILGWU—began shadowing Mendoza in her day-to-day labor organizing efforts. Because Schechter ran in similar progressive circles and was "so active in the community," Mendoza "ended up signing him up for life."[106] Likewise, Mimi Lozano met her Jewish husband in a UCLA graduate class in 1955. Mimi wished to be a playground director; her soon-to-be husband, a physical education

major just out of the army, was pursuing his teaching credential. As Mimi described it, "I socialized with my classmates, but there weren't that many Mexicans at UCLA at that time." In spite of his family's initial resistance to their relationship, the couple prioritized their common interests and married shortly thereafter.[107]

New social and cultural encounters thus provided opportunities for Mexican American women to practice a more heterogeneous womanhood in the postwar era. Yet even as women of Mexican descent intermarried in greater numbers, their choices in partners did not necessarily reflect a decision to assimilate. Many, like Ida Escobedo, maintained a sense of pride in their heritage, and taught their children to do the same.[108] Others, like Hope Mendoza Schechter, remained politically active on behalf of the Mexican community for much of the twentieth century.[109] As historian Margie Brown-Coronel notes, rather than posing a threat to the preservation of Mexican culture, those "Latinas in the twentieth century who intermarried demonstrated that cultural coalescence remained a dynamic force."[110]

In their public and private lives, then, Mexican women shaped 1950s womanhood in unique ways. As their middle-class white counterparts became forever immortalized in popular culture for their heightened femininity, attention to domesticity, and role as helpmates in the anti-Communist cause, Mexican women tended to forge a unique path.[111] True, many "pachucas" and "Rosita the Riveters" more often than not hung up their zoot suits—literally and figuratively—making the choice to marry, settle down, and raise families alongside the rest of the World War II generation. Indeed, the zoot suit style tended to fall out of both style and disfavor in the 1950s as those youths who had worn zoot suits grew into adulthood, jazz moved from swing to bebop, and the Los Angeles populace increasingly focused on the anti-Communist cause.[112] And yet in spite of some growing similarities with Euro-American wives and mothers, as women of color, Mexican American women found that their lives were defined as much by continued discrimination as they were by a drive to remedy injustices.

In the end, many Mexican American former Rosies would not have considered themselves to be political activists in the strictest sense of the word, as women like Hope Mendoza Schechter were an exception. In fact, when I first began searching for women to interview for this project, most of them humbly stated that I would be better off interviewing someone else, as their wartime experiences were nothing out of the ordinary. Of course once the tape started rolling, and their stories began to flow off their tongues, it became clear that nothing could be further from the truth. In both their public

and private daily lives, Mexican American women of the wartime generation found creative ways to navigate the opportunities and limitations of the Second World War and its aftermath. Given their participation in the war, many felt a greater sense of belonging, of their place as American citizens, and of the need to challenge exclusion in the everyday. As such, their lives represent the personal acts that contribute to a community's struggle for civil rights, the individual shifts in social relations that happen in the day-to-day, at times with wide-ranging impact.

EPILOGUE

In October of 2007, filmmaker Ken Burns released *The War*, a fifteen-hour documentary on World War II, amid a firestorm of controversy. During the film's initial screenings in late 2006, it had become clear to the Latina/o community that their war stories would not be included in the publically funded PBS series, an omission that quickly prompted a groundswell of protest nationwide. Burns and his production team had spent nearly six years interviewing over 600 individuals from four American towns—Waterbury, Connecticut; Mobile, Alabama; Sacramento, California; and Luverne, Minnesota—with the intended purpose of capturing the "intimate" wartime stories of each community's citizenry, both at home and abroad. Yet for all of its attention to geographical diversity, and much to the indignation of the Latina/o population, the initial film made not a single reference to the contributions and unique experiences of military personnel and defense workers of Latina/o descent.[1]

As evidence of their growing discontent, Latina/o academics, public officials, journalists, and members of the "Greatest Generation" aired their grievances in news outlets and a letter-writing campaign aimed at both Ken Burns and PBS. While PBS officials touted *The War* as a documentary meant "to reach into every home and classroom—so together we can better understand what we as a nation accomplished," grassroots organizers affiliated with the newly formed Defend the Honor campaign called attention to the film's rather narrow national vision of "we." As Frederick P. Aguirre, cofounder of Latino Advocates for Education, Inc., wrote to Burns on 31 January 2007: "Given the fact that Hispanic Americans are now the largest ethnic minority group in our nation . . . that historically Latinos have been subjected to second-class citizenship in our country but have patriotically served in every war that we have fought, and to promote PBS's mission, it is proper and fitting that the Mexican American experience be documented and included in 'The War.'"[2]

Initial attempts to justify the content of the documentary relied by and large on a defense of artistic freedom. Hoping to quell the growing controversy, Burns and PBS officials proclaimed that *The War* was simply one story that this particular filmmaker wished to tell, and thus was not meant to be considered a comprehensive history. Writing in response to a letter of protest from the National Association of Hispanic Journalists, Lea Sloan, vice president of communications for PBS, explained that "millions of stories are not explored in the film, which is not, and never was intended to be, the definitive history of the Second World War."[3] Likewise, Burns expressed his own personal frustrations over the debate by appealing to the principle of artistic license: "If I want to paint a bowl of fruit and I just don't happen to put a mango in it, I'm not saying anything bad about mangos. It's just my vision," he stated.[4]

Critics, on the other hand, called the omission of Latina/os curious, especially because the series did not shy away from addressing the diversity of the World War II experience in regard to African Americans and Japanese Americans. In fact, the film remained quite attuned to the many racial ironies of the Second World War, documenting how the United States fought for a free world abroad with a segregated military and internment camps for its Japanese population at home. Yet when asked about the documentary's comparative inattention to Latinos, film adviser and military historian Roger Spiller stated simply that "Hispanics had a war that looked more or less like everyone else's in the majority." As Spiller explained, "During the war, the armed forces had no classification for Hispanic personnel; they were simply counted under the 'White' category. Hispanics weren't singled out, so we didn't single them out either."[5]

In contrast to Spiller's categorization of the Latino wartime experience as universal, those who protested the film did so by calling attention to the Latino community's distinctiveness. Supporters of the Defend the Honor campaign pointed to the half a million Latinos who served in World War II, earning more medals of honor (thirteen) in relation to their population than any other ethnic group. They highlighted the hundreds of thousands of Latinas that demonstrated their patriotism and increased their earning power on home front assembly lines, in addition to the 200,000 Mexicans that made the decision to emigrate to the United States in order to labor in agricultural fields as braceros.[6] Perhaps most importantly, Latino members of the "Greatest Generation" called attention to the contradictory nature of their wartime experiences. For many, the conflict represented one of the first moments when they felt a sense of belonging in the United States. "I always think

of World War II as being the moment in history when the Latino American became acceptable as a full-fledged American," said Bill Lansford, a Mexican American and former World War II marine from East Los Angeles. "It's very hard to look at the guy in the foxhole and say, 'Oh, he's a Mexican.' That was the watershed; that was the turning point for Latinos. When we came out of the war, we knew that we were Americans."[7] Yet in spite of their newfound connection to the nation, Latina/o veterans and defense workers by war's end would still face an America where segregated schools, housing, and public places defined their daily lives. Given their wartime sacrifices, former veterans and defense workers felt imbued with a new sense of confidence and entitlement to their right to equal treatment, an outlook that would contribute to continued civil rights activism in the postwar era.[8]

Ultimately, voices of opposition did prove somewhat influential. In April of 2007, PBS made the announcement that Burns had decided to reconsider his approach. According to PBS officials, series producers of The War would hire Hector Galán, a Chicano documentary filmmaker, to oversee new segments featuring Latino soldiers. Questions remained, however, as to how the additional material would be included in the series.[9] In the end, the production team added twenty-eight minutes of new interviews and photographs to the film, excerpts that focused specifically on the stories of two Latino marines and one Native American serviceman.[10]

For many Latina/os, however, Burns's capitulation was too little, too late. Burns chose not to reconceptualize the project in light of the additional footage; rather, the new interviews with Latino servicemen were added on to the ends of two separate episodes in the series, never fully integrated into the original film. Moreover, the accompanying book, The War: An Intimate History, 1941–1945, contained no mention of Latina/o contributions to the Second World War. According to Raul Yzaguirre, a professor at the Center for Community Development and Civil Rights at Arizona State University, The War erred most significantly in its depiction of Latinos as "sidebars" to history.[11]

At the very least, the controversy surrounding Ken Burns and The War provided the American public with a rather eye-opening awareness of the ways in which we typically teach and think about history. Sacramento, one of the four American towns featured in The War, had been home to a small but vibrant Mexican community since the early twentieth century.[12] Here, hundreds of Mexican families settled and found employment in agriculture, railroad yards, and local canneries, jobs made even more readily available by federal restrictions that imposed limits on Southern and Eastern European

immigration and barred Asian immigration entirely in 1924. By the Second World War, Sacramento's Mexican population had increased dramatically, with members of the community serving in the armed services abroad and in war industries on the home front. The Bracero Program brought hundreds of Mexicans north to work at the Southern Pacific railroad yards, while Mexicans comprised up to 40–50 percent of all wartime employment in Sacramento canneries.[13] Notably, Burns's film includes a still photograph of war workers in one such cannery—the Pacific Fruit Express—where workers on 6 June 1944 bowed their heads in a moment of prayer, an effort to wish a safe homecoming for 100 former employees now in the armed forces.[14] Yet nowhere in the narration is it mentioned that Mexican women and men made up the lion's share of this patriotic workforce.

In rendering the wartime lives of Mexicans invisible, Burns missed an important opportunity to expand our nation's knowledge of Latino history and to allow for a richer national dialogue on issues surrounding race. Simply equating the home front and battlefield experiences of Latina/os to those of Euro-Americans is not an adequate reflection of the unique racial position occupied by Latina/o groups like Mexican Americans in the mid-twentieth century. As members of an "in-between" racial population, Mexican Americans encountered numerous improvements in social status and race relations during the Second World War, and yet racial barriers by no means disappeared. Overlooking or generalizing these historical experiences fundamentally misrepresents the many complexities of our country's racial past, and thus the collective history of all Americans.

Amid a political climate that too often perpetuates notions of Mexican Americans as newcomers or outsiders in the United States, it remains all the more important to understand the long-standing participation of Latina/os in key moments of national formation. Burns himself seemed all too aware of these larger political ramifications during a 2007 interview with *Time*, where he attributed the "defensive posture on the part of Hispanics" to present-day anti-immigrant rhetoric from pundits like "Pat Buchanan saying 'they're propagating faster than us and there will be more of them soon.'" Yet in further elaborating his position, Burns declared that "Hispanics" simply represented the latest in a long line of immigrant groups to be reviled in the United States. "Every 30 years in the history of our country an immigrant group—first it was the Irish, then the Germans—became the villain," Burns stated. "And in 30 years we'll be talking about the new immigrant group from Mars that's not getting their due." Thus even in a potentially well-meaning attempt to demonstrate himself "an ally of [Hispanic] sympathies," Burns still

significantly misrepresented the overall historical experience of the Latina/o community.[15] Comparing the present-day Latina/o community to earlier waves of immigrants only serves to reify stereotypes of Mexican Americans as foreigners or recent arrivals. Given our shared border, the United States will always be home to new immigrants from Mexico, immigrants that benefit their new country in countless ways. And yet just as important to this national story is the long-standing presence of American-born Latina/os and their many significant contributions to the United States.

Recognizing the long-standing history of the Latina/o population, it is all the more important for future students of history to be made aware that *their* ancestors made significant contributions to the United States. Mexican Americans who came of age during the wartime era appeared particularly aggrieved by Burns's portrayal of the Second World War, largely because they take great pride in their wartime experiences and wish for future generations to be made aware of their contributions. In the wake of the Burns controversy, veteran Francisco Vega sent a letter to *San Antonio Express-News* columnist Carlos Guerra, proudly detailing his volunteer enlistment in the U.S. Army in 1942 and subsequent participation in both the D-Day assault landing on the beaches of Normandy and the Battle of the Bulge months later. In an effort to combat "the ignorance and apparent bias to the works done by Ken Burns," Vega implored Guerra to help spread awareness of the many Latina/o war stories like his own, stories that "should be recorded for posterity to help in the education of our general population[,] and the Mexican population in particular[,] as to the service to [the] country that we have performed."[16] Likewise, Bill Lansford, one of two Latino marines ultimately featured in *The War*, explained to a *Los Angeles Times* reporter that his long-standing dream of erecting a monument in Los Angeles to pay tribute to the nation's forty Latino Congressional Medal of Honor recipients, in addition to his desire "to obviate [the] earlier omission" by Burns, compelled him to be interviewed for the film, even as he found it painful to discuss his memories of Guadalcanal and Iwo Jima. According to Lansford, his efforts to bring attention to those Latinos who served valiantly in World War II "[haven't] been about pride or conceit." "We're not Mexicans, we're not Puerto Ricans, we don't belong to the Old Country," said Lansford. "The simple reason is that we wanted people to know that if our country was in danger we were prepared to defend her. And that we're Americans and nothing else."[17] Even for those individuals of the World War II era who did not serve on battlefields abroad, the issue of proper representation of Latina/os in history remains significant. As Mimi Lozano, a Mexican American woman who came of age during the Second World War,

stated in an editorial critical of Burns's series, "We must make a change . . . our kids need to see themselves in the picture of America!"[18] Indeed, as this generation tells us, Latino history is not a subset of U.S. history; rather, it represents a lens through which we can tell a richer and more accurate story about key moments in our national consciousness, providing future generations with a sense of cultural pride and belonging.

Perhaps the most important lesson to be learned from the Burns controversy is the fact that if we don't tell history in a way that makes the stories of previously overlooked populations visible, these stories are forever lost. Nothing made me more aware of this reality than my work on *From Coveralls to Zoot Suits*. I first began interviewing Mexican American women for this project more than ten years ago, and most have long since passed away. As relatives reached out to tell me of their loved one's passing, and my letters were returned with a postmaster stamp that simply read "deceased," I became all too aware of the sheer magnitude of experience and knowledge that had been lost along with them.

For these reasons it is important to listen to the unique stories of the Latina/o wartime generation. U.S. history *is* Ida Escobedo choosing to wear the controversial zoot suit; Beatrice Morales taking a riveting job at Lockheed, in spite of her husband's protestations; and Andrea Pérez having the courage to agree to use her marriage as an opportunity to advance racial equality. It is about the everyday experiences of women like Ernestine Escobedo, Irene Malagon, Connie Velarde, and Hope Mendoza—a generation of women from a historically marginalized community who rose to the extraordinary challenges of serving their nation during the Second World War, and did so with determination and dignity. In so doing, they saw changes not only within themselves but within their families and communities. They remained proud of what they had accomplished and shared their stories with enthusiasm and good cheer. For all of their hopes, struggles, failures, and triumphs, ours is a richer history.

NOTES

ABBREVIATIONS USED IN THE NOTES

FEPC Records Records of the Committee on Fair Employment Practice, Record Group 228, National Archives and Records Administration, College Park, Md.

Galarza Papers Ernesto Galarza Papers, Stanford University, Special Collections, Manuscripts Division

IPUMS Integrated Public Use Microdata Series

McWilliams Papers Carey McWilliams Papers 1243, University of California at Los Angeles, Special Collections, Charles E. Young Research Library

NARA National Archives and Records Administration

OCIAA Records Records of the Office of Inter-American Affairs, Record Group 229, National Archives and Records Administration, College Park, Md.

OWI Records Records of the Office of War Information, Record Group 208, National Archives and Records Administration, College Park, Md.

Region XII FEPC Records Records of the Committee on Fair Employment Practice, Record Group 228, National Archives and Records Administration, San Bruno, Calif.

Region XII WMC Records Records of the War Manpower Commission, Record Group 211, National Archives and Records Administration, San Bruno, Calif.

Rosie the Riveter Project Rosie the Riveter Revisited Oral History Project, Special Collections, California State University, Long Beach

Ruiz Papers Manuel Ruiz Papers, Stanford University, Special Collections, Manuscripts Division

SLDC Records	Sleepy Lagoon Defense Committee Records, University of California at Los Angeles, Special Collections, Charles E. Young Research Library
VOAHA	Virtual Oral/Aural History Archive, California State University, Long Beach
Warren Papers	Earl Warren Papers, California State Archives, Sacramento, Calif.
YWCA Collection	Young Women's Christian Association of Los Angeles Collection, California State University, Northridge, Urban Archives Center

INTRODUCTION

1 Gonzáles Bernal, interview; Gonzáles Benavidez, interview, 6 November 2000. When applicable, throughout the text of this study I use the maiden, Spanish surnames of the women interviewed, even though many have married since World War II. I provide the married names of the interviewees within the notes.

2 Gonzáles Bernal, interview.

3 Escobedo Atterbury, interview, 6 January 1998; Escobedo Burdette, interview.

4 Escobedo Atterbury, interview, 6 January 1998; Escobedo Atterbury, interview, 30 November 2010. As this study demonstrates, the labels "pachuca/o" and "zoot suiter" were contested terms that carried different meanings during the World War II era, largely dependent on who applied the label, to whom, and when they did so. More often than not, wartime critics of the zoot subculture—including Los Angeles authorities and major metropolitan newspapers—utilized the labels in a pejorative manner. In spite of the negative connotations originally associated with such labels, much scholarship has tended to utilize terms like "pachuca/o," "zoot suiter," and "zooter" liberally, whether or not the young men and women being studied would have specifically identified themselves as such. Using imposed terms that are not necessarily self-referents is admittedly problematic. Yet for the sake of narrative flow, I have opted at times to employ the terms "zoot suiter" and/or "pachuca/o" to refer collectively to those Mexican Americans who participated in zoot culture in some way. This being said, throughout the text I do take care to try to refer to individuals in a way in which they would have self-identified. Additionally, I explore the many complexities of both the "pachuca" and "zoot suiter" labels in the wartime context, highlighting the various manifestations of identity associated with these referents. For examples of the range of ways in which the terminology "pachuca/o" and "zoot suiter" can be employed and understood, see Ramírez, *Woman in the Zoot Suit*, xxv–xxvi; Alvarez, *Power of the Zoot*, 249–50 n. 25; and Pagán, *Murder at the Sleepy Lagoon*, 230.

5 In this study I use the term "Mexican" as an umbrella term to describe the Mexican-origin population in Los Angeles, either first or second generation. When a more

specific distinction needs to be made, I utilize the term "Mexican American" to describe people of Mexican heritage born in the United States and "Mexican immigrant" or "Mexican parents" to refer to individuals born in, and maintaining citizenship in, Mexico. I have also chosen to utilize the terms "Anglo," "white," and "Euro-American" to refer to non-Mexican whites. Mexican American women frequently utilized the former two terms in their reflections on the wartime home front, while "Euro-American" attempts to convey the diverse "white" population of Los Angeles during the World War II years.

6 See, for example, Kryder, *Divided Arsenal*; Gerstle, *American Crucible*; Leonard, *Battle for Los Angeles*. One exception is Takaki, *Double Victory*.

7 See, for example, Guglielmo, "Fighting for Caucasian Rights"; Griswold del Castillo, *World War II and Mexican American Civil Rights*; Zamora, *Claiming Rights and Righting Wrongs in Texas*; Vargas, *Labor Rights Are Civil Rights*; Ramos, *American GI Forum*; García, *Mexican Americans*.

8 Examples include Shockley, *"We, Too, Are Americans"*; Lemke-Santangelo, *Abiding Courage*; Anderson, *Wartime Women*; Campbell, *Women at War with America*. An exception can be found in the work of Sherna Berger Gluck, who includes Mexican American women's testimonies in her collection of oral histories of women war workers. See Gluck, *Rosie the Riveter Revisited*. Similarly, two studies have utilized oral histories to shed light on the World War II workplace experiences of "Rosita the Riveter," and yet these works do not address race in a comparative context. See Quiñonez, "Rosita the Riveter," and Santillán, "Rosita the Riveter."

9 Ramírez, *Woman in the Zoot Suit*; Alvarez, *Power of the Zoot*; Pagán, *Murder at the Sleepy Lagoon*. Ramírez uses the phrase "constitutive other." See Ramírez, *Woman in the Zoot Suit*, 9.

10 This study is indebted to Vicki Ruiz's rich discussion of the ways in which second-generation women of Mexican descent developed distinctly Mexican American identities based on their participation in female work cultures, consumerism, and challenges to patriarchal relationships in the early twentieth century. See Ruiz, *From Out of the Shadows* and *Cannery Women*. Ruiz explains "cultural coalescence" in *From Out of the Shadows*, xvi, 67. Monica Perales also deftly utilizes the concept in her discussion of Mexican American womanhood in South Texas during the first half of the twentieth century. See Perales, *Smeltertown*, 14–15, 185–222.

11 Ruiz, *From Out of the Shadows*, 51–71.

12 Barrera, *Race and Class in the Southwest*, 136; Romo, *East Los Angeles*, 118; Sánchez, *Becoming Mexican American*, 202.

13 "Some Notes on the Mexican Population in Los Angeles County," December 1941, Prepared by the Information Division, Los Angeles County Coordinating Councils, WPA Project 11887, Box 4, Folder 10, Mexican Minority in Los Angeles, SLDC Records; "Testimony of Carey McWilliams, Chief, Division of Immigration and Housing, Department of Industrial Relations, State of California, Before the Los Angeles County Grand Jury, 8 October 1942," attached to letter from Carey McWilliams to Katharine F. Lenroot, chief of the Children's Bureau, 13 October 1942, Central File,

1941–1944, 0-2-9-3 to 0-2-9-6-5, Box 36, Folder "Mexicans," RG 102, Records of the Children's Bureau, NARA.

14 Balderrama and Rodríguez, *Decade of Betrayal*, 67, 151.

15 Sánchez, *Becoming Mexican American*, 314 n. 3.

16 U.S. Bureau of the Census, *Population of Spanish Mother Tongue*, 3; Sánchez, *Becoming Mexican American*, 228.

17 Sánchez, *Becoming Mexican American*, 209–69.

18 For scholarship on Mexican American women and their involvement in political activities in California, see Ruiz, *Cannery Women* and *From Out of the Shadows*. Other titles that provide discussions of Mexican American women's activism in California include Vargas, *Labor Rights Are Civil Rights*; Alamillo, *Making Lemonade Out of Lemons*; and Sánchez, *Becoming Mexican American*.

19 Quotation found in Boris, "'You Wouldn't Want One of 'Em Dancing with Your Wife,'" 98. On race and liberalism, see Brilliant, *Color of America Has Changed*; Horton, *Race and the Making of American Liberalism*; Jackson, *Gunnar Myrdal and America's Conscience*; and Kellogg, "Civil Rights Consciousness in the 1940s."

20 Sides, *L.A. City Limits*, 37.

21 Verge, "Impact of the Second World War on Los Angeles," 237–38.

22 Sides, *L.A. City Limits*, 37.

23 Although historically the undercounting of poor and ethnic and racial populations has always been a problem, according to the U.S. Census, by 1930 the nonwhite population in Los Angeles numbered the following: Mexican population, 97,000; African American population, 39,000; Japanese population, 21,000; and Chinese population, between 2,000 and 3,000. See Sánchez, *Becoming Mexican American*, 90–91; and Leonard, *Battle for Los Angeles*, 6–7.

24 For discussion of the Los Angeles Japanese American community and internment during World War II, see, for example, Kurashige, *Shifting Grounds of Race*.

25 Gregory, *American Exodus*, 174; Vargas, *Labor Rights Are Civil Rights*, 224.

26 Verge, "Impact of the Second World War on Los Angeles," 244; Sides, *L.A. City Limits*, 43. According to census data, African Americans made up approximately 2.6 percent of the Los Angeles and Orange County populations in 1940 and 4.9 percent in 1950. Many of the demographic calculations in this study rely on census figures compiled from the Integrated Public Use Microdata Series developed by historians at the University of Minnesota in cooperation with the Census Bureau. Unless otherwise noted, these are a weighted 1 percent sampling of individual households in Los Angeles and Orange Counties taken from each census except 1930. As samples, they are of course subject to some degree of error, including the undercounting of poorer immigrant populations and participant omissions and/or inaccuracies. Additionally, a Spanish-surnamed female marrying a Euro-American will show up as non-Hispanic in the sampling, while not all Spanish surnames recognized by the database can be perfectly identified as Mexican. In using this data, I have defined the "Mexican descent" population as anyone with a Spanish surname or born in Mexico or having at least one parent who was born in Mexico. Labor force statistics include women fourteen

years of age and older. See http://www.ipums.umn.edu/ for more information. My sincere gratitude to Jim Gregory for introducing me to these sources and for helping me navigate them.

27 McWilliams, *Southern California Country*, 372.

28 Nash, *American West Transformed*, 62–63; Pagán, *Murder at the Sleepy Lagoon*, 145–48.

29 For discussion of the Zoot Suit Riots of 1943, see Pagán, *Murder at the Sleepy Lagoon*; Alvarez, *Power of the Zoot*; Escobar, *Race, Police, and the Making of a Political Identity*; and Mazón, *Zoot-Suit Riots*.

30 Boris, "'You Wouldn't Want One of 'Em Dancing with Your Wife,'" 79.

31 Ramírez, *Woman in the Zoot Suit*, xii, 56.

32 For discussion of the historically "in-between" racial status of Mexicans, see Foley, "Partly Colored or Other White"; and Pascoe, *What Comes Naturally*, 121–23. Historian Charlotte Brooks makes a similar observation regarding Japanese Americans in World War II Chicago, arguing that most Chicagoans "came to see Japanese Americans as occupying an inbetween position in the city's racial hierarchy—a position lacking easy definition." See Brooks, "In the Twilight Zone between Black and White," 1656. Scholars that explore the feminine ideals and archetypes predominating World War II discourse include Ramírez, *Woman in the Zoot Suit*, 64–68; Winchell, *Good Girls*, 44–75; and Honey, *Creating Rosie the Riveter*.

33 For a discussion of the utilization of black women as symbols of both racial progress and decline, see, for example, Craig, *Ain't I a Beauty Queen?*.

34 Escobedo Atterbury, interview, 6 January 1998.

35 Ruiz, *From Out of the Shadows, xiii*.

36 Mendoza Schechter, interview.

CHAPTER ONE

1 "Brass Knuckles Found on Woman 'Zoot Suiter,'" *Los Angeles Times*, 10 June 1943, A.

2 Ibid.; *People v. Amelia Venegas*, Los Angeles County Superior Court, case number 93615, 1943, Los Angeles Superior Court Archives and Records Center. Venegas is deemed a "pachuco" in Watson, "Zoot Suit, Mexican Style," 10. Interestingly, in spite of how Venegas is labeled, neither the court nor the press made mention of the young woman ever actually wearing a zoot suit. Likewise, as Catherine Ramírez observes, newspaper photographs do not show her wearing "identifying features of the pachuca look in wartime Los Angeles." Ramírez, *Woman in the Zoot Suit*, 83.

3 For an excellent study of the pachuca's fashion style and representation, see Ramírez, *Woman in the Zoot Suit*. Further descriptions of pachucas include Bogardus, "Gangs of Mexican-American Youth," 56; Adler, "1943 Zoot Suit Riots," 152; Griffith, *American Me*, 47; and McWilliams, *North from Mexico*, 219.

4 In utilizing juvenile court records to discuss the pachuca phenomenon, I do not mean to equate being "pachuca" with being delinquent. Rather, as I hope to demonstrate, the term "pachuca" held multiple and at times contradictory meanings during World

War II, both inside and outside the juvenile justice system. As historical sources, juvenile court records remain valuable yet limited in their ability to shed light on the pachuca phenomenon. On the one hand, the files tell only those stories of women in conflict with the law and thus provide perspectives that are by and large mediated by unsympathetic outsiders. But given the paucity of primary sources on Mexican American women who adopted aspects of the pachuca identity—or were deemed "pachuca" by others—juvenile files can provide important insights into the ways in which so-called pachucas were conceived of and treated by parents and law enforcement, in addition to the ways in which the young women defined and thought of themselves, especially as they tried to articulate and defend their circumstances to court officials.

5 For in-depth discussion of Mexican American zoot-clad youth and zoot culture in wartime Los Angeles, see Alvarez, *Power of the Zoot*; Escobar, *Race, Police, and the Making of a Political Identity*; Pagán, *Murder at the Sleepy Lagoon*; Macías, *Mexican American Mojo*. Pagán and Alvarez document the zoot subculture among working-class African Americans, Asian Americans, and Euro-Americans as well.

6 Pagán, *Murder at the Sleepy Lagoon*, 11, 39, 108; Alvarez, *Power of the Zoot*, 83–84.

7 Pagán, *Murder at the Sleepy Lagoon*, 19–20; Alvarez, *Power of the Zoot*, 94.

8 Alvarez, *Power of the Zoot*, 18.

9 Ibid., 96.

10 Cosgrove, "Zoot-Suit and Style Warfare."

11 Alvarez, *Power of the Zoot*, 44.

12 Los Angeles passed a curfew ordinance in 1942 that prohibited anyone under seventeen from loitering in public places after 9:00 P.M. For a discussion of the conflict-ridden relationship between the LAPD and Mexican American youths during the war years, see Escobar, *Race, Police, and the Making of a Political Identity*, chaps. 8 and 9. According to Escobar, reported crime actually fell in Los Angeles during 1942–43—the years of the alleged crime wave—testifying to the fact that "large numbers of Mexican American youths found themselves arrested for no other reason than the fact that they were of Mexican descent" (Escobar, *Race, Police, and the Making of a Political Identity*, 174).

13 Pagán, *Murder at the Sleepy Lagoon*, 89. The phrase "zoot suit' murder case" is from "Jury's Gang-Case Verdict Disproves 'Persecution,'" *Los Angeles Times*, January 14, 1943, A4. For the history of the Sleepy Lagoon trial and its outcome, see Escobar, *Race, Police, and the Making of a Political Identity*; Pagán, *Murder at the Sleepy Lagoon*; Alvarez, *Power of the Zoot*; McWilliams, *North from Mexico*; and the PBS *American Experience* documentary "Zoot Suit Riots" (Boston: WGBH Educational Foundation, 2001).

14 For discussion of the SLDC and the diverse makeup of its membership, see Barajas, "Defense Committees of Sleepy Lagoon"; Bernstein, *Bridges of Reform*, 87–89; and Johnson, "Constellations of Struggle."

15 "Twenty-three Youths Indicted on Gang Murder Charges; 6 Additional John Does Also Accused; Case of 10 Girls Given to Juvenile Court," *Los Angeles Times*, 7 August

1942, A10; Ramírez, *Woman in the Zoot Suit*, 29; Ramírez, "Pachuca in Chicana/o Art, Literature and History," 20.

16 "Youthful Gang Evil, Vigorous Action Imperative in View of Seriousness of Situation," *Los Angeles Evening Herald and Express*, 4 August 1942, B2.

17 "Three Teen-Age Girls Held in Boy-Gang Slaying Inquiry; All Insist They Did Not Belong to Group Involved, in Investigation Undertaken by County Grand Jury," *Los Angeles Times*, 5 August 1942, A12.

18 See Pagán, "Sleepy Lagoon," 115–16 and 158–59; "Twenty-three Youths Indicted on Gang Murder Charges; 6 Additional John Does Also Accused; Cases of 10 Girls Given to Juvenile Court," *Los Angeles Times*, 7 August 1942, A10; Guy Endore, *The Sleepy Lagoon Mystery* (manuscript draft), 58, Box 2, Folder 4, SLDC Records; "150 Rounded Up in Killing Gang Terror," not dated, newspaper unknown, folder marked "News clippings, 1942–44," Ruiz Papers. See also the untitled 30 April 1943 summary of the injustices of the Sleepy Lagoon case by Rita Michaels, American Federation of Teachers, SLDC Records; and handwritten account of the trial, dated 29 October 1942, author unknown, SLDC Records.

19 See Guy Endore, *The Sleepy Lagoon Mystery* (manuscript draft), 58–63, Box 2, Folder 4, SLDC Records.

20 Dora Barrios, Betty Zeiss, and Juanita Gonzáles are listed as paroled from the Ventura School for Girls in 1943, although they officially remained wards of the state until their twenty-first birthdays. See "Paroled to Southern California Supervisor during 1943, Ventura School for Girls," Administrative Files, Corrections, Governor's Prison Committee, Ventura School for Girls, 1937–1944, F3640:992, Warren Papers. Frances Silva is listed as being committed to the Ventura School for Girls in 1943 for "Mexican fights." See "Ventura School for Girls, Girls Over 18," Administrative Files, Corrections, Governor's Prison Committee, Ventura School for Girls, 1937–1944, F3640:992, Warren Papers. Discussion of Lorena Encinas's incarceration at the Ventura School can be viewed on the PBS *American Experience* documentary "Zoot Suit Riots." There is documentation of Bertha Aguilar's stay at the Ventura School in two court cases separate from that of the Sleepy Lagoon trial, referred to officially as *People v. Zammora*. See *The People, Respondent, v. Sam Marino Renteria, Apellant*, Crim. No. 3715, Court of Appeal of California, Second Appellate District, Division Three, 60 Cal. App. 2d 463; 141 P.2d 37; 1943 Cal App. LEXIS 541; and the testimony of Bertha Aguilar, court case number CR025817, Ventura County Courthouse, 1943. Josephine Gonzáles testified at the Sleepy Lagoon trial that she had been sent to the Ventura reformatory for girls; see her testimony, Court Transcript, 764–1168, SLDC Records. Lupe Ynostroza was eventually sent to Duarte Sanatorium; see Henry Ynostroza biography, SLDC Records.

21 My assessment of the type of inmate typically sentenced to the Ventura School comes from my readings of court case files brought before the Los Angeles County Superior Court, Juvenile Division, between the years 1939 and 1945. When the women of Sleepy Lagoon entered the school in late 1942, the institution's custodial and disciplinary procedures rivaled those of state prisons. A 1943 committee appointed by

Governor Earl Warren to investigate California's penal institutions, for instance, described the punishments implemented in the Ventura School disciplinary cottage as a "disgrace to the state." See "Final Report of Governor's Investigation Committee on Penal Affairs," 21 January 1944, 110–1, Administrative Files, Corrections, Governor's Prison Committee, Reports, F3640:975, Warren Papers.

22 The cases cited in this chapter are examples of files where the labels "pachuco" and/or "pachuca" are included in the probation officer's description of the juvenile. Although the records used in this study are officially closed to the public, I petitioned the Juvenile Division of the Los Angeles County Superior Court for special permission to look at the files. Case files consist primarily of Los Angeles County Probation Department Intake Face Sheets and Los Angeles Police Department Juvenile Investigation and Disposition Reports; Probation Officer Reports and Recommendations based on interviews conducted with the juvenile family members, school and reformatory officials, and other related parties; and medical reports filed upon examination of the juvenile while in detention. To protect privacy and maintain confidentiality, I changed all names of the youths, friends, and family members mentioned in the juvenile case files. I have, however, tried to retain the ethnic characteristics of surnames.

23 Pagán, *Murder at the Sleepy Lagoon*, 37–39, 130–31.

24 Ramírez, *Woman in the Zoot Suit*, xii. Like Ramírez's, my descriptions of Mexican American women who adorned aspects of the zoot look during the World War II era come from contemporary photographs and interviews conducted with Mexican American women who either adopted the zoot style themselves or came of age when the zoot suit was popular with Mexican Americans.

25 Superior Court of California, County of Los Angeles Juvenile Court, case number 104932, Los Angeles Superior Court Archives and Records Center (hereafter cited as "case number").

26 Case number 103922.

27 Case numbers 107165, 116621.

28 Malagon, interview. Anna Morales Marquez similarly recalled wearing aspects of the zoot style during the 1940s but claimed in her interview that she did not self-identify as a "pachuca." Morales Marquez, interview.

29 Case number 106170.

30 Ruiz, *From Out of the Shadows*, 51–52; Odem, *Delinquent Daughters*, 44–45, 49.

31 Escobedo Atterbury, interview, 6 January 1998; Escobedo Atterbury, interview, 30 November 2010.

32 Case number 105230.

33 Velarde, interview; Hurtado Davis, interview.

34 Pallan Valadez, interview.

35 Hernández Jefferes, interview.

36 "Origenes de 'Pachucos' y 'Malinches,'" *La Opinión*, 26 August 1942, 2. The attitudes of *La Opinión* toward the pachuca/o population were not particularly surprising, given the political bent of the Spanish-language daily. Recognizing the vulnerability of the Mexican population in the United States, the newspaper urged the Mexican

population to conduct themselves honorably while living in Los Angeles. See García, "*La Frontera*," 95–96. Discussions of La Malinche can be found in Romero and Harris, *Feminism, Nation, and Myth*. For further analysis of *La Opinión*'s use of the term "malinches" to describe the pachuca, see Ramírez, *Woman in the Zoot Suit*, 38–39.

37 "Girl 'Zoot Suiters' Gird to Join Gangland Battle, Pachucas Stand by Beaten Pachucos," *Los Angeles Evening Herald and Express*, 10 June 1943, A3.

38 Case numbers 131627, 103259, 104932, 105230.

39 Pagán, *Murder at the Sleepy Lagoon*, 123. Several newspapers and magazines spoke of female gangs with names such as the "Black Widows" and the "Cherries." See, for example, "Girl 'Zoot Suiters' Gird to Join Gangland Battle, Pachucas Stand by Beaten Pachucos," *Los Angeles Evening Herald and Express*, 10 June 1943, A3; "Youthful Gang Secrets Exposed," *Los Angeles Times*, 16 July 1944, A1; "Origenes de 'Pachucos' y 'Malinches,'" *La Opinión*, 26 August 1942, 2. See also Moore, *Going Down to the Barrio*, 27–29.

40 Mary Odem discusses similar issues regarding sexual delinquency charges and the social circumstances affecting turn-of-the-century working-class daughters in *Delinquent Daughters*.

41 Griffith, *American Me*, 52.

42 Case number 112504.

43 Ruiz, *From Out of the Shadows*, 83. Similarly, during a meeting of the Coordinating Council for Latin American Youth—a community group founded in 1941 to address the situation of Mexican American youths in urban barrios—it was stated that only 9/10 of 1 percent of Mexican girls were considered juvenile delinquents. See "CCLAY Minutes," 7 June 1943, Minutes, 1943, Folder 8, Box 3, Ruiz Papers.

44 Pagán, *Murder at the Sleepy Lagoon*, 132.

45 For a general discussion of fears surrounding women's changing roles during World War II, see May, "Rosie the Riveter Gets Married," 133–34.

46 For information about "victory girls" and increased efforts to police female sexuality during World War II, see Hegarty, *Victory Girls, Khaki-Wackies, and Patriotutes*. According to Hegarty, in an effort to cut down on prostitution and the spread of venereal disease to servicemen, the 1941 May Act made prostitution in military areas a federal crime, giving federal agencies like the Social Protection Division of the Office of Community War Services "a powerful tool to control prostitutes and so-called promiscuous women" (Hegarty, *Victory Girls, Khaki-Wackies, and Patriotutes*, 19).

47 "Girl 'Zoot Suiters' Gird to Join Gangland Battle, Pachucas Stand by Beaten Pachucos," *Los Angeles Evening Herald and Express*, 10 June 1943, A3; "Youth Gangs Leading Cause of Delinquencies," *Los Angeles Times*, 2 June 1943, A10; "Origenes de 'Pachucos' y 'Malinches,'" *La Opinión*, 26 August 1942, 2.

48 For a discussion of twentieth-century miscegenation laws and understandings of Mexicans as legally "white," see Hollinger, "Amalgamation and Hypodescent," 1375–77; and Pascoe, *What Comes Naturally*, 120–23.

49 "Zoot Suits and Service Stripes: Race Tension Behind the Riots," *Newsweek*, 21 June 1943, 35–36.

50 Case number 115630.

51 Case number 111288.

52 Ruiz, "'Star Struck,'" 133–37.

53 Tuck, *Not with the Fist*, 127.

54 Court officials eventually encouraged Mrs. Preciado to get her daughter away from her undesirable companions by placing her with relatives or her godmother. It is unclear from the court record if she ever took this course of action. As of January 1948, Cecelia remained in the home of her parents; her case was dismissed in July of that year. See Case number 122004. For an in-depth discussion of working-class, immigrant parents' use of the juvenile justice system to reform behavior of troublesome daughters during the late nineteenth and early twentieth centuries, see Odem, *Delinquent Daughters*.

55 Memo from Adele Calhoun to Frank J. DeAndreis, "Pachuco Situation in Los Angeles," 16 June 1943, Administrative, Department of Justice, Attorney General, Law Enforcement, 1943, F3640:2625, Warren Papers, 1–2.

56 For information on accusations of Sinarquista activities in the Mexican American community, see Barajas, "Defense Committees of Sleepy Lagoon"; and Escobar, *Race, Police, and the Making of a Political Identity*, 221–22, 227–28. For an example of the similarities in news coverage regarding the enemy Japanese and enemy Mexican gangs, see the front page of the *Los Angeles Times*, 10 August 1942, where the headlines "Allied Bombers Hit Japs in Rear" and "Police Seize 300 in Boys' Gang Drive" appear parallel to one another.

57 Case number 101591.

58 Case number 131627.

59 Case number 107502.

60 Myrdal, *American Dilemma*, 1021.

61 My thinking is informed here by scholar Nikhil Singh's discussion of Myrdal's *American Dilemma* and contemporary understandings of race and nation in World War II, in *Black Is a Country*, 38–42, 107–14.

62 Singh, *Black Is a Country*, 254 n. 30. See also Sollors, *Beyond Ethnicity*.

63 Singh, *Black Is a Country*, 113; Omi and Winant, *Racial Formation in the United States*, 14–18; Jacobson, *Whiteness of a Different Color*, 95–96; Gerstle, *American Crucible*, 187–96. Gerstle calls this belief in the erosion of ethnic differences "the growth of a common Americanness." See Gerstle, *American Crucible*, 196.

64 Several scholars, including George Lipsitz, Robin Kelley, and Luis Alvarez, have explored the important ways in which everyday cultural practices, including styles of clothing, can be viewed as examples of political expression and/or cultural politics. See, for instance, Lipsitz, *Rainbow at Midnight*, 83–86; Kelley, *Race Rebels*; and Alvarez, *Power of the Zoot*. In her book *Zoot Suit*, historian Kathy Peiss cautions against the "enduringly problematic practice of reading aesthetic forms as politics," calling upon scholars to "examine more closely the circumstances in which a cultural style may or may not be in fact political." Peiss does argue, however, that in Los Angeles— given campaigns by law enforcement and the press to denigrate zoot suits and to

associate those who wore them with criminality—the look "took on a more politicized meaning," particularly for Mexican Americans. See Peiss, *Zoot Suit*, 1–14, 114–17 (quotations on 8, 4, 117).

65 Ruiz, *From Out of the Shadows*, 57.

66 Peiss, *Hope in a Jar*, 239–45; McEuen, *Making War, Making Women*.

67 Pagán, *Murder at the Sleepy Lagoon*, 102, 104. Mexican American women who came of age in wartime Los Angeles describe the "rat" as a beauty accessory consisting of a foam insert or patch of synthetic or human hair, placed on the head to add lift and fullness to the pompadour hairstyle. As described in Gonzáles Benavidez, interview, 6 November 2000; Rivera Cardenas, interview; Malagon, interview.

68 Case number 106170.

69 Alvarez, *Power of the Zoot*, 3.

70 Case numbers 103922, 114005. For further discussion of attempts by Mexican American youths to resist authority in California reform schools, see Chávez-García, "Youth, Evidence, and Agency."

71 "Reporter's Transcript of Proceedings of Governor Earl Warren's Special Committee Investigating California Penal Institutions, Ventura School for Girls, vol. IX," 3 January 1944, F3640:956–1007, Warren Papers, 1666–68.

72 Ibid.; case number 101591 and Pagán, *Murder at the Sleepy Lagoon*, 7.

73 Case number 102135.

74 See case numbers 103193, 98670. George J. Sánchez discusses earlier reformers' Americanization efforts in " 'Go after the Women,' " 256.

75 See case numbers 107165, 112504, and 101591.

76 Case number 98670.

77 Case number 101591.

78 For a discussion of similar failures within the juvenile justice system in Boston during the nineteenth and early twentieth centuries, see Schneider, *In the Web of Class*.

79 See, for example, case number 131627.

80 Case number 101591.

81 Case number 118703.

82 Case number 131627.

83 See Kunzel, *Fallen Women, Problem Girls*, 163–64.

84 "Youth Gangs Leading Cause of Delinquencies," *Los Angeles Times*, 2 June 1943, A10.

85 Memo from Adele Calhoun to Frank J. DeAndreis, "Pachuco Situation in Los Angeles," 16 June 1943, Administrative, Department of Justice, Attorney General, Law Enforcement, 1943, F3640:2625, Warren Papers, 5.

86 Case number 122004.

87 See Sánchez, " 'Go after the Women,' " 256; and Odem, *Delinquent Daughters*, 182.

88 Case number 107502.

89 According to historian George Sánchez, Mexican immigrant women became the target of Progressive Era Americanization programs by and large because they were seen as the individuals most responsible for the "transmission of values in the home." Reformers thus hoped to influence the second generation by way of their mothers

while simultaneously teaching Mexican immigrant women the skills necessary to enter the labor market. See Sánchez, "'Go after the Women,'" 254–55.

90 Memo from Adele Calhoun to Frank J. DeAndreis, "Pachuco Situation in Los Angeles," 16 June 1943, Administrative, Department of Justice, Attorney General, Law Enforcement, 1943, F3640:2625, Warren Papers, 3.

91 Case number 109532.

92 Here, too, Mexican American mothers were not the only ones condemned. Ruth Feldstein discusses the perceived "maternal failure" of 1940s black and white women in her work *Motherhood in Black and White*.

93 "Origenes de 'Pachucos' y 'Malinches,'" *La Opinión*, 26 August 1942, 2. Eduardo Pagán makes a similar argument about pachucos and the middle class in his "'Who Are These Troublemakers?'"

94 For in-depth discussion of the Zoot Suit Riots, see Pagán, *Murder at the Sleepy Lagoon*; Mazón, *Zoot-Suit Riots*; McWilliams, *North from Mexico*; and PBS *American Experience*, "Zoot Suit Riots."

95 "Sailor 'Task Force' Hits L.A. Zooters, Send 5 to Hospital in Riots," *Los Angeles Evening Herald and Express*, 5 June 1943, A1, 4.

96 "Girl 'Zoot Suiters' Gird to Join Gangland Battle, Pachucas Stand by Beaten Pachucos," *Los Angeles Evening Herald and Express*, 10 June 1943, A3.

97 "Train-Attacking Zoot Gangs Broken Up," *Los Angeles Evening Herald and Express*, 11 June 1943, A1.

98 Sánchez, *Becoming Mexican American*, 268; "Mother Tears Up Zoot Suit of Boy Wounded in Clash," *Los Angeles Times*, 11 June 1943, A.

99 Moore, *Going Down to the Barrio*, 71–72.

CHAPTER TWO

1 Norman Rockwell, "Rosie the Riveter 1943," *Saturday Evening Post*, 29 May 1943, cover; J. Howard Miller, "We Can Do It," N.D. Westinghouse War Production Coordinating Committee, NARA. The Westinghouse Company's War Production Coordinating Committee was part of the U.S. War Production Board. See Schipske, *Rosie the Riveter in Long Beach*, 32.

2 On early-twentieth-century white women's politics and their relationship with the state, see Mink, *Wages of Motherhood*; Gordon, *Pitied but Not Entitled*; and Ladd-Taylor, *Mother-Work*. Mink also emphasizes the inequities of the welfare state, particularly in regard to African American women.

3 In 1930s Arizona, for example, a mother's pension law made assistance available only to those widows whose husbands had been citizens, and who were citizens themselves, thereby excluding most Mexican women from coverage. Similarly, the exclusion of agricultural and domestic workers, in addition to residency and citizenship requirements, for Social Security benefits disqualified many Mexicans from programs like Aid to Dependent Children. Anderson, *Changing Woman*, 109. See also Ladd-Taylor, *Mother-Work*, 149.

4 Sánchez, *Becoming Mexican American*, 95; Sánchez, "'Go after the Women,'" 250, 254.

5 My overall thinking in regard to Mexican women's changing relationship with federal institutions during World War II is greatly indebted to Megan Taylor Shockley's analysis of African American women and the wartime state in her work *"We, Too, Are Americans."*

6 The language of the "Mexican problem" began during the mass migration of wartime refugees from the 1910 revolution in Mexico and revived during the repatriation campaigns of the Great Depression. See, for example, Reisler, *By the Sweat of Their Brow,* and Balderrama and Rodríguez, *Decade of Betrayal.*

7 For discussion of the international diplomacy behind U.S. officials' increased interest in the issue of discrimination against Mexicans in the United States, see Hart, "Making Democracy Safe for the World"; Bernstein, *Bridges of Reform,* 64–80; and Zamora, *Claiming Rights and Righting Wrongs in Texas,* 63–96. Begun in August of 1942, the Bracero Program, officially called the Emergency Farm Labor Program, was a bilateral labor agreement between the United States and Mexico that allowed Mexican workers into the United States as a temporary emergency measure. Although the U.S. government promised that braceros would not be subject to racial discrimination, American employers routinely abused the workers. After the expiration of the initial agreement in 1947, the program was continued in agriculture under a variety of laws and agreements until its formal end in 1964. For more information, see Cohen, *Braceros*; Galarza, *Merchants of Labor*; Calavita, *Inside the State*; and Rosas, "Breaking the Silence."

8 Franklin Delano Roosevelt, "First Inaugural Address," 1933, http://historymatters. gmu.edu/d/5057/ (30 March 2012). For in-depth discussion of the Good Neighbor Policy, see, for example, Marks, *Wind Over Sand*; Pike, *FDR's Good Neighbor Policy*; and Wood, *Making of the Good Neighbor Policy.*

9 In October of 1941, in consultation with a variety of Southwestern legislators and educators, California Commissioner of Immigration and Housing Carey McWilliams submitted plans for the improvement of "Anglo-Hispano relations" to OCIAA head Nelson Rockefeller. Two months later, after the attack on Pearl Harbor, Manuel Gonzales of LULAC followed suit, leading a delegation of Mexican American leadership to Washington, D.C., to lobby Rockefeller on the need to address discrimination against Mexican and Mexican American workers nationwide. See McWilliams, *North from Mexico,* 245–46; and Daniel, *Chicano Workers,* 17–19. According to Daniel, as a result of the lobbying efforts, Rockefeller hesitatingly agreed to create a Spanish-speaking division within his OCIAA office.

10 For background on the OCIAA, see Rowland, *History of the Office of the Coordinator of Inter-American Affairs*; for a history of the OWI, see Winkler, *Politics of Propaganda.* Clete Daniel discusses the federal studies of the Mexican population in *Chicano Workers,* 19–22.

11 "Program for Cooperation with Spanish-Speaking Minorities in the United States: Progress Report of Resident Latin American Unit," 1 July 1942, MLR Entry 222, NC 148, Box 1082, Subject File of the Chief, "Spanish" Folder, OWI Records, foreword.

12 "Spanish-Americans in the Southwest and War Effort," First "edition," Report No. 24, Special Services Division, Bureau of Intelligence, Office of War Information, 18 August 1942, Division of Review and Analysis, Reference Records, 1941–1946, L–M, Box 409, Entry 33, "Mexicans–Spanish Americans" Folder, FEPC Records, summary page.

13 Ibid., 11.

14 "Statement of Dr. Carlos E. Castañeda, Special Assistant on Latin American Problems to the Chairman of the President's Committee on Fair Employment Practice, Before the Senate Committee on Labor and Education in the Hearings Held 8 September 1944, on S Bill 2048, to Prohibit Discrimination Because of Race, Creed, Color, National Origin or Ancestry," 8 September 1944, Folder 6, Series IV, Box 58, Mexicans in the United States, Reports, 1944, Galarza Papers, 2, 5.

15 Ruiz, *Cannery Women*; Durón, "Mexican Women and Labor Conflict in Los Angeles"; Alamillo, *Making Lemonade Out of Lemons*. According to the 1940 U.S. Census, 6 percent of women of Mexican descent worked in canning; 16 percent worked in apparel; 12 percent worked in private households; and 7 percent worked in laundries in Los Angeles and Orange Counties. About 32 percent of Mexican women in these counties could be found in the very general classification of cooperative and kindred work, not elsewhere classified. See IPUMS 1940 sample.

16 "Spanish-Americans in the Southwest and War Effort," First "edition," Report No. 24, Special Services Division, Bureau of Intelligence, Office of War Information, 18 August 1942, Division of Review and Analysis, Reference Records, 1941–1946, L–M, Box 409, Entry 33, "Mexicans–Spanish Americans" Folder, FEPC Records, 11.

17 "Program for Cooperation with Spanish-Speaking Minorities in the United States: Progress Report of Resident Latin American Unit," 1 July 1942, MLR Entry 222, NC 148, Box 1082, Subject File of the Chief, "Spanish" Folder, OWI Records, foreword. For a brief description of López and his work with the OWI, see García, *Mexican Americans*, 325 n. 34.

18 García, "*La Frontera*," 97.

19 Ibid., 97–104. For more information on López, see Garcia, *World of Its Own*, 223–55; and Garcia, "Intraethnic Conflict and the Bracero Program."

20 Memorandum from Joseph E. Weckler to Walter T. Prendergast, "Rehabilitation work among Spanish-speaking people in the United States," 28 January 1943, Entry 1, General Records, Central Files, O. Inter-American Activities in the U.S., Spanish and Portuguese Speaking Minorities in U.S. Speaker's Service, Box 57, "Spanish and Portuguese Speaking Minorities, JAN–MAR, 1943" Folder, OCIAA Records, 1; Report from Alan Cranston to Elmer Davis, "Activities in Los Angeles," 28 November 1942, attached to office memorandum from Charles Olson to Robert Huse, 4 December 1942, Entry 1, Records of the Director 1942–1945, NC 148, Folder "Subversive Activities, 1942–43," Box 9, OWI Records, 7; McWilliams, *North from Mexico*, 246.

21 Savage, *Broadcasting Freedom*, 59; Gerstle, "Working Class Goes to War," 113–14. Interestingly, prior to the entrance of the United States into the Second World War, the

federal Office of Education produced a twenty-six-week, national radio series called *Americans All—Immigrants All*, broadcast in 1938 and 1939. The series sought to encourage acceptance of immigrant, African American, and Jewish populations living in the United States, particularly given the likely participation of the United States in a European war, and thus the need for national unity. For an in-depth discussion of the radio show, see Savage, *Broadcasting Freedom*, 21–62.

22 Joseph Goebbels, German politician and Reich minister of propaganda in Nazi Germany from 1933 to 1945, made a pronouncement in 1933 that "nothing will be easier than to produce a bloody revolution in North America. No other country has so many social and racial tensions." See Hart, "Making Democracy Safe for the World," 70.

23 Mehr, "Way We Thought We Were," 31–32; Slotkin, "Unit Pride"; Roeder, *Censored War*, 49; Gerstle, "Working Class Goes to War," 116–17. As part of the continued Good Neighbor Policy, and because of fears of a growing Nazi presence in Latin America, the OCIAA and the Production Code Administration of the federal government also hired Latin American specialist John Durland to oversee efforts to encourage Hollywood to produce "'authentic,' and thereby less offensive, representations of Latin America" during the World War II era. See O'Neil, "Demands of Authenticity."

24 Lipsitz, *Possessive Investment in Whiteness*, 216.

25 Memo from Ignacio L. López to Lee Falk, "Propaganda Material in Spanish, Suitable for Use in the Southwest and Other Sections of the Country Where Spanish-Speaking Groups Are Located," 18 November 1942, MLR Entry 222, NC 148, Box 1082, Subject File of the Chief, Folder Untitled, OWI Records, 3. Emphasis appears in the original document.

26 John Bright and Josephine Fierro de Bright, "Prospectus for the Office of Inter-American Affairs on the Mexican Americans of Southwestern United States," 10 November 1942, Box 4, Folder 11, Mexican Minority—General, SLDC Records.

27 Memo from Ignacio L. López to Lee Falk, "Propaganda Material in Spanish, Suitable for Use in the Southwest and Other Sections of the Country Where Spanish-Speaking Groups Are Located," 18 November 1942, MLR Entry 222, NC 148, Box 1082, Subject File of the Chief, Folder Untitled, OWI Records; memo from Ignacio L. López to Mr. Alan Cranston, "The Mexican in the War Effort," 17 December 1942, MLR Entry 222, NC 148, Box 1082, Subject File of the Chief, Folder Untitled, OWI Records.

28 Discussion of the ways in which the OWI hoped to reach Spanish Americans of the Southwest through media can be found in a memo from Alice Kahn to John A. Davis, "Summary of an Evaluation of Media for Reaching the Spanish-Americans of the Southwest (Report #23A OWI), 23 September 1943, Division of Review and Analysis, Office Files of Marjorie M. Lawson, 1942–45, Box 371, Entry 27, Folder "Mexican Study," FEPC Records.

29 Memo from Ignacio L. López to Mr. Alan Cranston, "The Mexican in the War Effort," 17 December 1942, MLR Entry 222, NC 148, Box 1082, Subject File of the Chief, Folder Untitled, OWI Records.

30 OCIAA, *Spanish-Speaking Americans in the War*. In early 1943, Alan Cranston planned for a circulation of one million copies of the publication. See Memo from Alan Cranston to Mr. Victor Borella, "Mexican American pamphlet," 20 April 1943, Entry 222, NC 148, Box 1077, Subject File of the Chief, Folder "Mexicans," OWI Records.

31 Report from Alan Cranston to Elmer Davis, "Activities in Los Angeles," 28 November 1942, attached to office memorandum from Charles Olson to Robert Huse, 4 December 1942, Entry 1, Records of the Director 1942–1945, NC 148, Box 9, Folder "Subversive Activities, 1942–43," OWI Records, 3.

32 Wilburn, "Social and Economic Aspects of the Aircraft Industry," 172. By January of 1943, Guy Nunn, field representative for the War Manpower Commission, informed Alan Cranston, head of the OWI's Foreign Language Division, that Douglas had begun "advertizing [sic] for workers in Spanish-language press and asking Mexican employees to recommend new personnel." See Telegram from Guy Nunn to Alan Cranston, 18 January 1943, Entry 222, NC 148, Box 1077, Subject File of the Chief, Folder "Foreign Language," OWI Records.

33 *El Segundo Airview News*, 7 December 1943, 8.

34 *Santa Monica Airview News*, 7 September 1943, 4.

35 "Company Employes [sic] Top Nation's Blood Donors at Year's End," *Santa Monica Airview News*, 7 December 1943, 7.

36 "Pilot of 1000th Fort Thanks B-17 Workers for 'Great Contribution,'" *Long Beach Airview News*, 10 October 1944, 1.

37 OCIAA, *Spanish-Speaking Americans in the War*.

38 Report from Alan Cranston to Elmer Davis, "Activities in Los Angeles," 28 November 1942, attached to office memorandum from Charles Olson to Robert Huse, 4 December 1942, Entry 1, Records of the Director 1942–1945, NC 148, Box 9, Folder "Subversive Activities, 1942–43," OWI Records, 1, 3. Alan Cranston would later go on to become an influential U.S. senator.

39 "Family Goes All Out for War; All 22 Members Doing Bit; Five of Cazares Clan in Armed Forces and Rest Filling Vital Jobs," *Los Angeles Times*, 19 January 1943, A1; "Cazares Clan Sets Record," *Daily News*, not dated, Entry 222, NC 148, Box 1077, Subject File of the Chief, Folder "Mexicans," OWI Records; memos from Howard Langley to James D. Secrest, "Mexican Relations Story" and "Cazares Family," 18 and 19 January 1943, Entry 222, NC 148, Box 1077, Subject File of the Chief, Folder "Mexicans," OWI Records; memo from Alan [Cranston] to Iggie [López], 28 January 1943, Entry 222, NC 148, Box 1077, Subject File of the Chief, Folder "Mexicans," OWI Records.

40 "Youth Gangs Leading Cause of Delinquencies," *Los Angeles Times*, 2 June 1943, A10.

41 "Mother Tears Up Zoot Suit of Boy Wounded in Clash," *Los Angeles Times*, 11 June 1943, A. For further discussion of the media's coverage of Mexican parental failings, see Ramírez, *Woman in the Zoot Suit*, 115.

42 Sánchez, *Becoming Mexican American*, 100, 102–3, and 106–7. For an analysis of the perception of Mexican women as welfare drains during the Great Depression, see Molina, *Fit to Be Citizens?*, 141–49.

43 "Mother of Seven Builds B-17s Has Super Attendance Mark," *Long Beach Airview News*, 13 July 1943, 11.

44 Report from Alan Cranston to Elmer Davis, "Activities in Los Angeles," 28 November 1942, attached to office memorandum from Charles Olson to Robert Huse, 4 December 1942, Entry 1, Records of the Director 1942–1945, NC 148, Box 9, Folder "Subversive Activities, 1942–43," OWI Records, 3.

45 "A Proposal for the Improvement of Relations Between the English and Spanish Speaking Residents of Southern California: A Program of Research and Action" and "Program of the Minority Section Project of the Southern California Council of Inter-American Affairs," undated, Entry 222, NC 148, Box 1077, Subject File of the Chief, Folder "Latin America," OWI Records; "The Southern California Council of Inter-American Affairs," Box 26, "Inter-American Affairs" Folder, McWilliams Papers. On the SCCIAA's opening day, see Nash, *American West Transformed*, 119–20.

46 Memo from Jane Pijoan to Raymond Rich, "Southern California Council, Excerpt from Hazan's Report, October 29," 3 November 1943, Entry 1, General Records, Central Files, O. Inter-American Activities in the U.S. Spanish and Portuguese Speaking Minorities in U.S. Speaker's Service, Folder "Spanish and Portuguese Speaking Minorities, JAN–MAR, 1943," Box 57, OCIAA Records.

47 Carey McWilliams criticized the SCCIAA in his writings. According to McWilliams, "The division acted as though it wanted to frustrate any real efforts on the part of Spanish-speaking people to improve their lot." He also critiqued the SCCIAA for its lack of Spanish-speaking members, and because it "insisted on working with the least representative elements in the various Spanish-speaking communities." See McWilliams, *North from Mexico*, 246. For the council's assimilative point of view, see "The Southern California Council of Inter-American Affairs," Box 26, "Inter-American Affairs" Folder, McWilliams Papers.

48 May, "Making the American Consensus," 77.

49 *These Are Americans* radio transcripts, included in correspondence between Miss Frances F. Wilder, Director of Education, Columbia Broadcasting System, Inc., and Katharine F. Lenroot, Chief of the Children's Bureau, U.S. Department of Labor, 28 January and 7 February 1944, Central File, 1941–1944, 0-2-9-3 to 0-2-9-6-5, Box 36, A1, Entry 3, Folder "Mexicans," RG 102, Records of the Children's Bureau, NARA (hereafter cited as *These Are Americans*).

50 Ibid., 12 August 1943, 7.

51 Ibid., 2 September 1943, 2.

52 Ibid., 5 August 1943, 6.

53 Ibid., 19 August 1943, 26 August 1943.

54 Ibid., 9 September 1943, 4–5. In 1943, KNX Radio in Los Angeles won a George Peabody Award in "Outstanding Community Service by a Regional Station" for its production of the *These Are Americans* series. See http://www.peabody.uga.edu/winners/PeabodyWinnersBook.pdf (15 January 2011). A subsequent series, also called *These Are Americans*, aired on KNX Radio in 1944 and addressed issues of concern facing the African American community. For discussion of the African American

version of the series, see Savage, *Broadcasting Freedom*, 180–84; and Johnston, "*Good Night, Chet,*" 34–35.

55 *These Are Americans*, 12 August 1943, 5, 7–8.

56 Ibid., 8–11.

57 *These Are Americans*, 2 September 1943, 4–5, 10.

58 May, "Making the American Consensus," 77.

59 *These Are Americans*, 9 September 1943, 6–7.

60 Feldstein, *Motherhood in Black and White*.

61 Ibid., 43.

62 Molina, *Fit to Be Citizens?*, 96–97.

63 Odem, *Delinquent Daughters*, 169–70; Molina, *Fit to Be Citizens?*, 97. Several scholars have shown that local officials across the United States routinely discriminated against women of color in allocating welfare funds, utilizing "different budgets for different nationalities" and often outright denying pensions to African American and Mexican widows and single mothers. See Anderson, *Changing Woman*, 109; Ladd-Taylor, *Mother-Work*, 149–50 (quotation on 149); and Glenn, *Forced to Care*, 163.

64 "Republican motherhood" refers to an ideology of the Revolutionary War era in which it was considered a patriotic responsibility of white mothers to educate their children to be moral and virtuous citizens, thereby infusing motherhood with a degree of political influence previously unseen. "Municipal housekeeping" refers to the ways in which Progressive Era women extended their authority as mothers and housewives to engage in public reform concerns. See, for example, Kerber, *Women of the Republic*; and Muncy, *Creating a Female Dominion*. Molina similarly invokes these concepts in *Fit to Be Citizens?*, 96–97.

65 Barbara Savage uses the phrase "umbrella of Americanness" in *Broadcasting Freedom*, 60.

66 For a study of the ways in which Mexican women utilized the San Antonio press to upend stereotypes of Mexican women as "unladylike" and violent in the post–World War II era, see Flores, "Unladylike Strike Fashionably Clothed."

67 The letter to the editor appears in Manchester Boddy, "Views of the News," *Los Angeles Daily News*, 11 June 1943, 1, 36. For a similar discussion of the letter, see Ramírez, *Woman in the Zoot Suit*, 43–44.

68 "A Mexican Mother Writes to Bowron: 'Will My Boys Grow Up to be Thrown Around?,'" undated newspaper clipping, Box 28, "Mexicans—Discrimination—Brutality and Violence 2" Folder, McWilliams Papers; "Protest Arrest of Boys: War Plant Hits Brutality to Mexican Youth," undated newspaper clipping, Box 28, "Mexicans—Discrimination—Brutality and Violence 2" Folder, McWilliams Papers; "Cops Kill Youth, Jail 4: Mayor Bowron to Get Facts on Brutality," undated newspaper clipping, Box 28, "Mexicans—Discrimination—Brutality and Violence 2" Folder, McWilliams Papers.

69 "Police Seize 300 in Boys' Gang Drive," *Los Angeles Times*, 10 August 1942, 6.

70 See, for example, "Three Teen-Age Girls Held in Boy-Gang Slaying Inquiry," *Los Angeles Times*, 5 August 1942, A12; "Twenty-three Youths Indicted on Gang Murder

Charges; 6 Additional John Does Also Accused; Case of 10 Girls Given to Juvenile Court," *Los Angeles Times*, 7 August 1942, A10; "Youthful Gang Evil, Vigorous Action Imperative in View of Seriousness of Situation," *Los Angeles Evening Herald and Express*, 4 August 1942; "Girls Questioned by Jury in Gang Murder Investigation," *Los Angeles Daily News*, 5 August 1942, 10; and "Police Round Up 325 Men, Boys; Anti-Gang Net Crowds Jails," *Los Angeles Examiner*, 10 August 1942, pt. ii, 1.

71 "Brass Knuckles Found on Woman 'Zoot Suiter,'" *Los Angeles Times*, 10 June 1943, A; "Policeman Is Ambushed, Run Over by Zoot Auto," *Los Angeles Evening Herald and Express*, 10 June 1943, A6; Ramírez, *Woman in the Zoot Suit*, 83, 100.

72 "Police Seize 300 in Boys' Gang Drive," *Los Angeles Times*, 10 August 1942, 1, 6.

73 "Five Youths Taken in Roundup Freed and Charges Dropped," *Los Angeles Times*, 12 August 1942, A2.

74 "Youth Gangs Leading Cause of Delinquencies," *Los Angeles Times*, 2 June 1943, A10.

75 Pagán, *Murder at the Sleepy Lagoon*, 36–37, 132, 142.

76 "CCLAY Minutes," 7 June 1943, Minutes, 1943, Box 3, Folder 8, Ruiz Papers.

77 García, "Americans All"; Pagán, "'Who Are These Troublemakers?,'" 15; and Escobar, *Race, Police, and the Making of a Political Identity*, 204–7. According to Escobar, two groups with the CCLAY acronym emerged during the early 1940s in Los Angeles. In 1941, the Coordinating Council for Latin American Youth was formed under Los Angeles mayor Fletcher Bowron, the L.A. County Board of Supervisors, the L.A. County Probation Department, and Chief of Police C. B. Horrall. Former El Congreso president Eduardo Quevedo chaired the committee, and Manuel Ruiz acted as secretary. Approximately a year later, the Los Angeles County Board of Supervisors created the Citizens' Committee for Latin American Youth, an almost identical group with matching goals and membership.

78 "CCLAY Minutes," 7 June 1943, Minutes, 1943, Box 3, Folder 8, Ruiz Papers.

79 "Mexican-American Girls Meet in Protest," *Eastside Journal*, 16 June 1943, 5.

80 See, for example, "Column Left," *Eastside Journal*, 16 June 1943, 1, 5; and "'No Room for Mob Rule,'" *Eastside Journal*, 23 June 1943, 7. Pagán discusses Al Waxman's meetings with zoot suiters to quell violence in Pagán, "Sleepy Lagoon," 263–65.

81 "Mexican-American Girls Meet in Protest," *Eastside Journal*, 16 June 1943, 5.

82 Ibid.

83 Ibid. The incident is also discussed in McWilliams, *North from Mexico*, 231; and Ramírez, *Woman in the Zoot Suit*, 44–47.

84 According to Ramírez, the *Eastside Journal* protest "invoked the disreputable, delinquent, and disloyal pachuca only to reject her" (*Woman in the Zoot Suit*, 47).

85 "Girl 'Zoot Suiters' Gird to Join Gangland Battle, Pachucas Stand by Beaten Pachucos," *Los Angeles Evening Herald and Express*, 10 June 1943, A3; McWilliams, *North from Mexico*, 231; Griffith, *American Me*, 322; Burt, *Search for a Civic Voice*, 43–44. More details regarding the 1943 *Los Angeles Evening Herald and Express* exposé of the "pachuca" lifestyle can be found in Chapter One.

86 Burt, *Search for a Civic Voice*, 43–44; Griffith, *American Me*, 322.

87 Letter from Mayor Fletcher Bowron to Elmer Davis, 28 June 1943, Correspondence, Carbon Copies from Mayor's Office, 1939–1945; Box 1, 1943, Folder January–June, Fletcher Bowron Collection, Huntington Library, Manuscripts Department, San Marino, Calif.

88 "Mexican Group Donates Blood to Aid Victory," *Los Angeles Times*, 2 July 1943, A2.

89 "L.A. Mexicans Give Blood to Red Cross," *Los Angeles Examiner*, 2 July 1943, 24; "Mexican Descendants Give Blood to Red Cross," *Los Angeles Examiner*, 2 July 1943, pt. ii, 8. In *Woman in the Zoot Suit*, Catherine Ramírez states that the "real pachucas" who insisted on pelvic exams never had their side of the story "presented to the public by a Los Angeles newspaper." Indeed, Los Angeles newspapers appear never to have covered the young women's anger and desire to prove their virginity, but evidence suggests that they did take part in the OWI blood donation publicity stunt, which was covered by the mainstream press. See Ramírez, *Woman in the Zoot Suit*, 46.

90 "Youthful Gang Secrets Exposed," *Los Angeles Times*, 16 July 1944, A1.

91 Winchell, *Good Girls*.

92 "Girls' Group Opposes L.A. Times Article," *Eastside Journal*, 9 August 1944, 1, 4.

93 George Sánchez discusses the limitations and failures of turn-of-the-century Americanization campaigns in " 'Go after the Women,' " 260–61.

CHAPTER THREE

1 Echeverría Mulligan, interview, vol. 27, Rosie the Riveter Project, 17–18, 21, 28–31.

2 Ruiz, *Cannery Women*, 80.

3 Echeverría Mulligan, interview, vol. 27, Rosie the Riveter Project, 25.

4 Wilburn, "Social and Economic Aspects of the Aircraft Industry," 44, 47.

5 Gluck, *Rosie the Riveter Revisited*, 9–11, 23. For more information on American women and labor during World War II, see Anderson, *Wartime Women*; Lemke-Santangelo, *Abiding Courage*; Gluck, *Rosie the Riveter Revisited*; and Hartmann, *Home Front and Beyond*.

6 Anderson, "Last Hired, First Fired," 87.

7 Orenstein, "Void for Vagueness," 369; Foner, *Story of American Freedom*, 39. With the Naturalization Act of 1790, Congress had stipulated that only "free white persons" could become U.S. citizens. Not until the act was amended in 1870 did blacks become eligible for citizenship; not until the 1940s did persons of Asian descent become eligible.

8 Foley, "Partly Colored or Other White"; Guglielmo, "Fighting for Caucasian Rights," 1215–16.

9 Verge, *Paradise Transformed*, 50.

10 "Hay 12,000 Mexicanos en la Douglas," *La Opinión*, 23 January 1944, 4; "Digest of Proceedings of Conference on the Vocational Future of Mexican Americans," Los Angeles, 19 February 1944, Box 58, Folder 6, Series IV, Mexicans in the United States,

Reports, 1944, Galarza Papers; "Mexican Americans Set Pace in Los Angeles War Plants," untitled and undated newspaper clipping, Box 58, Folder 3, Series IV, Mexicans in the United States, newsclippings, 1941–1959, Galarza Papers.

11 Leonard, "'Brothers under the Skin'?," 192. Leonard similarly discusses the integration of the wartime workplace in his book on race in World War II Los Angeles. See Leonard, *Battle for Los Angeles*, 19–48.

12 See Santillán, "Rosita the Riveter," 124–25.

13 Echeverría Mulligan, interview, vol. 27, Rosie the Riveter Project, 25.

14 Purdy, Interview 1c Segment 4 (7:46–12:33) Segkey: a4189, VOAHA; Purdy, Interview 1d Segment 8 (26:22–30:29) Segkey: a4202, VOAHA; Purdy, Interview 2a Segment 1 (0:00–4:00) Segkey: a4203, VOAHA.

15 Martínez Mason, interview, vol. 23, Rosie the Riveter Project, 71.

16 Vicki Ruiz utilizes the term "familial oligarchy" as a way to denote that it was not just male patriarchs exercising control over their daughters; mothers and female relatives played a critical role in surveillance as well. See Ruiz, *Cannery Women* and *From Out of the Shadows*, 175 n. 2.

17 Beatrice Morales Clifton, interview in Gluck, *Rosie the Riveter Revisited*, 200, 208–9; Takaki, *Double Victory*, 100–101. Historian Karen Anderson also discusses the self-esteem gained by wartime women laborers in her study of women and the Second World War. See Anderson, *Wartime Women*, 63.

18 Hernández Milligan, interview, vol. 26, Rosie the Riveter Project, 26.

19 Lemke-Santangelo, *Abiding Courage*, 107; Ruiz, *Cannery Women, Cannery Lives* and *From Out of the Shadows*; Glenn, "From Servitude to Service Work"; Yung, *Unbound Feet*, 263.

20 Ruiz, *Cannery Women*, 72.

21 Durón, "Mexican Women and Labor Conflict in Los Angeles," 149, 156.

22 Hine and Faragher, *American West*, 398.

23 Romero, *Maid in the U.S.A.*, 112.

24 Defense companies typically would provide small raises until employees reached the top of their job classification's wage scale. See Beatrice Morales Clifton, interview in Gluck, *Rosie the Riveter Revisited*, 211; Hill, interview, vol. 14, Rosie the Riveter Project, 58–59; Drake, interview, vol. 10, Rosie the Riveter Project, 33; Hernández Milligan, vol. 26, Rosie the Riveter Project, 42; Martínez Mason, interview, vol. 23, Rosie the Riveter Project, 87; and pay stubs of Marybelle Hagadorn, assembler at Lockheed from 1942 to 1945, in author's possession. On wages for specific aircraft occupations, see Sato, "Gender and Work," 160. See also "Factory Codes, Occupations and Rates," *Lockheed-Vega Star*, 7 May 1943, 3.

25 Ruiz, *Cannery Women*, 70–72.

26 Vargas, *Labor Rights Are Civil Rights*, 37.

27 Pesotta, *Bread Upon the Waters*, 23.

28 Fierro, interview, vol. 12, Rosie the Riveter Project, introduction.

29 Lemke-Santangelo discusses the importance of women's wage labor to African American families in *Abiding Courage*, 117. According to Vicki Ruiz, "in general,

women's employment in the food processing industry strengthened, rather than disrupted, Mexican families." See *Cannery Women*, 19.

30 Luna, interview, vol. 20, Rosie the Riveter Project, 27.

31 Escobedo Burdette, interview.

32 Molina Mariscal, interview.

33 Macías Reyes, interview.

34 "Six Women Workers Clean Up in 'Win With Wings' Drawing," *Santa Monica Airview News*, 22 June 1943, 5; "Win With Wings Application," *El Segundo Airview News*, 15 June 1943, 5.

35 Wilburn, "Social and Economic Aspects of the Aircraft Industry," 173, 185; Gluck, *Rosie the Riveter Revisited*, 263; Martínez Mason, interview, vol. 23, Rosie the Riveter Project, 70; Salazar McSweyn, Interview 2b Segment 6 (15:49–18:42) Segkey: a3629, VOAHA.

36 Malagon, interview.

37 Hurtado Davis, interview.

38 Morales Clifton, Interview 1c Segment 2 (2:00–6:23) Segkey: a3865, VOAHA; Morales Clifton, Interview 1c Segment 5 (20:36–23:53) Segkey: a3868, VOAHA.

39 Schipske, *Rosie the Riveter in Long Beach*, 7, 27.

40 Luna, Interview 2a Segment 4 (8:11–10:47) Segkey: a3530, VOAHA.

41 Schipske, *Rosie the Riveter in Long Beach*, 7.

42 Wilburn, "Social and Economic Aspects of the Aircraft Industry," 173.

43 Dotson, interview, vol. 9, Rosie the Riveter Project, 34.

44 Hurtado Tafolla, interview.

45 Margarita Salazar McSweyn interview in Gluck, *Rosie the Riveter Revisited*, 85–86.

46 Annie Hurtado Tafolla recalled seeing Mexican girls with pompadours and baggy pants at Douglas in Long Beach. See Hurtado Tafolla, interview. Photos from the Douglas *Airview News* also reveal the existence of women in zoot suit styles at work in the aircraft industry. See, for example, "Pert Miss," *Long Beach Airview News*, 12 October 1943, 20; and "Asleep on Graveyard," *El Segundo Airview News*, 11 January 1944, 4. It should be noted that wearing pants was certainly nothing novel or radical for farm workers. See, for instance, Fierro, Interview 2a Segment 4 (5:16–7:17) Segkey: a3951, VOAHA.

47 Singleton, interview, vol. 39, Rosie the Riveter Project, 31; Purdy, interview, vol. 35, Rosie the Riveter Project, introduction.

48 Douglas *Airview News*; Telephone Directory, Douglas Aircraft Company, Inc., August 1943 and March 1944, Boeing Historical Archives.

49 See Sato, "Gender and Work," 156–57.

50 Douglas *Airview News*; Telephone Directory, Douglas Aircraft Company, Inc., August 1943 and March 1944, Boeing Historical Archives.

51 Purdy, interview, vol. 35, Rosie the Riveter Project, introduction; Morales Clifton, Interview 2b Segment 5 (9:25–12:40) Segkey: a3882, VOAHA.

52 Luna, Interview 2a Segment 8 (20:09–23:48) Segkey: a3534, VOAHA.

53 Houston, interview, vol. 16, Rosie the Riveter Project, 69.

54 Margarita Salazar McSweyn interview in Gluck, *Rosie the Riveter Revisited*, 89–90.

55 Indeed, workplace injuries and death were commonplace during World War II. According to historian Geoffrey Perrett, nearly 300,000 workers died in industrial accidents on the home front, over a million were permanently disabled, and three million suffered "lesser wounds" by the end of the war. See Perrett, *Days of Sadness, Years of Triumph*, 399.

56 The two rulings by the National War Labor Board involved the Brown and Sharpe Manufacturing Company and General Motors. In its decision involving General Motors Company, the board "accepted the general principle that wages should be paid to female employees on the principle of equal pay for equal work. There should be no discrimination between employees whose production is substantially the same on comparable jobs." See Fisher, "Equal Pay for Equal Work Legislation," 51–52.

57 Milkman, *Gender at Work*. Unions that represented large numbers of women, like the United Cannery, Agricultural, Packing and Allied Workers of America/Food, Tobacco, Agricultural, and Allied Workers of America (UCAPAWA/FTA), advocated for equal pay for equal work in its labor contracts. See Ruiz, *Cannery Women*, 88.

58 Milkman, "Redefining 'Women's Work,'" 211. Emphasis is Milkman's.

59 Sato, "Gender and Work," 160; Wilburn, "Social and Economic Aspects of the Aircraft Industry," 229.

60 Milkman, "Redefining 'Women's Work,'" 216–18; Anderson, *Wartime Women*, 35.

61 Sato, "Gender and Work," 152.

62 Luna, interview, vol. 20, Rosie the Riveter Project, 35.

63 Margarita Salazar McSweyn, interview in Gluck, *Rosie the Riveter Revisited*, 86.

64 Anderson, *Wartime Women*, 56.

65 Gluck, *Rosie the Riveter Revisited*, 261.

66 Meredith, *Understanding the Literature of World War II*, 102.

67 Beatrice Morales Clifton, interview in Gluck, *Rosie the Riveter Revisited*, 210–11.

68 Marye Stumph, interview in Gluck, *Rosie the Riveter Revisited*, 63.

69 Sato, "Gender and Work," 158.

70 Marye Stumph, interview in Gluck, *Rosie the Riveter Revisited*, 63.

71 Douglas *Airview News*; Telephone Directory, Douglas Aircraft Company, Inc., August 1943 and March 1944, Boeing Historical Archives.

72 Sato, "Gender and Work," 154.

73 Margarita Salazar McSweyn, interview in Gluck, *Rosie the Riveter Revisited*, 86.

74 Morales Clifton, Interview 1c Segment 4 (13:33–20:36) Segkey: a3867, VOAHA.

75 Archibald, *Wartime Shipyard*, 17–18; Anderson, *Wartime Women*, 24–25.

76 Morales Clifton, Interview 1c Segment 4 (13:33–20:36) Segkey: a3867, VOAHA.

77 Beatrice Morales Clifton, interview in Gluck, *Rosie the Riveter Revisited*, 209.

78 Luna, interview, vol. 20, Rosie the Riveter Project, 35. Similarly, Vicki Ruiz documents the experience of Julia Luna Mount, a Mexican American woman who left the food-processing industry for a defense job at Douglas during World War II. Mount was eventually forced to quit her defense position after "unrelenting sexual harassment" on the job. See Ruiz, *From Out of the Shadows*, 101–2.

79 Douglas *Airview News*; Telephone Directory, Douglas Aircraft Company, Inc., August 1943 and March 1944, Boeing Historical Archives.

80 Houston, interview, vol. 16, Rosie the Riveter Project, 56.

81 Morales Clifton, Interview 2b Segment 3 (4:44–7:38) Segkey: a3880, VOAHA; Luna, Interview 2b Segment 6 (16:34–20:37) Segkey: a3543, VOAHA; Salazar McSweyn, Interview 2c Segment 4 (6:39–10:02) Segkey: a3635, VOAHA.

82 See, for example, "Douglas Filipinos Invited to Anniversary Program in Los Angeles Sunday," *Santa Monica Airview News*, 11 April 1944, 2; "Around the Clock at Douglas," *Santa Monica Airview News*, 7 September 1943, 20; "65 Chinese Boys Suddenly Appeared," *Santa Monica Airview News*, 26 October 1943, 12; "Six American-born Koreans Fight Hereditary Enemy—Japan," *Long Beach Airview News*, 11 January 1944, 7; and "Youngest of Group Leaders, That's Dolores Bartolome," *El Segundo Airview News*, 15 June 1943, 11.

83 See, for example, USES Form 510, Report of Discriminatory Hiring Practices, H. Copsy/Copsy's Café, 2 January 1945, Box 3607, Folder "FEPC—Forms 510 USES, A–L, January 1944–June 1945," Series 278, Region XII WMC Records; USES Form 510, Report of Discriminatory Hiring Practices, S.C. Bronson Co., 6 February 1945, Box 3607, Folder "FEPC—Forms 510 USES, A–L, January 1944–June 1945," Series 278, Region XII WMC Records; USES Form 510, Report of Discriminatory Hiring Practices, Union Ice Company, 1 December 1944, Box 3607, Folder "FEPC—Forms 510 USES, M–Z, January 1944–June 1945," Series 278, Region XII WMC Records.

84 USES Form 510, Report of Discriminatory Hiring Practices, National Car Loading Company, 16 October 1942, Box 2914, Folder "Labor Misc. 1942," Region XII WMC Records.

85 Anderson, "Last Hired, First Fired," 87. In 1944, the field superintendent of T. P. Pike Drilling Company first told WMC investigators that his crew would walk out if he were to hire blacks or Mexicans; later he admitted that "he, himself, would quit." See USES Form 510, Report of Discriminatory Hiring Practices, T. P. Pike Drilling Company, 21 August 1944, Box 3607, Folder "FEPC Form 510 USES M–Z, January 1944–June 1945," Region XII WMC Records. Federal officials regularly explained to problematic employers that black workers had mixed with other workers at plants nationwide, with negligible work stoppage. See, for example, USES Form 510, Report of Discriminatory Hiring Practices, E. J. Jenkins Service Company, 31 July 1944, Box 3607, Folder "FEPC—Forms 510 USES, A–L, January 1944–June 1945," Series 278, Region XII WMC Records.

86 Laughlin, Interview 1c Segment 3 (3:26–8:52) Segkey: a5971, VOAHA.

87 Wilburn, "Social and Economic Aspects of the Aircraft Industry," 180; Sides, *L.A. City Limits*, 83. According to historian Josh Sides, African Americans—particularly men—faced a much harsher color line in Los Angeles unions and defense industries like shipbuilding and longshoremen's work. See Sides, *L.A. City Limits*, chap. 3.

88 Wilburn, "Social and Economic Aspects of the Aircraft Industry," 177–78; "Buck O' Month Club Makes 'Y' Donation," *Lockheed Star*, 25 February 1944, 8.

89 Anderson, "Last Hired, First Fired," 86–87.

90 Houston, interview, vol. 16, Rosie the Riveter Project, 74–75.

91 Susan Laughlin, interview in Gluck, *Rosie the Riveter Revisited*, 250.

92 Ruiz, *Cannery Women*, 25, 29–30.

93 Jones, *Labor of Love, Labor of Sorrow*.

94 Wilburn, "Social and Economic Aspects of the Aircraft Industry," 177.

95 Singleton, interview, vol. 39, Rosie the Riveter Project, 24.

96 Morales Clifton, Interview 2c Segment 5 (8:20–12:03) Segkey: a3892, VOAHA; Luna, Interview 2b Segment 2 (2:11–9:51) Segkey: a3539, VOAHA; Drake, interview, vol. 10, Rosie the Riveter Project, 41; Marie Baker, interview in Gluck, *Rosie the Riveter Revisited*, 230; Santillán, "Rosita the Riveter," 127.

97 Letter from Mary Hines to Mr. President, 24 August 1943, Box 847, Folder "Lockheed Vega Plant 12-BR-1058," Region XII, Los Angeles, Closed Cases, L–M, Region XII FEPC Records.

98 JK, interview, vol. 18, Rosie the Riveter Project, 43–44.

99 Arrowhead Food Products Co. case file, Box 842, Regional Files, Region XII, Los Angeles Closed Cases, A–At, Folder "Arrowhead Food Products, 12-BN-1379," Region XII FEPC Records; USES Form 510, Report of Discriminatory Hiring Practices, Arrowhead Food Products, 16 August 1944, Box 3607, Folder "FEPC—Forms 510 USES, A–L, January 1944–June 1945," Series 278, Region XII WMC Records.

100 USES Form 510, Report of Discriminatory Hiring Practices, Bermite Powder Company, 8 July 1943, Box 3608 "Minority Discrimination Files," Folder "Discrimination Cases," Series 278, Region XII WMC Records. Although, by federal law, aliens were not allowed to work on "classified" jobs—including secret, confidential, restricted, and aeronautical contracts—employers could lawfully hire aliens if they acquired permission from the War and Navy Departments. In July of 1942, President Roosevelt made clear the illegality of refusing to hire aliens in wartime industries. According to the president's statement, "Persons should not hereafter be refused employment, or persons at present employed discharged, solely on the basis of the fact that they are aliens or that they were formerly nationals of any particular foreign country." The refusal to hire aliens, explained the president, represented "a general condemnation of [a] group or class of persons" and was "unfair and dangerous to the war effort." Employers were urged to acquire government permission—an overhauled process that would take a mere forty-eight hours. See "Employment of Aliens in National War Industries," 11 July 1942, Box 3, Folder 2, Defense Employment and Training, 1941–1943, Ruiz Papers.

101 FEPC case file of Pomposo Alba, Box 852, Regional Files XII, Non-docketable Cases A–Z, Pending Docketable Cases, "Non-Docketable Cases" Folder, Region XII FEPC Records. According to the NARA index, "non-docketable" FEPC case files involved four different kinds of complaints: those that were dismissed because the FEPC had no jurisdiction to handle them, those that were made anonymously, those that did not provide "essential facts," and those that alleged discrimination in matters other than employment.

102 Reed, *Seedtime for the Modern Civil Rights Movement*; Ruchames, *Race, Jobs & Politics*; Garfinkel, *When Negroes March*.

103 Daniel, *Chicano Workers*. FEPC hearings did take place in Los Angeles in the fall of 1941, but they were dominated by concerns raised by the African American community, with comparatively little discussion of Mexicans in Los Angeles. For a discussion of the Los Angeles FEPC hearings, see Leonard, *Battle for Los Angeles*, 28–48.

104 See Kersten, *Race, Jobs, and the War*; Shockley, *"We, Too, Are Americans."* For a specific discussion of the ways in which "many historians have denied the importance of the FEPC, suggesting that conditions in the labor market had a greater influence on minority employment," see *Race, Jobs, and the War*, 4. Eileen Boris discusses the agency's strengths and weaknesses, underscoring the latter. See Boris, " 'You Wouldn't Want One of 'Em Dancing with Your Wife,' " 82–83.

105 Memo from Vera Vetter to Harry L. Kingman, "Los Angeles Office Case Statistics as of December 31, 1944," 12 January 1945, Box 7, General Records, 1941–1945, Administrative Files, L.A. Office—XY, Folder "Los Angeles Office," Entry 85, Region XII FEPC Records; "FEPC and Discrimination against Mexicans," Headquarters Records, Division of Review and Analysis, Reference File, July 1941–April 1946, Studies and Reports Issued by Federal and Local Government Units and Organizations, Box 427, Entry 33, Folder "Memos Re: Mexican Workers," FEPC Records; Penrod, "Civil Rights Problems of Mexican-Americans," 87–88. These findings dispute those of Gerald Nash, who states: "A reading of the complete files of the more than 500 cases that came before Region 12 of the Fair Employment Practices Committee reveals that only one discrimination complaint was made by a Spanish-speaking person, despite the fact that Director Harry Kingman appointed a special agent in Los Angeles for Hispanic-Americans in the hope of publicizing the work of the commission and facilitating the use of its good offices" (Nash, *American West Transformed*, 121). Unfortunately, while I located thirty-five of the Los Angeles complaints by members of the Mexican population, I could not find all one hundred of the case files described in Vera Vetter's January 1945 memo to Harry L. Kingman.

106 Memo from Vera Vetter to Harry L. Kingman, "Los Angeles Office Case Statistics as of December 31, 1944," 12 January 1945, Box 7, General Records, 1941–1945, Administrative Files, L.A. Office—XY, Folder "Los Angeles Office," Entry 85, Region XII FEPC Records; Daniel, *Chicano Workers*, 3, 6.

107 Daniel, *Chicano Workers*, xi, 8.

108 Johnson, "Constellations of Struggle"; Bernstein, *Bridges of Reform*, 87–89.

109 Ruiz, "Luisa Moreno," 183.

110 Escobar, *Race, Police, and the Making of a Political Identity*, 171–72.

111 Letter from Harry L. Kingman to Carl Hagstrom, Civil Service Commission, 5 September 1943, Box 2, General Records, 1941–1945, Administrative Files, Pers-WMC, Folder "Personnel-Los Angeles Office," Entry 85, Region XII FEPC Records; letter from Ignacio L. López, Examiner, to Harry L. Kingman, Regional Director, 1 March 1945, Box 6, General Records, 1941–1945, Administrative Files, Requisitions-Personnel Consuls, Folder "FEPC-L.A. Ignacio López," Entry 85, Region XII FEPC Records.

112 FEPC case file of Francisco Torres, Box 850, Region XII, Los Angeles Closed Cases, S–T, Folder "Southern Pacific Company, 12-BN-1442," Region XII FEPC Records.

113 FEPC case file of Artemisa Carranza, Box 842, Regional Files, Region XII, L.A. Closed Cases, A–At, Folder "Atlas Export Packing Co., 12-BN-1541," Region XII FEPC Records; WMC case file of Artemisa Carranza, Box 3607, Minority Discrimination, Folder "FEPC-Forms 510 USES, A–L, Jan. 1944-June 1945," Region XII WMC Records.

114 In general, Lockheed and other aircraft corporations preferred the AFL over the CIO. For an in-depth discussion of labor unions in Los Angeles aircraft, see Wilburn, "Social and Economic Aspects of the Aircraft Industry," chap. 4.

115 Mendoza Schechter Oral History, 29.

116 *La Opinión*, 23 January 1944, 2.

117 Consuelo Andrade, 7-559 Grievance between North American Aviation, Inc. (Inglewood, Calif.), and United Automobile, Aircraft and Agricultural Implement Workers of America, Affiliated with the Congress of Industrial Organizations, Local 887 (labeled C-47), 9 November 1945, Box 8, Folder 3, UAW, Local 887 vs. North American Aviation, Inc.: arbitration awards, 1941–1946 (3 of 4), Southern California Arbitration Case File Collection, California State University, Northridge, Urban Archives Center.

118 Luna, Interview 2a Segment 10 (26:25–28:40) Segkey: a3536, VOAHA.

119 According to Jesus Fuentes, husband of aircraft worker Angela Fuentes, there were quite a few Mexican women in the UAW 148 during the World War II era. Fuentes, interview; Shelit, Interview 2c Segment 2 (5:29–6:46) Segkey: a4038, VOAHA.

120 Purdy, interview, vol. 35 of Rosie the Riveter Project.

121 Luna, Interview 2a Segment 10 (26:25–28:40) Segkey: a3536, VOAHA; Luna, Interview 2b Segment 1 (0:00–2:11) Segkey: a3538, VOAHA.

122 Foley, "Partly Colored or Other White"; Guglielmo, "Fighting for Caucasian Rights," 1215–16.

123 Sides, *L.A. City Limits*, 73.

124 USES Form 510, Report of Discriminatory Hiring Practices, California Almond, 9 September 1944, Box 3607, Folder "FEPC—Forms 510 USES, A–L, January 1944–June 1945," Series 278, Region XII WMC Records.

125 USES Form 510, Report of Discriminatory Hiring Practices, Los Angeles Paper Bag Co., 22 January 1945, "Minority Discrimination," Folder "FEPC—Forms 510 USES, A–L, January 1944–June 1945," Series 278, Region XII WMC Records.

126 USES Form 510, Report of Discriminatory Hiring Practices, E. J. Jenkins Service Company, 31 July 1944, Box 3607, Folder "FEPC—Forms 510 USES, A–L, January 1944–June 1945," Series 278, Region XII WMC Records.

127 Charlcia Neuman, interview in Gluck, *Rosie the Riveter Revisited*, 166.

128 Beatrice Morales Clifton, interview in Gluck, *Rosie the Riveter Revisited*, 208; Echeverría Mulligan, interview, vol. 27, Rosie the Riveter Project, 51, 53–54; Hurtado Tafolla, interview.

129 Quiñonez, "Rosita the Riveter," 264.

130 USES Form 510, Report of Discriminatory Hiring Practices, Pacific Fruit Express, 2 April 1943, Box 25, Folder "Labor—Discrimination General—1943," Series 269, Region XII WMC Records.

131 For a discussion of integrated restrooms as a "site of struggle," see Anderson, "Last Hired, First Fired," 86; and Boris, "'You Wouldn't Want One of 'Em Dancing with Your Wife,'" 93–97.

132 Foley, "Becoming Hispanic."

133 Gerstle, "Working Class Goes to War," 118.

134 Luna, Interview 2b Segment 6 (16:34–20:37) Segkey: a3543, VOAHA. For an in-depth study of "sundown towns," see Loewen, *Sundown Towns*.

135 Singleton, interview, vol. 39, Rosie the Riveter Project, 30.

136 Vicki Ruiz discusses the "cross-ethnic bridges" of friendship at the workplace in *Cannery Women*, 34–35.

137 Leonard, "'Brothers under the Skin?,'" 191–92.

138 Houston, interview, vol. 16, Rosie the Riveter Project, 75–76.

139 Helen Studer, interview in Gluck, *Rosie the Riveter Revisited*, 188.

140 Martínez Mason, interview, vol. 23, Rosie the Riveter Project, 79.

141 Luna, interview, vol. 20, Rosie the Riveter Project, 23, 38–39.

142 Vicki Ruiz discusses Mexican female networks of the cannery culture in *Cannery Women*, 19 and 33, and *From Out of the Shadows*, xv.

143 Ruiz, *Cannery Women*, 28.

144 Echeverría Mulligan, interview, vol. 27, Rosie the Riveter Project, 17.

CHAPTER FOUR

1 Ponce, *Hoyt Street*, 28, 33.

2 For a discussion of "cultural coalescence" and Mexican women, see Ruiz, *From Out of the Shadows*.

3 Giordano, *Social Dancing in America*, 79.

4 Winchell, *Good Girls*, 139, 151.

5 Lingeman, *Don't You Know There's a War On?*, 280–81.

6 For a discussion of pre–World War II leisure activities in the Mexican American community, see Escobedo, "Mexican American Home Front," 33–56.

7 Gonzáles Bernal, interview.

8 Rivera Cardenas, interview.

9 Lupe Leyvas recalled concocting plans with an older brother in order to bypass their parents' traditional expectations. See Pagán, *Murder at the Sleepy Lagoon*, 51. For an excellent discussion of the system of chaperonage, and efforts by second-generation daughters to transgress its limitations, see Ruiz, *From Out of the Shadows*, 58–71. For further discussion of conflicts between the immigrant and second generations, see also Monroy, *Rebirth*, 165–207.

10 Ruiz, *From Out of the Shadows*, 63.

11 Contreras Mojica, interview.

12 Luna, interview, vol. 20, Rosie the Riveter Project, 29.

13 Velarde, interview.

14 Ruiz, "Nuestra América," 666.

15 Echeverría Mulligan, interview, vol. 27, Rosie the Riveter Project, 25.

16 Gonzáles Benavidez, interviews by author, 6 November 2000 and 6 December 2000.

17 Escobedo Burdette, interview.

18 Lozano Holtzman, interview, 8 October 2000.

19 See Chapter 3 for more discussion of defense wage rates.

20 Davenport, "Swing It, Swing Shift!"

21 Vicki Ruiz uses the term "cannery culture" to discuss women's interactions at work in Southern California canneries, arguing that labor activities facilitated communication among women of diverse ethnic groups. See Ruiz, *Cannery Women*, 31–39, 69–71. Margarita Salazar McSweyn learned about dating and romance from her Italian American coworker and girlfriend. See her interview in Gluck, *Rosie the Riveter Revisited*, 83, 86.

22 Luna, interview, vol. 20, Rosie the Riveter Project, 36; Mendoza Schechter, interview.

23 Hernández Milligan, interview, vol. 26, Rosie the Riveter Project, 37–40.

24 Erenberg, *Swingin' the Dream*, 182; Erenberg, "Swing Goes to War," 145.

25 Macías, *Mexican American Mojo*, 51. Chapters 1 and 2 of Macías's book provide nuanced and detailed discussion of Mexican American youths and the swing and jazz scene. Eduardo Pagán also provides an excellent analysis of the various ways in which Mexican American youths utilized jazz to negotiate their sense of place in Los Angeles during World War II. See Pagán, *Murder at the Sleepy Lagoon*.

26 Rivera Alonzo, interview.

27 Erenberg, *Swingin' the Dream*; Lara Acosta, interview; Escobedo Atterbury, interview, 6 January 1998.

28 Pagán, "Sleepy Lagoon," 98.

29 Ferguson, interview; Rodríguez Raugi, interview.

30 Gloria Berlin interview, "Dance Halls," "Zoot Suit Riots," PBS *American Experience*, http://www.pbs.org/wgbh/amex/zoot/eng_sfeature/sf_zoot_text.html (19 March 2010); Erenberg, *Swingin' the Dream*, 40.

31 Lupe Leyvas interview, "Girls' Style," "Zoot Suit Riots," PBS *American Experience*, http://www.pbs.org/wgbh/amex/zoot/eng_sfeature/sf_zoot_text.html (19 March 2010).

32 Castillo Molano, interview.

33 Griffith, *American Me*, 45.

34 Leyvas, interview.

35 Gloria Berlin interview, "Dance Halls," "Zoot Suit Riots," PBS *American Experience*, http://www.pbs.org/wgbh/amex/zoot/eng_sfeature/sf_zoot_text.html (19 March 2010).

36 Pagán, "Sleepy Lagoon," 104–5; Erenberg, *Swingin' the Dream*, 50.

37 Arthur Arenas interview, "Pachuco Attitude," "Zoot Suit Riots," PBS *American Experience*, http://www.pbs.org/wgbh/amex/zoot/eng_sfeature/sf_zoot_text.html (19 March 2010).

38 Stowe, *Swing Changes*, 44.

39 For discussion of the multiracial leisure scene in wartime Los Angeles, see Macías, *Mexican American Mojo*, chap. 1; Alvarez, *Power of the Zoot*, chap. 4; Pagán, *Murder*

at the Sleepy Lagoon, 49–54; España-Maram, "Brown 'Hordes' in McIntosh Suits." Quotation found in Arthur Arenas interview, "Downtown L.A.," "Zoot Suit Riots," PBS *American Experience*, http://www.pbs.org/wgbh/amex/zoot/eng_sfeature/sf_zoot_text.html (19 March 2010). Analysis of intercultural encounters in post–World War II dance halls can be found in Garcia, *World of Its Own*, 189–214.

40 Macías, *Mexican American Mojo*, 39–40, 69, 95; Davenport, "Swing It, Swing Shift!," 21, 26.

41 Alvarez, *Power of the Zoot*, 116, 134; Pagán, *Murder at the Sleepy Lagoon*, 50.

42 Villalobos Velasco, interview.

43 Rodríguez Raugi, interview; Gloria Berlin interview, "Dance Halls," "Zoot Suit Riots," PBS *American Experience*, http://www.pbs.org/wgbh/amex/zoot/eng_sfeature/sf_zoot_text.html (19 March 2010). Similarly, Mary López Burger claimed in her interview that she would go to dances that were "all mixed." As López explained it, "Everybody that asked you to dance you would dance with." See López Burger, interview.

44 I borrow the term "crossings" from Allison Varzally and her work on intercultural and interracial romances, "Romantic Crossings."

45 Roeder, *Censored War*, 44, 46–47; Romano, *Race Mixing*, 20–22. Black women Douglas employees did receive recognition for their efforts in forming an organization to entertain servicemen in 1943, but this was for a "colored battery," available only to black servicemen. See "'Something for the Boys,'" *Douglas Airview* 10, no. 6 (June–July 1943): 34–35.

46 "Beauty Isn't Rationed," *Long Beach Airview News*, 6 July 1943, 8; "118 Beauties Vie for 'Queen's' Crown," *Santa Monica Airview News*, 18 January 1944, 2–3; "Santa Monica: Long Live the Queen," *Douglas Airview* 12 (March 1945): 36; "Fifteen Sweethearts, One a Queen," *Santa Monica Airview News*, 13 February 1945, 2. For a discussion of beauty pageantry and the ways in which beauty contests represent a forum for those deemed "proper" representatives of a nation, see Banet-Weiser, *Most Beautiful Girl in the World*; and Banner, *American Beauty*, 249–70.

47 "Petite Beauty Collects, Buys, Distributes Gifts to Hospitalized Vets," *Long Beach Airview News*, 7 December 1943, 9. Interestingly, Geraldine Ciqueiros is a cousin of former Los Angeles city councilman and California Democratic representative Edward Roybal. See "Celebrating the Life of Carmen N. Ciqueiros Tafoya Perkins Mullaly," Hon. Lucille Roybal-Allard of California in the House of Representatives, *Congressional Record*, 7 October 2005.

48 "Geraldine Ciqueiros (402) Weds Lieut. Glen Overton," *Long Beach Airview News*, 4 July 1944, 5.

49 "'Boy Meets Girl' Experiment Proves Holiday Success," *Santa Monica Airview News*, 4 January 1944, 9. Lupe Leyvas, sister of Sleepy Lagoon defendant Hank Leyvas, similarly recalled traveling to March Field with fellow Mexican American girls and Mexican mothers to dance with servicemen—many Euro-American—as a benefit to raise awareness of the injustices of the Sleepy Lagoon case. See Leyvas, interview.

50 Panunzio, "Intermarriage in Los Angeles," 692. Manuel Gamio reports a similar finding in *Mexican Immigration to the United States*, 55.

51 Macías, *Mexican American Mojo*, 20.

52 Varzally, *Making a Non-White America*, 89.

53 Arevalo Baca, interview.

54 Romo, *East Los Angeles*, 152; Monroy, *Rebirth*, 62–63; Ríos-Bustamante and Castillo, *Illustrated History of Mexican Los Angeles*, 139; Gluck, *Rosie the Riveter Revisited*, 74.

55 My knowledge of Mexican youth clubs comes from extensive reading of *La Opinión*, the Los Angeles Spanish-language daily, in which their social activities were frequently documented in the late 1930s and 1940s.

56 Alma Joven program found in Salazar McSweyn, interview, vol. 25, Rosie the Riveter Project. For discussion of the "México de Afuera" worldview, see Monroy, *Rebirth*; and García, "*La Frontera*," 90–97.

57 Alma Joven program, Salazar McSweyn, interview, vol. 25, Rosie the Riveter Project.

58 Margarita Salazar McSweyn, interview in Gluck, *Rosie the Riveter Revisited*, 82–83; Salazar McSweyn, interview, vol. 25, Rosie the Riveter Project, 59–60.

59 Margarita Salazar McSweyn, interview in Gluck, *Rosie the Riveter Revisited*, 83.

60 Historian Valerie Matsumoto documents a similarly vibrant Nisei youth club culture that developed in Los Angeles in the 1930s. According to Matsumoto, Nisei clubs provided Japanese American women with opportunities to experiment with positions of leadership and to engage in charitable endeavors and recreation, cultivating both "ethnic pride" and "modern womanhood." See Matsumoto, "Japanese American Women and Nisei Culture."

61 Margarita Salazar McSweyn, interview in Gluck, *Rosie the Riveter Revisited*, 86.

62 Nisei social clubs also faced disruption during the war years, but for very different reasons. As Valerie Matsumoto argues, the internment of Japanese and Japanese Americans "dashed many Nisei dreams and shattered Japanese American communities." However, she also documents that within internment camps young Japanese American women witnessed a breakdown of patriarchal authority and supervision, thus allowing them new opportunities to socialize and engage in recreational activities. See Matsumoto, "Japanese American Women and Nisei Culture," 303; and Matsumoto, "Japanese American Women during World War II."

63 Martínez, interview.

64 Luna, interview, vol. 20, Rosie the Riveter Project, 52.

65 For a comprehensive history of USO volunteers and patrons during World War II, see Winchell, *Good Girls*.

66 Campbell, *Women at War with America*, 68; Lingeman, *Don't You Know There's a War On?*, 280; Winchell, *Good Girls*, 12, 48–49.

67 Echeverría Mulligan, interview, vol. 27, Rosie the Riveter Project, 26.

68 Winchell, *Good Girls*, 47, 53–55. Former defense worker Rose Singleton recalls her experiences with segregated USOs in Southern California. See Singleton, interview, vol. 39, Rosie the Riveter Project, 39. Winchell does point out, however, that black female hostesses were at times added to USO staff in order to prevent interracial dancing that offended some junior hostess captains and servicemen.

69 For a discussion of Japanese American women and USOs in the U.S. South, see Howard, "Politics of Dancing." Howard notes the ways in which Japanese Americans in general demonstrated "a significant ability to move in and across a number of spaces segregated as white" in the wartime South, but in the realm of courtship and matrimony, southern USOs strictly encouraged only intraethnic dating for Japanese American troops and internees (quotation on 129).

70 "Confidential Report of the Conference on the Spanish-Speaking Minority Program in the Southwest, Held by the Division of Inter-American Activities in the U.S., OCIAA, Washington, D.C.," 12–14 July 1943, Entry 1, General Records, Central Files, O. Inter-American Activities in the U.S. Spanish and Portuguese Speaking Minorities in U.S. Speaker's Service, Box 57, Folder "Spanish and Portuguese Speaking Minorities, JAN–MAR, 1943," OCIAA Records, 21.

71 Margarita Salazar McSweyn, interview in Gluck, *Rosie the Riveter Revisited*, 87.

72 Echeverría Mulligan, Interview 1c Segment 7 (25:04–29:23) Segkey: a4084, VOAHA.

73 Ophelia Ferguson remembered attending "dances to cheer up the fellas" at various military bases in Southern California during World War II. Here she "met a lot of young service personnel and they were not of Mexican descent." See Ferguson, interview.

74 Velarde, interview.

75 For a study that discusses the relative freedoms and liberties of the West, particularly in comparison to the racism of the South, see Sides, *L.A. City Limits*, 11–13. Similarly, Mark Wild argues that cities in the West were relatively more integrated, cosmopolitan, and diverse than other American cities, especially in the Northeast. See Wild, *Street Meeting*, 2.

76 "Confidential Report of the Conference on the Spanish-Speaking Minority Program in the Southwest, Held by the Division of Inter-American Activities in the U.S., OCIAA, Washington, D.C.," 12–14 July 1943, Entry 1, General Records, Central Files, O. Inter-American Activities in the U.S. Spanish and Portuguese Speaking Minorities in U.S. Speaker's Service, Box 57, Folder "Spanish and Portuguese Speaking Minorities, JAN–MAR, 1943," OCIAA Records, 14–15.

77 Winchell, *Good Girls*, 157–58.

78 Sánchez, "Pachucos in the Making."

79 Winchell, *Good Girls*, 164.

80 Margarita Salazar McSweyn, interview in Gluck, *Rosie the Riveter Revisited*, 88. Ophelia Ferguson witnessed a similar shift in her parents' attitude during the war. Although as a teenager she was always expected to have a relative join her when she went to a movie or a local malt shop, her father did not mind when she began to attend dances on military bases. See Ferguson, interview. For a brief discussion of the respectability associated with social activities for GIs, see Gluck, *Rosie the Riveter Revisited*, 87.

81 Winchell, *Good Girls*, 68–72.

82 Velarde, interview.

83 *Los Angeles Evening Herald and Express*, 19 December 1941, Young Women's Christian Association of Los Angeles Series VI: Scrapbook, YWCA/1 Box (OV) 52, Folder 1, Series VI: Scrapbooks, YWCA Collection.

84 For a history of the YWCA and race, see Robertson, *Christian Sisterhood*. The YWCA, founded in New York City by a group of elite white women engaged in the evangelical Protestant religious movement of the 1850s, eventually expanded to become a national reform organization with the purpose of providing social services, education, and leadership training for women across the country. According to Robertson, in spite of its promotion of interracialism, the YWCA officially remained a segregated institution for African Americans until 1946. See Robertson, *Christian Sisterhood*, 164.

85 "YWCA Designed to Teach Girls Life; Institution Organized to Aid Young Women in Application of Golden Rule," no newspaper title, 1933 date in pencil, Young Women's Christian Association of Los Angeles Series VI: Scrapbook, YWCA/1 Box (OV) 48, Folder 1, Announcement, list, newspaper clipping, photographs, 1927, 1931–1941, YWCA Collection.

86 Ibid.; "Mexican Dinner at YWCA Girls' Meet," *Los Angeles Evening Herald and Express*, 27 October 1938, Young Women's Christian Association of Los Angeles Series VI: Scrapbook, YWCA/1 Box (OV) 51, Folder 1, Newspaper clippings, 1938–1941, Series VI: Scrapbooks, YWCA Collection; "Carnival Planned by Y's Owls Club," *Los Angeles Times*, 5 December 1941, 18; "Bazaar Set by Y's Owls," *Los Angeles Times*, 1 December 1942, Young Women's Christian Association of Los Angeles Series VI: Scrapbook, YWCA/1 Box (OV) 52, Folder 1, Series VI: Scrapbooks, YWCA Collection. Valerie Matsumoto discusses the similar participation of Nisei women in YWCA clubs and activities during the 1930s. See Matsumoto, "Japanese American Women and Nisei Culture," 301–2. Mexican American women in World War II Los Angeles also engaged in the leisure world of sports—including tennis, softball, and gymnastics—in order to navigate their Mexican and American social worlds. See Alamillo, "Playing Across Borders."

87 "CCLAY Minutes," 4 January 1943, Minutes, 1943, Box 3, Folder 8, Ruiz Papers; "Confidential Report of the Conference on the Spanish-Speaking Minority Program in the Southwest, Held by the Division of Inter-American Activities in the U.S., OCIAA, Washington, D.C.," 12–14 July 1943, Entry 1, General Records, Central Files, O. Inter-American Activities in the U.S. Spanish and Portuguese Speaking Minorities in U.S. Speaker's Service, Box 57, Folder "Spanish and Portuguese Speaking Minorities, JAN–MAR, 1943," OCIAA Records, 21.

88 In order to trace the origins of the membership of the Latin American USO, I cross-referenced names from newspaper coverage of the Y's Owls, the Ideales Señoritas, and the full membership list of the Latin American USO group found in "Girls' Group Opposes L.A. Times Article," *Eastside Journal*, 9 August 1944, 4. See, for example, "Bazaar Set by Y's Owls," *Los Angeles Times*, 1 December 1942, Young

Women's Christian Association of Los Angeles Series VI: Scrapbook, YWCA/1 Box (OV) 52, Folder 1, Series VI: Scrapbooks, YWCA Collection; "Party Will Hold Flavor of Mexico," *Los Angeles Times*, 27 June 1943, D8; "Hoy Sera La 'Noche Mexicana' del Club Ideal de Señoritas," *La Opinión*, 20 June 1942, 4; "Animada Fiesta de las Miembros del 'Club de Señoritas,'" *La Opinión*, 11 January 1944, 4; and "Tuvo Elecciones el 'Ideal de Señoritas,'" *La Opinión*, 30 January 1944, 5. Although the group later became known as the Señoritas USO, the name Latin American USO was used during CCLAY meetings in 1943. See "CCLAY Minutes," 19 April 1943, Minutes, 1943, Box 3, Folder 8, Ruiz Papers; and "CCLAY Minutes," 3 May 1943, Minutes, 1943, Box 3, Folder 8, Ruiz Papers. In the postwar era the group called themselves "Las Señoritas de las Americas," and their charity work focused on Catholic churches. See, for example, "Señoritas Plan Ball Saturday," *Los Angeles Times*, 26 August 1948, B4; "Dance Set By Señoritas de Las Americas Club," *Los Angeles Times*, 14 August 1950, B5; "Señoritas Will Hold Dance," *Los Angeles Times*, 18 August 1955, B6.

89 "CCLAY Minutes," 19 April 1943, Minutes, 1943, Box 3, Folder 8, Ruiz Papers.

90 "CCLAY Minutes," 3 May 1943, Minutes, 1943, Box 3, Folder 8, Ruiz Papers.

91 On USO policy toward servicemen, see Winchell, *Good Girls*, 55. "CCLAY Minutes," 3 May 1943, Minutes, 1943, Box 3, Folder 8, Ruiz Papers. The official start date of the Latin American USO is documented in "Estableceran Un Centro USO Mexicano," *La Opinión*, 24 September 1944, 1.

92 "Estableceran Un Centro USO Mexicano," *La Opinión*, 24 September 1944, 1; letter from Aida Almanzán, Vice President of El Club Latino Americano del USO, to Manuel Ruiz, 14 January 1944, Correspondence, in-coming, Ag–Co, Box 2, Folder 18, Ruiz Papers; "Aids War Effort," *Eastside Journal*, 16 February 1944, 3.

93 "Estableceran Un Centro USO Mexicano," *La Opinión*, 24 September 1944, 1.

94 "Local USO Plans Spanish Fiesta Here," *Eastside Journal*, 13 October 1943, 3; "Aids War Effort," *Eastside Journal*, 16 February 1944, 3; "Esta Noche Habra Serenata Mexicana en La Placita; Las "Señoritas USO," presentarán el programa, con Crispín Martin de M.C.," *La Opinión*, 31 August 1944, 3; "Un Brillante Programa en la Placita; Lo presentaron las señoritas del USO el jueves," *La Opinión*, 2 September 1944, 8; "Estableceran Un Centro USO Mexicano," *La Opinión*, 24 September 1944, 1; "Girls' Group Opposes L.A. Times Article," *Eastside Journal*, 9 August 1944, 1. Description of La Placita found in Hayes-Bautista, *La Nueva California*, 17.

95 "Girls' Group Opposes L.A. Times Article," *Eastside Journal*, 9 August 1944, 1. See Chapter 2 for a more in-depth discussion of the Señoritas' calls for inclusion and equal treatment.

96 Letter from Aida Almanzán, Vice President of El Club Latino Americano del USO, to Manuel Ruiz, 14 January 1944, Correspondence, in-coming, Ag–Co, Box 2, Folder 18, Ruiz Papers.

97 The wartime self-presentation efforts of the Señoritas USO strike similarities with the ways in which historian Matt Garcia describes the Mexican Players at the Padua

Hills Theater who "just put on that Padua Hills smile." As Garcia explains it, even in the face of adversity, Paduanos "upheld an image that did not seriously threaten white spectators," allowing them to gain certain privileges typically unavailable to the Mexican population in the twentieth century. See Garcia, *A World of Its Own*, 121–54.

98 On the history of intermarriage between whites and Spanish/Mexicans in the nineteenth century, see, for example, González, *Refusing the Favor*; and Casas, *Married to a Daughter of the Land*.

99 Pagán, *Murder at the Sleepy Lagoon*, 18; Ramírez, *Woman in the Zoot Suit*, 40–43.

100 Himes, "Zoot Riots Are Race Riots," 200–201, 222. Mexican American women likewise recalled receiving harassment from Euro-American soldiers on city streets of wartime Los Angeles. Juanita Valencia Goodwin, a sixteen-year-old in 1942, remembered four soldiers stopping her on a city street and jostling her around. Years later she asked, "Would they have done that to a white woman? I think not." See "Trials Reawaken Memories of Sleepy Lagoon," *Los Angeles Times*, 15 February 1993, http://articles.latimes.com/1993-02-15/local/me-19_1_sleepy-lagoon (4 April 2011). Similarly, Juana Alvarez, thirteen years old at the time of the riots, recalled that her best friend was "attacked by some white sailors." "They asked her if she had been in Tijuana the week before with them. Four of them grabbed her. I was the only one she told." See interview by Larry R. Solomon with Juana Alvarez, 26 July 1992, as quoted in Solomon, *Roots of Justice*, 27.

101 "Navy-Battered Zoot Suiters Jailed by Police," *Los Angeles Examiner*, 7 June 1943, 1; "Letters to Herald-Express," *Los Angeles Evening Herald and Express*, 10 June 1943, B2. Ramírez provides an extensive list of the newspapers carrying coverage of zoot suiters allegedly raping and attacking white women. See Ramírez, *Woman in the Zoot Suit*, 36, 165 n. 4.

102 Leyvas, interview; Boris, "'You Wouldn't Want One of 'Em Dancing with Your Wife,'" 90.

103 Martínez, interview.

104 Ramírez, *Woman in the Zoot Suit*, 40–43. Horace R. Cayton references the "closed society" of Mexicans in "Riot Causes: Sex Was an Important Factor Leading to Zoot Suit War on the Coast," *Pittsburgh Courier*, 25 September 1943, 13.

105 Boris, "'You Wouldn't Want One of 'Em Dancing with Your Wife,'" 89.

106 Pascoe, *What Comes Naturally*, 118–123. According to historian Allison Varzally, at the beginning of the twentieth century, California antimiscegenation laws prohibited a "white" person from marrying "a Negro, Mulatto, or Mongolian." By 1933, the category of "white" excluded other groups—including "Malays" (Filipinos) and Japanese—thereby excluding them from legal unions with "whites." See Varzally, *Making a Non-White America*, 85.

107 Ramírez, *Woman in the Zoot Suit*, 37.

108 José Alamillo similarly finds that during the 1920s Mexican American women of the lemon industry in California used the leisure realms of churches, movie theaters,

and community festivals to "find a comfortable medium between so-called tradi-
tional and modern forms of femininity." See Alamillo, *Making Lemonade Out of
Lemons*, 98.

CHAPTER FIVE

1 Affidavit of Guadalupe Cordero, Emma Acosta, Luisa Martínez, Reina Ramírez, and
Agrippina Guillen, Box 852, Regional Files XII, Non-docketable Cases A–Z, Pend-
ing Docketable Cases, "Non-Docketable Cases" Folder, Region XII FEPC Records.

2 Ibid.

3 Ibid.

4 See Chafe, *Paradox of Change*, 156–57. For a discussion of women in the postwar era
more generally, see Anderson, *Wartime Women*, 154–78.

5 Schiesl, "Airplanes to Aerospace," 136.

6 Gluck, *Rosie the Riveter Revisited*, 261, 273 n. 4.

7 Purdy, Interview 1d Segment 1 (0:00–10:39) Segkey: a4195, VOAHA.

8 Gluck, *Rosie the Riveter Revisited*, 265.

9 Margarita Salazar McSweyn, interview in Gluck, *Rosie the Riveter Revisited*, 89–90.

10 Hernández Milligan, interview, vol. 26, Rosie the Riveter Project, introduction.

11 Beatrice Morales Clifton, interview in Gluck, *Rosie the Riveter Revisited*, 210–19, 265.

12 "Revised ES-510 Procedure—Northern California and Southern California," Box
2958, Minorities File, Region XII, Central Files, 1942–1945, Entry 269, Inventory
No. 6, Region XII WMC Records.

13 Sides, *L.A. City Limits*, 83.

14 Sato, "Gender and Work," 167.

15 FEPC, *Final Report*, 82–83. According to the report, by late 1945 and early 1946,
over 30 percent of job orders in manufacturing as a whole had exclusionary hiring
policies; 17 percent of service industry and 40 percent of garment industry work or-
ders proved discriminatory. Discrimination took place most often in regard to race,
although citizenship and religion also remained areas of concern.

16 Rivera Alonzo, interview.

17 Hart, "Making Democracy Safe for the World," 82.

18 FEPC, *Final Report*, ix–x.

19 "Statement of Dr. Carlos E. Castañeda, Special Assistant on Latin-American Prob-
lems to the Chairman of the President's Committee on Fair Employment Practice,
Before the Senate Committee on Labor and Education in the Hearings Held 8 Sep-
tember 1944, on S Bill 2048, to Prohibit Discrimination Because of Race, Creed,
Color, National Origin or Ancestry," 8 September 1944, Folder 6, Series IV, Box 58,
Mexicans in the United States, Reports, 1944, Galarza Papers. For a detailed descrip-
tion of wartime and postwar congressional battles over the FEPC, see Kersten, *Race,
Jobs, and the War*, 126–40; and Garfinkel, *When Negroes March*, 162–70.

20 Historian Kevin Leonard discusses the 1946 battle over Proposition 11, documenting
the ways in which Los Angeles newspapers covered the conflict. See Leonard, *Battle*

for Los Angeles, 283–93. According to Leonard, opponents of Proposition 11 argued that the measure was "Communist inspired" and that its passage would exacerbate racial tensions and infringe upon the rights and liberties of Americans.

21 For discussion of the fight for fair employment practices in postwar California, see Brilliant, *Color of America Has Changed*, chaps. 4–6.

22 Kersten, *Race, Jobs, and the War*, 140.

23 In 1940, 15,439 Mexican women were working in Los Angeles and Orange Counties; by 1950, this number had more than doubled to 30,878. See IPUMS 1940 and 1950 samples.

24 Chafe, *Paradox of Change*, 162–63.

25 Margarita Salazar McSweyn, interview in Gluck, *Rosie the Riveter Revisited*, 94.

26 Interviews in the sample include those conducted by and in possession of the author, in addition to those located in the Rosie the Riveter Project.

27 Gluck, *Rosie the Riveter Revisited*, 261; Sides, *L.A. City Limits*, 91.

28 Barrera, *Race and Class in the Southwest*, 136.

29 Sides, *L.A. City Limits*, 92; Greer, "Participation of Ethnic Minorities," 61. According to Greer, however, even Mexican women found it hard to escape preferences for light skin. As a representative for the AFL Retail Clerks union commented in 1952: "The lighter skinned Mexicans have no trouble—they're very flexible, and scattered all over. But the darker ones are at a disadvantage."

30 California State Chamber of Commerce, *Examination of California's Electronics Industry*, 4.

31 Sides, *L.A. City Limits*, 81–82.

32 Ibid., 84.

33 IPUMS 1940 and 1950 samples for Los Angeles County.

34 IPUMS 1960 sample for California, by metropolitan status. Comparable statistics on the number of Mexican aircraft workers in 1960s Los Angeles County remain unavailable because the 1960 IPUMS sample does not report data by cities or counties, only by state.

35 Wilburn, "Social and Economic Aspects of the Aircraft Industry," 237. According to Sherna Gluck, Lockheed statistics showed the number of hourly women workers beginning a "slow steady climb" above 20 percent after April 1951. Likewise, women leads at Douglas estimated that about 25 percent of production workers were women during the 1950s. See Gluck, *Rosie the Riveter Revisited*, 274 n. 11.

36 Northrup, "Negro in the Aerospace Industry," 266, 268, 275–76. Northrup further estimated that by 1966, black women constituted 8.6 percent of all skilled crafts positions and 15 percent of all semiskilled operative positions in the aerospace industry nationwide.

37 Beatrice Morales Clifton and Fanny Christina Hill interviews in Gluck, *Rosie the Riveter Revisited*, 25, 201.

38 Escobedo Atterbury, interview, 6 January 1998; Escobedo Burdette, interview.

39 For a discussion of the impact of the GI Bill on suburbia and American society, see, for instance, Metler, *Soldiers to Citizens*. Eric Avila discusses some of the implications

of suburban life for Mexican Americans more specifically in Avila, *Popular Culture in the Age of White Flight*, 142.

40 Arellano, "Mi Casa Es Mi Casa"; Arellano, "Cal State Fullerton Grad Student Finds Missing Link." According to Arellano, the research of scholar Luis F. Fernandez unearthed an amici curiae brief filed for the Supreme Court housing covenant case *Sipes v. McGhee*, a companion case to *Shelley v. Kraemer*, that specifically cites *Doss v. Bernal* as legal precedent. On race and housing, see Sugrue, *Origins of the Urban Crisis*; and Meyer, *As Long As They Don't Move Next Door*.

41 Sides, *L.A. City Limits*, 110–11.

42 For an example of progressive-minded whites showing greater interest in the residential integration of Mexican Americans, see Matt Garcia's discussion of the Intercultural Council in Pomona, California, in *World of Its Own*, 241–55.

43 Bender, *Tierra y Libertad*, 46, 86. George Lipsitz discusses the nation's overall failure to enforce fair-housing legislation in the wake of the *Shelley v. Kraemer* decision. See Lipsitz, *Possessive Investment in Whiteness*, 25–33.

44 "Civil Rights Advocate Ralph Guzman Reveals Discrimination's 'New Look,' 1956," in Nicolaides and Wiese, *Suburb Reader*, 331–33. From this document, it is unclear as to whether the Portugal family was native or foreign born.

45 McEntire, *Residence and Race*, 241–42.

46 Mendoza Schechter Oral History, 29; Mendoza Schechter, interview.

47 In 1950, only 4 percent of Spanish-surnamed women and 4.6 percent of Spanish-surnamed men went to college in California, well below the college attendance rates of the rest of the state's population. Approximately 10 percent of nonwhite men and nonwhite women—not including the Spanish-surname population—attended college in California in 1950, compared to 19 percent of the state's total male population and 17.5 percent of the state's total female population. See State of California, Department of Industrial Relations, Division of Fair Employment Practices, *Californians of Spanish Surname*, 6, 9, 13, 29, 49. For discussion of the *Mendez* case and ruling, see Arriola, "Knocking on the Schoolhouse Door"; Gonzáles, *Chicano Education in the Era of Segregation*; and Strum, *Mendez v. Westminster*. Interestingly, the judge presiding over the *Mendez* case ruled that segregating Mexican children in schools was unconstitutional because of their being "white," not because segregation was itself unconstitutional. See Bernstein, *Bridges of Reform*, 169. As historian Vicki Ruiz notes, higher education numbers for Mexican Americans in the Southwest were not appreciably better in 1970 or 1980. See Ruiz, "And Miles to Go."

48 Johnson, "Constellations of Struggle."

49 Bernstein, *Bridges of Reform*.

50 See Bernstein, "From California to the Nation," 87–88; Escobar, "Bloody Christmas"; and Al Camarillo, *Chicanos in California*, 81–82.

51 Rose, "Gender and Civic Activism," 189. For more on Mexican American women's involvement in the CSO, see Apodaca, "They Kept the Home Fires Burning."

52 Mendoza Schechter Oral History, 28.

53 Mendoza Schechter, interview.

54 Ibid.; Rose, "Gender and Civic Activism," 184–89.

55 Foner, *Story of American Freedom*, 238.

56 Sánchez, " 'What's Good for Boyle Heights,' " 652; Chávez, *"Mi Raza Primero!,"* 11. For more historical context on leftists in twentieth-century Los Angeles and their fight to address racial injustice and discrimination, see Hurewitz, *Bohemian Los Angeles.*

57 Sánchez, " 'What's Good for Boyle Heights,' " 649; Lipsitz, *Rainbow at Midnight*, 204.

58 For a discussion of the CIO purges and the impact of Cold War domestic politics on labor in the United States, see Lipsitz, *Rainbow at Midnight*, 157–225. On the fate of UCAPAWA/FTA, see Ruiz, "Luisa Moreno," 189; and Ruiz, *Cannery Women*, 103–23.

59 Sánchez, " 'What's Good for Boyle Heights,' " 649.

60 Ruiz, *From Out of the Shadows*, 84.

61 Sánchez, " 'What's Good for Boyle Heights,' " 649.

62 Vargas discusses the right-wing backlash against Mexican American labor and civil rights activists in *Labor Rights Are Civil Rights*, 270–73. For a discussion of specific activists deported under the Internal Security Act, see Buelna, "Resistance from the Margins," 294–95.

63 Bernstein, "From Civic Defense to Civil Rights," 70.

64 Bernstein, *Bridges of Reform*, 9–10.

65 Buelna, "Resistance from the Margins," 210; Vargas, *Labor Rights Are Civil Rights*, 276.

66 García, *Mexican Americans*, 200.

67 Ibid., 202.

68 Ibid., 203.

69 Ibid., 222; Buelna, "Asociación Nacional México-Americana," 67–68.

70 Buelna, "Resistance from the Margins," 215; Buelna, "Asociación Nacional México-Americana."

71 Buelna, "Resistance from the Margins," 214–15; Buelna, "Asociación Nacional México-Americana," 67.

72 García, *Mexican Americans*, 218–19; Buelna, "Asociación Nacional México-Americana"; Ruiz, *From Out of the Shadows*, 101–2. According to Mauricio Terrazas, executive director of ANMA in Los Angeles, about one-third of ANMA's membership in Southern California were women. See García, *Mexican Americans*, 218–19.

73 Buelna, "Resistance from the Margins," 294; García, *Mexican Americans*, 213.

74 Ngai, *Impossible Subjects*, 156.

75 Gutiérrez, *Walls and Mirrors*, 174–75.

76 Buelna, "Resistance from the Margins," 299–300.

77 Garcilazo, "McCarthyism," 283.

78 Sánchez, " 'What's Good for Boyle Heights.' " For more information on the LACPFB, see Buelna, "Resistance from the Margins"; Garcilazo, "McCarthyism"; Gutiérrez, *Walls and Mirrors*, 172–76; and Malagon, interview.

79 García, *Mexican Americans*, 223–25.

80 Malagon, interview. Created in 1938 amid conservative opposition to President Roosevelt's New Deal, HUAC directed its efforts at uncovering "subversive and un-American propaganda." See Fried, *Nightmare in Red*, 47.

81 U.S. House of Representatives, Committee on Un-American Activities, *Communist Political Subversion*, 6632.

82 "Testimony of Mrs. Irene Terrazas," in U.S. House of Representatives, Committee on Un-American Activities, *Communist Political Subversion*, 6837–38. Note that Malagon testified before HUAC under her then married name of Terrazas.

83 Ibid.; "Testimony of Mrs. Josephine Yañez Van Leuven," in U.S. House of Representatives, Committee on Un-American Activities, *Communist Political Subversion*, 6697–6703; Malagon, interview. For a discussion of HUAC and the general climate of the Red Scare during the 1950s, see Schrecker, *Many Are the Crimes*; Fried, *Nightmare in Red*; and Caute, *Great Fear*.

84 Garcilazo, "McCarthyism," 294; García, *Mexican Americans*, 226–27; Vargas, *Labor Rights Are Civil Rights*, 277.

85 Malagon, interview. For further discussion of the Festival of Nationalities, see Buelna, "Resistance from the Margins," 302.

86 Malagon, interview.

87 Orenstein, "Void for Vagueness," 367–68; Pascoe, *What Comes Naturally*, 207.

88 Orenstein, "Void for Vagueness," 368; Ruiz, "*Perez v. Sharp.*"

89 Enforcement of the law depended in large measure on the discretion of city and county clerks. In Imperial County, for instance, clerks issued marriage licenses to Punjabi/Mexican couples. See Leonard, *Making Ethnic Choices*. County clerks had also "routinely turned a blind eye to Mexican-Filipino marriages, especially along California's central coast" (Ruiz, "*Perez v. Sharp*").

90 For in-depth discussion and analysis of *Perez* and the couple behind the case, see Orenstein, "Void for Vagueness"; Pascoe, *What Comes Naturally*, 205–23; and Brilliant, *Color of America Has Changed*, 105–14. In my discussions of the couple and the court case, I refer to the case as Perez, without an accent, as this is how it is referenced in legal documentation. When referring to Andrea Pérez the individual, I use an accent, as this is how she spelled her name.

91 Pascoe, *What Comes Naturally*, 205, 221–22; Orenstein, "Void for Vagueness," 404–5.

92 Romano, *Race Mixing*, 42–43.

93 Escobedo Atterbury, interview, 17 August 2010; Escobedo Atterbury, interview, 24 January 2011; Escobedo Burdette, interview.

94 Escobedo Atterbury, interview, 17 August 2010; Escobedo Atterbury, interview, 24 January 2011.

95 Burma, "Research Note," 588.

96 Panunzio, "Intermarriage in Los Angeles," 692.

97 Varzally, *Making a Non-White America*, 93. Varzally's findings come from her analysis of marriage licenses from 1940 and 1949 in Los Angeles and San Joaquin Counties, available through the Los Angeles Regional Family History Center.

98 Burma, "Interethnic Marriage in Los Angeles," 158. See also Pascoe, *What Comes Naturally*, 150–59.

99 Panunzio, "Intermarriage in Los Angeles"; Grebler, Moore, and Guzman, *Mexican-American People*, 405–8. Data from the 1963 study demonstrate that Mexican women tended to intermarry slightly more than the men of their community, with rates of 27 percent and 24 percent, respectively. See Grebler, Moore, and Guzman, *Mexican-American People*, 408. In her analysis of marriage licenses, Varzally found that "83 percent of those Mexicans who got married in Los Angeles married other Mexicans in 1940, 80 percent in 1949." See Varzally, *Making a Non-White America*, 86.

100 Interviews in the sample include those conducted by and in possession of the author, in addition to those located in the Rosie the Riveter Project.

101 Ruiz, *From Out of the Shadows*, 70–71.

102 Matzigkeit, "Influence of Six Mexican Cultural Factors," 70–71.

103 Ruiz, *From Out of the Shadows*, 71.

104 Echeverría Mulligan, Interview 2c Segment 3 (17:48–20:39) Segkey: a4111, VOAHA.

105 Escobedo Atterbury, interview, 6 January 1998; Escobedo Atterbury, interview, 17 August 2010; Escobedo Atterbury, interview, 22 September 2011.

106 Mendoza Schechter Oral History, 106–7.

107 Lozano Holtzman, interview, 23 September 2011.

108 Escobedo Atterbury, interview, 6 January 1998.

109 After getting married in 1955, Schechter became involved in the board of directors of the Council of Mexican American Affairs and the Mexican American Youth Opportunities Foundation. See Mendoza Schechter Oral History, xii.

110 Brown-Coronel, "Intermarriage, Contemporary," 344.

111 For scholarship that emphasizes women's domesticity and femininity in the 1950s, see May, *Homeward Bound*; Eisler, *Private Lives*; Dinnerstein, *Women between Two Worlds*; and Harvey, *Fifties*. For an anthology that aims "to subvert the persistent stereotype of domestic, quiescent, suburban womanhood," see Meyerowitz, *Not June Cleaver*. Quotation found on page 11.

112 Pagán, *Murder at the Sleepy Lagoon*, 18.

EPILOGUE

1 For an in-depth study of the controversy surrounding Latina/os and the release of *The War*, see Lazcano, "Historical Memory Negotiated."

2 Cordova, "Tug of 'War,'"; letter from Frederick P. Aguirre, Latino Advocates for Education, Inc., to Ken Burns, 31 January 2007, http://www.latinoadvocates.org/KenBurnsWeb.htm (8 December 2011). Maggie Rivas-Rodriguez, a journalism professor and director of the U.S. Latino and Latina World War II Oral History Project at the University of Texas–Austin, spearheaded the Defend the Honor campaign when it became clear that Latina/os would not be represented in *The War*. According to Rivas-Rodriguez, "For Mexican Americans, World War II was the beginning of our

civil rights movement. This was a huge watershed moment for Latinos. This is a significant part of our history, and we keep getting left out over and over again."

3 Lazcano, "Historical Memory Negotiated," 120.

4 Cordova, "Tug of 'War.'"

5 Wetta and Novelli, "More Like a Painting," 1402.

6 See, for example, letter from Matt Garcia, then associate professor of American Civilization, History, and Ethnic Studies at Brown University to Ken Burns, 18 February 2007, http://defendthehonor.org/wp-content/uploads/2010/03/Garcia_Matt_to_Burns_letter3-18-07.pdf (8 December 2011); letter from U.S. senators Ken Salazar and Robert Menendez to Paula Kerger, president, Public Broadcasting System, 30 March 2007, http://defendthehonor.org/wp-content/uploads/2010/03/Senators-Salazar-Menendez-PBS-Letter.pdf (8 December 2011); Mariscal, "World War II Heroes Ken Burns Forgot."

7 Montgomery, "After the War."

8 For examples of scholarship that contend World War II facilitated "a new attitude of entitlement" among returning veterans, see Rivas-Rodriguez, *Mexican Americans and World War II*, xviii; Rivas-Rodriguez, *Legacy Greater than Words*; Oropeza, *¡Raza Sí! ¡Guerra No!*; and Guglielmo, "Fighting for Caucasian Rights."

9 Lazcano, "Historical Memory Negotiated," 126–28.

10 Behrens, "Focused on Commonalities of War."

11 Ward, *War*; Cordova, "Tug of 'War.'"

12 Ernesto Galarza's *Barrio Boy* is an autobiographical narrative that depicts his family's early-twentieth-century immigration from Mexico to Sacramento, California. See Galarza, *Barrio Boy*.

13 Avella, *Sacramento*, 108–10.

14 Ward, *War*, 214.

15 Poniewozik, "Ken Burns, the Interview."

16 Letter from Francisco M. Vega to Carlos Guerra, 15 June 2008, *Somos Primos*, July 2008, http://www.somosprimos.com/sp2008/spjul08/spjul08.htm (22 February 2012).

17 Martin Miller, "A Latino Veteran Finally Shares His Battlefield Tales," *Los Angeles Times*, 21 September 2007, E1.

18 Lozano, "Action Items."

BIBLIOGRAPHY

ARCHIVAL AND MANUSCRIPT COLLECTIONS

Boeing Historical Archives, Huntington Beach, Calif.
California State Archives, Sacramento, Calif.
 Earl Warren Papers
 Youth Authority Records
California State University Northridge, Urban Archives Center
 Southern California Arbitration Case Files Collection
 Young Women's Christian Association of Los Angeles Collection
Huntington Library, Manuscripts Department, San Marino, Calif.
 Fletcher Bowron Collection
 John Anson Ford Papers
Los Angeles Superior Court Archives and Records Center, Los Angeles, Calif.
 Los Angeles County Juvenile Court Case Files, 1939–45
National Archives and Records Administration, College Park, Md.
 Record Group 102, Records of the Children's Bureau
 Record Group 208, Records of the Office of War Information
 Record Group 228, Records of the Committee on Fair Employment Practice
 Record Group 229, Records of the Office of Inter-American Affairs
National Archives and Records Administration, San Bruno, Calif.
 Record Group 211, Records of the War Manpower Commission
 Record Group 228, Records of the Committee on Fair Employment Practice
Southern California Library for Social Studies and Research, Los Angeles, Calif.
 Los Angeles Committee for Protection of Foreign Born Records
Stanford University, Special Collections, Manuscripts Division
 Ernesto Galarza Papers
 Manuel Ruiz Papers
University of California at Los Angeles, Special Collections, Charles E. Young
 Research Library
 Alice Greenfield McGrath Papers
 Carey McWilliams Papers 1243
 Sleepy Lagoon Defense Committee Records

GOVERNMENT PUBLICATIONS AND REPORTS

California State Chamber of Commerce. *An Examination of California's Electronics Industry*. California: Research Department, California Chamber of Commerce, 1952.

Fair Employment Practice Committee. *Final Report*. Washington, D.C.: Government Printing Office, 1947.

Integrated Public Use Microdata Series 1940, 1950, and 1960, www.ipums.umn.edu.

Office of the Coordinator of Inter-American Affairs. *Spanish-Speaking Americans in the War: The Southwest*. Washington, D.C.: Office of the Coordinator of Inter-American Affairs, 1943.

Rowland, Donald W. *History of the Office of the Coordinator of Inter-American Affairs*. Washington, D.C.: Government Printing Office, 1947.

State of California, Department of Industrial Relations, Division of Fair Employment Practices. *Californians of Spanish Surname*. San Francisco: Fair Employment Practice Commission, May 1964 (reprinted July 1967).

U.S. Bureau of the Census. *Population of Spanish Mother Tongue: 1940*, ser. P-15, no. 1. Washington, D.C.: Government Printing Office, 9 June 1942.

U.S. Congress. *Fair Employment Practice Committee Hearings*. Washington, D.C.: Government Printing Office, 1944.

———. House. "Celebrating the Life of Carmen N. Ciqueiros Tafoya Perkins Mullaly." *Congressional Record*, vol. 151, Issue 130 (7 October 2005): E2075.

———. House. Committee on Un-American Activities. *Communist Political Subversion, Part 1, Hearings Before the Committee on Un-American Activities*, 84th Cong., 2d sess. Washington, D.C.: Government Printing Office, 1957.

INTERVIEWS

Mendoza Schechter, Hope. Oral History Interview by Malca Chall, conducted 1977–78. Bancroft Library Regional History Office, University of California Berkeley, 1980.

The following interviews were conducted by the author. Recordings and/or notes are currently in the author's possession.

Acosta, Ann Lara. 5 October 2000, El Sereno, Calif.

Alonzo, Connie Rivera. 6 November 2000, Pico Rivera, Calif.

Atterbury, Ida Escobedo. 6 January 1998, Orcutt, Calif.

Atterbury, Ida Escobedo. Telephone interview, 17 August 2010, 30 November 2010, 24 January 2011, 22 September 2011.

Baca, Alicia Arevalo. 31 March 2000, Los Angeles, Calif.

Barragan, Stella. 5 October 2000, El Sereno, Calif.

Benavidez, Virginia Gonzáles. 6 November 2000, Whittier, Calif.

Benavidez, Virginia Gonzáles, Ortencia Contreras Mojica, and Margaret Rodríguez Raugi. 6 December 2000, Whittier, Calif.

Bernal, Connie Gonzáles. 13 December 2000, Los Angeles, Calif.

Burdette, Ernestine Escobedo. 14 December 2000, Inglewood, Calif.

Burger, Mary López. 5 October 2000, El Sereno, Calif.

Cardenas, Teresa Rivera. 19 October 2000, El Sereno, Calif.

Davis, Mary Hurtado. Telephone interview, 13 February 2000.

Ferguson, Ophelia. Telephone interview, 1 March 1998.

Fuentes, Jesus. Telephone interview, 2 February 2000.

Gonzalez, Hortensia. Telephone interview, 7 September 2000.

Holtzman, Mimi Lozano. Telephone interview, 8 October 2000, 23 September 2011.

Jefferes, Noemi Hernández. 25 February 1998, Thousand Oaks, Calif.

Leyvas, Lupe. 2 March 1998, Los Angeles, Calif.

Litchfield, Isabel Molina. 11 May 2001, Tukwila, Wash.

López, Rosemary. Telephone interview, 23 May 2000.

Malagon, Irene. 14 March 2000, Los Angeles, Calif.

Mariscal, Irene Molina. 1 June 2000, Long Beach, Calif.

Marquez, Anna Morales. 4 August 2000, Los Angeles, Calif.

Martínez, Margarita. 2 November 2000, El Sereno, Calif.

Molano, Alice Castillo. 5 December 2000, Los Angeles, Calif.

Reyes, Concepcíon Macías. 5 October 2000, El Sereno, Calif.

Romero, Beatriz. 12 May 2000, Los Angeles, Calif.

Schechter, Hope Mendoza. 27 February 1998, Sherman Oaks, Calif.

Tafolla, Annie Hurtado. 18 January 2000, Fullerton, Calif.

Valadez, Teresa Pallan. 26 February 1998, Alhambra, Calif.

Velarde, Connie. 8 August 2000, Panorama City, Calif.

Velasco, Juanita Villalobos. 19 July 2000, Los Angeles, Calif.

Vergara, Carmen. Telephone interview, 27 September 2000.

The following interviews are held in the Rosie the Riveter Revisited Oral History Project, Special Collections, California State University, Long Beach, and are also available in the Virtual Oral/Aural History Archive, California State University, Long Beach, http://www.csulb.edu/voaha. Audio files accessed on 6 April 2012.

Clifton, Beatrice Morales. Interviewed by Sherna Berger Gluck. 23 January 1981.

Dotson, Alma. Interviewed by Jan Fischer. 20 October 1980.

Drake, Videll. Interviewed by Jan Fischer. 14 November 1980.

Fierro, Maria. Interviewed by Cindy Cleary. 24 February 1981.

Hill, Fanny Christina. Interviewed by Jan Fischer. 29 June 1980.

Houston, Josephine. Interviewed by Jan Fischer. 11 July 1980.

JK, alias. Interviewed by Jan Fischer. 31 March 1980.

Laughlin, Susan. Interviewed by Sherna Berger Gluck. 12 October 1979.

Luna, Mary. Interviewed by Cindy Cleary. 2 February 1981.

Mason, Belen Martínez. Interviewed by Sherna Berger Gluck. 6 February 1981.

McSweyn, Margarita Salazar. Interviewed by Sherna Berger Gluck. 29 October 1980.

Milligan, Adele Hernández. Interviewed by Sherna Berger Gluck. 21 January 1981.

Mulligan, Rose Echeverría. Interviewed by Cindy Cleary. 20 January 1981.

Purdy, Lupe. Interviewed by Cindy Cleary. 22 April 1981.
Shelit, Alicia. Interviewed by Cindy Cleary. 19 February 1981.
Singleton, Rose. Interviewed by Cindy Cleary. 17 June 1980.

Excerpts from the following interviews are at the PBS *American Experience* website, http://www.pbs.org/wgbh/amex/zoot/eng_sfeature/sf_zoot_text.html, 19 March 2010.
Arenas, Arthur
Berlin, Gloria
Leyvas, Lupe

NEWSPAPERS AND PERIODICALS

Douglas Airview
Eastside Journal
El Segundo Airview News
La Opinión
Lockheed Star
Lockheed-Vega Star
Long Beach Airview News
Los Angeles Daily News
Los Angeles Examiner
Los Angeles Evening Herald and Express
Los Angeles Times
Low Rider
Newsweek
New York Times
Pittsburgh Courier
Santa Monica Airview News
The Saturday Evening Post
Time

PUBLISHED WORKS

Adler, Patricia Rae. "The 1943 Zoot-Suit Riot: Brief Episode in a Long Conflict." In *An Awakened Minority: The Mexican Americans*, edited by Manuel P. Servín, 142–58. Beverly Hills, Calif.: Glencoe Press, 1970.
Alamillo, José M. *Making Lemonade Out of Lemons: Mexican American Labor and Leisure in a California Town, 1880–1960*. Urbana: University of Illinois Press, 2006.
———. "Playing Across Borders: Transnational Sports and Identities in Southern California and Mexico, 1930–1945." *Pacific Historical Review* 79, no. 3 (August 2010): 360–92.

Alvarez, Luis. *The Power of the Zoot: Youth Culture and Resistance during World War II.* Berkeley: University of California Press, 2009.

Anderson, Karen. *Changing Woman: A History of Racial Ethnic Women in Modern America.* New York: Oxford University Press, 1996.

———. "Last Hired, First Fired: Black Women Workers during World War II." *Journal of American History* 69, no. 1 (June 1982): 82–97.

———. *Wartime Women: Sex Roles, Family Relations, and the Status of Women during World War II.* Westport, Conn.: Greenwood Press, 1981.

Archibald, Katherine. *Wartime Shipyard: A Study in Social Disunity.* Berkeley: University of California Press, 1947.

Arellano, Gustavo. "Cal State Fullerton Grad Student Finds Missing Link Between Alex Bernal Housing Covenant Case and the Supreme Court." *OC Weekly*, 18 September 2010. http://blogs.ocweekly.com/navelgazing/2010/09/cal_state_fullerton_grad_stude.php. 30 November 2011.

———. "Mi Casa Es Mi Casa: How Fullerton Resident Alex Bernal's 1943 Battle against Housing Discrimination Helped Change the Course of American Civil Rights." *OC Weekly*, 6 May 2010. http://www.ocweekly.com/content/printVersion/699430/ 30 November 2011.

Arriola, Christopher. "Knocking on the Schoolhouse Door: *Mendez v. Westminster*— Equal Protection, Public Education, and Mexican Americans in the 1940s." *La Raza Law Journal* 8, no. 2 (1995): 166–207.

Avella, Steven M. *Sacramento: Indomitable City.* Charleston: Arcadia Publishing, 2003.

Avila, Eric. *Popular Culture in the Age of White Flight: Fear and Fantasy in Suburban Los Angeles.* Berkeley: University of California Press, 2006.

Balderrama, Francisco E., and Raymond Rodríguez. *Decade of Betrayal: Mexican Repatriation in the 1930s.* Albuquerque: University of New Mexico Press, 1995.

Banet-Weiser, Sarah. *The Most Beautiful Girl in the World: Beauty Pageants and National Identity.* Berkeley: University of California Press, 1999.

Banner, Lois W. *American Beauty.* Chicago: University of Chicago Press, 1983.

Barajas, Frank P. "The Defense Committees of Sleepy Lagoon: A Convergent Struggle against Fascism, 1942–1944." *Aztlán* 31 (Spring 2006): 33–62.

Barrera, Mario. *Race and Class in the Southwest: A Theory of Racial Inequality.* Notre Dame, Ind.: University of Notre Dame Press, 1979.

Behrens, Steve. "Focused on Commonalities of War, Burns Agrees to Show Differences." *Current*, 23 July 2007. http://www.current.org/hi/hio713burnswar.shtml. 8 December 2011.

Bender, Steven W. *Tierra y Libertad: Land, Liberty, and Latino Housing.* New York: New York University Press, 2010.

Bernstein, Shana. *Bridges of Reform: Interracial Civil Rights Activism in Twentieth-Century Los Angeles.* New York: Oxford University Press, 2010.

———. "From California to the Nation: Rethinking the History of 20th Century U.S. Civil Rights Struggles through a Mexican American and Multiracial Lens." *Berkeley La Raza Law Journal* 18 (2007): 87–95.

———. "From Civic Defense to Civil Rights: The Growth of Jewish American Interracial Civil Rights Activism in Los Angeles." In *A Cultural History of Jews in California: The Jewish Role in American Life*, edited by William Deverell, 55–80. West Lafayette, Ind.: Purdue University Press, 2009.

Bogardus, Emory S. "Gangs of Mexican-American Youth." *Sociology and Social Research* 28 (1943): 55–66.

Boris, Eileen. "'You Wouldn't Want One of 'Em Dancing with Your Wife': Racialized Bodies on the Job in World War II." *American Quarterly* 50, no. 1 (March 1998): 77–108.

Brilliant, Mark. *The Color of America Has Changed: How Racial Diversity Shaped Civil Rights Reform in California, 1941–1978*. New York: Oxford University Press, 2010.

Brooks, Charlotte. "In the Twilight Zone between Black and White: Japanese American Resettlement and Community in Chicago, 1942–1945." *Journal of American History* 86, no. 4 (March 2000): 1655–87.

Brown-Coronel, Margie. "Intermarriage, Contemporary." In *Latinas in the United States: A Historical Encyclopedia*, edited by Vicki L. Ruiz and Virginia Sánchez Korrol, 342–44. Bloomington: Indiana University Press, 2006.

Buelna, Enrique M. "Asociación Nacional México-Americana (ANMA) (1949–1954)." In *Latinas in the United States: A Historical Encyclopedia*, edited by Vicki L. Ruiz and Virginia Sánchez Korrol, 67–68. Bloomington: Indiana University Press, 2006.

Burma, John H. "Interethnic Marriage in Los Angeles, 1948–1959." *Social Forces* 42 (December 1963): 156–65.

———. "Research Note on the Measurement of Interracial Marriage." *American Journal of Sociology* 57 (May 1952): 587–89.

Burt, Kenneth. *The Search for a Civic Voice: California Latino Politics*. Claremont: Regina Books, 2007.

Calavita, Kitty. *Inside the State: The Bracero Program, Immigration, and the I.N.S.* New York: Routledge, 1992.

Camarillo, Albert. *Chicanos in California: A History of Mexican Americans in California*. San Francisco: Boyd & Fraser, 1984.

Campbell, D'Ann. *Women at War with America: Private Lives in a Patriotic Era*. Cambridge, Mass.: Harvard University Press, 1984.

Casas, María Raquél. *Married to a Daughter of the Land: Spanish-Mexican Women and Interethnic Marriage in California, 1820–1880*. Reno: University of Nevada Press, 2007.

Caute, David. *The Great Fear: The Anti-Communist Purge under Truman and Eisenhower*. New York: Simon and Schuster, 1978.

Chafe, William. *The Paradox of Change: American Women in the Twentieth Century*. New York: Oxford University Press, 1991.

Chávez, Ernesto. *"Mi Raza Primero!" Nationalism, Identity, and Insurgency in the Chicano Movement in Los Angeles, 1966–1978*. Berkeley: University of California Press, 2002.

Chávez-García, Miroslava. "Youth, Evidence, and Agency: Mexican and Mexican American Youth at the Whittier State School, 1890–1920." *Aztlán* 31 (Fall 2006): 55–83.

Cohen, Deborah. *Braceros: Migrant Citizens and Transnational Subjects in the Postwar United States and Mexico.* Chapel Hill: University of North Carolina Press, 2011.

Cordova, Randy. "Tug of 'War' WWII Documentary Pits Artistic License against Special Interests, Public Funds." *Arizona Republic,* 23 September 2007. http://www.azcentral. com/arizonarepublic/ae/articles/0923war0923.html?&wired. 8 December 2011.

Cosgrove, Stuart. "The Zoot Suit and Style Warfare." *History Workshop Journal* 18 (1984): 77–91.

Craig, Maxine Leeds. *Ain't I a Beauty Queen? Black Women, Beauty, and the Politics of Race.* New York: Oxford University Press, 2002.

Daniel, Clete. *Chicano Workers and the Politics of Fairness: The FEPC in the Southwest, 1941–1945.* Austin: University of Texas Press, 1991.

Davenport, Walter. "Swing It, Swing Shift!." *Colliers* 110, no. 8 (August 22, 1942): 21–28.

Dinnerstein, Myra. *Women between Two Worlds: Midlife Reflections on Work and Family.* Philadelphia: Temple University Press, 1992.

Durón, Clementina. "Mexican Women and Labor Conflict in Los Angeles: the ILGWU Dressmakers' Strike of 1933." *Aztlán* 15, no. 1 (1984): 145–61.

Eisler, Benita. *Private Lives: Men and Women of the Fifties.* New York: Franklin Watts, 1986.

Erenberg, Lewis A. "Swing Goes to War: Glenn Miller and the Popular Music of World War II." In *The War in American Culture: Society and Consciousness during World War II,* edited by Lewis Erenberg and Susan Hirsch, 144–65. Chicago: University of Chicago Press, 1996.

———. *Swingin' the Dream: Big Band Jazz and the Rebirth of American Culture.* Chicago: University of Chicago Press, 1998.

Escobar, Edward J. "Bloody Christmas and the Irony of Police Professionalism: The Los Angeles Police Department, Mexican Americans, and Police Reform in the 1950s." *Pacific Historical Review* 72, no. 2 (May 2003): 171–99.

———. *Race, Police, and the Making of a Political Identity: Mexican Americans and the Los Angeles Police Department, 1900–1945.* Berkeley: University of California Press, 1999.

España-Maram, Linda. "Brown 'Hordes' in McIntosh Suits: Filipinos, Taxi Dance Halls, and Performing the Immigrant Body in Los Angeles, 1930s-1940s." In *Generations of Youth: Youth Cultures and History in Twentieth-Century America,* edited by Joe Austin and Michael Nevin Willard, 118–35. New York: New York University Press, 1998.

Feldstein, Ruth. *Motherhood in Black and White: Race and Sex in American Liberalism, 1930–1965.* Ithaca, N.Y.: Cornell University Press, 2000.

Fisher, Marguerite J. "Equal Pay for Equal Work Legislation." *Industrial and Labor Relations Review* 2, no. 1 (October 1948): 50–58.

Flores, Lori A. "An Unladylike Strike Fashionably Clothed: Mexicana and Anglo Women Garment Workers against Tex-Son, 1959–1963." *Pacific Historical Review* 78, no. 3 (2009): 367–402.

Foley, Neil. "Becoming Hispanic: Mexican Americans and the Faustian Pact with Whiteness." In *Reflexiones 1997: New Directions in Mexican American Studies,* edited

by Neil Foley, 53–70. Austin: Center for Mexican American Studies, University of Texas, 1998.

———. "Partly Colored or Other White: Mexican Americans and Their Problem with the Color Line." In *American Dreaming, Global Realities: Rethinking U.S. Immigration History*, edited by Donna R. Gabaccia and Vicki L. Ruiz, 361–78. Urbana: University of Illinois Press, 2006.

———. *The White Scourge: Mexicans, Blacks, and Poor Whites in Texas Cotton Culture*. Berkeley: University of California Press, 1997.

Foner, Eric. *The Story of American Freedom*. New York: W. W. Norton, 1998.

Fried, Richard M. *Nightmare in Red: The McCarthy Era in Perspective*. New York: Oxford University Press, 1990.

Galarza, Ernesto. *Barrio Boy*. Notre Dame, Ind.: University of Notre Dame Press, 1971.

———. *Merchants of Labor: The Mexican Bracero Story*. Chicago: Rand McNally, 1996.

Gamboa, Erasmo. *Mexican Laborers and World War II: Braceros in the Pacific Northwest, 1942–1947*. Austin: University of Texas Press, 1990.

Gamio, Manuel. *Mexican Immigration to the United States: A Study of Human Migration and Adjustment*. 1930. Reprint, New York: Dover, 1971.

García, Mario T. "Americans All: The Mexican American Generation and the Politics of Wartime Los Angeles, 1941–1945." *Social Science Quarterly* 68 (June 1987): 278–89.

———. "*La Frontera*: The Border as Symbol and Reality in Mexican-American Thought." In *Between Two Worlds: Mexican Immigrants in the United States*, edited by David G. Gutiérrez, 89–117. Delaware: Scholarly Resources, 1996.

———. *Mexican Americans: Leadership, Ideology, and Identity, 1930–1960*. New Haven: Yale University Press, 1989.

Garcia, Matt. "Intraethnic Conflict and the Bracero Program during World War II." In *American Dreaming, Global Realities: Rethinking U.S. Immigration History*, edited by Donna R. Gabaccia and Vicki L. Ruiz, 399–410. Urbana: University of Illinois Press, 2006.

———. *A World of Its Own: Race, Labor, and Citrus in the Making of Greater Los Angeles, 1900–1970*. Chapel Hill: University of North Carolina Press, 2001.

Garcilazo, Jeffrey M. "McCarthyism, Mexican Americans, and the Los Angeles Committee for Protection of the Foreign-Born, 1950–1954." *Western Historical Quarterly* 32, no. 3 (Autumn 2001): 273–95.

Garfinkel, Herbert. *When Negroes March: The March on Washington Movement in the Organizational Politics for FEPC*. Glencoe, Ill.: Free Press, 1959.

Gerstle, Gary. *American Crucible: Race and Nation in the Twentieth Century*. Princeton, N.J.: Princeton University Press, 2001.

———. "The Working Class Goes to War." In *The War in American Culture: Society and Consciousness during World War II*, edited by Lewis Erenberg and Susan Hirsch, 105–27. Chicago: University of Chicago Press, 1996.

Giordano, Ralph G. *Social Dancing in America: A History and Reference*. Vol. 2. Westport, Conn.: Greenwood Press, 2007.

Glenn, Evelyn Nakano. *Forced to Care: Coercion and Caregiving in America*. Cambridge, Mass.: Harvard University Press, 2010.

———. "From Servitude to Service Work: Historical Continuities in the Racial Division of Paid Reproductive Labor." In *Unequal Sisters: A Multicultural Reader in U.S. Women's History*, edited by Ellen Carol DuBois and Vicki L. Ruiz, 436–65. New York: Routledge, 2000.

Gluck, Sherna Berger. *Rosie the Riveter Revisited: Women, the War, and Social Change*. New York: New American Library, 1987.

González, Deena J. *Refusing the Favor: The Spanish-Mexican Women of Santa Fe, 1820–1880*. New York: Oxford University Press, 1999.

Gonzáles, Gilbert G. *Chicano Education in the Era of Segregation*. Philadelphia: Balch Institute Press, 1990.

Gordon, Linda. *Pitied but Not Entitled: Single Mothers and the History of Welfare, 1890–1935*. New York: Free Press, 1994.

Grebler, Leo, Joan W. Moore, and Ralph Guzman. *The Mexican-American People: The Nation's Second Largest Minority*. New York: Free Press, 1970.

Gregory, James N. *American Exodus: The Dust Bowl Migration and Okie Culture in California*. New York: Oxford University Press, 1989.

Griffith, Beatrice. *American Me*. Boston: Houghton Mifflin, 1948.

Griswold del Castillo, Richard. *La Familia: Chicano Families in the Urban Southwest, 1848 to the Present*. Notre Dame, Ind.: University of Notre Dame Press, 1984.

———, ed. *World War II and Mexican American Civil Rights*. Austin: University of Texas Press, 2008.

Guglielmo, Thomas A. "Fighting for Caucasian Rights: Mexicans, Mexican Americans, and the Transnational Struggle for Civil Rights in World War II Texas." *Journal of American History* 92, no. 4 (March 2006): 1212–37.

Gutiérrez, David G. *Walls and Mirrors: Mexican Americans, Mexican Immigrants, and the Politics of Ethnicity in the American Southwest*. Berkeley: University of California Press, 1995.

Hart, Justin. "Making Democracy Safe for the World: Race, Propaganda, and the Transformation of U.S. Foreign Policy during World War II." *Pacific Historical Review* 73, no. 1 (2004): 49–84.

Hartmann, Susan. *The Home Front and Beyond: American Women in the 1940s*. Boston: Twayne Publishers, 1982.

Harvey, Brett. *The Fifties: A Women's Oral History*. New York: HarperCollins, 1993.

Hayes-Bautista, David E. *La Nueva California: Latinos in the Golden State*. Berkeley: University of California Press, 2004.

Hegarty, Marilyn E. *Victory Girls, Khaki-Wackies, and Patriotutes: The Regulation of Female Sexuality during World War II*. New York: New York University Press, 2008.

Himes, Chester B. "Zoot Riots Are Race Riots." *The Crisis* 50, no. 7 (July 1943): 200–201, 222.

Hine, Robert V., and John Mack Faragher. *The American West: A New Interpretative History*. New Haven, Conn.: Yale University Press, 2000.

Hollinger, David A. "Amalgamation and Hypodescent: The Question of Ethnoracial Mixture in the History of the United States." *American Historical Review* 108 (December 2003): 1363–90.

Honey, Maureen. *Creating Rosie the Riveter: Class, Gender, and Propaganda during World War II*. Amherst: University of Massachusetts Press, 1984.

Horton, Carol A. *Race and the Making of American Liberalism*. New York: Oxford University Press, 2005.

Howard, John. "The Politics of Dancing under Japanese-American Incarceration." *History Workshop Journal*, no. 52 (Autumn 2001): 123–51.

Hurewitz, Daniel. *Bohemian Los Angeles and the Making of Modern Politics*. Berkeley: University of California Press, 2007.

Jacobson, Matthew Frye. *Whiteness of a Different Color: European Immigrants and the Alchemy of Race*. Cambridge, Mass.: Harvard University Press, 1998.

Jackson, Walter. *Gunnar Myrdal and America's Conscience: Social Engineering and Racial Liberalism, 1938–1987*. Chapel Hill: University of North Carolina Press, 1990.

Johnson, Gaye Theresa. "Constellations of Struggle: Luisa Moreno, Charlotta Bass, and the Legacy for Ethnic Studies." *Aztlán* 33 (Spring 2008): 155–72.

Johnston, Lyle. *"Good Night, Chet": A Biography of Chet Huntley*. Jefferson, N.C.: McFarland, 2003.

Jones, Jacqueline. *Labor of Love, Labor of Sorrow: Black Women, Work, and the Family, from Slavery to the Present*. New York: Basic Books, 1985.

Kelley, Robin D. G. *Race Rebels: Culture, Politics, and the Black Working Class*. New York: Free Press, 1994.

Kellogg, Peter. "Civil Rights Consciousness in the 1940s." *The Historian* 42 (November 1979): 18–41.

Kerber, Linda K. *Women of the Republic: Intellect and Ideology in Revolutionary America*. Chapel Hill: University of North Carolina Press, 1997.

Kersten, Andrew Edmund. *Race, Jobs, and the War: The FEPC in the Midwest, 1941–1946*. Urbana: University of Illinois Press, 2000.

Kryder, Daniel. *Divided Arsenal: Race and the American State during World War II*. New York: Cambridge University Press, 2000.

Kunzel, Regina G. *Fallen Women, Problem Girls: Unmarried Mothers and the Professionalization of Social Work, 1890–1945*. New Haven, Conn.: Yale University Press, 1993.

Kurashige, Scott. *The Shifting Grounds of Race: Black and Japanese Americans in the Making of Multiethnic Los Angeles*. Princeton, N.J.: Princeton University Press, 2007.

Ladd-Taylor, Molly. *Mother-Work: Women, Child Welfare, and the State, 1890–1930*. Urbana: University of Illinois Press, 1995.

Lemke-Santangelo, Gretchen. *Abiding Courage: African American Migrant Women and the East Bay Community*. Chapel Hill: University of North Carolina Press, 1996.

Leonard, Karen Isaksen. *Making Ethnic Choices: California's Punjabi Mexican Americans*. Philadelphia: Temple University Press, 1992.

Leonard, Kevin Allen. *The Battle for Los Angeles: Racial Ideology and World War II.* Albuquerque: University of New Mexico Press, 2006.

———. "'Brothers under the Skin'?: African Americans, Mexican Americans, and World War II in California." In *The Way We Really Were: The Golden State in the Second Great War,* edited by Roger W. Lotchin, 187–214. Urbana: University of Illinois Press, 2000.

Lingeman, Richard. *Don't You Know There's a War On? The American Home Front, 1941–1945.* New York: G. P. Putnam's Sons, 1970.

Lipsitz, George. *The Possessive Investment in Whiteness: How White People Profit from Identity Politics.* Philadelphia: Temple University Press, 1998.

———. *Rainbow at Midnight: Labor and Culture in the 1940s.* Urbana: University of Illinois Press, 1994.

Loewen, James W. *Sundown Towns: A Hidden Dimension of American Racism.* New York: New Press, 2005.

Lozano, Mimi. "Action Items." *Somos Primos,* March 2007. http://www.somosprimos.com/sp2007/spmar07/spmar07.htm. 8 December 2011.

Macías, Anthony F. *Mexican American Mojo: Popular Music, Dance, and Urban Culture in Los Angeles, 1935–1968.* Durham, N.C.: Duke University Press, 2008.

Mariscal, Jorge. "The World War II Heroes Ken Burns Forgot." *Hispanic Link Weekly Report,* February 2007. http://defendthehonor.org/?p=20. 8 December 2011.

Marks, Frederick W., III. *Wind Over Sand: The Diplomacy of Franklin Roosevelt.* Athens: University of Georgia Press, 1988.

Matsumoto, Valerie J. "Japanese American Women and Nisei Culture." In *Over the Edge: Remapping the American West,* edited by Valerie J. Matsumoto and Blake Allmendinger, 291–306. Berkeley: University of California Press, 1999.

———. "Japanese American Women during World War II." In *Unequal Sisters: A Multicultural Reader in U.S. Women's History,* edited by Ellen Carol DuBois and Vicki L. Ruiz, 373–86. New York: Routledge, 1990.

May, Elaine Tyler. *Homeward Bound: American Families in the Cold War Era.* New York: Basic Books, 1988.

———. "Rosie the Riveter Gets Married." In *The War in American Culture: Society and Consciousness during World War II,* edited by Lewis Erenberg and Susan Hirsch, 128–43. Chicago: University of Chicago Press, 1996.

May, Lary. "Making the American Consensus: The Narrative of Conversion and Subversion in World War II Films." In *The War in American Culture: Society and Consciousness during World War II,* edited by Lewis Erenberg and Susan Hirsch, 71–102. Chicago: University of Chicago Press, 1996.

Mazón, Mauricio. *The Zoot-Suit Riots: The Psychology of Symbolic Annihilation.* Austin: University of Texas Press, 1984.

McEntire, Davis. *Residence and Race: Final and Comprehensive Report to the Commission on Race and Housing.* Berkeley: University of California Press, 1960.

McEuen, Melissa A. *Making War, Making Women: Femininity and Duty on the American Home Front, 1941–1945.* Athens: University of Georgia Press, 2011.

McWilliams, Carey. *North from Mexico: The Spanish-Speaking People of the United States.* Philadelphia: J. B. Lippincott, 1949.

———. *Southern California Country: An Island on the Land.* New York: Duell, Sloan & Pearce, 1946.

Mehr, Linda Harris. "The Way We Thought We Were: Images in World War II Films." In *The Way We Really Were: The Golden State in the Second Great War,* edited by Roger W. Lotchin, 30–46. Urbana: University of Illinois Press, 2000.

Meredith, James H. *Understanding the Literature of World War II: A Student Casebook to Issues, Sources, and Historical Documents.* Westport, Conn: Greenwood Press, 1999.

Metler, Suzanne. *Soldiers to Citizens: The GI Bill and the Making of the Greatest Generation.* New York: Oxford University Press, 2005.

Meyer, Stephen Grant. *As Long as They Don't Move Next Door: Segregation and Racial Conflict in American Neighborhoods.* Lanham, Md.: Rowman & Littlefield, 2001.

Meyerowitz, Joanne, ed. *Not June Cleaver: Women and Gender in Postwar America, 1945–1960.* Philadelphia: Temple University Press, 1994.

Milkman, Ruth. *Gender at Work: The Dynamics of Job Segregation by Sex during World War II.* Urbana: University of Illinois Press, 1987.

———. "Redefining 'Women's Work': The Sexual Division of Labor in the Auto Industry during World War II." In *Women and Power in American History: A Reader.* Vol. 2, edited by Kathryn Kish Sklar and Thomas Dublin, 209–22. Englewood Cliffs, N.J.: Prentice Hall, 1991.

Mink, Gwendolyn. *The Wages of Motherhood: Inequality in the Welfare State, 1917–1942.* Ithaca, N.Y.: Cornell University Press, 1995.

Molina, Natalia. *Fit to Be Citizens? Public Health and Race in Los Angeles, 1879–1939.* Berkeley: University of California Press, 2006.

Monroy, Douglas. *Rebirth: Mexican Los Angeles from the Great Migration to the Great Depression.* Berkeley: University of California Press, 1999.

Montgomery, David. "After the War, A Struggle for Equality." *Washington Post,* 22 September 2007. http://defendthehonor.org/?p=535. 8 December 2011.

Moore, Joan W. *Going Down to the Barrio: Homeboys and Homegirls in Change.* Philadelphia: Temple University Press, 1991.

Muncy, Robyn. *Creating a Female Dominion in American Reform, 1890–1935.* New York: Oxford University Press, 1994.

Myrdal, Gunnar. *An American Dilemma: The Negro Problem and Modern Democracy.* New York: Harper and Brothers, 1944.

Nash, Gerald. *The American West Transformed: The Impact of the Second World War.* Bloomington: Indiana University Press, 1985.

Ngai, Mae. *Impossible Subjects: Illegal Aliens and the Making of Modern America.* Princeton, N.J.: Princeton University Press, 2004.

Nicolaides, Becky M., and Andrew Weise, eds. *The Suburb Reader.* New York: Routledge, 2006.

Northrup, Herbert R. "The Negro in the Aerospace Industry." In *A Hammer in Their Hands: A Documentary History of Technology and the African-American*

Experience, edited by Carroll Pursell, 265–76. Cambridge, Mass.: MIT Press, 2005.

Odem, Mary. *Delinquent Daughters: Protecting and Policing Adolescent Female Sexuality in the United States, 1885–1920*. Chapel Hill: University of North Carolina Press, 1995.

Omi, Michael, and Howard Winant. *Racial Formation in the United States from the 1960s to the 1990s*. New York: Routledge, 1994.

O'Neil, Brian. "The Demands of Authenticity: Addison Durland and Hollywood's Latin Images during World War II." In *Classic Hollywood, Classic Whiteness*, edited by Daniel Bernardi, 359–85. Minneapolis: University of Minnesota Press, 2001.

Orenstein, Dara. "Void for Vagueness: Mexicans and the Collapse of Miscegenation Law in California." *Pacific Historical Review* 74, no. 3 (2005): 367–407.

Oropeza, Lorena. *¡Raza Sí! ¡Guerra No! Chicano Protest and Patriotism during the Viet Nam War Era*. Berkeley: University of California Press, 2005.

Pagán, Eduardo Obregón. *Murder at the Sleepy Lagoon: Zoot Suits, Race, and Riot in Wartime L.A.* Chapel Hill: University of North Carolina Press, 2003.

Panunzio, Constantine. "Intermarriage in Los Angeles, 1924–1933." *American Journal of Sociology* 48 (1942): 690–701.

Pascoe, Peggy. *What Comes Naturally: Miscegenation Law and the Making of Race in America*. New York: Oxford University Press, 2009.

Peiss, Kathy. *Hope in a Jar: The Making of America's Beauty Culture*. New York: Metropolitan Books, 1998.

———. *Zoot Suit: The Enigmatic Career of an Extreme Style*. Philadelphia: University of Pennsylvania Press, 2011.

Perales, Monica. *Smeltertown: Making and Remembering a Southwest Border Community*. Chapel Hill: University of North Carolina Press, 2010.

Perrett, Geoffrey. *Days of Sadness, Years of Triumph: The American People, 1939–1945*. Madison: University of Wisconsin Press, 1973.

Pesotta, Rose. *Bread Upon the Waters*. New York: Dodd, Mead, 1944.

Pike, Frederick B. *FDR's Good Neighbor Policy: Sixty Years of Generally Gentle Chaos*. Austin: University of Texas Press, 1995.

Ponce, Mary Helen. *Hoyt Street: Memories of a Chicana Childhood*. New York: Anchor Books, Doubleday, 1993.

Poniewozik, James. "Ken Burns, the Interview: Episode 2—The Hispanic Controversy," 21 September 2007. http://entertainment.time.com/2007/09/21/ken_burns_the_interview_episod_1/. 8 December 2011.

Quiñonez, Naomi. "Rosita the Riveter: Welding Tradition with Wartime Transformations." In *Mexican Americans and World War II*, edited by Maggie Rivas-Rodriguez, 245–68. Austin: University of Texas Press, 2005.

Ramírez, Catherine Sue. "Crimes of Fashion: The Pachuca and Chicana Style Politics." *Meridians: Feminism, Race, Transnationalism* 2, no. 2 (2002): 1–35.

———. *The Woman in the Zoot Suit: Gender, Nationalism, and the Cultural Politics of Memory*. Durham, N.C.: Duke University Press, 2009.

Ramos, Henry A. J. *The American GI Forum: In Pursuit of the Dream, 1948–1983*. Houston, Tex.: Arte Público Press, 1998.

Reed, Merl Elwyn. *Seedtime for the Modern Civil Rights Movement: The President's Committee on Fair Employment Practice, 1941–1946*. Baton Rouge: Louisiana State University Press, 1991.

Reisler, Mark. *By the Sweat of Their Brow: Mexican Immigrant Labor in the United States, 1900–1940*. Westport, Conn.: Greenwood Press, 1976.

Ríos-Bustamante, Antonio, and Pedro Castillo. *An Illustrated History of Mexican Los Angeles, 1781–1985*. Los Angeles: University of California, Chicano Studies Research Center Publications, 1986.

Rivas-Rodriguez, Maggie, et al. *A Legacy Greater than Words: Stories of U.S. Latinos and Latinas of the WWII Generation*. Austin: University of Texas Press, 2006.

———, ed. *Mexican Americans and World War II*. Austin: University of Texas Press, 2005.

Robertson, Nancy Marie. *Christian Sisterhood, Race Relations, and the YWCA, 1906–1946*. Urbana: University of Illinois Press, 2007.

Roeder, George H., Jr. *The Censored War: American Visual Experience during World War II*. New Haven, Conn.: Yale University Press, 1993.

Romano, Renee C. *Race Mixing: Black-White Marriage in Postwar America*. Cambridge, Mass.: Harvard University Press, 2003.

Romero, Mary. *Maid in the U.S.A.* New York: Routledge, 2002.

Romero, Rolando, and Amanda Nolacea Harris, eds. *Feminism, Nation, and Myth: La Malinche*. Houston, Tex.: Arte Público Press, 2005.

Romo, Ricardo. *East Los Angeles: History of a Barrio*. Austin: University of Texas Press, 1983.

Rosas, Ana Elizabeth. "Breaking the Silence: Mexican Children and Women's Confrontation of Bracero Family Separation, 1942–1964." *Gender & History* 23, no. 2 (August 2011): 382–400.

Rose, Margaret. "Gender and Civic Activism in Mexican American Barrios in California: The Community Service Organization, 1947–1962." In *Not June Cleaver: Women and Gender in Postwar America, 1945–1960*, edited by Joanne Meyerowitz, 177–200. Philadelphia: Temple University Press, 1994.

Ruchames, Louis. *Race, Jobs & Politics: The Story of FEPC*. New York: Columbia University Press, 1953.

Ruiz, Vicki L. "And Miles to Go . . .": Mexican Women and Work, 1930–1985." In *Western Women: Their Land, Their Lives*, edited by Vicki L. Ruiz, Lillian Schlissel, and Janice Monk, 117–36. Albuquerque: University of New Mexico Press, 1989.

———. *Cannery Women, Cannery Lives: Mexican Women, Unionization, and the California Food Processing Industry, 1930–1950*. Albuquerque: University of New Mexico Press, 1987.

———. *From Out of the Shadows: Mexican Women in Twentieth-Century America*. New York: Oxford University Press, 1998.

———. "Luisa Moreno and Latina Labor Activism." In *Latina Legacies: Identity, Biography, and Community*, edited by Vicki L. Ruiz and Virginia Sánchez Korrol, 175–92. New York: Oxford University Press, 2005.

———. "Nuestra América: Latino History as United States History." *Journal of American History* 93, no. 3 (December 2006): 655–72.

———. "*Perez v. Sharp*." In *Latinas in the United States: A Historical Encyclopedia*, edited by Vicki L. Ruiz and Virginia Sánchez Korrol, 573. Bloomington: Indiana University Press, 2006.

———. "'Star Struck': Acculturation, Adolescence, and the Mexican American Woman, 1920–1950." In *Between Two Worlds: Mexican Immigrants in the United States*, edited by David G. Gutiérrez, 125–47. Wilmington, Del.: Scholarly Resources, 1996.

Rupp, Leila J. *Mobilizing Women for War: German and American Propaganda, 1939–1945*. Princeton, N.J.: Princeton University Press, 1979.

Sánchez, George I. "Pachucos in the Making." *Common Ground* (Fall 1943): 13–20.

Sánchez, George J. *Becoming Mexican American: Ethnicity, Culture, and Identity in Chicano Los Angeles, 1900–1945*. New York: Oxford University Press, 1993.

———. "'Go after the Women': Americanization and the Mexican Immigrant Woman, 1915–1929." In *Unequal Sisters: A Multicultural Reader in U.S. Women's History*, edited by Ellen Carol DuBois and Vicki Ruiz, 250–63. New York: Routledge, 1990.

———. "'What's Good for Boyle Heights Is Good for the Jews: Creating Multiracialism on the Eastside during the 1950s." *American Quarterly* 56, no. 3 (2004): 633–61.

Santillán, Richard. "Rosita the Riveter: Midwest Mexican American Women during World War II, 1941–1945." *Perspectives in Mexican American Studies* 2 (1989): 115–47.

Sato, Chitose. "Gender and Work in the American Aircraft Industry during World War II." *Japanese Journal of American Studies* no. 11 (2000): 147–72.

Savage, Barbara Dianne. *Broadcasting Freedom: Radio, War, and the Politics of Race, 1938–1948*. Chapel Hill: University of North Carolina Press, 1999.

Schiesl, Martin J. "Airplanes to Aerospace: Defense Spending and Economic Growth in the Los Angeles Region, 1945–1960." In *The Martial Metropolis: U.S. Cities in War and Peace*, edited by Roger W. Lotchin, 135–49. New York: Praeger, 1984.

Schipske, Gerrie. *Rosie the Riveter in Long Beach*. Charleston: Arcadia Publishing, 2008.

Schneider, Eric C. *In the Web of Class: Delinquents and Reformers in Boston, 1810s-1930s*. New York: NYU Press, 2007.

Schrecker, Ellen. *Many Are the Crimes: McCarthyism in America*. Boston: Little, Brown, 1998.

Shockley, Megan Taylor. *"We, Too, Are Americans": African American Women in Detroit and Richmond, 1940–1954*. Urbana: University of Illinois Press, 2004.

Sides, Josh. *L.A. City Limits: African American Los Angeles from the Great Depression to the Present*. Berkeley: University of California Press, 2003.

Singh, Nikhil Pal. *Black Is a Country: Race and the Unfinished Struggle for Democracy*. Cambridge, Mass.: Harvard University Press, 2004.

Slotkin, Richard. "Unit Pride: Ethnic Platoons and the Myths of American Nationality." *American Literary History* 13, no. 3 (2001): 469–98.

Sollors, Werner. *Beyond Ethnicity: Consent and Descent in American Culture*. New York: Oxford University Press, 1986.

Solomon, Larry R. *Roots of Justice: Stories of Organizing in Communities of Color.* Berkeley, Calif.: Chardon Press, 1998.

Stowe, David W. *Swing Changes: Big-Band Jazz in New Deal America.* Cambridge, Mass.: Harvard University Press, 1996.

Strum, Philippa. *Mendez v. Westminster: School Desegregation and Mexican-American Rights.* Lawrence: University Press of Kansas, 2010.

Sugrue, Thomas J. *The Origins of the Urban Crisis: Race and Inequality in Postwar Detroit.* Princeton, N.J.: Princeton University Press, 1996.

Takaki, Ronald. *Double Victory: A Multicultural History of America in World War II.* Boston: Little, Brown, 2000.

Tuck, Ruth D. *Not with the Fist: Mexican Americans in a Southwest City.* New York: Harcourt, Brace, 1946.

Vargas, Zaragosa. *Labor Rights Are Civil Rights: Mexican American Workers in Twentieth Century America.* Princeton, N.J.: Princeton University Press, 2007.

Varzally, Allison. *Making a Non-White America: Californians Coloring Outside Ethnic Lines, 1925–1955.* Berkeley: University of California Press, 2008.

———. "Romantic Crossings: Making Love, Family, and Non-Whiteness in California, 1925–1950." *Journal of American Ethnic History* 23, no. 1 (Fall 2003): 3–54.

Verge, Arthur C. "The Impact of the Second World War on Los Angeles." In *The American West: The Reader,* edited by Walter Nugent and Martin Ridge, 234–54. Bloomington: Indiana University Press, 1999.

———. *Paradise Transformed: Los Angeles during the Second World War.* Dubuque, Iowa: Kendall/Hunt, 1993.

Ward, Geoffrey C. *The War: An Intimate History, 1941–1945.* New York: Alfred A. Knopf, 2007.

Watson, Kendrick W. "Zoot Suit, Mexican Style." *The Intercollegian* (September 1943): 9–10.

Wetta, Frank J., and Martin A. Novelli. "More Like a Painting—*The War: A Ken Burns Film*: An Interview with Roger Spiller." *Journal of Military History* 73, no. 4 (October 2009): 1397–1405.

Wild, Mark. *Street Meeting: Multiethnic Neighborhoods in Early Twentieth-Century Los Angeles.* Berkeley: University of California Press, 2005.

Winchell, Meghan K. *Good Girls, Good Food, Good Fun: The Story of USO Hostesses during World War II.* Chapel Hill: University of North Carolina Press, 2008.

Winkler, Allan M. *The Politics of Propaganda: The Office of War Information, 1942–1945.* New Haven, Conn.: Yale University Press, 1978.

Wood, Bryce. *The Making of the Good Neighbor Policy.* New York: Columbia University Press, 1961.

Yung, Judy. *Unbound Feet: A Social History of Chinese Women in San Francisco.* Berkeley: University of California Press, 1995.

Zamora, Emilio. *Claiming Rights and Righting Wrongs in Texas: Mexican Workers and Job Politics during World War II.* College Station: Texas A&M University Press, 2009.

UNPUBLISHED WORKS

Alvarez, Luis Alberto. "The Power of the Zoot: Race, Community, and Resistance in American Youth Culture, 1940–1945." Ph.D. diss., University of Texas at Austin, 2001.

Apodaca, Maria Linda. "They Kept the Home Fires Burning: Mexican-American Women and Social Change." Ph.D. diss., University of California, Irvine, 1994.

Buelna, Enrique Meza. "Resistance from the Margins: Mexican American Radical Activism in Los Angeles, 1930–1970." Ph.D. diss., University of California, Irvine, 2007.

Escobedo, Elizabeth R. "Mexican American Home Front: The Politics of Gender, Culture, and Community in World War II Los Angeles." Ph.D. diss., University of Washington, 2004.

Greer, Scott. "The Participation of Ethnic Minorities in the Labor Unions of Los Angeles County." Ph.D. diss., University of California, Los Angeles, 1962.

Lazcano, Yazmin. "Historical Memory Negotiated: Latino/a Rhetorical Reception to Ken Burns' 'The War.'" Master's thesis, Texas State University, San Marcos, 2009.

Matzigkeit, Wesley. "The Influence of Six Mexican Cultural Factors on Group Behavior." Master's thesis, University of Southern California, 1947.

Pagán, Eduardo Obregón. "Sleepy Lagoon: The Politics of Youth and Race in Wartime Los Angeles, 1940–1945." Ph.D. diss., Princeton University, Princeton, N.J., 1996.

——. "'Who Are These Troublemakers?' The Mexican-American Middle Class Reacts to Pachucos, 1940–1944." Paper presented at the Annual Meeting of the Organization of American Historians, 1993.

Penrod, Vesta. "Civil Rights Problems of Mexican-Americans in Southern California." Master's thesis, Claremont Graduate School, 1948.

Ramírez, Catherine Sue. "The Pachuca in Chicana/o Art, Literature and History: Reexamining Nation, Cultural Nationalism and Resistance." Ph.D. diss., University of California, Berkeley, 2000.

Wilburn, James R. "Social and Economic Aspects of the Aircraft Industry in Metropolitan Los Angeles during World War II." Ph.D. diss., University of California, Los Angeles, 1971.

VIDEO

The War. Directed by Ken Burns, PBS Home Video, dvd, 2007.
Zoot Suit Riots. Directed by Joseph Tovares, PBS Home Video, videocassette, 2002.

INDEX

Page numbers in italics indicate illustrations.

and, 129; Mexican and Mexican American women's utilization of, 93–95, 125–26; postwar dissolution of, 129; reevaluation of, 91–92

Ferguson, Ophelia, 108

Festival of Nationalities, 141

Fierro, Maria, 78

Fifth Amendment, 133, 140

Figueroa, Dolores, 63

Filipinas, 74, 87, 144

First Amendment, 140

Flores, Eva, 33–34, 35, 39, 40

Flores, Francisca, 138

Foley, Neil, 99

Food, Tobacco, Agricultural, and Allied Workers of America (FTA), 136–37

Food processors, 5, 74, 89, 98–99, 152

Foremen, 84–85, 91, 94, 96

"Four-Four Plan" (student defense work), 73

Four Freedoms, 58

442nd Regiment, 50

Fourteenth Amendment, 133, 142

Fuentes, Angela, 96

Fullerton (Calif.), 133

Galán, Hector, 151

Galvan, Alma, 28

Gang activity, 17, 19, 21, 22, 25, 29, 30, 41, 64, 65, 69, 70

García, Mario, 49

García, Thelma, 52–53

Garfield High School (Los Angeles), 34, 73, 98

Garment workers, 1, 2, 5, 49, 74, 77, 129, 135; unionization of, 136; wages of, 78

Garza, Sandra, 31

Gender conventions: defense work assignments and, 89–90; defense work challenges to, 85, 86, 87; defense work layoffs and, 126–27; Mexican American women's challenge to, 1, 2, 5–6, 8, 9–10, 22, 76–77, 103–23, 145,

154; Mexican family double standard of, 26, 105; pachuca challenge to, 18, 43–44; postwar turn to traditional roles and, 126–27, 146; respectable womanhood image and, 10, 112, 114, 116; sexualized stereotypes and, 12, 109, 120–23; traditional Mexican, 1, 3, 6, 9, 19, 32, 41–42, 76–77, 86, 105, 106, 107, 112–13, 116, 120, 122, 145; USO hostesses and, 10, 70, 113–14, 116; "women's jobs" and, 127; World War II effects on, 30, 113. *See also* Femininity

Gender equity, 5, 14, 84–85, 89, 130

Gerstle, Gary, 99

GI Bill, 132

GI Forum, 3

Gillcraft Aviation Co., 90–91

Girl Reserves clubs, 117

Glendale, 133

Gluck, Sherna, 85

Gonzáles, Anna, 79

Gonzáles, Connie, 1, 2, 3, 10, 12, 105

Gonzáles, Josephine, 22, 24

Gonzáles, Juanita, 22, 24

Gonzáles, Virgie, 106

Good Neighbor Policy, 47–48, 91

Grajeda, Josephine, 52, 54

Great Depression (1930s), 5, 77, 95

Guadalcanal Diary (film), 50, 52

Guadalupe Hidalgo, Treaty of (1848), 75

Guerra, Carlos, 153

Guillen, Agrippina, 125–26

Hair style: male zoot suiter, 19; female pompadour look, 9, 11, 25, 26, 29, 32, 36, 37, 38, 108

Harrison, Celia, 41

Hawthorne, 99, 100, 133

Hayes, Patrick, 52, 54

Helguera, Leon, 50–51, 51

Hernández, Adele, 77, 107, 111, 127

Hernández, Noemi, 28–29

and, 4, 5; Americanization movement and, 41–42, 46, 56, 57–60; antagonism toward interracial marriage of, 143–44; authority relationships shift in, 105; Burns World War II documentary and, 149–54; condemnation of child-rearing practices of, 41–42; continued second-class status of, 71; cultural boundaries faced by, 60; daughters' financial contribution to, 79, 105; daughters' socializing with non-Mexicans and, 31, 111, 116, 121–22; demographic shift in, 5; deportation/repatriation of, 5, 71, 139, 141; discrimination against, 2, 40, 60, 62, 90, 91, 98, 115, 125–26; federal employment discrimination ban and, 91–92; "good" mothers' positive role and, 60–63; Los Angeles neighborhoods of, 8, 111, 120; middle-class anti–juvenile delinquency efforts and, 65; motherhood images of, 41–42, 56–57, 60–63; negative image of, 41–42, 62; outsider status of, 10, 18, 45–47, 71; OWI image-improvement campaign and, 50–52, 53–56, 71; pachuca challenge to, 10, 18, 19, 26, 29, 31–33, 43–44; pathologization of culture of, 61; patriarchalism of, 19, 76–77, 106; patriotism of, 53–57, 76; postwar conditions and, 125–47; sexual morality stereotype and, 42, 61–62; stereotypes of, 42, 47, 56, 57, 61–62, 100, 153; traditional low-wage work of, 5; USO activity acceptance by, 116; wartime changes and, 76–77, 103, 104; "white" status of, 31, 75, 97, 122

"Mexican Girls Meet in Protest" (newspaper article), 66–67, 67, 68

Mexican War, 75

Mexico, 5, 24, 26, 31, 32, 33, 42, 47, 90, 100, 112, 153

Migrant workers, 77, 150

Military personnel. *See* Armed forces

Milkman, Ruth, 84

Miller, Glenn, 107, 108

Miller, Laura, 52, 54

Million Dollar Theater, 108

Minimum wage, 77

Miscegenation, 9, 30–31, 60, 116, 120, 141–44; first successful state law challenge to, 142; statues against, 31, 122, 142, 144

Mobile (Ala.), 149

Molina, Irene, 79

Molina, Natalia, 61

Monte Verde (Mexican American youth club), 112

Morales, Beatrice, 76–77, 80, 83, 85, 87, 98, 127–28, 132, 154

Moreno, Luisa, 92, 137

Motherhood (Mexican), 41–42, 56–57, 60–63; pachuca subculture and, 32–33

Motherhood in Black and White (Feldstein), 61

Mount, Julia Luna, 139

Movie houses, 106

Mutual aid organizations, 111–13

Myrdal, Gunnar, 142; *The Negro Problem,* 34–35

National Association for the Advancement of Colored People, 92–93, 137

National Association of Hispanic Journalists, 150

National Association of Real Estate Boards, Code of Ethics, 134

National Biscuit Company, 129

National Car Loading Company, 87

National Labor Relations Board, 136

National War Labor Board, 84

Native Americans, 151

Naval Reserve Training School, U.S., 8, 120

Navarro, Gloria, 64

Navy Drydocks, U.S. (Terminal Island), 8

Navy Supply Depot, U.S. (San Pedro), 8

Spiller, Roger, 150
State Department, U.S., 129
Steel production, 7
Strikes, 95–96
Studer, Helen, 100
Stumph, Marye, 86
Suburban housing, 133–34
Subversive organizations, 140
Superba (Mexican American youth club), 112
Supreme Court, U.S., 133
Swing music, 107, 108, 109
Swing shift, 83–84, 99–100; leisure activities following, 106–7

Tafoya, Soccorro, 64
Taft-Hartley Act of 1947, 136–37
Texas, 92, 115–16, 122
These Are Americans (radio series), 58–60
Thirty-eighth Street, 21–22
This Is America (Douglas Aircraft photo), 54
Time (magazine), 152
Torrance, 133
Torres, Francisco, 94
Torres, Helen, 1
Tosti, Don, 111
Traynor, Roger, 142
Trujillo, Vera Duarte, 43, 56
Truman, Harry, 129
Tucker, C. H., 64

Unions. *See* Labor movement; *specific unions*
United Auto Workers–Congress of Industrial Organizations (UAW-CIO), 95–96
United Cannery, Agricultural, Packing and Allied Workers of America, 6, 136–37, 139
United Service Organizations. *See* USO
United States Employment Service (USES), 87, 97, 98, 128

University of Texas, 129; Inter-American Committee, 115
Urban League, Los Angeles, 88
USES. *See* United States Employment Service
USO (United Service Organization), 15, 51, 113–18; founding/purpose of, 113; hostess ladylike image, 10, 70, 113–14, 116; Mexican American affiliate of, 15, 69–71, 116–20, *119*

Vargas, Gloria, 108
Vargas, Zaragosa, 137
Vega, Francisco, 153
Vega Aircraft, 7
Velarde, Connie, 105–6, 116, 154
Velarde family, 105–6
Vélez, Lupe, 4
Venegas, Amelia, 17–18, 19, 44, 63–64
Venereal disease, 31
Ventura School for Girls, 23–24, 38, 39, 40
Veterans, 127, 132
"Victory girls," 30–31
Vietnam War, 131
Villa, Sarah, 40
Villalobos, Juanita, 109
Virginity, 26, 68
Volunteerism, 14, 46, 51, 113, 114, 116. *See also* USO
Vultee Aircraft, 7, 86, 98

Wages: California minimum wage, 77; in defense industry, 1, 2, 4, 14, 21, 28, 73, 74, 77–78, 84; discrimination against Mexican workers and, 77, 78, 94; Mexican American women's autonomy and, 105–6, 107; uniform scale of, 84, 89; unionization effects on, 97; women's segregation and, 85; women's wartime leisure pursuits and, 105–6, 107
Wallace, Henry, 138